Elizabeth B

Kurt Schwit
Merzbau:
The Cath

Princeton Arc

Published by
Princeton Architectural Press
37 East 7th Street
New York, NY 10003
212.995.9620
www.papress.com

Editor: Eugenia Bell
Layout: Mia Ihara
Cover Design: Sara Stemen
Cover Image: Hannover Merzbau,
photograph c. 1930 (courtesy of the
Museum of Modern Art, New York).

Special thanks: Ann Alter, Jan Cigliano,
Jane Garvie, Caroline Green, Beth Harrison,
Clare Jacobson, Leslie Ann Kent,
Mark Lamster, Annie Nitschke,
Lottchen Shivers, and Jennifer Thompson
of Princeton Architectural Press
—Kevin C. Lippert, publisher

Library of Congress
Cataloging-in-Publication Data

Gamard, Elizabeth Burns, 1958–
 Kurt Schwitters, Merzbau : the Cathedral
of erotic misery /
Elizabeth Burns Gamard
 p. cm.
 ISBN: 1-56898-136-8 (alk. paper)
 1. Schwitters, Kurt, 1887-1948. Merzbau.
2. Schwitters, Kurt, 1887–1948—Criticism
and interpretation. 3. Assemblage (Art)
Germany. 4. Expressionism (Art)—
Germany. I. Title.
N6888.S42 A7 1998
709'.2—dc21 97-45031
 CIP

ACKNOWLEDGEMENTS

Dedicated to the study of Kurt Schwitters' pre-eminent work of art, the Hannover Merzbau, the sum of this book has taken six years to write—though it has been several more years in the making. I am indebted to a number of institutions and individuals who have supported this project.

The assistance provided by the Graham Foundation for Advanced Studies in the Fine Arts during the early stages of the project enabled travel to several archives and museums. Of these, I would like to thank the Kurt Schwitters Archiv, Stadtbibiothek Hannover, particularly Frau Maria Haldenwanger who was exceedingly helpful and generous with her time. I would also like to thank Dr. Isabel Schulz, Director of the Kurt Schwitters Archiv at the Sprengel Museum-Hannover (SMH), for her help with the latter stages of the project. In Paris, the correspondence archives of the Bibliothèque Nationale and the Bibliothèque Littéraire Jacques Doucet-Bibliothèque Ste. Geneviève were indispensable to an understanding of the myriad relationships, both personal and professional, that informed Schwitters' creative activities; the Bauhaus Archiv, especially Frau Sigrid Heimrich and Dr. Peter Hahn, the Museum für Verkehr und Technik-Berlin (now the Deutsche Technikmuseum Berlin), and the Akademie der Künste-Berlin for their accomodation of a West Berliner Museum Exchange Grant. I would also like to thank the staff of the Museum of Modern Art Photographic Archive, especially Mikki Carpenter, for helping locate several works by Schwitters, a task that was also aided by Marlborough Fine Arts Ltd. London; the Beineke Rare Book Library and Archiv at Yale University and the Art and Architecture Library, also at Yale; Jet Prendeville of the Brown Fine Arts Library at Rice University; Galerie Gmurzynska; Cologne, the Solomon R. Guggenheim Museum, New York; the Moderna Museet, Stockholm; and Galerie Kornfeld, Bern. Of special mention are my students at the Central European University in Prague, many of whom kept me up all night, every night with their questions and insights into an expanded avant-garde project, their motivated (and motivating) transgression of limits, and

their commitment to immersive research into a new world born. I am still learning from them.

I am deeply indebted to Dr. Hans Frei and Ursula Suter Frei (Zürich) for helping me to frame the issues while introducing me to Dauphinéer's Switzerland and going along with my request to visit every city in search of Kurt Schwitters and Joseph Beuys; to Donald Gatzke, Dean of the School of Architecture at Tulane University for the gift of time; to Professor John Casbarian for his support and advice on the project and life in general; to Dr. Richard Wolin for the acuity of his intellectual critique and his shared enthusiasms; to the late Dr. Konstantin Kolenda for introducing me to Ludwig Wittgenstein and going over my writing word by word, phrase by phrase; to Dr. William Camfield for his generosity of spirit and the bounty of his work; to Kevin Lippert for his enthused interest at the beginning of the project; to Spencer Parsons for his peripatetic view of Paris and his prodding of discipline; to Dr. Gwendolen Webster for her encouragement and the timely autobiographical study of Schwitters; to Dr. Annegreth Nill for her enormous insight into Schwitters' work, in particular her search for the hermeneutic content of Schwitters' Merz-paintings and literary works; to Christian Schmidt for backing up my translations, helping me locate sources on Schwitters in Berlin, and for reminding me in general of my time living and working in Berlin, before and after die Wende; and Dr. Richard Ingersoll for his honest and deliberative critique of my earlier writings on Schwitters, and for asking the questions that uncovered veins of research that have become central to my work, and other important things.

I wish to also thank my colleagues at Tulane, in particular Professor Ashley Schafer for her challenge that we make it a race to the finish line; Dr. Carol McMichael Reese for her grace under fire, irreverent wit and an appreciation of what it takes; Dr. Elizabeth English, whose work on Russian mysticism enlightened my own work on German mysticism; Dr. Ila Berman for her deep reservoir of empathy and still more ideas; Francine Judd for her beautiful photography and way of seeing; and Terry Hogan for help with the details. I would also like to thank my fellow travelers, Professors Sharon Matthews, Andrea Kahn, and Carol Burns especially, for their demands for rigor and reminding me to keep it all in perspective; and Professor Vincent Castagnacci for opening my eyes, heart and mind to the world by releasing me from the burdens of habit.

For their abiding faith, and more than a few meals and cups of coffee, I wish to express my gratitude to those who have been through the thick and

thin of this project, and who have supported me to the highest degree imaginable, personally and otherwise: Kate Gottsegen, Cheryl R. Becnel, John Terry, Betty Yates Burns, and J. Keenan Burns, Sr. I must here end my scroll by recognizing the significant contributions of Eugenia Bell, my editor at Princeton Architectural Press, whose endless patience, directness, encouragement, and friendship have enabled me to sustain the project over the past two years.

Finally, I am most indebted to Lindy Roy, who made much of this possible by recognizing, hearing, and applauding my voice as it struggled in the thinner air of another place and time. To Lindy I extend my heartfelt and deepest gratitude.

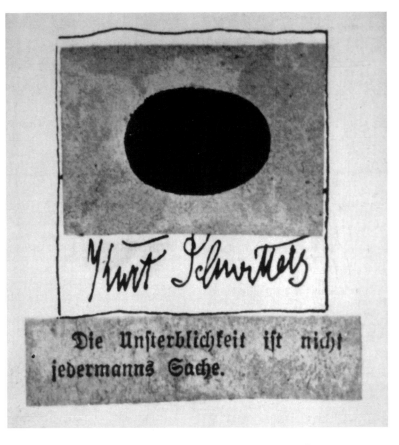

Kurt Schwitters. *Die Unsterblichkeit ist nicht jedermanns Sache*
(*Immortality is not everybody's thing*); 1922, 25.4 x 20.3 cm.
(Sprengel Museum, Hannover)

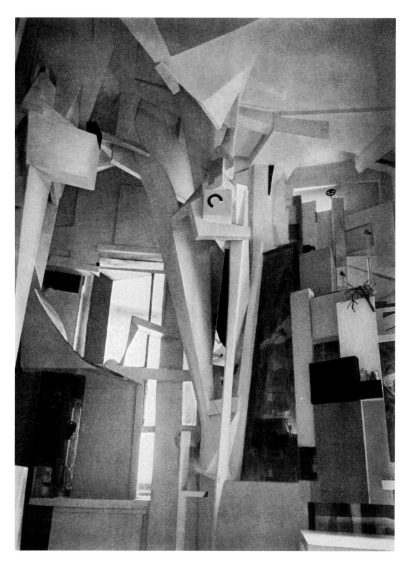

FIG. I Kurt Schwitters. *Hannover Merzbau, mit blaues Fenster* (*Blue Window*); c. 1930, photograph. (Museum of Modern Art, New York)

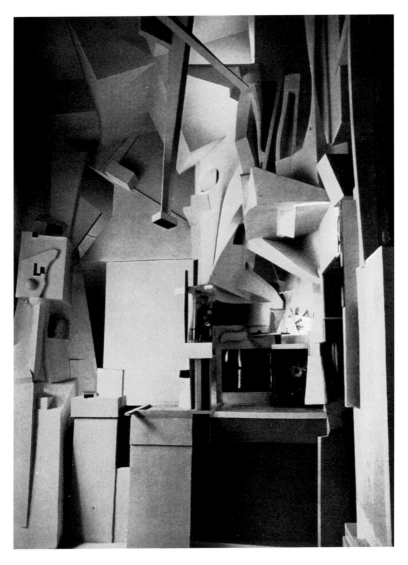

FIG. 2 Kurt Schwitters. Hannover Merzbau, showing the *Gold Group, Big Group* and *Moveabale Column*, c. 1930, photograph. (Museum of Modern Art, New York)

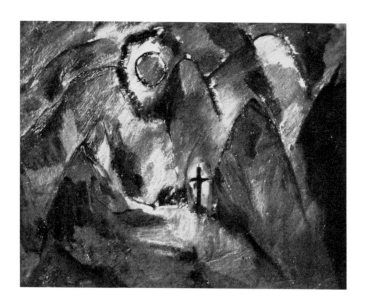

FIG. 3 Kurt Schwitters. G Expression 2, *die Sonne im Hochgebirge*
(*The Sun in High Mountains*); 1917, oil. (whereabouts unknown)

FIG. 4 Kurt Schwitters. *Landschaft aus Opherdicke* (*Opherdicke Landscape*);
1917, oil on board, 55.6 x 50.2 cm. (Marlborough Fine Art, London)

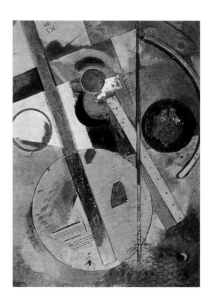

FIG. 5 Kurt Schwitters. *Das Arbeiterbild* (*The Worker Picture*); collage, 125 x 91.3 cm. (Moderna Museet, Stockholm)

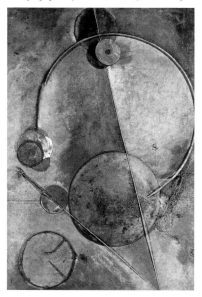

FIG. 6 Kurt Schwitters. *Das Kreisen* (*The Circle*); 1919, assemblage, 117.5 x 83 cm. (Marlborough-Gersen Gallery, New York)

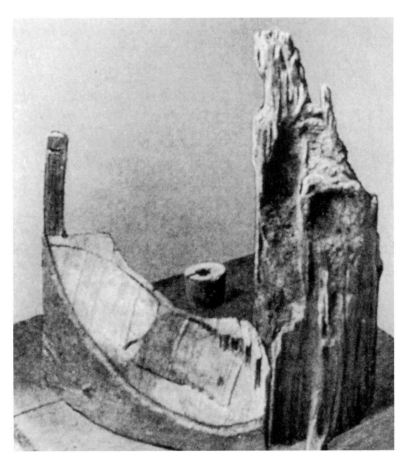

FIG. 7 Kurt Schwitters. *Schloss und Katherale mit Hofbrunnen* (*Castle and Cathedral with Courtyard Well*); assemblage/constrution. (whereabouts unknown)

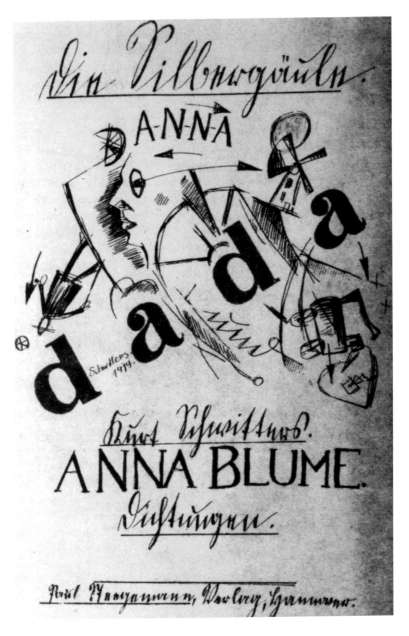

FIG. 8 Kurt Schwitters. Cover design for *Anna Blume Dichtungen* (*Anna Blume Poems*);
1919, lithograph, 22.3 x 14.4 cm.

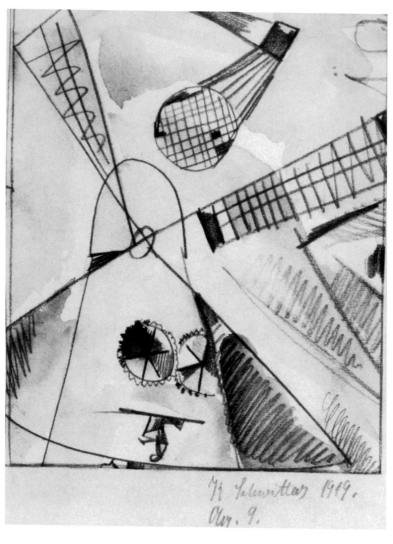

FIG. 9 Kurt Schwitters. *Aq. 9 Windmülle* (*Windmill*); 1919, watercolor and pencil on paper, 17.15 x 14.29 cm. (Galerie Kornfeld, Bern)

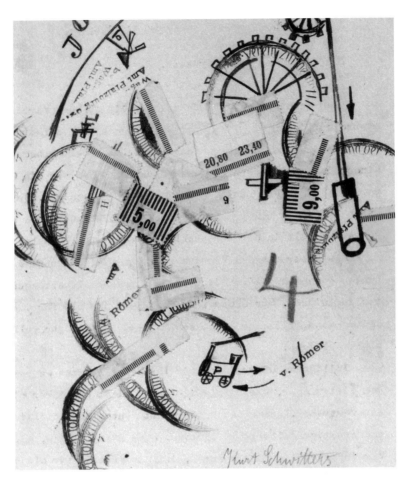

FIG. 10 Kurt Schwitters. *mit oter vier* (*with red four*); 1919, stamp drawing and collage, 17.5 x 15.2 cm. (Marlborough Fine Art, London)

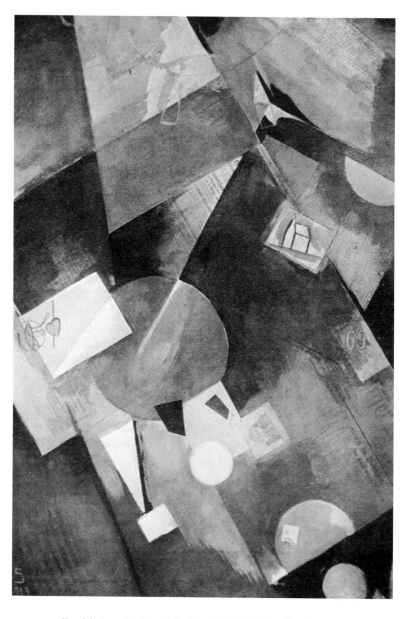

FIG. II Kurt Schwitters. Merzbild 5B *Rot-Herz-Kirche* (*Red-Heart-Church*); painted collage, 83.5 x 60.2 cm. (Solomon R. Guggenheim Museum, New York)

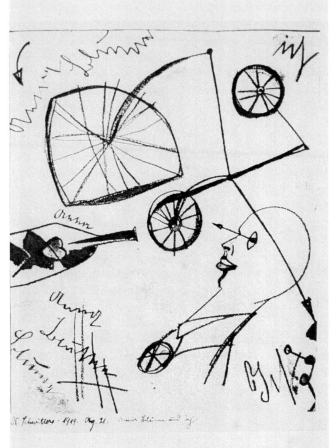

Figure 52. Schwitters, *Aq. 21, Anna Blume und Ich* [Anna Blu~
~nd crayon, 21.1 × 17.2 cm. Private collection, Switzerland.

FIG. 12 Kurt Schwitters. *Aq. 21 Anna Blume und Ich* (*Anna Blume and I*); 1919, watercolor and crayon, 21.1 x 17.2 cm. (Private collection, Switzerland)

FIG. 13 Kurt Schwitters. *Die heilige Bekümmernis* (*The Holy Afliction*); c. 1920, assemblage. (project destroyed)

FIG. 14 Kurt Schwitters. *Die Kultpumpe* (*The Cult Pump*); c. 1919,
assemblage. (whereabouts unknown)

FIG. 15 Kurt Schwitters. *Der Lustgalgen* (*The Pleasure Gallows*); c. 1919,
assemblage. (whereabouts unknown)

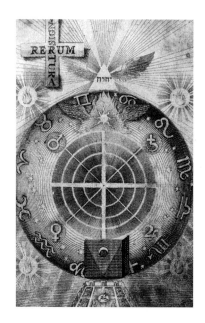

FIG. 16 Jakob Bohme. *The Wheel*
(*Properties of Planets or Source of Spirits according to JB*); drawing.

FIG. 17 Kurt Schwitters. *Aquarell Nr. 1 Das Herz geht vom Zucker zum Kaffee*
(*The Heart Goes from Sugar to Coffee*); 1919, watercolor and pencil, 30.2 x 22.8 cm.
(The Museum of Modern Art, New York)

FIG. 18 Max Ernst. *la canalisation de gaz rigofirié* (*Canalisation of Refrigerated Gas*); 1919–20,
imprinted drawing, stamps of printer's blocks with ink, watercolor, and gouache on paper,
54 x 38 cm. (The Menil Collection, Houston)
© 2000 Artists Rights Society (ARS), New York/ADAGP, Paris

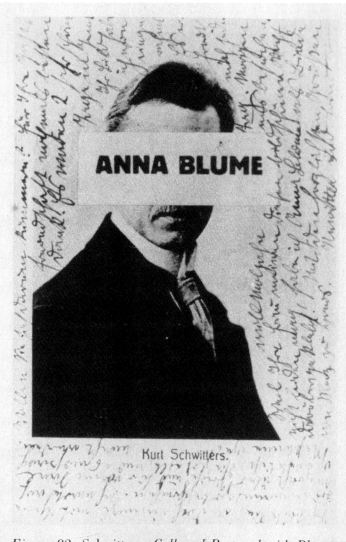

Figure 82. Schwitters, *Collaged Postcard with Photograph of Schwitters: "Anna Blume,"* 1921. Collage, 14 × 9 cm. Galerie Gmurzynska, Cologne.

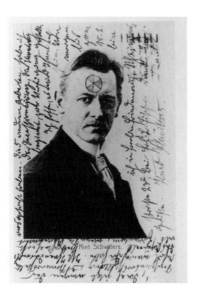

FIG. 20 Kurt Schwitters. *Wheel*; 1921, collaged postcard with photograph of Schwitters, 14 x 9 cm. (Galerie Gmurzynska, Cologne)

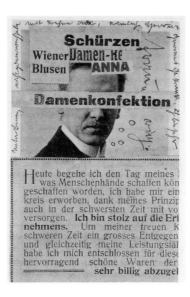

FIG. 21 Kurt Schwitters. *Damenkonfektion* (*Women's Ready-to-Wear*); 1921, collaged postcard with photograph of Schwitters, 14 x 9 cm. (Galerie Gmurzynska, Cologne)

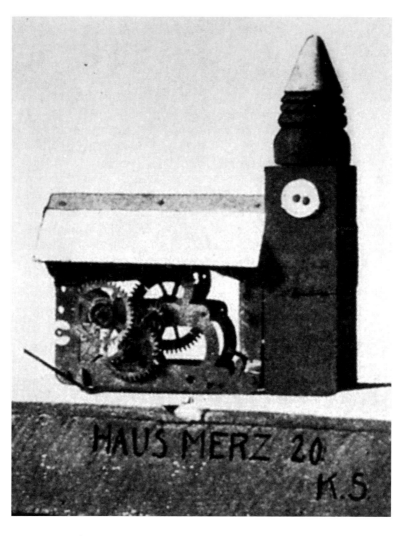

FIG. 22 Kurt Schwitters. *Haus Merz* (*House Merz*); c.1920, assemblage. (whereabouts unknown)

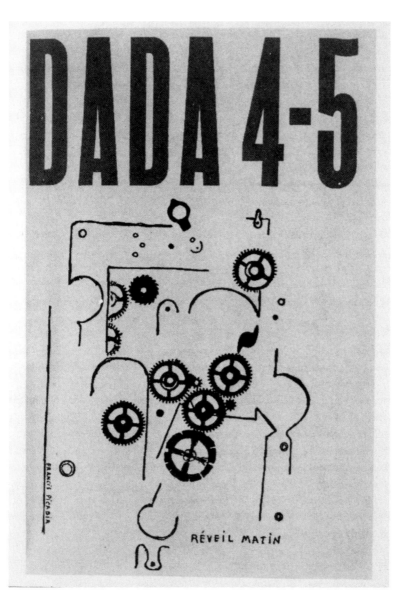

FIG. 23 Francis Picabia. *Révil-matin* (*Alarm Clock*); title page for *Dada*, no. 4-5, 1919.

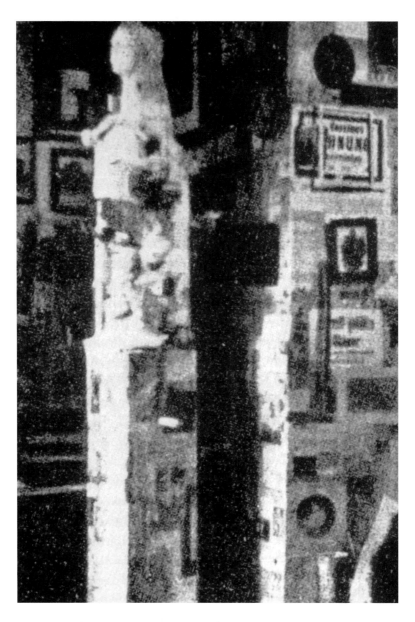

FIG. 24 Kurt Schwitters. *Der erste Tag Merz-saule* (*The First Day Merz-column* with *Leiden sculpture*);
c. 1920, assemblage. (whereabouts unknown, photograph courtesy of Kurt Schwitters Archive,
Sprengel Museum, Hannover)

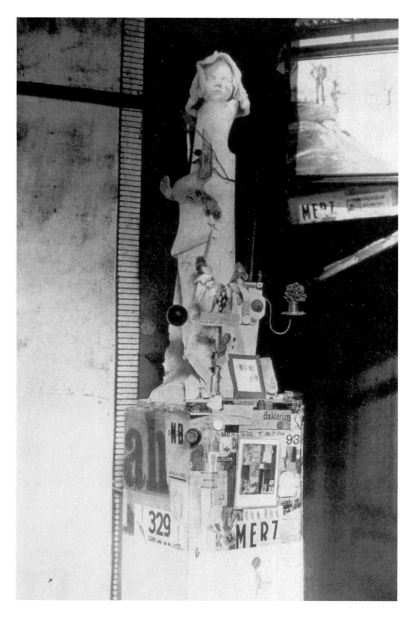

FIG. 25 Kurt Schwitters. Hannover Merzbau, *Merzsaule* (*Merz-column* with death mask of first son, Gerd); c.1923 assemblage. (whereabouts unknown, photograph courtesy of Kurt Schwitters Archive, Sprengel Museum, Hannover)

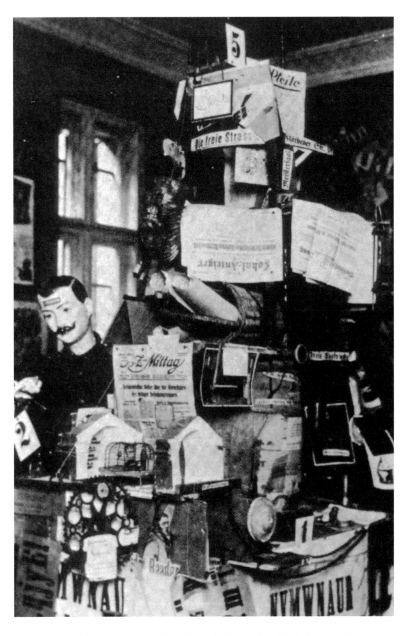

FIG. 26 Kurt Schwitters. *Das grosse Plasto-Dio-Dada-Drama: Deutchlands Grösse und Untergang* (*Great Plasto-Dio-Dada-Drama: Germany's Greatness and Downfall*); 1920, assemblage. (whereabouts unknown)

FIG. 27 Kurt Schwitters. *Der erste Tag Collage* (*The First Day Collage*); c. 1918–19, collage.
(whereabouts unknown, photograph courtesy of Kurt Schwitters Archive,
Sprengel Museum, Hannover)

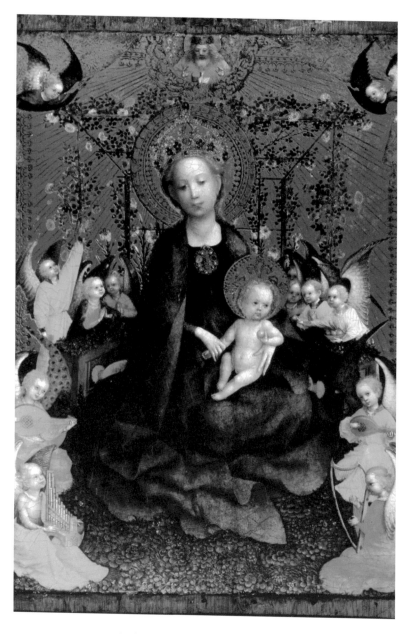

FIG. 28 Stephen Lochner. *Madonna in the Rose Bower*; c. 1448.

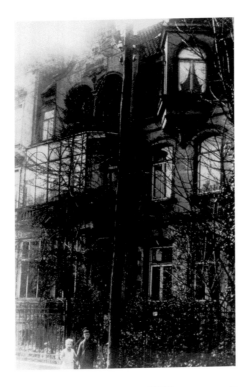

FIG. 29 Photograph of Schwitters' house at Waldhausenstrasse 5, Hannover
(with artist's son, Ernst Schwitters, at foreground at right); c. 1926.

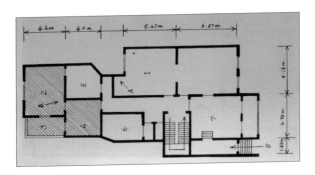

FIG. 30 Waldenhausenstrasse 5: Ground floor plan of Schwitters' apartment. Shaded areas
indicate principal rooms occupied by the *Merzbau*. 1. Schwitters' first studio, c. 1918–21; A: Site
of the 1920 Column; 2. Schwitters' principal studio and the most fully developed room of the
Merzbau.; B. Site of the 1923 Column; 3. Balcony, *Merzbau* extended here, c. 1925-26; 5. and 6.
Kitchens; 7. Entrance hall; 8. Street entrance to house, 1926. (Museum of Modern Art)

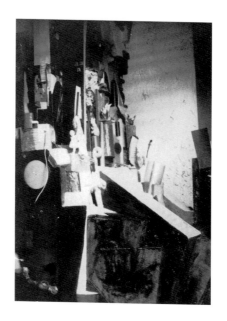

FIG. 31 Kurt Schwitters. *Hannover Merzbau: Kathedrale des errotischen Elends*; c. 1928.

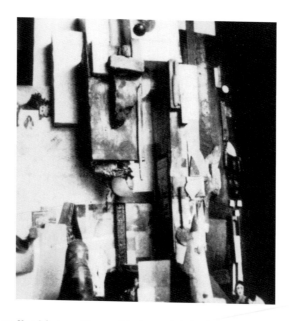

FIG. 32 Kurt Schwitters. *Hannover Merzbau: Kathedrale des erotischen Elends*; c. 1928.

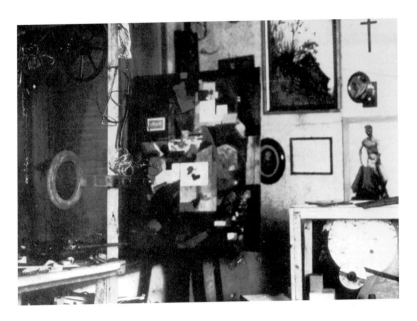

FIG. 33 Kurt Schwitters' studio in Hannover with Kurt Schwitters' *Merzbürne/Normalbühne* (*Merz-theatre*) at bottom right hand of image. (photograph courtesy of Kurt Schwitters Archive, Sprengel Museum, Hannover)

FIG. 34 Hugo Ball reciting poetry at the cafe Voltaire, Zurich; 1917.

FIG. 35 *Ursonate* (opening pages); 1922-23. (Kurt Schwitters Archive, Sprengel Museum, Hannover)

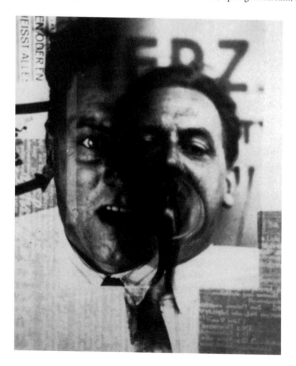

FIG. 36 Kurt Schwitters performing *Die Ursonate*; photo by El Lissitzky.

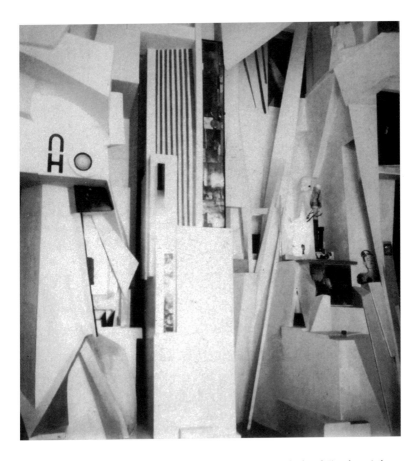

FIG. 37 Kurt Schwitters. *Hannover Merzbau Kathedrale des erotischen Elends* (*KdeE*); column in later state, c. 1930. (photograph courtesy of Kurt Schwitters Archive, Sprengel Museum, Hannover)

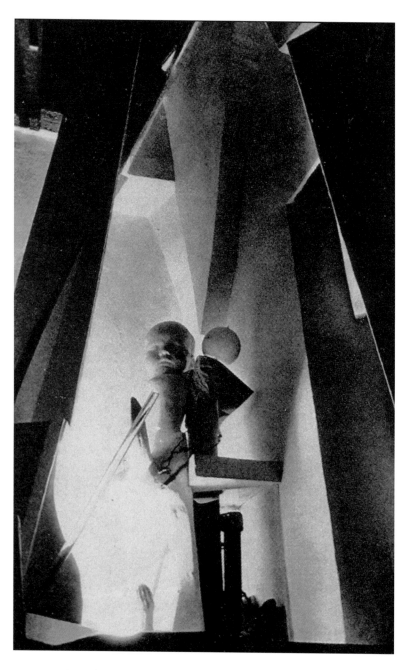

FIG. 38 Kurt Schwitters. *Hannover Merzbau: Kathedrale des erotischen Elends*; general view with 1923 column, c. 1930.

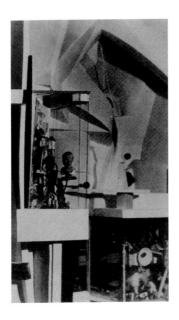

FIG. 39 Kurt Schwitters. *Hannover Merzbau: Kathedrale des erotischen Elends*; *The Gold Grotto*, c. 1932.

FIG. 40 Kurt Schwitters. *Merzbild 1924: 1 Relief mit Kreuz und Kugel* (*Relief with cross and ball*); 1924. (photograph courtesy Kurt Schwitters Archive, Sprengel Museum, Hannover)

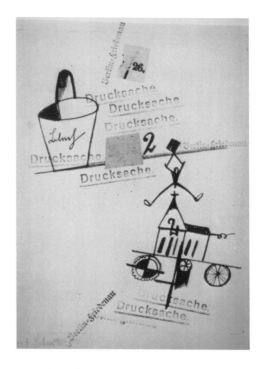

FIG. 41 Kurt Schwitters. *Stempelzeichnung* (*Stamp Drawing*);
from the *Sturmbilderbucr,* 1919.

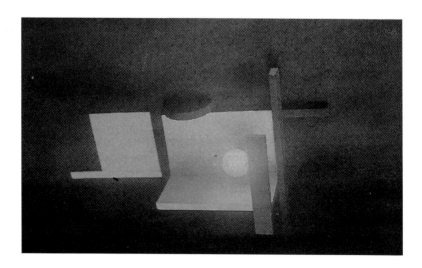

FIG. 42 Kurt Schwitters. *Hannover Merzbau*; detail.

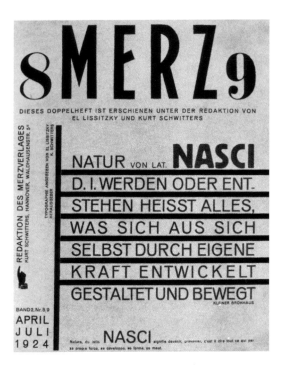

FIG. 43 Kurt Schwitters. Cover of *Natur/Naci* issue of *Merz*, 1924. (Kurt Schwitters
Archive, Sprengel Museum, Hannover)

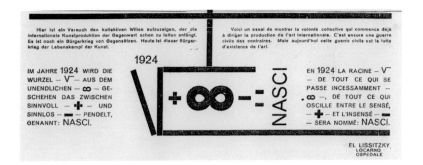

FIG. 44 Theo Van Doesburg. *Infinity Diagram* from *Natur/Naci* issue of *Merz*, 1924.

FIG. 45 Kurt Schwitters and El Lisstizky. Double page spread from *Merz*, 1924.

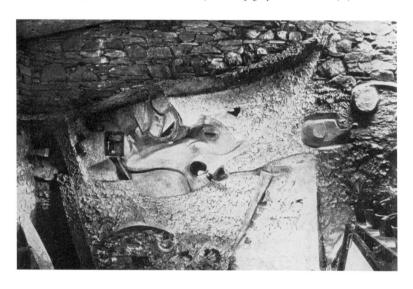

FIG. 46 Kurt Schwitters. *Merzbau* in Little Langdale (*Merzbarn*).
(photograph courtesy University of New Castle, England)

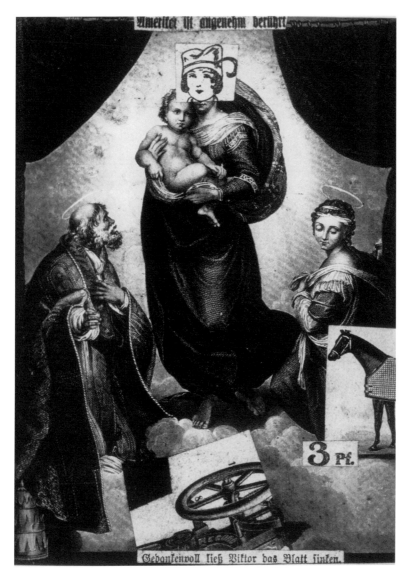

FIG. 47 Kurt Schwitters. *Das Wenzel Kind* (*Knave child*); collage, 17.1 x 12.9 cm. (Sprengel Museum, Hannover)

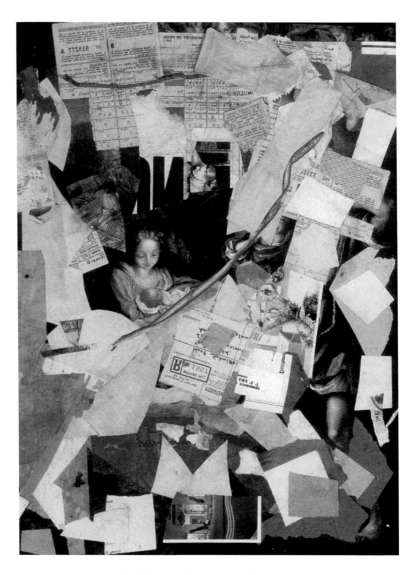

FIG. 48 Kurt Schwitters. *Correggio*; 1947, collage, 52.9 x 38.8 cm.

FIG. 49 Kurt Schwitters. *Modemadonna*; 1924, collage.
(Sprengel Museum, Hannover)

FIG. 50 Kurt Schwitters. *Hannover Merzbau Madonna*; c. 1923, light wood,
plaster, paint, assemblage.

KURT SCHWITTERS' *SEHNSUCHT*

Although completely destroyed by Allied bombing raids over Hannover in 1943, Kurt Schwitters' vast architectural construction, *Die Kathedrale des erotischen Elends* (*The Cathedral of Erotic Misery*, or *Merzbau*, remains one of the most compelling artworks of the twentieth-century (*figs.1 and 2*). Recent interpretations of the *Merzbau* have attempted to explicitly situate the project in terms of contemporary issues in art and architecture, comparing Schwitters' construction with works as diverse as the Francesco Colonna's late-sixteenth century architectural parable *Hypnerotomachia* (*Love and Strife in a Dream*), also known as the *Polyphili*,[1] Abbot Suger's Cathedral at St. Denis, Sir John Soane's House and Museum, and Walter Benjamin's unfinished *Passagenwerk, The Arcades Project.*[2] Artists Robert Rauschenberg and Joseph Beuys, among others have also sought to extend Schwitters' overall artistic project within the framework of their own creative practices.[3] In architecture, the project has been afforded the same talismanic status as Mies van der Rohe's Barcelona Pavilion and Frank Lloyd Wright's Larkin Building in Buffalo. More recently, it has been suggested that architect Rem Koolhaas' research and practice contains traces of both the method and content of Schwitters' unique approach to assemblage. As Ernst Nündel suggests, the physical nature of the *Merzbau*, as well as the ideas that are manifest in the project, continue to develop and grow, "... in the memory of those who have seen it, in the imagination of its descendants, and in the speculations of art historians. Each individual has his or her own interpretation of the *Merzbau.*"[4]

The chaos of Schwitters' personal life and career echoes the tumult of the era in which he lived. Born in 1887, Schwitters' artistic coming-of-age did not occur until after World War I, when he had already reached his thirtieth birthday. Moving successively through expressionism, dada, and constructivism, the rapid development that characterized Schwitters' work was similar to that of most of his contemporaries.[5] In 1937, Schwitters was designated an *entartete Künstler* (degenerate artist) by the Nazis. As a consequence of this and the

ensuing events of World War II, many of his artworks were either lost or destroyed.[6] While Schwitters likely could have managed to forestall any overt action against him by the fascist regime by remaining silent, he chose instead to speak out, privately and publicly, against Hitler's government.[7]

The 'suspicious' activities of Schwitters and many of his close friends and colleagues, finally forced Schwitters to leave for Norway in January of 1938, barely avoiding arrest (officially stated as a request for an interview) by the Gestapo.[8] His son, Ernst, had also been in jeopardy for some time and had left Hannover via Hamburg for Oslo in the early hours of 26 December 1937, thereby preceding his father's emigration by several days. When Nazi Germany invaded Norway in 1940, father and son were again on the move, traveling further to the north before crossing by boat to England where they were incarcerated by the British government and held in internment camps for eighteen months.[9] After their release, Schwitters and his son lived in London before finally moving to the countryside north of the city (Ambleside).

While the degenerate and difficult conditions of his internment resulted in extensive physical and emotional scars, the war and subsequent exile from Germany left him destitute and disoriented in the most literal sense. Virtually unknown in art circles (excepting the United States), Schwitters died in England on the 8th of January 1948. In chronicling his life, Werner Schmalenbach, the German art historian perhaps most responsible for resurrecting Schwitters after the Second World War, described the resonance of Schwitters' legacy at the time of his death: "When Kurt Schwitters died in Englanin his sixty-first year, the event went virtually unnoticed; indeed, his name meant little save to old friends and members of the avant-garde of the 1920s on the Continent. First the Hitler Terror and then the war had scattered these people all over the globe . . . in Germany, he was almost totally forgotten . . . German art circles from 1945 on were mainly concerned with rediscovering the expressionists."[10] Yet despite personal and professional misfortune over the course of his lifetime, Schwitters never lost the sense of who he was as an individual and as an artist. In the words of Walter Benjamin, he was "like a shipwrecked man who keeps afloat by climbing to the top of a mast that is already disintegrating. But from there he has a chance to signal for his rescue."[11] It is one of the sadder pages in modern history that Kurt Schwitters was not rescued during the course of his lifetime. Only recently has the full import of his artwork and contributions begun to be recognized, contributions which are not limited to the world of art and architecture alone, but resonate throughout philosophy and literature as well.

While the resurgence of interest in Schwitters' *Merzbau* has likely been the result of the project's formal characteristics (characteristics that evoke the potential of a variety of current theoretical positions in architecture) it is also due to the relevance of the underlying themes that inform Schwitters' construction. These themes include the role of mysticism, sexuality, and autobiography in the production of art and architecture, as well as the possible reading of the project as a *Wunderkammer*, an archive of the time and space in which it was situated. Developed during a period of intense upheaval in European history, the *Merzbau* indeed represents not only a condensed version of one man's creative and personal life, but a luminous manuscript of events surrounding the First World War, events that continue to resonate throughout the course of art and architectural history.

The actual form and contents of Kurt Schwitters' Hannover *Merzbau* remain somewhat of a mystery still today. Recent scholarship has attempted to unveil the considerable mythology surrounding the project. Rivaled only by the enigmatic content of Marcel Duchamp's *Large Glass* (*The Bride Stripped Bare by Her Bachelors Even*), the *Merzbau* has been described by John Elderfield as a "phantasmagoria and dream grotto." Besides Elderfield's and Schmalenbach's analyses of the *Merzbau*, Dietmar Elger's *Werkmonographie* and Dorothea Dietrich's writings on Schwitters' work have shed considerable light on the project.[12] With her 1997 biography on Kurt "Merz" Schwitters, Gwendolen Webster relied on her conversations with Schwitters' son, Ernst, who elaborated on his own experience playing and living in the project.[13] Literary critic and scholar Ute Brandes' commentary on the *Merzbau* is indispensable in situating the project in terms of German cultural history and, alternately, in terms of Schwitters complex and multifaceted relationship to women.[14] Particular note must be made of the more specialized material developed by Janice Schall[15] and Annegreth Nill,[16] both of whom have attempted to place Schwitters' works in light of recent scholarship on dada. Even more recently, Marc Dachy has suggested that Schwitters' impulse to create a vast *Merzkunstwerk* (Merz work of art),[17] one in which the spectator would be immersed in both time and space, parallels the various architectonic works by El Lissitzky (*Cabinet Abstrait, Prounenraum*), the De Stijl complex known as *l'Aubette à Strasbourg* (1926–1928), a collaborative effort by Hans Arp, Sophie Taüber, and Theo van Doesburg; and the constructions of dada-constructivists Erich Buchholz and Tomoyoshi Murayama, a Japanese national who lived in Berlin during the late-teens and early-twenties.[18] In this sense, Schwitters' construction could

also be compared to Josef Plecnik's extensive architectural ruminations for the city of Ljubljana and even Max Ernst's enigmatic murals installed in Max and Gala Eluard's house in the Paris suburb of Eaubonne as well, though Dachy does not mention these projects specifically. The sum of this material has provided considerable groundwork and insight into the form, method, and contents of the *Merzbau*.

While the *Merzbau* can indeed be viewed as a latent critique of the alienating conditions of modern technological culture (both Elger's and Dietrich's critiques fall into this category) its alternative title, *Die Kathedrale des erotischen Elends* (*The Cathedral of Erotic Misery*) or *KdeE*, suggests the possibility of additional interpretations. Schwitters' own pronouncements on the project were relatively few and far between, and the various anecdotes of individuals who saw the construction over the course of its development are not only fragmentary, but are often times based on the imperfect recall of distant memory. Attempts to unveil the numerous themes which underscore the *Merzbau* must therefore take into account not only Schwitters' statements and the multiple fragments of visitors to the project, but the literary and visual works that parallel its development. While these literary and visual works do not in themselves contain the necessary evidence for a definitive interpretation of Schwitters' specific intentions with regards to the *Merzbau*, selected components of his extensive literary and visual productions, as well as those of his contemporaries, do lend a significant amount of insight into the ideas he was working with from the point of the project's inception (sometime between 1919 and 1923) until his abrupt abandonment of the project at the time of his forced emigration to Norway on the second of January, 1937.

Perhaps the most difficult aspect of Schwitters' approach to his art was the fact that the work was both developmental and incorporative. He did not operate according to a fixed stratagem, but rather forged his material from events and circumstances as they presented themselves. Accordingly, there is no obvious fixed point or referent from which his overall approach might be apprehended. Rather, Schwitters' approach required a seamless interplay between his life and his art. To this end, he was not exclusive, but resolutely inclusive, preferring the accumulation of affects and effects to critical speculation. This is not to say that the work he produced was not subject to critical insight and refinement; he was clearly capable of adjusting and readjusting an initial idea for the sake of the work's efficacy. Yet he did not approach the work of art with a preconceived notion of what should be, but instead worked through the nature and use of materials and artifacts in terms of their intrin-

sic relationships. In this sense, Schwitters' artwork was never about the object itself, but the dynamic of relations that appeared in the course of its making. This approach became more and more refined to the point where nothing he created was not subject to possibile further revisions at some later date. As he stated in an article from 1931 entitled "Ich und meine Ziele" ("Me and my work"), an article that appears as part of *Merz 21. erstes Veilchenheft,* an issue of his *Merzheft* (*Merz-journal*) and contains the first and most elaborate discussion of his *Kathedrale,* the work was, "in principle, always in flux." [19]

While the vast majority of writing on modern art and architecture has extended the Enlightenment project of formulating a master narrative, Kurt Schwitters' literary and visual artworks stand out in their resistance to claims of totality and consolidation. The "modern project to rigor" implicitly exiles artists like Schwitters.[20] In art and architecture, significant recognition is afforded only to those whose works exhibit the necessary transparecy—figuratively and methodologically—for analysis. Schwitters' works dispute this imperative and hence remain largely peripheral to the artistic and critical imagination. Taken together, the peculiarities of his personal circumstances, as well as the opaque nature of his artistic project, have effectively worked in concert to deny Schwitters a significant place in the history of art and literature.

Even today, one of the most critical problems in approaching Schwitters' project lay not with the work itself, but with the terms that have been used to discuss the work. Until recently, nearly all art criticism has relied on formal categories. This is particularly true in the case of modern art criticism, which has conformed almost entirely to the language and ideology of formalist analysis. Hence, most, though not all, attempts to comprehend Schwitters' oeuvre have relied almost entirely on the art-historical context in which he worked, a context which has been developed and refined in such a way as to promote exclusive rather than inclusive categories. The institutional bias present in art museums and the academy resists alternative or exceptional cases. This is clearly the case with Schwitters, who, despite highly publicized exhibitions and the appropriation of his works in support of various movements and individuals, remains marginal to the recognized project of modernism. The art historian Rudi Fuchs, in his short book entitled *Conflicts with Modernism or the Absence of Kurt Schwitters,* renders the following observations on the position of Kurt Schwitters as a 'modern' artist:

Unlike Mondrian (and unlike many contemporary abstract artists who reflect Mondrian's attitude), Kurt Schwitters was never fanatic about purity. He was a very

"impure" artist. And, when I speak of Schwitters' absence, I also mean to say that the very idea of impurity (or the idea of compromise and aesthetic contamination as a source of inspiration) is largely absent from Modernist artistic consciousness. Modernism's insistence on abstraction and on the way to arrive at it, by stripping the medium of its unnecessary or impure elements, had to result in a very rarified idea of an artwork as a thing of extreme clarity, physical elegance, balance, intelligence and perfection...a juggler like Schwitters is seen as a renegade...there was little single-mindedness in his career; there were too many things he wanted to do at the same time. That easily raises the suspicions of amateurism. He had no great interest in the finely chiseled ultimate artwork. He was the practical and poetic magician.[21]

In *Decoding Merz*, Annegreth Nill also confronts this problem, stating that most of Schwitters' work has been almost universally interpreted from a formalist-modernist stance. Among scholars and critics of Schwitters' work there remain, according to Nill, "a veritable conspiracy of denial of [literary] content," that is, questions of meaning.[22] To date, the formal concerns have by and large eclipsed any attempts to apprehend the content, a condition which Schwitters himself contributed to with his repeated allusions to the primacy of form over content in statements regarding his art. Yet it is through the question of content, not in a symbolic sense, but in a hermeneutic sense, that we may begin to understand the intimate relationship between Schwitters' ideas, processes, and productions.

The most complicated and enigmatic of his projects, Schwitters' *Merzbau* mirrors the artist's fitful attempts to negotiate a path through the miasma of his work and life. While he was the primary interlocutor and advocate for this undertaking, Schwitters was also its prevailing subject. Characterized by Hans Richter as "a proliferation that never ceased," the *Merzbau* was a vast, organic enterprise destined to grow unchecked.[23] The literal residence of Schwitters' experience, as well as a primary site of his artistic meditations, the construction did not represent a plan or project in the traditional sense, having no beginning or end. In full accordance with Schwitters' defining principle, the *Merzbau* was perpetually unfinished, capable of being worked and reworked repeatedly; formal refinement and artistic containment were anathema to Schwitters' approach to both life and art.[24] With its labyrinth of associations and inflections, the construction at once responded to the outside world while also remaining wholly removed from it. Representative of the artist's highly individualized cosmology, the *Merzbau* functioned as a safe harbor from the prevailing chaos of Weimar Germany.

Yet it also provided the material for Schwitters' general resistance to the dominant norms of the social, political, and cultural milieu that surrounded him. Countless obstacles make any attempt to decode the form, contents, and meaning of the *Merzbau* a formidable task. First and foremost, perhaps, is the fact that the project no longer exists. The only evidence of it that remains is the recorded anecdotes of individuals who saw the project, a few brief statements regarding the project by Schwitters himself, and a series of photographs which Schwitters took of the project over a period of several years. These personal anecdotes and photographs—images that Schwitters and his son, Ernst, recorded in a highly unsystematic manner—are the primary literary and physical documents scholars and historians have used to reconstitute the project.[25] Consistent with Schwitters' general approach to all his creative undertakings, there was no actual 'plan' for the project. However, there are sketched plans drawn up retrospectively pertaining to the succession of tenants in Waldhauserstrasse 5, the apartment building Schwitters and his family resided in following his marriage to his wife Helma in 1917, sketches that detail the purported ongoing extensions of Schwitters' residence and atelier from 1919 to 1937 provide some insight.[26] These sketches, found by Dietmar Elger around 1980 and confirmed as accurate by the artist's son, are important because they buttress the disputed claims of Hans Richter and others regarding the extent of the construction.[27] Nonetheless, additional plans, sections, and elevations that might specifically detail the architectural dimensions, limits, and contents of the *Merzbau*, if they ever existed, have been lost.[28] Bearing a note describing the project as a "model of a monument to humanity," photographs of the project appeared in a catalogue the 1936–37 New York Museum of Modern Art exhibition entitled "Fantastic Art, dada and Surrealism." While the illustrations from the catalogue "only showed sections of the original *Merzbau* room...by 1936 the *Merzbau* had expanded so rapidly that it started to sprout through the outer shell of the house (stretching finally) from the subterranean to the sky."[29]

Other notable exceptions are materials lists and sketches Schwitters made for Alfred Barr, Jr., upon attempting to solicit funds for the rebuilding of the *Merzbau* following World War II, and a letter, supplemented by a plan sketch, the artist wrote to his friends the publisher Christof Spengemann and his wife, Luise, on 25 April 1946:[30]

Eight spaces were merzed in the house. Practically, my *Merzbau* was not an individual space, but ... sections of the *Merzbau* were distributed over the whole house, from one

room to the next, on the balcony, in two spaces in the cellar, on the second floor, on the earth [outside].[31]

Schwitters himself did little to clarify the situation. Later, in the same letter to the Spengemanns, the project is described as 'essentially limitless.' Another problem that surfaces is the fact that Schwitters himself did not seek to expose the project to public scrutiny through either publication or exhibit.[32] Despite his penchant for actively promoting not only his own work but the work of many friends and colleagues he supported, Schwitters made relatively few published statements regarding the *Merzbau*. The earliest printed statements concerning the project were in the 1931 article "Ich und meine Ziele," and in 1933 photographs of the *Merzbau* were published, approximately ten to twelve years after its probable inception.[33] In "Ich und meine Ziele," Schwitters discusses his *Kathedrale des Erotischen Elends* when detailing the full range of his work.[34] He did not, however, refer to the project as the *Merzbau*—the title by which it is most well known, until his article "*Le Merzbau*" appeared in an issue of the short-lived journal *abstraction-création, art non-figuratif* in 1933.[35] Though his brief descriptions of the work and its methodology are significant for outlining the various components of the construction, Schwitters refrains from explaining the myriad literary and historical associations which resonate throughout, suggesting that it would be too complicated to do so.[36] Instead, he leaves the task of interpreting the work to the viewer.

The deliberately private nature of the project further exaggerates the difficulty in comprehending the *Merzbau*. Since the construction was almost entirely contained within the apartment he shared with his wife and son, few people saw it.[37] While some of those individuals who did see it have contributed significantly to the understanding of the *Merzbau*, the record of what they saw has often been written many years after having seen the project and is likely inaccurate. In addition, few of these individuals, Richard Huelsenbeck and Ernst Schwitters being the most notable exceptions, have attempted to speculate on the nature of its content. That the project remained all but hidden from view during the more than thirteen years Schwitters was known to have worked on it is itself remarkable. Not unlike his dadaist associates Huelsenbeck and Tristan Tzara, Schwitters was equally at ease in the world of commerce and publishing as he was in the world of art. The extent of his promotional endeavors suggests that the artist was of an uncommon, if ironic, practical bent and, as such, perhaps unmatched among his peers in terms of his business acumen. Yet despite his competence as a

businessman and propagandist, Schwitters was reticent to discuss or promote the *Merzbau* publicly. It was "pure, unsaleable creation," wholly distinct from his manifold and notoriously public activities.[38]

In the early-1980s, a reconstruction of the largest and most well documented room of the Hannover *Merzbau* was installed in the Sprengel Museum in Hannover. While the installation has made a significant contribution to understanding the formal and material nature of the later phases of the work, it does not describe the overall spatial parameters of the Schwitters construction.[39] Since the reconstruction depends almost entirely on photographs taken at least seven years after the initial inception of the project, it does not—indeed cannot—incorporate the materials and artifacts that make up the core, the 'heart,' of the *Merzbau*. While the relative scale of what is thought to be the main room, a room given the subtitle *Das Blaue Fenster* (*Blue Window*), is established, the way into and through the *Merzbau* is obscured by the overwhelming sculptural affect of the later developments. The rooms, cavities, and sculptural excrescences contained within the inner recesses of the *Merzbau* are all but hidden by the "purist" forms Schwitters used to cover over the earlier phases of the project during the late-twenties and thirties.[40] Neither can the reconstruction adequately explore the temporal nature of the work. The fact that the *Merzbau* was developed over the space of a number of years and that it retained the material residue of its earlier stages in many ways supercedes the significance of its formal appearance.[41] However difficult it may be to assess the exact parameters and meaning of Schwitters' elaborate undertaking, it is still possible to establish a series of readings—some admittedly more speculative than others—that may aid in the understanding of the project. While Schwitters himself regarded the 'formal' aspects of his art to be of primary significance, questions surrounding content cannot be wholly disregarded: his literary preoccupations, while obscure, clearly resonate throughout the entirety of his artistic productions. Even a cursory review of the literary content of the *Merzbau* reveals allusions to alchemy, mysticism, hermeticism, and romanticism.[42]

The search for traces of embodied meaning, while important, must be understood to parallel the artist's understanding of the nature of art itself. Eventually, these parallel pursuits become interwoven in Schwitters' artistic universe, evidenced by his dual doctrines of *Formung und Entformung* (roughly, forming and deforming). The way in which Schwitters interpreted the problem of form in the work of art as a dynamic metamorphosis of becoming rather than a static end in itself is displayed by both his actions

and the resulting products—works of art that could be subject to further action at a later date. Still, neither anecdotal evidence nor the record of Schwitters' own statements regarding the *Merzbau*, however useful, can in and of themselves afford meaningfully insight into the project. Initial interpretations of the work as that of a madman are still relevant today, and given Schwitters' success at concealing his motives and subject matter while simultaneously playing at revealing it, the *Merzbau* remains a circumspect work. Yet as John Elderfield, a principle chronicler of Schwitters' life and works, states, the *Merzbau* "was not the by-product of an amusingly eccentric way of life, but a visually and thematically remarkable, complex and ambitious work of art."43 Thus Elderfield, rather than marginalizing the project or granting it recognition as a curiosity, recognizes the work as central to Schwitters' entire artistic oeuvre by suggesting that there are both visual and thematic intentions to the *Merzbau* and that glimpses of the artist's intentions may no longer be said and therefore heard, but can be shown. These intentions however, are displayed in all manner of inconvenience, arrayed like clues in a scavenger hunt that can only be interpreted according to yet another foraging game—a foil consistent with Schwitters' melancholic personality. Found in one constellation of poems or collages, in his letters and publications, in a photograph of the work or a newly unearthed chronology, visual and thematic clues are woven together as threads of a worn tapestry—a tapestry backed by Schwitters' highly personal artistic doctrine—thus revealing elaborate and difficult internal and external associations and references.

These tendencies, coupled with several earnest autobiographical explanations that were at the time radical for their self-exposure, contribute to the rather odd mosaic one is confronted with when viewing the labyrinthine nature of his overall development. Thematic and visual sources are not completely lacking, but seem to go underground, or in the case of the *Merzbau*, are hidden behind closed doors and ample material, as well as verbal dissembling by the artist himself. Consistent with his regard for art as nature, prominent themes do surface, all of which are found in esoteric spiritual and intellectual traditions. These themes are not historically bound, but remain constant, backgrounded material that resists normative critical speculation. Central to alchemy, hermeticism, and the occult arts, they include an emphasis on process (intermittently staged as product), performative autobiography, atemporal temporality, love and death, disease and decay, melancholy, organic unity, and aesthetic redemption.

Merz, the movement by which Schwitters is most well known and by far the most significant of his creative episodes, occurred over an extended period of time, from the 1918 until his death in 1948. It should be remarked at the outset that Schwitters' Merz was not a movement in the traditional sense (he was the both the progenitor and sole 'member'), but a methodology, or, to put it more exactly, a way of life. While there are aspects of many, if not all, the major avant-garde movements present in Schwitters' work, Merz represented a singular departure from the organizational and collective goals of other avant-garde groups. Admittedly, none of these groups was in themselves a coherent unit, yet they shared certain aims and collaborations. Schwitters was unique in this sense, preferring to forge his own path. To this end, he became a one-man promoter, publisher, and organizer.[44] The public and private aspects of his art, however, were not conceived as separate entities, but as a tightly knit field of endeavors under the general rubric of Merz. Schwitters' revolution was both personal and thematic, contingent on the interface of autobiographical circumstances and the context, or contexts, in which he operated. Materially and thematically dynamic, this interface propelled the ongoing development of Schwitters' unique project for art and life.

Kurt Schwitters' faith in the project of art, in its immediacy and necessity of communication through visual and literary means, suggests a similar mode of inquiry. This is perhaps why he endeavored in so many different media to articulate himself; the normative means by which art and literature operated were, in Schwitters' mind, no longer adequate to the task of representing the true nature of human experience. It is also why he invoked the proposition that art is the result of "strict artistic discipline."[45] To him, art was not only a religion and a philosophy; it was a way of life, nothing of which was determined according to discrete categories. Most importantly, however, the production of art, the revelation of the creative capacity and vision of an individual, constituted an ethical imperative; it could not be corrupted by forces or ideas that lay beneath its lofty realm. For Kurt Schwitters, the *Merzbau*, his *Kathedrale des erotischen Elends*, was the site of his most extensive and elaborate inquiry into the fundamentals, elements, and firmament of his creative endeavors. At once restive and restful, it was the primary residence, *the summa theologia*, of his living art.

NOTES

1 The comparison to the Hypnerotomachia is my own, and is largely based on the thematic contents of the original parable. Alberto Peréz-Goméz's most recent book *Polyphilo or The Dark Forest Revisited: An Erotic Epiphany of Architecture*, (MIT Press: Cambridge, Massachusetts, 1992), speaks, albeit in highly explicit and personal terms, to many of the autobiographical issues present in Schwitters' *Die Kathedrale des erotischen Elends*. According to Linda Fierz-David, what the Hypnerotomachia relates is a mystery, i.e. it is the story of a mysterious action, which has a secret purpose and in which the miraculous is the natural. See Linda Fierz-David, *The Hynerotomachia* (New York: Pantheon Books, 1950), p. 2. The comparison of Abbot Suger's Cathedral at St. Denis is suggested by Christian Schneider in a brief article entitled "Schwitters Kathedrale. Eine Perodie," in *Kurt Schwitters Almanach*, 1983, Postkriptum, herausg. von Michael Erloff (Hannover: Kulturamtes der Stadt Hannover [Postkriptum Verlag], 1983), pp. 26-32.

2 Elysabeth Yates Burns McKee (Gamard), "*L'Esthétique de la rédemption: le Merzbau de Kurt Schwitters*," *FACES: journal d'Architectures*, no. 27, spring 1993 (Journal of theUniversity of Geneva) (Genève: l'Université de Genève, 1993), pp. 36-43. See also Dorothea Dietrich, *The Collages of Kurt Schwitters* (Cambridge: Cambridge University Press, 1993), pp. 164-205. For a comparison to John Soane's Museum, see Patricia Falguières, "Désoeuvrement de Kurt Schwitters," in *Kurt Schwitters* (Paris: Èditions du Centre Pompidou, 1994), pp. 152-159.

3 As Gwendolen Webster observes, this list of artists is not definitive. Indeed, with each successive generation of artists the individuals and movements that purport to bear Schwitters' influence expands. For a commentary regarding the impact of Schwitters on contemporary art, see Gwendolen Webster, *Kurt Merz Schwitters: A Biographical Study* (Cardiff: University of Wales Press, 1997).

4 Ernst Nündel, Kurt Schwitters in *Selbstzeugnissen und Bilddokumenten* (Reinbek bei Hamburg, 1981), p. 16.

5 A chronicle of the artistic development of Marcel Duchamp, Max Ernst, Hans Arp, and Theo van Doesburg, among others, is consistent with that of Schwitters. However, Schwitters' own artistic development lagged somewhat behind many of his peers, the result of his being situated in the then provincial city of Hannover.

6 The Entartete Kunst exhibition, organized by the RDBK (*Reichskammer der bildenden Künst*), was put on in conjunction with the 1937 inaugural exhibition of Paul Ludwig Troost's *Haus des deutsches Kunst* (*House of German Art*) in Munich. The inaugural exhibition is known as Hitler's "day of German art," works by artists classified as "degenerate" were displayed in order to explicate the differences between true German art and un-German (Bolshevik, Jewish, Bohemian) art. See P.O. Rave's *Entartete Kunst* (Hamburg, 1949) and Hildegard Brenner's *Die Kunstpolitik des Naionalsozialismus*

INTRODUCTION

(Hamburg, 1963). See also Barbara Miller Lane, *Architecture and Politics in Germany 1918–1945* (Cambridge, Massachusetts: Harvard University Press, 1985), pp. 125-216.

7 The full extent of Schwitters' resistance activities—as well as the repeated attempts by the authorities to interrogate him—have only recently come to light. Schwitters suspected for some time that he had been shadowed by the Gestapo, and that his incoming and outgoing mail was being screened for information regarding his political activities. See Webster, *Kurt Merz Schwitters*, pp. 255-277.

8 Schwitters' agitation against the Nazi regime was not affiliated with any organized political resistance, yet he did speak out against Fascism when the opportunity presented itself. One of the more interesting anecdotes regarding Schwitters' resistance to Nazi propaganda and the suppression of modern ("un-German") art is recorded by Sibyl Moholy-Nagy in Robert Motherwell, ed. *Dada Painters and Poets* (New York: Wittenborn Art Books, 1981), pp. xxix-xxx.

9 Though pursued by their own government, both Kurt and Ernst Schwitters were still classified as German nationals and therefore held 'under suspicion,' a problem even more exaggerated since both lacked the necessary papers. The course of their various internments and intermittent separations, as well as information regarding the nature of the various camp facilities (including the famous Hutchison Camp on the Isle of Man) is outlined in Webster, pp. 307-324.

10 See Werner Schmalenbach, Kurt Schwitters (New York: Harry N. Abrams, Inc., 1967). pp. 7 and 157. See also Elderfield, *Kurt Schwitters*, (London: Thames and Hudson, 1985), p. 199.

11 Walter Benjamin (1931), cit. Richard Wolin, *Walter Benjamin: An Aesthetic of Redemption* (New York: Columbia University Press, 1982), p. ix.

12 Elger's discussion of the Merzbau focuses on the social and cultural context of Wilhelmine Germany and the aftermath of World War I, with a specific emphasis on Hannover. Dietrich's analysis, contained in her book *The Collages of Kurt Schwitters*, aligns the project with Walter Benjamin's study of allegory in the *Trauerspiel*. See Dietmar Elger, *Der Merzbau. Eine Werkmonographie* (Köln: Walter König, 1984); and Dorothea Dietrich, *The Collages of Kurt Schwitters*, pp. 182-3.

13 Webster, *Kurt Merz Schwitters*, p. 213-216.

14 Uta Brandes, "*Merzbau im Biedermeier: Die Kathedrale des erotischen Elends*," in *Kurt Schwitters Almanach 1982: Postkriptum* (Hannover: Kulturamtes der Stadt Hannover [Postkriptum Verlag GmbH, Hannover], 1983), pp. 39-54. In "*Merzbau im Biedermeier*," Brandes discusses both Schwitters' personal relationship to objects in light of the Biedermeier period, and the intrinsic relationship of the *Merzbau* to other iconic 'architectural' objects like Mies van der Rohe's Seagram Building (New York, 1954–58) and Tatlin's "Tower" (1920). Brandes' article on Schwitters' relationship to the various

13

women in his life See Uta Brandes, "Helma, Wantee, Käte, Nelly, Suze, Arren und andere," in *Kurt Schwitters Almanach Nummer 9: Postkriptum* (Hannover: Kulturamtes der Stadt Hannover [Postkriptum Verlag GmbH, Hannover], 1990), pp. 71-118. The final section of her article, entitled "Erotisches Elend und reine Form (Erotic misery and perfect form)," is discussed at a later point in this book. The entire issue of *Kurt Schwitters Almanach Nummer 9: Postskriptum* is devoted to Schwitters relationship to women.

15 Janice Schall, Rhythm and Art in Germany, 1900–1930 (Ann Arbor: University of Michigan Press, 1989). While Schall's text is primarily an account of the influences of Nietzsche's works on German art during the early part of the twentieth century, she does provide a compelling account of Schwitters' dada-Merz work (pp. 260-277).

16 Annegreth Nill, *Decoding Merz: An interpretive study of Kurt Schwitters' early work, 1918–1922*, (Ann Arbor: University of Michigan Press, 1990). Nill's book deals specifically with the early years of Merz, concentrating on the small *Merzbilder* (Merz-collages) developed by Schwitters over a period of five years (1918–1923).

17 The notion of a *Merzkunstwerk* is an obvious play on the romantic-expressionist notion of a *Gesamtkunstwerk* (total work of art), an idea that originates with Richard Wagner and continued to inform the imagination of nineteenth- and twentieth- century artists and architects.

18 Marc Dachy, *Kurt Schwitters MERZ: Ecrits choisis et presentes par Marc Dachy* (Paris: Éditions Gérard Lebovici, 1990), p. 26. See also Gwendolen Webster, *Kurt Merz Schwitters: A Biographical Study*, p. 209.

19 Kurt Schwitters, "Ich und meine Ziele," in *Das literarishe Werk*, Bd. 5, p. 343. "*Ausserdem ist sie unfertig, und zwar aus Prinzip.*" This article originally appeared in *Merz 21 erstes Veilchenheft* (Hannover, 1931), pp. 113-117. There is an English translation of the article by Eugène Jolas, under the title of "*CoEm,*" originally written for the journal *Transition* (July 1936) in *Das literarische Werk*, 5, pp. 423-424.

20 Patrick Madigan, *The Modern Project to Rigor: Descartes to Nietzsche* (Lanham: University Press of America, 1986).

21 Rudi Fuchs, *Conflicts with Modernism or the Absence of Kurt Schwitters* (Bern: Verlag Gachnang und Springer, 1991), pp. 19-21.

22 Annegreth Nill, *Decoding Merz*, p. 4.

23 Hans Richter, *Dada: Kunst und Anti Art* (Cologne: M. DuMont Verlag, 1964), pp. 152-153; cit. Dietmar Elger, "*L'oeuvre d'une vie: les Merzbau*" in *Kurt Schwitters* (Paris, 1994), p. 141

24 Schwitters, "*Ich und meine Ziele,*" *Das literarische Werk*, p. 343. "*Ausserdem ist sie unfertig, und zwar aus Prinzip.*"

25 The last photographs of the *Merzbau* were taken by Ernst Schwitters after his father had already fled to Norway.

26 For additional descriptions of the ongoing transformation of Schwitters' residence and atelier, see Dietmar Elger, "*Die Enstehung des Merzbaus*," in *Kurt Schwitters Almanach* 1982: Postkriptum, hrsg. Michael Erloff, (Hannover: Kulturamtes der Stadt Hannover [Postkriptum Verlag], 1982), pp. 28-38. In a letter to Hannah Höch written in January of 1944, Helma Schwitters wrote that the *Merzbau* "needed to extend beyond the studio, and the balcony was completely glassed for this purpose... from there the *Merzbau* grew further, with compartments developing in other places." On the occasion of his visit to the site of the *Merzbau* as a guest of Helma Schwitters (8-9 October, 1943), Professor Doktor Hans Freudenthal writes; "Connections were created with *Vermerzungen* (Merzing) in the stairway...." This latter statement was communicated to Dietmar Elger in a letter written to Elger on May 31, 1982, in anticipation of the reconstruction of the Hannover *Merzbau* in the Sprengel Museum-Hannover. Nonetheless, the actual parameters of the *Merzbau* continue to be in dispute.

27 Cited by Elderfield, *Kurt Schwitters*, p. 146. On page 155, Elderfield notes Ernst Schwitters' recollection of the central room of the Merzbau, a room containing the column described as *Die Kathedrale des erotischen Elends* (*The Cathedral of Erotic Misery*), a title Schwitters eventually used to describe the entire project.

28 Schwitters did attempt to outline the extent of the Hannover *Merzbau* in a crude plan sketch he sent to Museum of Modern Art Director Albert Barr, Jr., during the 1940s as part of a letter requesting grant monies to aid in a reconstruction of the piece.

29 Webster, *Kurt Merz Schwitters*, p. 270; cit. Elderfield, p. 157. Alfred Barr, Jr., at the time the Director of the Museum of Modern Art in New York, "turned up unannounced on the Schwitters' doorstep in June 1935 (and) ensured that Merz was represented in two of the museum's exhibitions, Cubism and Abstract Art and the mentioned Fantastic Art, Dada and Surrealism." A later shown, entitled "Dada, Surrealism, and Their Heritage," contains references to Schwitters and the earlier exhibitions. See William S. Rubin, *Dada, Surrealism, and Their Heritage* (New York: The Museum of Modern Art, 1968).

30 The Museum of Modern Art Archives, New York. Using photographs of the project, John Elderfield has produced a series of diagrams suggesting the dimensions of the largest room of the *Merzbau*. In addition, he has located the various components contained in this part of Schwitters' construction. These diagrams, as well as those suggesting the formal components and layout of the subsequent *Merzbau* in Lysaker, Norway (1937–1941) and the Elterwater *Merzbarn* in England (1944–1948) are presented in his article for the Pompidou Center's major retrospective exhibition on Schwitters in 1995. See Elger, "L'oeuvre d'une vie," pp. 140-151.

31 Kurt Schwitters, *Briefe (Wir spielen, bis uns der Tod abholdt)*, p. 230 and p.246, cited in Nündel, pp.57-8 (translated by Gamard).

32 In the late 1920s, Schwitters stated that only three individuals could understand the constitution and ideas of the *Merzbau*: the *Sturm* critic Herwarth Walden, the architectural historian Sigfried Giedion, and the artist Hans Arp. See Kurt Schwitters, "Ich und meine Ziele," in *Das literarishe Werk*, 5, p. 345. However, he also made mention in another text associated with the *Merzbau* that the art critic F. Vordemberg-Gildewart and his friend Käte Steinitz were also able to appreciate the work.

33 The first reproductions of the piece appeared in the magazine *G*, published by Hans Richter, Mies van der Rohe, and Werner Graeff (no. 3). Two reproductions also appeared in the no. 2 issue of the magazine *abstraction-création–art non-figuratif*, published in the same year.

34 Schwitters, "Ich und meine Ziele," *Das literarishe Werk*, 5, pp. 344-345.

35 Schwitters, "Le Merzbau," in *Das literarishe Werk*, 5, p. 354.

36 Schwitters, "Ich und meine Ziele," *Das literarishe Werk*, 5, p. 346.

37 Schwitters claimed that only close friends and "those who would understand it" were introduced to the *Merzbau*—usually after one of the "soirées" he held at his home.

38 Richter, *Dada: Kunst und Anti Art*, p. 152.

39 Notes and articles on the reconstruction of the *Merzbau* for a 1987 exhibition on Kurt Schwitters by the Sprengel Museum in Hannover are contained in the catalogue for the exhibition, entitled *Kurt Schwitters* (Hannover: Landeshaupt-Hannover, Der Oberstadtdirektor Sprengel-Museum Hannover, 1987).

40 Dietmar Elger, "L'oeuvre d'une vie," p. 145. Hans Richter suggests that the "constructivist" phase of Schwitters construction was becoming progressively more fluid ("curvilinear") in nature over the course of time. This observation is notable given the fact that Schwitters' later editions of the *Merzbau* in Norway and England are much more organic than the 'constructivist-purist' phase noted by other individuals who visited the project. The most complete outline of the later *Merzbau* projects is contained in Dietmar Elger's article for the Pompidou exhibition. See Hans Richter, *Dada: Kunst und Anti Art*, p. 153.

41 The text that accompanied the opening of the reconstruction of Schwitters' Hannover *Merzbau* did, however, aid in the understanding of the social and political context for the project. See Dietmar Elger, *Der Merzbau: Eine Werkmonographie*.

42 Resurfacing in what are considered to be romantic periods in the history of human culture and often used interchangeably, the terms alchemy (including alchemical processes), mysticism, and hermeticism refer to the esoteric or occult arts. Alchemy and hermeticism represent medieval chemical sciences and speculative philosophy aimed at achieving the transmutation of one material into another. Mysticism, often designated according to specific

religious or ethnic practices such as "nature mysticism" or Russian mysticism, at once suggests both a generalized and highly specific approach to achieving a direct communion with an ultimate reality. See William James, *The Varieties of Religious Experience* (New York: MacMillan Publishing Company, 1997) pp. 319-357. See also Alexander Roob, *The Hermetic Museum* (Köln: Taschen, 1997).

43 Elderfield, *Kurt Schwitters*, p. 156.

44 Schwitters' promotions and publications were not limited to his self-assigned Merz project, but extended into any endeavor he believed maintained an abiding faith in the paramount project of art. Thus, he could include artists as diverse as Mondrian, Van Doesburg, Hannah Höch, El Lissitzky, Raoul Hausmann, Tristan Tzara, and Hans Arp, while at the same time excluding those individuals he felt were corrupted by extrinsic agendas such as Richard Huelsenbeck. Nonetheless, it is clear that he included many more artists than he excluded.

45 Elderfield, *Kurt Schwitters*, p. 27. Schwitters' simple declaration of Merz is as follows: "Merz stands for freedom from all fetters, for the sake of artistic creation. Freedom is not lack of restraint, but the product of strict artistic discipline." This statement originally appeared in Schwitters article entitled "Merz" which was published in *Der Ararat* (1920). It is republished as "Merz (für den Ararat geschreiben)" in *Das literarische Werk*, 5, p. 76.

THE ARTISTIC REVOLUTION OF KURT "MERZ" SCHWITTERS: HANNOVER—DRESDEN—HANNOVER—REVON(NAH)

Kurt Schwitters' approach to his artistic education not only gives an indication of the developmental nature of his art, but his overall artistic ethic. Having spent a year at the *Kunstgewerbe* (School of Applied Art) in Hannover, Schwitters transferred to the *Dresden Kunstakademie* where he studied "academic" painting from 1909 to 1914. During this time, he maintained a traditional approach to painting, creating still-lifes and landscape paintings using traditional techniques and subject matter.[1] At the time, Schwitters appears to have remained largely unaffected by the Dresdner expressionists, despite both his imminent embrace of expressionist ideas and aims in the waning years of World War I and the relative notoriety that accompanied their works and persons at the time.[2] The nascent Expressionist movement known as *Die Brücke* (The Bridge), of which Erich Heckel, Karl Schmidt-Rottluf, and Ludwig Kirchner had been founding members, was formed in Dresden only a few years prior to Schwitters' arrival in the city. After this period of Academic painting, Schwitters' work evolved quickly, moving through a succession of styles, from "Impressionism (*plein-air* painting) (1914–17), expressionism (1917), Abstraction (1917–18), then Merz itself (1918–19)."[3] Though not becoming a master of any one approach, Schwitters worked through the development of modern painting on his own. Yet these self-described phases of development were not successive, one replacing the other, but rather incorporative. As an artist, he never completely dispensed with any of the subject matter or techniques he had either acquired or developed over the course of his research, but used what he deemed necessary as the situation required.

The fact that Schwitters continued to paint portraits, still lifes, and landscape paintings until his death in 1948, while deeply problematic from an art historical point of view, is indicative of Schwitters' unique approach to art. The evidence of his incorporation of both affect and effect—what some might view as simply stylistic play—can be seen in his simultaneous produc-

tion of expressionist, figurative, landscape, and abstract paintings, and proto-Merz collages, poetry, and graphic techniques during the years 1917 through 1919—an overlap that does not register in Schwitters' autobiographical piece (*figs. 3 and 4*).4 Entitled *Merz*, Schwitters treats his forays into expressionist, figurative, and landscape painting initially as successive phases, only to tell his readers (and perhaps himself) that he had not in fact 'given up' any one of them, but used the subject matter and stylistic techniques associated with each type of painting as necessary—thereby treating the superficial nature of their styles as something other than the underlying motivations behind his own aesthetic enterprise. An incorporative approach to art can also be viewed as a denial of artistic authority and originality—prominent components of a critic's approach to modern art.

This method of incorporation or 'working through' (a component of *Formung* and *Entformung*) was to inform the development of his artistic oeuvre. Many of his artworks do in fact appear to be derivative of the ideas and techniques of his many of his colleagues, a condition which has led to the misunderstanding that he was merely appropriating or imitating the works and method of those artists he admired. Yet this too was part of Schwitters' ethical approach to art: art was not something that could be owned, nor could it be co-opted by the cult of personality. To Schwitters, art was autonomous and developmental, a living organism manifest of a complex web of formal and informal associations. Drawn from life and art, his use of multiple genres and techniques countered the critical, historicizing trajectory that informed the reception of modern art, in particular the art of the avant-garde. Given that Schwitters use of multiple associations did not privilege any particular period or group, many of his contemporaries, viewed his work unfavorably, both in terms of the expansiveness of his approach as well as his tendency to situate his work at once outside of and within the incipient norms of the various movements which populated the artistic imagination of post-World War I Europe. Even then, Schwitters confounded his critics and compatriots—despite their renouncement of him amid loud protestations concerning the radical nature of their own observations and work. In this respect, Schwitters' repeated attempts to defend his position by increasing his output of impious artifacts, experimental prose and poetry, and experimentation in the graphic, theatrical, and performance art, not to mention manifestoes and criticism, exposes the exceptional, even transgressive nature of his artistic project. Utilizing a strategy that succeeded only when 'enemy lines' were finely drawn, Schwitters' tactics depended on a combination of

targeted propaganda, highly publicized performances, and overwhelming output. Yet the by-products of Schwitters' offensive moves are in themselves useful, indicative of his unswerving commitment to his unique process. Like the relentless beat of a drum, Schwitters creative process is expressive of his understanding of art as a continuous rhythmic impulse, the *Ur-grund* (original ground) of human culture. Thus what may be regarded as an inconsistent and derivative approach according to the apperceived terms of modern art was in fact highly consistent with his artistic ethic. Throughout, it is clear that his creative work was not the end-game, but a means itself: Schwitters saw art not in terms of the efficacy of objects, but as a vital, open process of engagement.

Schwitters approach to art complicated his standing not only among his colleagues, but among art critics of the time as well. While at times reacting poorly to what he perceived to be a misunderstanding of his project, he also viewed the negative reception of his work as an affirmation of his overall project.[5] Typical of Schwitters' ability to turn the negative into the positive, he constituted his own movement in "Merz." And while he was the progenitor of Merz, he also regarded his unique "movement" as a universal project, one that could not be owned by any one individual or group of individuals. Clearly, Merz was not an identifiable movement per se, but a way of thinking and, perhaps more importantly, a way of living. While Schwitters made the statement, "I am Merz," often enough, this statement should not be taken at face value, but must instead be understood as an ethical proposition that supplants the identity of the individual with the autonomous and irrevocable identity of art.

Despite the difficulties regarding the extent and nature of the project, it is possible to construct a series of interpretations of the Hannover *Merzbau*, some of which are more obvious than others. These readings require an extensive familiarity with the entire range of Schwitters' literary and artistic works—artifacts and documents unrivaled in terms of its breadth of modes and media

Similarly, one must also understand the contexts in which they were created.These contexts include both the general context of social, political, and cultural events in Weimar and Nazi Germany and Europe as well as the more specific context of the artist's experiences as a child and young adult in provincial Hannover. Thematic and visual issues pertaining to German romanticism that appear in Schwitters' more general ethos, due to the influences of his traditional "academic" education in Dresden or perhaps through his own acquaintance with Germany's ongoing anxiety of influence and iden-

tity, recognized by both internal and external parties as a hyper-stimulated and recurrent spiritual crisis. German romanticism, percieved as an antidote to the totalizing universe of Enlightenment reason, was alternately understood as a salve for Germany's spiritual crisis or, conversely, as the sickness of virulent nationalism and subjective excess, both of which were thought to be the source of German resentment and external aggression. The suggested duplicity of German romanticism continued to play itself out during the years of the Weimar Republic, lending further credence to Germany's identity crisis, its general spiritual deprivation, and its vulnerability to the promises of a national 'savior.' Even the notion that artists and writers are burdened with the responsibility for the nation's spiritual condition has its roots in German romanticism, in particular the works of the *Frühromantiker* (Early Romantics), where the artist was viewed as a shaman—the seat of community anxieties and pathologies who could act out, simultaneously, in his own person, the roles of liberator, victim, and villain.

German expressionism inherited the mantle of German romanticism: its primary thrust was the recognition of *Einfühlung* ('feeling') in the face of an increasingly rational, mechanized universe. *Einfühlung* was also characterized by mystical overtones—the resort to religiously-derived subject-matter such as Gothic cathedrals, crosses in the forest, and existential figures un-tethered from the ground—and the search for liberative dissociated experiences that denied the presence of external reality as it sought an ultimate, higher reality. Coinciding with a period of great upheaval in the artist's personal and professional life, a period of time in which he recognized himself as having a singular mission—making art—Schwitters' delayed embrace of expressionist ideals is found in numerous artifacts and prose pieces of 1917–1920. It was an artistic mode a framework continued to inform his art for the rest of his life.

Schwitters' embrace of German romanticism, has been remarked on by numerous scholars of Schwitters' work. In a letter to Werner Schmalenbach, Richard Huelsenbeck, a fellow dadaist and situated critic of Schwitters', situates the artist squarely within the legacy of German romanticism, in retrospect stating that "Schwitters was at that time in my eyes a German Romantic," an observation that no doubt contributed to the falling out between the *bürgerlich* (bourgeois) Schwitters and the more cosmopolitan Huelsenbeck during their dada years.[6] Carola Giedion-Welcker, a supportive critic of Schwitters, saw his artistic affiliations with the *Frühromantiker* as key to understanding his work.[7] Other contemporaries of Schwitters were even more pointed in their critique of the artist—criticism that softened some-

what as the various dada organizations were subsumed into other artistic endeavors. In 1920, a Cologne-based dada publication entitled *Die Schammade* that included Tristan Tzara, Johannes Baargeld, Hans Arp, and Max Ernst among its contributors lambasted German (Berlin) dada for its "dada-Neo-expressionism," proclaiming that the German dadaists were "counterfeits of dada" and that they could "neither shit or pee without ideologies."[8] Many German dadaists were simply omitted from the publication, while others, including Kurt Schwitters, were openly derided. In *Die Schammade*, the artist was referred to as "The *Sturmpuben* (Sturm-pubescent) Schwitters," and a "Schleiermacher epigone." While *Sturmpuben* is a composite word that likely referred to the Herwarth Walden's Berlin Expressionist gallery Sturm, it also suggested the arrested professional (and maybe personal) behaviors perceived by Schwitters' numerous critics. Backing up Huelsenbeck's (and Giedion-Welcker's) suggestion that Schwitters was more closely affiliated with the backward looking romanticism, Ernst's characterization of Schwitters as the long-dead German romantic philosopher Schleiermacher is clear.[9]

More recently, Annegreth Nill takes up Schwitters' romanticism by focusing on his landscape paintings, paintings he continued to do throughout his life and of which he was quite proud. Gwendolen Webster, on the other hand, focuses not so much on the paintings (they are in her estimation nascent experiments with style) but on his easy grasp of the style and sentiments used in expressionist poetry, examples of which graphically exhibit his frustrations with war and sex.[10] Inevitably, the conflicting ambiguities of an artist who is subject to his context while attempting to possess a critical, objective view of events and circumstances possesses a complexity of character which leads to any number of highly suggestive narratives when attempting to chip away at the manifold layers of information embedded in the artworks. In what became the manner of course, Schwitters continued to move between several roles, marked at one extreme by his subjective, empathic, and private self, and on the other, by an almost disinterested, businesslike approach to his various entrepreneurial activities as a publisher, organizer, and graphic artist. The calculated resolve of the businessman-entrepreneur could not effectively veil his impassioned response to the circumstances and events that surrounded him; nor could it subdue his empathic nature, burdened as it was with an exceptional degree of *Einfühlung*.

Consistent with an abiding faith in expressionism and its eventual sublimation into certain forms of dada, Schwitters' work resonates with a recog-

nition of autobiographical and cultural pathologies—the underlying sicknesses and impulses that pulse through the veins of personal and cultural belief systems. As before, the rhythms that are found just beneath the surface are necessary to a proper understanding, perhaps even a tentative diagnosis of the pathologies harbored by the deeper levels of consciousness. Consequently, Schwitters understood himself not as an artist who could transcend his context, but as someone who was deeply immersed in the turbulence of post-war Germany to the point where his personal experience mirrored the experience of his fellow Hannoverians, if not that of all Germans. The grandiosity of his vision—remarked upon by others who noted the unadulterated zeal with which he approached his artistic vision—was not grounded in the normative terms of the European avant-garde, a group always subject to the project of history, but was instead transhistorical in nature and therefore at once profoundly sentimental and messianic. The difference between an appeal to history versus an attempt to transcend history by producing an art that suggests there is a deeper set of meanings that exist *through time* is an important distinction, and one that interested not only Schwitters but other members of his coterie who resisted the historicizing claims of the avant-garde.[11] The supposition of a transhistorical view of human creativity governed by underlying mechanisims that focus on the native impulse to create was an alternative view that lead the way to an embrace of mystical tenets and the associative creative processes articulated by alchemy and hermeticism.

The suggestion of hermeticism is not incidental to Schwitters' creative production. The expressionist themes in his work, many of which extend from German nature mysticism, were full of references to alchemical processes. In addition, dadaists such as Max Ernst and Marcel Duchamp were drawn to alchemy and hermeticism in their work of a hybrid genre recognized of late as 'dada-expressionism.' While splitting off from the primary direction which dada in Germany was taking—towards constructivism and hence a concern for abstract, mystical "form"—both Ernst's and Duchamp's alchemical formulations did not appear suddenly with their turn towards surrealism.[12] Rather, the suggestion of these ideas is recorded in their respective works during the period in which they were most strongly allied with dadaist ideas. Also notable among Schwitters' influences during the late-teens and early-twenties was the secret society *Die Gläserne Kette* (*The Glass Chain*), a cult of architects and writers centered around the expressionist architect Bruno Taut.[13] In an article Schwitters prepared for Taut's journal *Frühlicht*, the

sculpture *Schloss und Kathedrale mit Hofbrunnen* (*Cathedral and Courtyard with Well*) (1922) (*fig. 7*) was featured. Though the sculpture itself was regarded more as an intellectual model rather than a proposal for a real building, Schwitters, detailing both the concept and method for a 'Merz-architecture,' nonetheless had practical applications in mind.[14] The goal of his architecture, which he referred to as a *Merzkunstwerk*, was to facilitate the development of *neue Gestaltung* ("new methods of forming," or simply "new forms"). Following closely on the heels of his public embrace of the Expressionist concept of *Gesamtkunstwerk* (total work of art) in the article he wrote for *Der Ararat*, the essay accompanying a photograph of the sculpture identifies the notion of a *Gesamtkunstwerk* with his Merz project:[15]

> My aim is the total work of art (*Gesamtkunstwerk*), which combines all branches of art into an artistic work... First I combined individual categories of art. I have pasted poems from words and sentences so as to produce a rhythmic design. I have on the other hand pasted up pictures and drawings so that sentences could be read in them. I have driven nails into pictures so as to produce a plastic relief apart from the pictorial quality of the paintings. I did so as to efface the boundaries between the arts.

Schwitters' creative development after the war quickly dispensed with any obvious associations with German expressionism's supposed irrationalist impulses, though he continued to use themes central to expressionist work. His alliance with Berlin dada (Huelsenbeck's "husk-dadaists"), the dadaist organization with whom he is most often associated, was also short-lived due to what Schwitters perceived to be the explicit political orientation of the group, as well as what he regarded as their incendiary negativity.[16] Explicitly exiled from Huelsenbeck's Berlin dada group in 1920, Schwitters began to plan his 'counter-attack.' Prior to this event, he had made the acquaintance of Hans Arp, a member of the Zürich-based "kernel-dadaists" (core-dadaists), as Schwitters referred to them. Inspired by Arp's artistic credo, Schwitters eventually declared his own 'artistic liberation' in terms of his friendship with Arp.[17] In his article for *Der Ararat* Schwitters asserted as much: "Merz stands for freedom from all fetters, for the sake of artistic creation. Freedom is not lack of restraint, but the product of strict artistic discipline."[18] And in 1930, recalling the events of 9 November 1918, the date which marked the end of the Wilhelmine Empire and the founding of the Weimar Republic, Schwitters moved his personal revolution from its previous date of inception to the date of the founding of Weimar, thus signifying that even autobiographical details could be "merzed."

I felt myself freed and had to shout my jubilation out to the world. Out of parsimony I took whatever I found to do this, because we were now a poor country. One can even shout out through refuse, and this is what I did, nailing and gluing it together. I called it "Merz," it was a prayer about the victorious end of the war, victorious as once again peace had won in the end; everything had broken down in any case and new things had to be made out of fragments: and this is Merz.[19]

In Merz, an arbitrary and effectively meaningless word fragment culled from the German word *Kommerzbank* (Bank of Commerce) which appeared by chance in an early collage, Schwitters stressed not only protest and revolution, but what might be regarded as an "aesthetic of redemption."[20] Thus the concept of "Merz" never coalesced into an absolute method or style, but seemed more like a developmental organism—a method-style-creed perpetually redefined according to the nature of the circumstances in which it was put to work:

> The word Merz had no meaning when I found it. Now it has the meaning that I gave it. The meaning of the concept Merz changes with the change in insight of those who continue to work with it.[21]

To Schwitters the work of art, if it in fact was a work of art, could not be regarded as a manifest of socio-political commentary but was instead autonomous, ever-developing according to a singular criteria and means. Art historian and critic Carola Giedion-Welcker suggests that Schwitters refrained from a "didactic presentation of a contemporary situation, be it in sociological or political terms, but (was primarily concerned) with attaining pure art even through the use of rubbish. The result was not an elementary demystification of art, but an artistic act of sublimation."[22] Yet it is the method Schwitters employed to create his works that is even more indicative of his transposition of alchemical processes. The words Schwitters used to describe both his conceptual apparatus and method for his literary and visual works were *Formung* and *Entformung*. A neologism Schwitters invented, *Entformung* translates roughly as the 'metamorphosis' or 'dissociation' of form(s) from its original context. In terms of his art, *Formung and Entformung* meant the transformation, or transubstantiation, of the old into the new, that is, the "making (of) new art from the remains of a former culture."[23] In an article Schwitters published in the first issue of his journal, *Merz* (*Merz I: Holland Dada*), he explained the nature of his process:

Every means is right when it serves its end...What the material signified before its use in the work of art is a matter of indifference so long as it is properly evaluated and given meaning in the work of art. And so I began to construct pictures out of materials I happened to have at hand, such as streetcar tickets, cloakroom checks, bits of wood, wire, twine, bent wheels, tissue paper, tin cans, chips of glass, etc. These things are inserted into the picture either as they are or else modified in accordance with what the picture requires. They lose their individual character, their own *Eigengift* [special essence], by being evaluated against one another, by being *entmaterialisiert* [dematerialized] they become material for the picture.[24]

Yet the goal of Schwitters work was not the radical *replacement* of the past with the present, but rather the *preservation* of remnants—both literal and figurative—of the past for the present, an artistic ethos that implicitly *maintains and affirms* the future. Not only did Schwitters choose to use the *Abfall* (garbage, refuse) of modern society, he was also concerned with maintaining the efficacy of art as an autonomous enterprise, for to him "art was a law unto itself, answerable only to itself."[25] Yet Schwitters' promotion of aesthetic values did not rely on a set of merely formal concerns, the efficacy of the object, but was grounded in his recognition of art's liberating function, a dialectical process of exchange that could redeem society by virtue of its revelatory activity. Delving into Schwitters' promotion of art as a dynamics of exchange issuing from within and without, John Elderfield suggests that the procedural bias of the work, a process built on the often precarious demands for radical *inclusivity.*

While objects do refer to their original use, equally they refer to how they have changed from these uses. They act as evidence of their own transformation (in function though not in looks) through the forming process. The autobiographical iconography of the materials thus acts as a factual reminder of Schwitters' "forms" of behavior—and the relationships of the materials demand some degree of "completion" by the viewer, who is invited to reconstitute the manner of the behavior (while yet aware of individual iconographic references). Schwitters' work-emphasizing its procedures–places an important formative responsibility on the viewer, demanding... not only to be seen but to be known. In this way, there is no hard and fast line between the art and its audience. These works are art (the objects are included); but the precariousness of their inclusions (referring beyond their unique art contexts to earlier stylistic conventions and stealing from life) they function also as systems expediting the perception of art, as perceptual fields within which the viewer is encouraged to perform.[26]

In this sense, art is not an elitist, transcendental undertaking; rather, it harbors a fundamental responsibility to dematerialize (*entmaterialisiert*) and reform the world in which it exists, patterning it anew. To Schwitters, then, art must be recognized as a *Lebensform*, a form of life emblematic of both the myriad possibilities and multiple voices at work in the life-world (*Lebenswelt*). At its most basic level, art contributes a dynamics of exchange which functions to re-inform the world and its inhabitants.

The discussion of Schwitters' creative activity as a form of life links his work directly with Ludwig Wittgenstein's philosophical investigation of language-games as forms of life. The discussion of language as a "form of life" represents a difficult and much-debated aspect of Wittgenstein's philosophy. Two passages from Wittgenstein's *Philosophical Investigations* are pertinent here. In these passages, Wittgenstein describes language and the production of meaning in language as dependent on the activity to which it is engaged. The first of these passages (19) is a discourse on the process of building—a process that Schwitters also uses in both an allegorical and metaphorical context. The second passage (24) describes a more fundamental definition, linking developments in language to those in in mathematics, developments which Schwitters was also interested in, particularly during his period of association with El Lissitzky and Theo van Doesburg: " . . . But how many kinds of sentences are there? Say assertion, question, and command? There are countless kinds . . . And this multiplicity is not something fixed, given once for all; but new types of language, new language-games, as we may say, come into existence, and others (similar to mathematics) become obsolete and get forgotten . . . Here the term "language-game" is meant to bring into prominence the fact that the speaking of language is part of an activity, or form of life."27 Schwitters' *Formung and Entformung* actions that promote a kind of speech (Merz), condition Schwitters' primary ethos—art as a form of life. Thus *Formung and Entformung* cannot only be used to describe his visual works, but are indicative of a similar method he used in the construction of his poetry. In both cases, the works are created through a process of tearing, clipping, pasting, and assembling materials and words extracted from their original context, reconstituting them and redeeming them simultaneously. Yet again, not only is the *literal* material redeemed, but its *context* is redeemed as well. From this point of view, Schwitters' art, bearing the marks of a salvaging process, is also that which signals a path of rescue, a means to salvation. The artist, in this case Schwitters, is both saved and savior in what may be regarded as a protracted passion play.

As a "redemptive aesthetic" Schwitters' dual process of *Formung* and *Entformung* is similar to Hegel's concept of *Aufhebung* (sublation). Implying both the simultaneous negation and preservation of the past (of culture and art), the "contents of tradition" are dialectically preserved in a different, "redeemed" form. Its aim is to access the increasingly remote "recesses of past life" so that culture, memory, can be preserved.[28] Formulated as an antidote to cultural and spiritual oblivion, the operative effect of *Aufhebung* is to illuminate the remnants of the past at the moment of their disappearance. Yet the momentary apprehension of the remnants of cultural production is not a nostalgic enterprise, but rather a search for the underlying, connective tissue between past and present, the primal continuum that flows through time. Hence, the negation of the past does not govern the dialectical process of *Aufhebung*, but rather enables its preservation, for "...this fleeting image of truth is not the process of exposure that destroys the secret, but a revelation which does it justice."[29] Mirroring Hegel's philosophical premise, Schwitters' version of *Aufhebung* renounces purely idealist contemplation and its habit of illusory remedies by recognizing that the resolution of problems inherent in the life-world can only be accomplished within the sphere of material life itself. The vitality of art, its living nature, necessitates a regard for *practical* immediacy, the same immediacy that informs the daily life of modern culture. In short, art must insert itself directly into the framework of life. Creative processes, the practice of aesthetic redemption, recognize the flow of human experience as a continual, regenerative process.

It appeared self-evident to some of his contemporaries that Schwitters struggled with the tension between nostalgia for what had been and the pursuit of cultural revolution and social change through art.[30] In a 1957 article entitled "dada and Existentialism," Richard Huelsenbeck recounted Berlin dada's reception of Schwitters' work and person. Schwitters' strained relationship with Huelsenbeck (Berlin dada was essentially Huelsenbeck's organization) was one of the reasons that led Schwitters eventually to chart his own course in Merz.

> The remodeling of life seemed to us (the Berlin Dadaists) to be of prime importance and made us take part in political movements. But Schwitters wanted to have it expressed only by means of artistic symbols... He had nothing of the audacity, the love of adventure, the forward push, the keenness, the personal thrust, and will born of conviction, that, to me, made up most of dadaist philosophy. To me, at that time a very unruly and intolerant fellow, he was a genius in a frock coat. We called him the abstract Spitzweg, the Kaspar (sic) David Friedrich of the dadaist revolution.[31]

While Schwitters never explicitly rejected these characterizations, his writings don't respond directly to the criticism, but address questions regarding his work in a proactive rather than reactive way. Aside from Huelsenbeck's personal denunciations, his criticism of Schwitters' work as problematic in terms of its place in history is indicative of a more general misunderstanding of the artist's work. What was and in some cases still is regarded as nostalgia was in fact a belief in the autonomy of art as a spiritual enterprise—a thoroughly romantic point of view in keeping with art as a messianic impulse constant across cultures and through time. Written a decade after his fellow dadaists' characterization of his work as sentimental and nostalgic, a characteristic he was undoubtedly aware of, Schwitters' article "Ich und meine Ziele," self-consciously revisits the question of history in his work. Casting it in a transhistorical vein, Schwitters suggests that his art is shadowed by the entire history of art, a history that he understood as representative of an uneffaced relationship between religion and art:

> Do not consider this work to be a blaspheme of the concept of divinity, [a concept] which has gathered humanity together for millennia, and which has broken down national and social barriers, and has presented us with beautiful art. The immersion in art, like the immersion in religious faith, liberates man from the worries of daily life.[32]

While Schwitters came close to pronouncing art religion and religion art, his concept of religion was not grounded in the historicizing institutions of doctrinal faith, but rather in that underlying desire for faith. In this sense, his idea of religious faith is more closely allied with the intuitive ideals of German mysticism and is thus both more abstract and more concrete. German nature mysticism on the other hand does not focus on the object per se, but on the processes of creative life itself, with the heavens and earth arrayed in the mystical communion of energies associated with the life-force and burdened with the care of forms of life.[33] Art from this point of view is a dynamic instrument capable of both revealing and rendering faith. While also pursuing universal redemption, Russian mysticism in contrast pursues the divine nature of the icon, understood as a literal, albeit abstract, manifestation of God.

Working in accordance with the quasi-mystical categories of German romanticism, it is difficult to recognize Schwitters' work as either indicative of or explicitly motivated by the social and political context in which he

worked. While the situation in Germany was indeed chaotic and highly charged, Schwitters appeared to seek an antidote to the inevitable historicizing tendency the burden of mirroring social and political issues would require. His rejection of art as an instrument of propaganda is a case in point. Yet the social and political context could not be completely avoided for it too was possessed of an underlying rhythmic impulse constant across space and time.

With the close of World War I and the fall of the Wilhelmine Empire, Germany was plunged into political and cultural chaos. The identity of the new nation was heralded in the adoption of Weimar as its capital: no longer would Germany be a nation who looked to Bismarck and Schlieffen for guidance; as a nation-state it would now pay homage to the humanists Goethe and Humboldt. As an "idea seeking to become reality," the forging of a new identity was nonetheless fraught with extremes and conflict. In the introduction to *The Weimar Republic Sourcebook*, the situation was characterized as follows:

> The result [of the Republic's multiple visions] was a frantic, kaleidoscopic shuffling of the fragments of nascent modernity and the remnants of a persistent past. Odd combinations of progressive traditionalism and reactionary modernism vied with the seemingly more appropriate alliances of avant-garde or conservative political, social, and cultural ideology. Innocent expressions of radical hope struggled against a mood of resigned world-weariness. What one Weimar survivor, Theodor W. Adorno, dubbed the "jargon of authenticity" competed with what later German commentator, Peter Sloterdijk, called the corrosive effect of "cynical reason." The categories of "high" and "low," whether applied to politics, culture, or social relations no longer seemed relevant.[35]

While Schwitters' coming of age paralleled these developments, his artistic project was only incidentally critical of the day-to-day social, political and cultural context in which he operated. In point of fact, Schwitters was highly suspicious of political diatribes. While many of his pieces (*Das Arbeiterbild* (*fig. 5*) and *Das Bäumerbild* are two examples) bear the mark of socio-political critique, the works themselves are not documents that merely represent the conditions that informed their inception. On the contrary, for Schwitters, to see art as an instrument of its time, a critical response to the Zeitgeist would be to deny its proper function as an immersive, liberative project. Art would no longer be like religion.[36] While not necessarily negating the specifics of their content, Schwitters at once sought to transcend the

particularities of the work's immediate cultural context in favor of an art of multivalence.[37] To this end, he repeatedly made light of the various readings which attempted to unmask political intentions, noting at one point: "For me, art is too precious to be misused as a tool; I prefer to distance myself from contemporary events... but I am more deeply rooted in my time than the politicians who hover over the decade."[38] Schwitters' characteristic proclamation "I am Merz," was, as he put it, a recognition of the revolution in and through him, and he was an artist, not a politician or social critic:

> In the war, things were in terrible turmoil. What I had learned at the academy was of no use to me, and the useful new ideas were still unready... Then suddenly the glorious revolution was upon us. I don't think highly of revolutions; mankind has to be ripe for such things. It is as though the wind shakes down the unripe apples, such a shame... It was like an image of the revolution within me, not as it was, but as it should have been.[39]

It is important to note the paradoxes inherent in Schwitters' statement. He is at once wary of revolutions ("...the wind shaking down the unripe apples, such a shame..."), yet fully engaged in the possibilities inherent in change. It is apparent, however, that the political and social revolution that informed Weimar Germany was, for Schwitters, inadequate; he, a 'true revolutionary,' was the ultimate guide.[40] As an artist, Schwitters saw himself as illuminated by the image of the revolution, an unadultered revolution "as it should have been," borne within his heart and soul. Unlike political revolutions, however, Schwitters' "revolution" is not a temporal event but represents a kind of revelation that leads to religious conversion. This particular type of revelation and the consequent demand for conversion is essential to mysticism. In Schwitters, momentary revelation and the immediate impulse to convert (by definition a spiritual revolution) is generated reflectively. Accordingly, art, and more specifically the creative principles found in Merz, could engender revelation and lead to a demand for conversion, albeit a conversion of *Weltanschauung* (world view) rather than a conversion to a particular faith, or ideolology. Thus Merz, mirroring aspects of alchemical and hermetic transmutation, seeks the liberation of the world through the recognition of the creative potential evident in the world brought upon by the awakening of the poetic impulse inherent in individuals themselves.

The double function of Schwitters' arresting statement mirrors the complexity and paradox of Schwitters' work; while revolutionary in sentiment, it

operated in light of the need to respect the contiguous, redemptive process of aesthetic production through time. He did not subscribe to the wholesale dismissal of the old, but recognized the underlying impulse of art as the ultimate shock therapy. Dada-constructivist Hans Richter, in recalling his association with Schwitters during the 1920s, remarked that Schwitters' "...genius had not time for transforming the world, or values, or the present, or the future, or the past; no time in fact for any of the things that were heralded by [the] blasts of Berlin's Trumpet of Doom. There was no talk of the 'death of art,' or 'non-art,' or 'anti-art' with him."[41] The simple aggregate of historical time, a proposition ceded by much of the avant-garde—including Huelsenbeck's Berlin dadaists—did not define Schwitters' artistic undertaking.

As Lambert Wiesing asserts, Schwitters' revolution bore very specific connotations. In the inaugural issue of his journal *Merz Holland Dada* Schwitters, in a manner reminiscent of the nineteenth-century German philosopher and iconoclast Friedrich Nietzsche, intones: "We hope that in the foreseeable future our efforts to make known the enormous lack of style within our culture will give birth to a mighty will and a great yearning for style. Then we will turn against dada and campaign only for style."[42] To Schwitters, style was the material evidence of a creative life-force. Countering the predominance of metaphysical prerogatives, nothing was hidden, but was fully manifest in the staged processes necessary to the generation of forms of life (*Lebensform*) and therefore form itself—a premise efficently articulated by Schwitters' *Formung and Entformung*. Form as such was always present, no one stage was valued more than another. Unlike classical metaphysics, what was seen (the devalued corrupt and corrupting life-world) did not defer to a higher ideal (the higher reality of pure cognition); rather, reality—what was apparent—was valued as a revelation of the life-force (creative energy).

In the formulation of Schwitters' Merz, "a mode of artistic creation," the pursuit of mystical categories is fundamental. According to James, mystical states of consciousness produced an awareness of the oneness of all things as they are participant in being (*Sein*).[43] In accordance with Schwitters' understanding of art as a spiritual enterprise, art's direct manifestation of creative energy undercuts classical representation by supposing that art operates in a manner of presentation. The dialectical struggle between subject and object, seen and unseen, suggests that something is hidden. In Schwitters, however, meaning is not hidden by the world of appearances but is formulated according to the manner and nature of things as they are—simply, in what is found there. Ideological categories, on the contrary, rely on precisely what is not

apparent, dialectical relationships configured according to a gap that exists between the real and the ideal. To Schwitters, there was no absolute truth that conditioned reality; the obverse of classical metaphysics, Schwitters' reality—manifest in the work of art—did not allude to any 'higher' set of truths, but was instead a discursive activity based on dialectical exchange.

This point of view suggests that the recognition of an ultimate authority and order of things is found in the world both as it is and as it behaves. Thus the world of things is both creative and creating. The meaning of the world is formulated through dynamic interchange, the exchange of energy between all manner of things. Accordingly, meaning does not have its source in either the object or subject but is found only in its coming into the play of communicative interrelationships. While the context for meaning is clearly made up of matter—matter that bears indications of peculiarities and circumstances by which it is formed and in which it exists—the principle of creativity that underlies this position supposes that method is also of critical importance. Purpose, however, is otherwise, for the function of things in the world is wholly dependent on their relations, their play within and among the panopoly of things.

Hence, Schwitters' artistic productions cannot be understood as thematic representations but thematic and visual presentations or, in Schwitters' terms, style. Portrayed in a different light than more current interpretations, style was for Schwitters a living, dynamic, and highly particularized aesthetic condition manifest of the singular oneness or wholeness of its own nature: from this point of view the suggestion that something has 'style' implies that it is has integrity. As in forms of life, style consists of the intertwining of form, method, material, structure, and function, all of which serve to define a particular condition that can achieve multiple variations and accept external influence. In what at first appears to be a paradox, a totalizing universe, complete, bound and unmediated by difference or the infusion of new organisms, does not admit the corruption necessary to change and development and is thus anathema to the vitality of organisms (*Lebensformen*). However—and this is the paradox—the integrity of organisms depends on their completion at any given moment in time, while the maintenance (or sustaining) of organisms *over time*—the duration that Schwitters suggests is necessary for art—relies on an admission of new ideas, structures and material into its system, thus informing the organism while being reformed in turn.

Discussing the *Weltanschauung* of Merz in his autobiographical sketch for *Der Ararat*, Schwitters specifically rejects the expression of social and political categories in art as "injurious to art": "art is a primordial concept, exalted

as the godhead, inexplicable as life, indefinable and without purpose ... " Thus, the process of making art is not preconditioned by concepts or ideas external to its nature. And like nature, art is also atemporal and immersive and therefore ahistorical: "I know only how I make it, I know only my medium, of which I partake, to what end I know not ... the medium is as unimportant as I myself." As in forms of life, the unconscious striving to exist is the primary motive. Any search for the essence of things is illusory, for "essential is only the forming."[44]

In his article entitled "Style in Philosophy and Art," Lambert Wiesing compares the philosophies of Kurt Schwitters and Ludwig Wittgenstein:

> To Schwitters, truth did not represent the correspondence of idea and thing but only the self-manifestation of a form, the form's showing of itself. Style becomes a concept of truth with the possibility of being pluralized; whereas singularity and universality are peculiar to truth, plurality and particularity are characteristic of style.[45]

Rather than the search for an absolute truth that marks most revolutionary causes, Schwitters' revolution was motivated primarily by an aesthetic form of philosophizing which promoted the liberating effects of style:[46]

> Everything is true, but also its opposite. Therefore I agree with everyone so as to preclude in advance the possibility of discussion [and] more eternal truths! There is only one truth of our age just as there were truths of other ages.

While the loss of absolute truth was to Schwitters a positive liberation ("no values, no tragedy"), to the more politically oriented Berlin dadaists this same loss of truth was a "diagnosis of fear." [47]

Hence, to Schwitters, art was *the* primary constituent for a redeemed life and, as such, the processes and project of art could forge the path of personal and consequently universal liberation. The iconic presence of the artwork, manifest as pure form, was revelatory, a 'shock-therapy' that forever altered the circumstances in which it appeared. Moreover, it did not rely on the mediating effect of critical interpretation, but constituted an entire cosmos in its own right. It was not only a world, but the manifestation of the world as it makes itself known at the moment of its coming into being. The developmental aspects of the work of art, its coming to be and its operative effect on the circumstances in which it situates itself, mirrors the valueless impulse of life and nature. As such, "expression" does not lie outside the work (the expression *of* something is not the aim of the work), but resides in the fact of its existence. It

is in this sense that the work of art is revelatory in the instant in which it accomplishes itself. Surpassing "common knowledge and experience," art is, for Schwitters, the ground upon which and through which the world is constituted; *in extremis*, art represents the "transvaluing of all values."[48] It is not a matter of how the work operates in the world, but that it *is* in the world. The result of *Formung and Entformung*, art cannot be adulterated by its being put to use. Indicative of the complex nature of Schwitters' artistic project—and the apparent reason for its omission from the canon of modern art and architecture—is that it is precisely at this point that modernism and mysticism intersect.

It should be noted, however, that Schwitters nonetheless continued to struggle with vagaries of expressionism in his work. In terms typical of German expressionism, Schwitters stated that his 'Expressionist' work reflected these ideals: "The personal grasp of nature now seemed the most important thing to me . . . The picture became an intermediary between me and the spectator. I had impressions (*Eindrücke*), painted a picture in accordance with them: the picture has expression."[49] Shortly after tendering this statement, Schwitters accomplished the feat of establishing his own particular mode of operation in Merz, through which he felt he had successfully removed himself from even residual ties to expressionist sentiment: "today, the striving for expression seems to me to be injurious to art . . . the work of art comes into being through the artistic evaluation of its elements. Only forming (*Formung*) is essential."[50] In rejecting the transference of emotive subjectivity to the work of art, a condition marked by the riotous use of color and the quasi-religious symbolism of neo-romanticism, Schwitters began to promote a more deliberative formulation of his work. This shift is marked by Schwitters' emphasis on a quasi-scientific process and the concomitant disregard for representational subject-matter: results could not be predicted but could be found as the evidence is gathered, assembled (*Formung*), and de-assembled (*Entformung*). There were no rules or fixed principles for either life or art, but an ongoing research that was itself developmental and generative, in effect mirroring the constantly fluctuating circumstances and contingencies by which and through which it was formulated. In his book *The Postmodern Condition: A Report on Knowledge*, Jean-François Lyotard advises that a similar methodology is present in the works of artists and writers who have been classified as "postmodern":

> A postmodern artist or writer is in the position of a philosopher: the text he writes, the work he produces are not in principle governed by pre-established rules . . . [These] rules and categories are what the work of art itself is looking for. The

artist, or writer, then, is working without rules in order to formulate the rules of what will have been done. Hence, the fact that work and text have the characters of event.[51]

The sum of Schwitters' visual and literary works suggests, in the manner of Goethe, a "chorus which points to a secret law." The perceived inconsistencies in his statements and works harbored a double function. First, the inconsistencies were formal, thereby undermining the critic's ability to derive fixed characteristics that might serve to define the genre in which Schwitters worked. Secondly, inconsistency was part of the method that he undertook to stretch the limits of what was known. What was known was not only that which informed the world around him, but the multiple revelatory episodes resulting from Schwitters' transubstantive actions of *Formung and Entformung*. It is here that the constitution of the art of nature paralleled the nature of art. Accordingly, the "modern project to rigor," a dialectical project that seeks to overcome the circumstances and contingencies of creative play, ran counter to Schwitters' artistic ethic.[52] To him, art was not *like* nature, but equivalent to nature and thus a living system in which subject and object, engaged in the activity of the creative field, became part of an indeterminate, albeit highly particularized, flow of circumstances and events. In her book *Sequel to History*, Elizabeth Deeds Ermarth suggests a similar ethic in her critique of instrumentalized reason:

A living system is always in process, incomplete, in play, whereas a system without play is functionally dead: doomed to perfectly rational but lifeless exactitude because it has followed to its conclusion the structural impulse to foreclose play...the very idea of structure is essentially a rational instrument that has the goal of all putatively rational systems to...exclude play as much as possible, to the extent of achieving total rigidity.[53]

Characteristically, it is difficult to pin down Schwitters' underlying theophilosophical perspective outside the events and performances that populate his existence in the world. This too is consistent with his thoughts on the nature of perspective—itself a mechanism that supposes critical objectivity. In his writings and works, Schwitters suggests the possibility of his consignment to a kind of spiritual existentialism, perhaps the reason for the retention of many of expressionism's ideas throughout his work. Given his rejection of totalization and universals for the sake of particularities and contin-

gencies, any attempt to sketch a coherent and decisive spiritual program would rely on a highly selective reading of his works and person. Over the course of his artistic career, he consciously operated against distillation and definition, providing direct insight only into the processes by which the work of art came to be. According to Schwitters, any revelation of the work's hermeneutic content—its meaning—would inherently compromise the work itself: external explanations were treated as folly. However, they too could become something found and gathered, and 'formed' in accordance with the principles of Merz. While his attempts to render explanations of his work and person do reveal a significant amount of insight into his mode of operation, they must be approached with caution. In most of them, Schwitters vacillates between and among wry humorisms, stalwart objectifications, homages to other artists, and diatribes, oftentimes throwing his readers or viewers off the mark or in some cases setting them onto another path altogether.[54] This is clearly the case in several of his *Merzbilder* from the 1920s, in particular those that appear to allude to social, political and social critique—subjects he did not feel worthy of artistic deliberation.

NOTES

1 For a detailed outline of Schwitters' early artistic development, see Schmalenbach (Köln, 1967), pp. 7-34.

2 The Dresdner expressionists included, among others, Erich Heckel, Christian Schmidt-Rottluf, and Ernst Ludwig Kirchner. Jean-Christophe Bailly, *Kurt Schwitters*, pp. 18-19. Schwitters' work in Dresden was largely confined to the traditional: landscape paintings, still-lifes, and portraits were his favored subject matter during this period. See also Schmalenbach, *Kurt Schwitters* (München: Prestel-Verlag, 1984), p. 30.

3 Schwitters, "Merz," in *Das literarische Werk*, 5, p. 75.

4 Idem.

5 Nill exposes the depth of Schwitters' ongoing difficulty with critics, a difficulty which aided and abetted his understanding of his artistic mission. See Nill, Decoding Merz, pp. 230-282.

6 Schmalenbach, *Kurt Schwitters* (Köln, 1967) p. 366, n. 66.

7 Carola Giedion-Welcker, "Kurt Schwitters, Konstruktive Metamorphose des Chaos (Kurt Schwitters: The Constructive Metamorphosis of Chaos), repeated in Carola Giedion-Welcker, *Schriften 1926–1971*, ed. Reinhold Hohl (Köln: M. DuMont Shauberg, 1973).

8 Ernst letter to Tzara, February 17, 1920, as quoted in William Camfield, *Max Ernst: Dada and the Dawn of Surrealism* (Münich: Prestel-Verlag and the Menil Collection, Houston, 1993), p. 67.

9 Camfield, *Max Ernst*, p.67.

10 Nill takes up this point at length in *Decoding Merz*, pp. 164-229. See also Webster, pp. 29-32.

11 For arguments involving critical history and historicism see Friedrich Nietzsche, "The Use and Abuse of History," in Unzeitgemasse Betrachten (*Unmodern Observations*), ed. William Arrowsmith (New Haven: Yale University Press, 1980).

12 For further elaboration on the mystical underpinnings of the Russian avant-garde, in particular the argument that particular 'factions' of Russian constructivism were not 'rational and systematic,' but rather 'intuitive and mystical,' see Elizabeth English "Ivan Vladislavovich Zholtovskii and his Influence on the Soviet Avant-Garde," published in *ACSA National Conference Proceedings*, Minneapolis, 1999 (Washington, DC: American Collegiate Schools of Architecture Press, 1999).

13 Dietmar Elger, *L'oeuvre d'une vie*, p. 145. Founded in 1919 directly on the heels of the First World War, the principle mission of *Die Gläserne Kette* entailed the radical revision of society according to Expressionist ideals. *The Glass Chain Letters* are a series of quasi-anonymous secret correspondences that were exchanged among the members of the group, many of whom had code names in the manner of medieval (secret) societies. See Paul Scheerbart and Bruno Taut, *Glass Architecture and Alpine Architecture*, ed. Dennis

Sharp (New York: Praeger Publishers, 1972).

14 The example Schwitters elaborates on was for the merzing of Berlin. This project entailed the "working through" of both old and new—in this case architecture—to form a unified whole. This working through, which he referred to as the absorption (sublation) of both beautiful and ugly buildings, required the appropriation of superior rhythms in the manner of "rightly distributed accents" or "focal points" and materials. The city was to be transformed from a set of fragmentary episodes into a continuous, if reconstituted, fabric of light and color, whereby the "important centers" would naturally correspond with the "nodes of circulation." According to Schwitters, Merz architecture, in clarifying the nature of the city, would add a "significant degree of value to the center of the city." See "Schloss und Kathedrale mit Hofbrunnen," in *Das literarishe Werk*, 5, pp. 95-96. Also see Dietmar Elger, "*L'oeuvre d'une vie,*" p. 145.

15 Kurt Schwitters, "Merz (für den "Ararat" geschreiben)" (1920), in *Das literarishe Werk*, p. 74. Also see Elderfield, *Kurt Schwitters*, p. 15.

16 In his *Dada Almanach* of 1920, Richard Huelsenbeck, organizer and voice of the Berlin Dadaists, explicitly rejected Schwitters' contributions to dada, stating: "Dada rejects emphatically and as a matter of principle works like the famous 'Anna Blume' of Kurt Schwitters." Schwitters' counter-attack was published shortly thereafter in the article "Merz (für den "Ararat" geschreiben)" (December 1920). In "Merz," a seminal statement regarding his artistic project, Schwitters detailed his reaction to the "husk-Dadaists," so named because of what Schwitters' felt to be their derivative meanderings from the original dada program. The designation was also a pun on Huelsenbeck's name: "In his introduction to the recently published *Dada Almanach*, Huelsenbeck writes: "Dada is making a kind of propaganda against culture." Thus Huelsendadaismus is politically oriented, against art and against culture. I am tolerant and allow everyone his own view of the world, but am compelled to state that such an outlook is alien to Merz. Merz aims, as a matter of principle, only at art, because no man can serve two masters." Still further, he writes: "Merz maintains a close artistic friendship with Core dadaism... Merz energetically and as a matter of principle rejects Herr Richard Huelsenbeck's inconsequential and dilettantish views on art." For a detailed outline of Schwitters' profession of anti-dada, see Elderfield, *Kurt Schwitters*, p. 41.

17 Nill, *Decoding Merz*, p. 29. Nill states that Schwitters met Hans Arp sometime after the armistice in 1918. In a 1920 letter to Hans Arp, Schwitters asserts that Arp "unlocked the fountains." In another letter to the Hannover artist Otto Gleichmann, he calls Arp "*die Zukunft*" (the future), stating that he had used Arp's inspiration "as a bridge to obtain the opposite shore."

18 Schwitters, "Merz," *Das literarische Werk*, Bd. 5, p. 77, trans. Elderfield.

19 Translation from Schmalenbach, *Kurt Schwitters*, New York, p. 32. See Schwitters, "Kurt Schwitters," *Das literarishe Werk*, 5, p. 335.

20 I owe this phrase to Richard Wolin's critical writings on Walter Benjamin entitled *Walter Benjamin: An Aesthetic of Redemption* (New York: Columbia University Press, 1982).

21 Schwitters, "Merz," in *Das literarische Werk*, 5, pp. 76-82, trans. in Jerome Rothenberg and Pierre Joris (*Kurt Schwitters, PPPPPP: Poetry Performance Pieces*) pp. xxix and 215.

22 Carola Giedion-Welcker, introduction to *Kurt Schwitters* (exhibition catalogue), trans. David Britt, (Marlborough Fine Art [London] Ltd., Oct. 1972), p. 5. In this same article, Giedion-Welcker locates Schwitters artistic roots in German romanticism.

23 Elderfield, *Kurt Schwitters* (London: Thames and Hudson, 1985), pp. 43, 45, 235, and 237.

24 Schwitters, "Die Bedeutung des Merzgedankens in der Welt," in *Das literarische Werk*, Bd. 5, p. 134. Translation from the English edition of Werner Schamlenbach, *Kurt Schwitters* (New York: Harry N. Abrams, 1967), p. 94. For a further explanation of *Entmaterialisiert*, see *Zeichen des Glaubens. Gest der Avantgarde*, ed. Wieland Schmied (Stuttgart: Klett and Cotta, 1980), p. 125; cit. in Nill, *Decoding Merz*, p. 328.

25 Schmalenbach, *Kurt Schwitters* (Köln, 1967), p. 64.

26 Elderfield, "The Early Works of Kurt Schwitters," *Artforum*, 10, No. 3 (Nov. 1971, pp. 54-67.

27 Ludwig Wittgenstein, *Philosophical Investigations*, Third edition, trans. G.E.M. Anscombe (New York: MacMillan Press, 1953), pp. 8e (19), 11e (23), 88 e (241).

28 Nathan Schwarz-Salant, *Jung on Alchemy* (Princeton: Princeton University Press, 1995), pp. 36-37.

29 Susan Buck-Morss, *The Dialectics of Seeing: The Arcades Project* (Cambridge, Massachusetts: MIT Press, 1989), p. 146, cit. Walter Benjamin, *Trauerspiel*, I, p. 211.

30 Huelsenbeck's 1957 article was clearly an attempt to explain the schism between Berlin dada and Schwitters' Hannover dada: See Richard Huelsenbeck, "Dada and Existentialism," in *Dada Monograph of a Movement*, ed. Willy Verkauf (London: Alec Tiranti Ltd., 1957), p. 56.

31 The German artist Karl Spitzweg was an immensely popular nineteenth-century vernacular painter whose work appealed to the petit-Bourgeoisie in Germany. While the designation of Schwitters in terms of Caspar David Friedrich was obviously partially derogatory, the association of his name with Spitzweg was clearly meant as a direct affront.

32 Schwitters, "Ich und meine Ziele," in *Das literarische Werk*, 5, p. 342.

33 This view of art as icon (pure form) is similar to ideas set forth by the Suprematists, whereby pure intuition (spirit) is manifest in the 'real' as 'pure painting' devoid of representational content. It is also found in the works of Piet Mondrian and Theo van Doesburg (De Stijl). The notion that pure abstraction could lead to utopian social harmony, and consequently universal redemption, was a hallmark of these movements. See

Charles Harrison and Paul Wood, *Art and Theory: 1900–1990* (Oxford, England: Blackwell Publishers, 1992), pp. 166-176; p. 221.

34 In his book on Weimar culture, Peter Gay describes the general climate of the Weimar Republic as follows: "…Weimar came to symbolize a prediction, or at least a hope, for a new start; it was tacit acknowledgement of the charge, widely made in Allied countries during the war and indignantly denied in Germany, that there were really two Germanys: the Germany of military swagger, abject submission to authority, aggressive foreign adventure, and obsessive preoccupation with form, and the Germany of lyrical poetry, Humanist philosophy, and pacific cosmopolitanism." See Peter Gay, *Weimar Culture: The Outsider as Insider* (New York: Harper and Row, 1968), pp. 1-23.

35 *The Weimar Republic Sourcebook*, eds. Anton Kaes, Martin Jay, Edward Dimendberg (Berkeley: University of California Press, 1994), p. xviii.

36 Two recent dissertations on Schwitters support his view. In the context of this argument, it is interesting to note the divergence of Annegreth Nill's argument regarding Schwitters' early collages and Janice Schall's attempts to distill the hermeneutic (literary) content of the pieces. Both present compelling arguments; Nill's in favor of promoting Schwitters as an artist consciously engaged in the a transhistorical view of the socio-political questions of his time, while Schall exposes the multiple references to biblical parables and the history of art. To Schall, the socio-political questions of the early *Merzbilder* are sublimated into Schwitters' own experience with the art world; she observes that, for Schwitters, time and eternity are weighted equally. See Annegreth Nill, *Decoding Merz*, inclusive, with emphasis pp. 25-121; and Schall, *Rhythm and Art in Germany*, pp. 215-67. Both Nill and Schall represent a departure from Dorothea Dietrich's analysis of the social, cultural and political content of Schwitters work in her book *The Collages of Kurt Schwitters*.

37 Nill's discussion of the two works in question, *Das Arbeiterbild* and *Das Baumerbild*, is particularly instructive in this regard. In her analysis, Nill shows how *Das Arbeiterbild* (*The Worker Picture*) is a work that is directly related to Gustave Courbet's *The Stone-breakers* (1849) and Adolf Menzel's *Das EisenwalzWerk* of 1875. The message of the work is not necessarily the specific political situation of the German revolution during the late-teens, but rather the currency of similar artistic subject- matter through time. The numerous fragments contained in the picture—wheels, a scythe, the colors red and black—contain multivalent associations that resonate throughout the course of history, associations which allude to cosmology and the developments of scientific thought in general. As Nill asserts, it is in this sense that *Das Arbeiterbild* "appears to go beyond being a celebration of the political revolution that gave birth to the Weimar Republic. It must clearly be seen as an icon, of the revolution of the human spirit." See Nill, *Decoding Merz*, pp. 77-91.

38 Schwitters, "Ich und meine Ziele," in *Das literarische Werk*, Bd. 5, pp. 340-341. Numerous essays have rendered the socio-political nature of Schwitters' various artworks, and the readings of certain pieces: *Merzbilder* such as *Das Bäumerbild*, *Das Sternenbild*, and the *Dada-column Die Heilige Bekümmernis* are examples of this, do lend themselves to socio-political commentary. However, he resisted ideological aims (*Weltschauung*) that were not concomitant with the primacy of art as art.

39 Schwitters, "Kurt Schwitters," in *Das literarishe Werk*, Bd. 5, p. 335. Translation in Schmalenbach, Kurt Schwitters (1967), p. 35.

40 The notion of the Weimar Republic as the seat of cultural revolution—as opposed to social and political revolution—was a familiar sentiment among many German artists and architects during the early years of the Weimar Republic. This hope for the incipient state is registered in their faith in the prospects of social change motivated by art, rather than politics. In his book *Scope of Total Architecture* (London: George Allen and Unwin Ltd., 1956), Walter Gropius expresses a similar set of ideas: "This is more than just a lost war. A world has come to an end. We must seek a radical solution to our problems."

41 Hans Richter, *Dada: Kunst und Anti Art*, p. 138.

42 "In absehbarer Zeit hoffen wir, Dass unsere aufklärende Tätigkeit über die enorme Stillosigkeit in unserer Kultur einen starken Willen und eine grosse Sehnsucht nach Stil wachrufen wird." Kurt Schwitters, *Das literarishe Werk*, Bd. 5, p. 132.

43 James, *The Varieties of Religious Experience*, pp. 318-326.

44 Schwitters, "Merz (Für den Ararat geschrieben)," in *Das literarische Werk*, Bd. 5, ed. Friedhelm Lach (Köln: Dumont Buchverlag, 1981), pp. 76-77. Originally published under the title "Merz" in *Der Ararat* (1920).

45 Wiesing, "Style in Philosophy and Art," *Museumjournaal voor Moderne Kunst* (Amsterdam: Stedelijk Museum), v. 3, no. 1, pp. 40-48. For an expansion of Wiesing's argument, see Lambert Wiesing, *Stil staat Wahrheit: Kurt Schwitters und Ludwig Wittgenstein Über Ästhetische Lebensformen* (München: Wilhelm Fink Verlag, 1991).

46 Kurt Schwitters, *Briefe* (*Wir Spielen, bis uns der Tod abholt*), ed. Ernst Nündel (Frankfurt-am-Main/Berlin: Verlag Ullstein, 1974), p. 159, as quoted in Wiesing, *Style in Philosophy and Art*, (Amsterdam, 1991), p. 41.

47 Wiesing, *Style in Philosophy and Art*, p. 40.

48 Andrew Weeks, *German Mysticism from Hildegard of Bingen to Ludwig Wittgenstein: a Literary and Intellectual History* (Albany: State University of New York Press, 1993), pp. 233-237.

49 Elderfield, *Kurt Schwitters*, p. 15.

50 Schwitters, "Merz," in *Das literarische Werk*, 5, p. 76.

51 Jean-François Lyotard, *The Postmodern Condition: A Report on Knowledge*, trans. Geoff Bennington and Brian Massumi (Minneapolis: University of Minnesota Press, 1984), p. 81.

52 Patrick Madigan, *The Modern Project to Rigor: Descartes to Nietzche* (Lanham: University Press of America).

53 Elizabeth Ermarth, *Sequel to History: Postmodernism and the Crisis of Representational Time* (Princeton: Princeton University Press, 1992), pp. 147-148.

54 Schwitters' literary works have been collected into five large volumes. These volumes, edited by Friedhelm Lach, provide the most significant source of information regarding Schwitters' ideas. What is fascinating about the collection is not only his repeated attempts to explicate his works and person, but the prolific nature with which he undertook to do so. See Kurt Schwitters, *Das literarische Werk*, Bands (volumes) 1-5 (Köln: M. DuMont Buchverlag, 1981).

PRELIMINARY PROJECTS:
LITERATURE AND SCULPTURE 1919–1922

The artist's problem lies in a conflict—to present oneself, then to draw back, to be seen and to remain invisible.　　　　　—Aaron Ronald Bodenheimer

The creation of two- and three-dimensional art is supplemented throughout Schwitters' career by extensive literary works, including poems, prose, children's fables (*Märchen*), manifestoes and criticism. With respect to the *Merzbau*, several pieces of poetry and prose, written during the same period of time construction on the project began, are critical. Coupled with sculptural pieces from the same period, these literary and sculptural works shed considerable light on the underlying motivations for the *Merzbau* specifically and Merz in general. While the *Abfall* used to create the sculptural works most clearly suggests the image of Baudelaire's ragpicker, Schwitters sees aspects of language in the same way—only in this case the material happens to be words; the method, linguistic play.

Literature

Beginning with experimental pieces penned at the time of his transitional phase immediately following World War I and continuing throughout the course of his life, Schwitters' poetry and prose pieces exhibit a barely concealed preoccupation with issues of sexual desire. This is also the case with his sculpture, small works whose interpretation depends on the short prose and poetry as much as the prose and poetry is illuminated by the sculptures. Schwitters' articulation of sexual desire establishes themes that in retrospect are preliminary studies for his "cathedral," themes that can be interpreted in large part as alchemical parables. One prose piece and two poems published in a small collection of Schwitters' literary works by Hannover publisher Paul Steegemann are particularly significant in this context. Collected under the title *Anna Blume Dichtungen* (*Anna Blume Poems*) (1919) they appear to have been written just prior to his public pronouncement of Merz and, given their

subject matter, implicitly suggest themes specific to the *Merzbau*. The first of these is a short, violent sprose piece entitled "*Die Zwiebel: Merzgedicht 8*" (The Onion: Merzpoem 8) (1919).[1] The protagonist and narrator is a man named Alves Bäsenstiel, or "Elvis Broomsticker." The choice of the narrator's name in this case likely points to Schwitters' assertion of his affiliation with the ideas of Tristan Tzara, a Romanian artist and member of Zürich dada. Including the allusion to Tzara's "sweeping and cleaning," ("Broomsticker") multiple references to Tzara's infamous "Manifest dada," an explicit protest against "logic," appear elsewhere in Schwitters' writings at the time, many of which suggest a latent hermetic impulse as well. Tzara:

> The new artist protests: he no longer paints ... but creates—directly in stone, wood, iron, tin, boulders—locomotive organisms capable of being turned in all directions by the limpid wind of momentary sensation. All pictorial or plastic work is useless: let it then be a monstrosity that frightens servile minds ...
>
> ... art ... is not as important as we, mercenaries of the spirit, have been proclaiming for centuries ... Logic is always wrong ... Morality creates atrophy like every plague produced by intelligence ...
>
> Let each man proclaim: there is a great negative work of destruction to be accomplished. We must sweep and clean. Affirm the cleanliness of the individual after the state of madness, aggressive complete madness of a world abandoned to the hands of bandits, who rend one another and destroy the centuries.[2]

In the course of the story, Bäsenstiel is physically broken apart only to be promptly reassembled—a dramatic proposition that mirrors Schwitters' *Formung* and *Entformung* in the construction of his visual works. The immediate effect of the story is quite disturbing, proceeding from what may be described as Bäsenstiel's disinterested participation (as the narrator he appears to be flatly reading a record of the immediate events recorded in the story). Bäsenstiel's initial dispassion breaks down almost right away, however, with premonitory evidence of his impending demise occurring through the increased frenzy of word play, syntactical disarray, and what appear to be ever more frequent interspersions of nonsensical statements. The form and content of the story, while representative of expressionist-dadaist literature, begins to take on the more specific thematic content and methods of Schwitters' *Merzgedichten* (Merz poems).

In formal terms, the entire effect is that of a montage of experience. Reflective of the expressionist (*Sturm*) poetical mode of *Weltgefühl* (world-

feeling), "Der Zwiebel" entails a mode of writing that attempts to express the emotive aspects of experience, in effect displaying them in all their immediacy. As in German romanticism, German expressionism sought the experiential instance of poetic *Weltgefühl* with the intention of generating cosmic feeling, a singular simultaneity of words and images that would hopefully provoke a mystical state of being. While the words themselves were important for their descriptive capabilities, the auditory aspects of language were even more important. Sonorous word play, conditioned by the play of sound against sound, reflected a preoccupation with music, the dynamic of note upon note in space and through time, a mode of experience that, while sensual, was also highly abstract.[3]

In Schwitters' case, the denotive aspects of *Sturm* writing can be viewed as a secondary issue, though this does not mean that the specific denotations—or connotations—can be disregarded entirely. As with expressionist painting, certain signs and symbols were chosen for their echo-effect, that is their ability to signal the underlying motives behind the work, motives that were often allied with religious, emotional, mystical, hermetic, and organic themes. The concentration on sounds, in particular the haunting abstractions of mystical echoes, appears to explicitly reference Kandinsky's "stage composition" of 1912 entitled *Der gelbe Klange* (The Yellow Sound). [4]

In early twentieth century Germany and Russia, the search for primal origins was a prominent theme in art, culture, and politics—a condition likely spurred by the quest for national identity coupled with an attempt to purify the excessive accumulations of several centuries of accelerated cultural development, increased materialism, and political unrest.[5] The quest for spiritual liberation, marked by attempts to return to mankind's essential origins, motivated many of the avant-garde movements during the late-nineteenth and early-twentieth centuries, including symbolism, German expressionism and suprematism, the immediate predecessor of Russian consructivism and Neue Sachlichkeit. The search for the elemental, spiritual condition of pure sound was a marked characteristic of the theoretical endeavors of expressionism in particular, a carry-over from the experiments of *Der Blaue Reiter*, a group of painters and poets who counted Kandinsky—also the author of *Concerning the Spiritual in Art*, a work published in the wake of *Der gelbe Klange*—as a member. In expressionist painting attempts to render *Einfühlung* through the application of dense layers of paint (impasto) laden with the artist's gestural marks and the use of primitive, raw color were seen as a way of effacing the differences between subject and object, thereby inducing the release of

untrammeled emotional and spiritual feelings. In sound poetry, the search for the underlying sense of language (Kandinsky's "yellow sound," the overlap of visual and auditory senses is explicit in this regard) reflects the pursuit of raw, primal sounds, a method of linguistic rendering that sought similar ends. The story of "Der Zwiebel," something of a recapitulation of Tzara's "Manifeste dada,"[6] reflects Schwitters' attempt to induce a kind of shock therapy. Based on a paradoxical, ambiguous and simultaneous exchange of both form and content, the overall effect of "Der Zwiebel" is one of breakdown and disarray that produces a collateral destruction of logic necessary to any critical apprehension of the piece. While there is a space of resolution, stasis is only a momentary illusion; the event immediatly following shatters the short-lived calm through a seemingly unchecked infusion of additional images, phrases, and sounds. Thus from moment to moment the work exists in its entirety, while at the same time it is governed, however paradoxically, by developmental processes, *ad infinitum.* Hence, the piece is performative; based in the projection of a series of activities, it is abetted by an insistent dynamic that inherently rejects the static nature of conceptual logic in the pursuit of unadulterated *Einfühlung.*

As in the production of the *Merzbilder,* the recombination of devalued fragments *(Abfall)* from both past and present informs Schwitters' literary method. In the myriad combinations that result, some make sense, while others do not. Since they are all set equal to one another in a field of associations, however, there is little possibility of privileging any one interpretation of the text. In countering the program of Berlin dada, an approach that did not always seek to recombine the dissolved materials to any effect, Schwitters' "Alves" is in fact recombined, albeit in an altered state. In being resurrected (or brought back from the brink of what would surely be his imminent demise), Bäsenstiel is redeemed—a necessary condition given Schwitters' faith in the project of art as a spiritual enterprise. Transposing the principles of *Formung, Entformung,* and *entmaterialisiert* to his literary works, Schwitters accomplished similar ends; the past is not negated, but brought forward, reconfigured according to the context of present circumstances, circumstances that were themselves in flux.

In characterizing the piece as a dada-expressionist hybrid or, better, as a distinct attempt at creating Merz literature, there is again the suggestion of a latent (hermeneutic) content pertaining to desire and redemption, a reading that bears itself out when obvious symbolic references are subject to analysis. The first symbolic association is found in the title, "Die Zwiebel"—a sign or

perhaps a reflexive warning by the story's author that any attempt at critical analysis may be folly. An onion is, of course, structured as a series of embedded layers; as each one is peeled away another is revealed leaving the onion still whole despite its ever-diminishing scale. Allegorically, just as one peels away the surface one finds yet another surface that is, in turn, succeeded by yet another. However disciplined the process of uncovering layer upon layer, the layers themselves are not complete and are even diminished at the outer edges, thus suggesting a blurring of distinctions when considering one layer with respect to another. The inner core or essence of the onion itself appears to perpetually recede until it is eventually revealed that the core is but another layer and there is no core but rather small buds that attest to potential regeneration. Across cultures, the metaphor of the onion is often used to denote a spiritual journey, a never-ending process of successive revelations and still further demands. In addition, the peeling of an onion produces tears, the universal and highly ambiguous symbol of pain, grief, suffering, joy and love. It is therefore a deeply ambivalent symbol of the alternating shifts between sex, love, death, and life, as well as a parable of consequences that represent the fallout of human desire. As with the peeling of the onion, however, there are additional signals, hidden meanings upon hidden meanings, which come to light only in the performance of the action, the telling of the tale.

In "Die Zwiebel," a parallel tale of spiritual journeying expressed in the terms of alchemical mechanics (dissolution, purification, trituration, union, cooking), and solution (re-assemblage), lurks just behind the story's expression. In addition, there are references to alchemical materials and symbols such as sulfur, salt, the color green (the intermediate color in the chromatic scale and hence the color of romance), flames ("Hollow burns stomach flame sulfur blood"), earthworms, fat, and silver. To both conceal and abet the message of the story, Schwitters intersperses the text with parenthetic remarks that initially appear nonsensical, but in further analysis may act as deliberate marks or traces of the alchemical process: "workers grind organs," "the sacrifices of a mother's love," "ducks are goosing in the meadow," "Thou art moving this day from the House of thy Father," "Fortuna grindstones," "Acetyline eliminates the smell of bodily secretions," "That's how one cleans, dusts, washes, steams, and dries bed feathers" and "the art of happy days in marriage." While some of these declarations and expressions may indeed be autobiographical (it is easy to read them as such), other remarks appear to parody the political and social situation immediately following the war: "For the ideals of socialism"; "All this for the Red Army"; "In all innocence you 'ave hal-

lowed thy heart for the Holy Alliance t'day!"; and "calling all white- and blue-collar workers." Still others appear to be inflections of minor events and notices that passed through Schwitters' mind and/or experience in a kind of free association: "20 cents per millimeter line per six-column page"; "Authentic Brussels handiwork"; and "Smoking forbidden. Even unlit cigars held in the hand are prohibited." In "Die Zwiebel," the narrator (Bäsenstiel), when re-assembled, is found to have special powers, becoming endowed with the "magnetic currents that permit him to realign his poorly assembled inner parts."[8]

Schwitters' tendency to follow the inviolate pandect of alchemy—the code of concealing the "true" subject matter of the alchemical and occult practices and productions—is consistently adhered to in the artist's sublimation of explanatory evidence. It also provides the opportunity for the story's interpreter to apply their own frame of reference, thereby enabling the essential perpetuity of process and effect. As Dietrich points out in her analysis of the "Die Zwiebel," "Alves" is an anagram for "salve," an evocation of "Salve regina" ("Salute the Queen" or "Hail Mary"). As a lever that pulls open a secret door, the name of the title character points to various biblical themes pertaining to the figure of Mary, including immaculate conception, procreation, birth, death, and subsequent rebirth; salve not only implies greeting, but is used to bid farewell. Moreover, the figure of Mary, herself a condensed version of numerous female figures in biblical literature, is not only the Mother of the Savior, but also a depiction of saving grace (as Intercessor, Co-Redemptrix) and, alternately, sorrow (*Mater Dolorosa*). The prayer "Hail Mary" suggests that Schwitters is attending to his preoccupation with the question of woman as the most potent and pervasive allegorical subject throughout the course of history. At the same time, he may be suggesting the inherent paradoxes of the female gender, all of which become fully articulate in the roles and treatment of women in Judeo-Christian texts—paradoxes and uncertainties that fascinated Symbolists, expressionists, dadaists and Surrealists in equal measure.

Also contained in the Steegemann publication, the poem *Grünes Kind: Gedicht 1* ("Green Child: Poem 1") displays a similar intent in terms of methodology.[9] Written in 1918 or 1919, *Grünes Kind* is significant not only for the insight it provides into Schwitters' literary methods, but in its thematic content as well. In a form even more exaggerated than "Der Zwiebel," sections of *Grünes Kind* include violent, almost syncopated references that appear as rhythmic linguistic shots or shocks emanating from the paralytic state of a traumatic dream:[10]

Enjailed air steeps.

The murder overdomes blood.

If only I could shard these walls!

O this glow of the embracing wall!

Jail unifies—

Blood jails—

Blood steeps—

[...]

Green.

Shot—

Who shoots?—

Blood?

Sulfur—

Blood—

Fear—

Chase—

Fly—

Scream—

Blood grins yellow—bright—yellow—

Yellowgreen

Blood grins brightsulfuryellowgreen.

If only I could wash the green blood!

[...]

Dear child—

Green—

Is child crying?

Sulfuryellow child, how firered Thou art!

[...]

Schwitters' use of color in the poem is precise: the exchange of red (passion) and white (purity) imply the transfer of energy from male to female (insemination) and the subsequent admixture of "white blood" in the bride. The movement from red (blood) to white is akin to the developmental nature of the alchemical enterprise which is in itself an ambiguous, revolving exchange of give and take between the necessary (natural) orders of the macrocosm and microcosm. According to Carl Jung, "...the lowest degree is as a program with the mere result of stimulation (red); the highest degree is a final transmutation of the psyche."[11] In alchemy, the transference of white

(*albedo*) to red (*lubedo*) and back again signals the manifestation of desire and the subsequent engagement of the passions that then leads to the admixture and thus the 'integration of the human soul' with the world-soul. Again according to Jung:

> [In the] state of 'whiteness' one does not live in the true sense of the word. It is a sort of abstract, ideal state. In order to make it come alive it must have 'blood,' it must have what the alchemists called lubedo, the 'redness' of life. Only the total experience of being can transform this ideal state into a fully human mode of existence. Blood alone can reanimate a glorious state of consciousness in which the last trace of blackness is dissolved, in which the devil no longer has an autonomous existence but rejoins the profound unity of the psyche. Then the opus magnum is finished: the human soul is completely integrated.[12]

The title, *Grünes Kind,* also points to the result of the romance, a child designated by the color green. Green (*viriditas*) falls in the middle of the chromatic scale and traditionally represents the color of romance, the middle ground between red and white; in addition, the green necessary for natural photosynthesis suggests balance and exchange. The combination of *albedo* and *lubedo* results in an admixture of purity and passion. The union of opposites, white mixed with red, purity combined with desire, represents the unification of the ideal with desire. At the same time, the joining of opposites signals an inherent ambivalence: the tension of identity juxtaposed to complete sublimation and the erasure of difference for the sake of producing a third condition. The figure of the "green child" can be viewed as the latter: the human soul "completely integrated."[13]

The poem can also be read as an autobiographical piece. The juxtaposition of "Der Zwiebel," with *Grünes Kind* reveals what may perhaps be a more personal, even melancholic sense to the poem. In *The Secret Language of Symbols*, David Fontana asserts that the color green symbolizes sensate life (the life of the senses). It also stands for nature, though not just for nature's creative urge or developmental growth, but for its necessary opposite, decomposition, death, and decay. Green is also a chromatic symbol of jealousy.[14] That Schwitters would speak of a "green child" signals the possibility of nature's creative and destructive force, in particular as it might be associated with the death of his first son, Gerd, in infancy, approximately three years prior to the publication of *Grünes Kind* in 1919. Schwitters never spoke publicly of his loss, and only recently has a reliable record of the birth and death

of the child surfaced. What the artist's actual thoughts were is a matter of speculation. However, there are abundant, if heavily veiled clues to Schwitters' lingering sorrow in his painting and literary works from 1916 (the year his Gerds died) on.

The poignant events reflected in the stories and poems of the late-teens, particularly the language and stylistic means Schwitters used to articulate their significance, provide important clues to the hermeneutic content of the *Merzbau*, Schwitters' *Cathedral of Erotic Misery*. Photographs, coupled with anecdotal evidence, indicate that Schwitters kept his infant son's death mask in his studio as something of a memorial or votive. The child's rigid countenance could have been a cautious reminder, though it is more likely that Schwitters viewed the mask as an emblem of the benevolent presence of his son. Thus, the mask provided Schwitters with the impulse to continue to perform affirmative acts of creation—an aura of repentance and longed for redemption that seems to govern both *Grüneskind* and "Der Zweibel." Gathering and condensing these references allows Schwitters to create, like the *Merzbilder*, a highly ambiguous situation that recognizes the dual facets of life, growth and development and death and decay at a number of scales and in several contexts. In this sense, the poem resonates with both broadly drawn and specific connotations. The longing (*Sehnsucht*) for his dead son and the inevitable lack such longing enforces focuses the creative enterprise as much on the redemptive nature of Schwitters' art as on the very condition of the material itself. Schwitters' embrace of *Abfall* in his daily collection of used materials and artifacts constitutes a reclamation of loss, decomposition, and decay. Life is coaxed out of dross, transmuting what is devalued into something valuable—the essential work of an aesthetic redemption.

In the context of Schwitters' *Merzbau*, yet another poem, or in this case a poetic grouping should be addressed. In 1919, Kurt Schwitters published his famous love poem *An Anna Blume*. Dedicated to his ideal mistress, *An Anna Blume* appeared, along with "Der Zwiebel" and *Grünes Kind*, as the signature piece for Schwitters' collection entitled *Anna Blume Dichtungen*.[15] The poem created something of a sensation, affording Schwitters a significant degree of notoriety. Even today, the original poem *An Anna Blume* is known by many schoolchildren throughout Germany, and it is through the popularity of this particular literary work that Kurt Schwitters is most remembered.[16] At the time of its publication, *An Anna Blume* was considered both radical and threatening, with its author (Schwitters) being accorded the role of "insane artist." Letters to his editor, Hannover publisher Paul Steegemann, were alter-

nately full of praise and damnation, with many readers granting credence to an "irrevocable diagnosis (of) insanity, mental illness, and dementia praecox."[17] The vociferousness of many of the reactions indicates that the poem struck a raw nerve among Germany's *bürgherliche*, the burgeoning middle class with whom Schwitters himself was identified. Published in several languages and versions, the poem was eventually translated by Schwitters into English in 1942, with slight, though not insignificant, variations. Developed and republished with variations on the original theme throughout the course of his life (the English titles were "eve Blossom" or, alternatively, "Anna Blossom Has Wheels")[18] the poem, as well as several variations of the poem composed in the interim, exhibits the Merz principle of having been 'worked through.' If juxtaposed to one another, the variations appeared like slightly offset images in a series, essentially the same and yet critically different, each version implying a slightly different "Anna."

In the first version and continuing in the poem's subsequent renditions, a women of unknown age, performs an implicit, if ambiguous repartée with a narrator (Schwitters) who is pleading in a flirtatious, if tenderly obscene, manner. In the dialogue, the dynamic between "Anna" and her suitor is replete with enticements and frustrated desire. The sum of "Anna" (at least the sum that is recorded by the poems) constitutes an array of sensibilities, all of which appear to the narrator of the poem (Schwitters) to be a manifestation of her alternating guises and the elusive, impudent play between paramour and pursuer: she is at once mercurial, childlike, ageless, wise, rejecting, desirable, difficult, and embracing. Despite their many similarities and differences, there is one condition that is constant. Collectively or seperately, they are women of Schwitters' imagination and thus always the subject of longing (*Sehnsucht*).[19]

In both "Die Zwiebel" and *Grünes Kind*, the overt playfulness disguised more serious motives, a condition that appears to inform *An Anna Blume* as well. Transcending the impact of "Der Zwiebel" and *Grünes Kind, An Anna Blume* appears to signal with even greater force Schwitters' deliberative search for the mystical sources and primal states underlying nature, art and life. For Schwitters, the character "Anna Blume" did not remain consigned to the pages of literature, but was to become Schwitters' idealized muse, the signature of "Manifeste Merz."[20] In point of fact, "Anna" became the focus of a variety of Schwitters' inspirational episodes and was clearly the subject of his "desire": she was his Eve, his mistress, and his Madonna, among other "personages" and figures.[21] In terms of the *Merzbau, An Anna Blume*, alone or

coupled with subsequent revisions of the poem, provides the most significant insight into what may be viewed as the hermeneutic program and content of Schwitters' *Kathedrale*; "she" ("Anna/eve") is perhaps the *Merzbau's* chief resident. The fact that he not only recognized Anna Blume's "presence" in poetry, prose, and painting, but also dedicated many of these works to his "female mistress," suggests that the character of Anna Blume was Schwitters' talismanic device in the fashioning of his private, highly esoteric magic kingdom.

Anna Blume
(Parts of the 1942 version, entitled "eve Blossom," are in parentheses.)[22]

O thou, beloved of my twenty-seven senses,

I love thine!

Thou thee thee thine, I thine, thou mine, we?

That (by the way) is beside the point!

Who art thou, countless female? Thou art–art

Thou art, art thou?

People say, thou'd be–

Let them talk, they don't know chalk from cheese.

Hat on foot thou walkst upon

thy hands, upon thou hands thee walk.

Hallo, thy red dress, sawn into white folds,

Red I love Anna Flower (eve Blossom), red I love thine!

Thou thine thee thou, I to thee, thou to I. –We?

That (by the way) belongs in the ashbox.

Red Flower, red Anna Flower, what do people say?

PRIZE QUESTION: 1. Anna Flower is a weird bird.

 2. Anna Flower is red.

 3. What colour is the bird?

(1942: PRIZE QUESTION: 1. eve Blossom is red,

 2. eve Blossom has wheels,

 3. what colour are the wheels?)

Blue is the colour of your yellow hair,

Red is the cooing of thy green bird (Red is the whirl of your green wheels),

Thou simple maiden in everyday dress,

Thou sweet green animal, I love thine!

Thou thine thee thou, I to thee, thou to I. –We?

That (by the way) belongs to the emberchest.

Anna Flower (eve Blossom),

Anna (eve),

A–N–N–A (E–V–E).

I drip your name.

You name drops like soft tallow.

Dost realize, Anna, dost realize it?

People can read thee back to front and thee,

thee most glorious girl, art both ways round: a-n-n-a.

Tallow dripplestroke across my back.

Ann Flower (eve Blossom),

Thou drippy animal,

I

Love

Thine!

Anna Blume Dichtungen shows a drawing by Schwitters containing numerous themes and symbols that appear in the artist's drawings, watercolors, and sculptures from the same period.[23] Many of these drawings and notations also appear in texts and drawings created by Schwitters' fellow dadaists, particularly in the works of Tzara, Francis Picabia, Hans Arp, and Max Ernst. Indeed, the most prevalent aspect of the cover sketch is the word "dada" rendered in bold and placed at an angle, a visual and verbal pronouncement that clearly signals Schwitters' affiliation with the ideas of Zürich dada, and to some degree Cologne dada. Also shown are a windmill, a heart, a locomotive (steam engine), a tilted *"flâneur* (walking man),"[24] numerous wheels, and a figure that appears to be a sun or a moon in the upper right. The word "A–N–N–A" appears just below the scripted title of Steegemann's series. The spread of the letters "A–N–N–A," along with the numerous arrows which reinforcing the notion of rotation, suggest that the perambulator wheel at the center of the drawing signals motion. The dispersal of the specific images—the locomotive train (or steam engine), the windmill, the heart, the *flâneur*, the profile of the face (Schwitters' own?) with one of the vectors pointing from the iris of the face to the windmill, and the name "Anna"—to the periphery suggests their being churned, or turned, by the action of the wheel. In this sense, the wheel and its peripheral figures may connote a roulette wheel, an incipient cosmology, or the rotation of the heavens.[25]

Assuming that the cover is an encoded device that introduces the "meaning" of *An Anna Blume*, the use of these figures as the frontispiece of the pub-

lication points in the direction of an alchemical parable. However, the possibility that this was Schwitters' primary intention is still overwhelmed by the play of associations and experience in the poem itself. Most commentary regarding the specific meanings of Schwitters' figures—the windmill, *flâneur*, and steam engine appear in a series of drawings and watercolors from the same period—proposes that the devices are metaphors for modern machine-age mechanisms, a reading that is supported by the prevalence of these symbols in the art of the early-twentieth century, in particular the works of the Futurists and dadaists (*figs. 9-11*).[26] Hence, the suggestion that the figures and symbols represent alchemical devices only adds to Schwitters' expanded field of associations. Given Schwitters' drive towards multivalence, all of these interpretations (*An Anna Blume* as satire, *An Anna Blume* as both a critique and subsumption of modernity, *An Anna Blume* as an expressionistic exposure of the sense surrounding modern experience, and *An Anna Blume* as a deliberately fashioned alchemical parable) are all possible.

Most interpretations of Schwitters' poem have not, however, centered on the visual material accompanying the poem, but on the literary devices and content embedded within the poem.[27] The most prevalent of these, and the one most often cited by contemporaries of Schwitters, alludes to his "making fun" of the "petit-bourgeois sentimentality...in petit-bourgeois language."[28] According to Werner Schmalenbach, it is "thus [that] the poem could become a real love poem, a love poem in which grammar and vocabulary were tangled up not only because dada demanded it but because the (pretended) intoxication of love demanded it."[29] Anna's last name, Blume (flower), recalls the romantic ideal of the "Blue Flower," a mystical symbol that was given its most poetic modern representation in the writings of the nineteenthth-century romantic Novalis (Frederich Von Hardenberg) and the representation of unrequited love still today. The association of Novalis with Schwitters lends some credence to the idea that the poem is a parody of sentimentality and excessive romanticism, an interpretation reinforced by Schwitters' performance of the poem for various dada soirées.

Schwitters continually elaborated "the case of Anna Blume" in subsequent writings, including the 1922 editions of *Elementar. Die Blume Anna. Die neue Anna Blume (Fundamental. The Flower Anna, The New Anna Blume) Memorien Anna Blumes in Bleie, eine leichtfaßliche Methode des Wahnsinns für jedermann (Anna Blume's Memoirs in Lead, an Easy-to-grasp Method of Madness for Everyone)*.[30] Both of these titles further suggest the association of *An Anna Blume* with alchemy: according to hermetic ideals,

lead, a base material presupposes the paradoxical burden of sexual desire, where on the one hand the possibility of transforming lead (dross) into gold signals continued vitality and creativity while on the other the act of procreation depends on disease, death and decay. Thus "Anna Blume" is not only an object of desire, but the subject of repute due to her transmission of death and decay.[31] The fact that "Anna Blume" remains central to Schwitters' works over the course of his lifetime suggests that she is in many ways his patron saint, his guide, muse and alter ego—as well as his most prominent subject. The complex relationship between Schwitters and "a certain woman" is recorded by several Merzbilder, including *Aq.21 Anna Blume und Ich* (*fig. 12*)

Sculpture

The initial components of the *Merzbau* are thought to have included a series of allegorical sculptures by Schwitters from the late-teens and early-twenties. Among these are *Die heilige Bekümmernis* (*Holy Affliction*) (*fig. 13*), a dadaist assemblage that takes its name from an obscure fifteenth- century German saint, Heilige Kümmernis (St. Uncumber).[32] The main body of the sculpture is a dressmaker's dummy, an artifact that, along with dolls and mannequins, was quite common in dadaist installations. Without a head, arms or legs, the torso of the dummy has been effectively denuded of its active parts, thus implying both physical and mental immobility, while the figure's pervasive 'silence' relies on a host of signs and symbols to tell its ambiguous story. A light-bulb—thought to be red—has replaced the head, suggesting the displacement of mental function with an unmediated primitive sexuality, and hence contradicting the lack of desire associated with the German saint. Around the neck is hung a hollowed out box on which bits of text are applied. Open to the front, the box signals any number of functions, including a hand organ, toy-theater, or a cigarette girl's tray. The presence of what appears to be a coffee-grinder crank on the right side leads one to believe that the box was meant to be a hand-organ since, when one turned the crank, the sculpture played popular Christmas carols.[33] Also on the right side is a Christmas ornament hung from the shoulder of the dummy. On the front of the box are a series of cutout images from magazines and newspapers with the words "*Wahnsinn! Fröhliche Weihnachten!*" (Madness! Happy Christmas!) displayed at the base. A beggar's notice, further complicating the assemblage, is also hung from the neck of the torso just above the box. Open to the front, the box is topped off with a lighted candle, signaling the possibility that the box is an altar where offerings of money, notes, or charms are left in the hopes

that prayer might redeem souls or events. The use of the two votive lights— one white and one red—recalls the complex interplay between eroticism, passion, inspiration, and purity, themes that not only appear in the fable of Heilige Kümmernis, but resonate throughout Judeo-Christian thought. The use of these two lights also suggests the play between cognition and Eros. The only photograph of the sculpture that survives shows Schwitters in dialogue with the piece, perhaps in a mode of entreaty similar to that which takes place in *An Anna Blume.*

Dorothea Dietrich suggests that Schwitters' sculpture constitutes a political critique of Germany's postwar nationalist sentiments. For Dietrich, the subject of the de-eroticized saint, a saint whose fervent devotion to Christ, parallels the nationalist's pursuit of a "pure" Germany, a cause which was not only current with the sculpture, but had informed German politics throughout the nineteenth- century. A critique of political attitudes that assent to this point of view supports Schwitters' rejection of jingoistic nationalism; as with most dadaists his subscription to internationalism was pronounced in both words and deeds.[34]

Dietrich's analysis, in exploring the underlying intentions of Schwitters' allegory, conflates the state of German politics with insanity.[35] While this is undeniably a credible interpretation, in particular because of Schwitters' consignment to dada, there are other ways of thinking about Schwitters' interest in madness that bear consideration as well. It should also be remarked that the specificity of Dietrich's reading may be misleading given the artist's usual stance regarding any direct critique of social and political events: such a reading would entail a degree of conceptual transparency on Schwitters' part. For Schwitters, art could not fulfill a particular purpose and thus could not be pressed into service for the sake of anything other than art. To the author of Merz there was no definitive or preconceived purpose to art. Nor could art strive for expression but rather [it] "came into being through [the] artistic evaluation of its elements." It was a primordial concept, exalted as the godhead ... inexplicable. Rather than rooted in a place and time, art mirrored the "concept of divinity which has gathered humanity together for millennia [breaking down] national and social barriers." However, various interpretations of the *Merzgedichte* and *Merzbilder,* even if they were misread as representing particular political or social views, were protected by the abiding, if nascent, principles of Merz.

Despite the limitations inherent in such an interpretation's dependence on a reading of the work in terms of the Zeitgeist, the social and political sub-

ject matter cannot be completely disregarded either. As evidenced in photographs from the First International dada Fair in Berlin of 1920, comparable themes were in play across the wide array of dada programs (in fact one of the placards proudly states "dada ist politisch" or "dada is political").[36] Schwitters' relationship with the self-appointed head of Berlin dada, Huelsenbeck, was, as has been noted, difficult—because, among other reasons, Schwitters rejected Huelsenbeck's demand that art serve political ends or, at the least, showcase social, political, and cultural critique.

Moving from the social and political connotations of the work to a consideration of Schwitters' prsonal context for his art, it is evident that *Die heilige Bekümmernis* is highly relevant to the development of Merz.[37] As in the prose and poetry written at around the same time the sculpture is created, Schwitters appears to turn to a reconsideration of romantic and mystical themes in his work, thus indicating his abiding interest in expressionist ideals. Though he may not have been fully aware of the implications of his shifting perspective at the time, this same recovery of spiritual issues was also reflected in the works of many of his fellow dadaists, marking their transition to yet other artistic platforms. In all its forms, dada represented a protracted threshold, a staging of protest, anxiety, and transgression that enabled the cross-fertilization of numerous ideas by artists who eventually took radically different positions and created widely disparate works of art. Schwitters' own participation in dada had a similar outcome. It appeared as a threshold through which he could pass over to Merz.

The recovery of art's spiritual consciousness was fundamental to the development of various strains of the avant-garde. This spiritual consciousness, however, was an attempt to focus on the impulse of artistic creativity. A central aspect of *Die heilige Bekümmernis* is the projection of madness. As a condition that spurs creativity and revelation, insanity has clear antecedents in the literature of German romanticism and expressionism where the subject arises again and again. In these venues, insanity is not treated as an unhealthy condition, but as a potentially useful, if deviant response to the circumstances and peculiarities of a place and time. Edward Munch, a modern Scandinavian painter, who like many of his Nordic colleagues was influenced by strains of the German romantic tradition, treated insanity as the essential and necessary condition for all creative action. From this point of view, pathological behavior and emotional illnesses were inextricably linked to a full panoply of inherently aberrant and no less necessary human traits and actions, including sex, excess, violence, and death. Notably, women are dele-

gated as the bearers of these pathologies, or at least the purveyors of the sickness that gives rise to them. Throughout human history, however, the principals bearing these pathologies or enabling their development have been alternately rejected or celebrated or both. According to the tenets of romanticism, those deemed mad or insane or inordinately sensitive, many of whom threatened existing social orders, were thought to bear the gift of mystical compulsion. As spiritually gifted or highly sensitive 'initiates,' these individuals were characterized as especially prone to experience and harbor the cognitive, spiritual or emotional excess that resisted normative perspectives, in particular perspectives that required objectivity and critical speculation.

As mentioned previously, Schwitters suffered from St. Vitus' Dance, at the time a common euphemism for epileptic seizures, during his childhood. Schwitters apparently saw his condition as fortuitous in some respects since, according to him, the sickness led directly to his 'turn to art.' Epilepsy is also a condition that can induce episodes similar to mystical immersion (and its consequence, mystical compulsion) in terms of the experience of similar qualities of dissociation. In addition, the initiation of an episode is often marked by a flash or spark-like event that seems to displace or explode the normal incidence of time (hence the euphemism "St. Vitus' Dance"). The pronounced transience of epileptic seizures, and the noetic, quasi-anaesthetic afterglow of an epileptic episode are all descriptions of phenomena found in literature written by or on mystical revelation. Accordingly, Schwitters' view of the world and himself in the world from an early age was informed by these experiences, some of which were clearly brought on by emotional traumas. His statement that he "feigned stupidity" in order to avoid conscription in the Germany army in all probability refers to this illness: overt manifestations of an active seizure are the loss of control and the appearance of infantilized or 'idiotic' behavior. Schwitters may have also been alluding to his own inspired play with insanity or childlike naiveté, a theme that according to the artist was the reason for his being rejected by the military draft.[39] In any case, his being recognized as "a *bürgher* and an idiot"—both of his own accord and by friends and critics—resonates throughout the course of his artistic career.[40] Still, autobiographical details remain largely anecdotal: Schwitters was known for his tendency to dissimulate in this regard, even to the point of claiming different birthplaces, points of origin and events, from the trivial and nonsensical to the grandiose.[41] The creativity with which he undertook to situate his life—the writing of alternative autobiographies which were themselves the product of 'working through' events and circum-

stances—portends the extent to which he was continually regenerating himself in search of an organic whole. As he put it, "...only Schwitters can write about Schwitters."[42]

The allusion to alchemical, hermetic and mystical themes provides another avenue for exploration, an avenue that, with the exception of Nill's *Decoding Merz*, has not been adequately addressed in the context of Schwitters' work before now—despite the fact that the works of several of his contemporaries and associates have been analyzed for their alchemical and mystical themes.[43] Perhaps not coincidentally, with the surge of interest in these themes, Herbert Silberer published a well-known treatise in 1914 entitled *Probleme der Mystik und ihrer Symbolik* (*Hidden Symbolism of Alchemy and the Occult Arts*), a work that is notable for its attempts to compare the enigmatic symbolism of alchemical legend with the works of Sigmund Freud and the early writings of Carl Jung. A prominent member of the Vienna School, Silberer used passages from, among others, the works of Hermes Trismegistus (patriarch of natural mysticism and alchemy), Paracelsus, and the German mystic Jakob Böhme, correlating them with the methods of psychoanalysis.

Whether or not Schwitters either knew of or read Silberer's work is not known; however, there are indications that he incorporated certain alchemical references into his work.[44] Schwitters' affiliation with the German expressionists and dadaists during the late-teens and early-twenties would have certainly led him to consider the possibility of incorporating alchemical and occult ideas and symbolism into his works. As noted, a primary aspect of German expressionism was the attention given to the religious and mystical aspects of art. To the expressionists, art and architecture were an extension of nature and thus could not to be corrupted by appeals to reason or the hard sciences; both practices were essentially matters of faith. Hence, the main thrust of expressionist art incorporated the intuitive, the irrational, the mystical, and the subjective. In addition, the artists and architects who worked in this mode reacted strongly against the tenets of traditional (academic) painting, preferring instead to concentrate on the emotive effects of color and form. The immediacy and crudeness of their artworks displays an attempt to move as quickly as possible from inspiration to actualization, ideas that Schwitters himself subscribed to. Their subject matter ranged from the autobiographical, animistic, and organic to highly charged psychosexual and religious themes, often times conflating any number of these issues in a single artwork. The expressionists' reaction to the method and contents of tradi-

tional (classical) painting, poetry and literature required that they resist traditional academic subjects such as still-lifes, pastoral scenes and allegory. Yet this reaction to tradition did not preclude their interest in religious iconography, in particular those images and ideas associated with medieval Christianity. Clearly reflecting the movement's strong alliance with German nature mysticism and nineteenth-century German romanticism, Franz Marc, a member of the *Der Blaue Reiter*, the group of Munich-based artists that included Kandinsky and Erich Heckel, articulated the essential motifs of expressionism:

> I am trying to intensify my ability to sense the organic rhythm that beats in all things, to develop a pantheistic sympathy for the trembling and flow of blood in nature, in trees, in animals, in the air. I am trying to make a picture from it, with new movements and with colours which make a mockery of the old kind of studio picture... [there is] one great truth, that there is no great, pure art without religion, that the more religious art has been, the more artistic it has been... [Artists should] create in their work symbols for their age, which will go on the altars of the coming spiritual religion.[46]

Commensurate with the enfolding of expressionism and dada-expressionism into other 'movements,' the range of Schwitters' artistic interests expanded rapidly in the late-teens and early-twenties. Forays into poetry, prose, performance, painting, sculpture, and avant-garde graphics provided a seemingly endless array of new methods and materials. Schwitters' familiarity with the art world and his cultivation of particular friendships and associations were increasing as well, broadening his perspective and extending his horizons. Several individuals with whom he had become acquainted—Max Ernst and Hans Arp especially—were interested in alchemical practices and the occult arts. A few of them had become advocates of a mystically inclined, mutually interdependent adaptation of nature as art and, conversely, art as nature. Yet art did not necessarily represent nature, but developed according to the principles of nature. In the same sense, nature could not be conflated with art, but was a manifestation of creative practices and energies (*Lebensformen*). The unifying measure of Schwitters' dada colleagues appeared to be a rejection of the social and political programs of Berlin dada and the concomitant embrace of an art conditioned by particularities and circumstances—a kind of nature-based, 'organic' dada. As a form of life, dada was declared to be "active(ly) indifferent, spontaneous and relative." The

Romanian dadaist Tristan Tzara effectively scripted the specifics of Zürich dada as a humanist counterclaim to classical rules and universal principals. It was a manifesto Schwitters adopted as his own:

> Dada was the materialization of my disgust. Before Dada, all modern writers held fast to a discipline, a rule, a unity. After Dada, active indifference, spontaneity, and relativity entered into life...If it is the INTELLECTUAL DRIVE which has always existed and which Apollonaire called the NEW SPIRIT (L'Esprit Nouveau), you wish to speak to me about, I must say that modernism interests me NOT AT ALL. And I believe it is a mistake to say that DADA, CUBISM, and FUTURISM have a common base. The two latter tendencies were based primarily on a principle of intellectual and technical perfectibility while Dada never rested on any theory and has never been anything but a protest. Poetry is a means of communicating a certain amount of humanity, of vital elements that the poet has within himself.[47]

The key to Schwitters' embrace of this particular form of dada is precisely that it is not a cognitive or critical approach to the making of art, but rather an immersive, immediate, and active 'indifference' that behaved, like alchemy and hermeticism, as life itself.[48]

While it must be stressed that there is no explicit information regarding Schwitters' interest in the riddles of the occult, the condensation of linguistic, thematic, and material play in *Die heilige Bekümmernis* can be viewed as an elaborate, if not wholly contained, alchemical play in at least two ways. The first of these reinterprets Dietrich's analysis of Schwitters' linguistic play though not in the terms of comparative linguistics, but in terms of the activity of word play or, to use Wittgenstein's phrase, "language games." That Schwitters' use of linguistic and symbolic references are arrayed in some relation to one another and allowed to foment in order to create new forms of energy suggests that both language and symbols themselves constitute forms of life, a condition consistent with the artist's explanation of Merz. The second interpretation rests largely on the treatment of the project as an analogue, an artistic framing that mirrors alchemical and hermetic enterprise.

In what might be Silberer's interpretation of Schwitters' alchemical parable, *Die heilige Bekümmernis*, the red and the white allude to the figures of man and woman—both of whom provide a fundamental site of interchange and exchange.[49] The mechanics of energy exchange occurs through a series of processes, all of which follow one another in quick succession: dissolution,

purification, union (trituration, grinding), corruption (the "putrefaction of the seed"), gestation, the birth of the child, and nutrition. The "forework" of trituration and purification is distinguished from the corruption and putrefaction that are themselves distinct from the productivity of reassembling and rebuilding. The initial dissolution of the elements is followed by "washing" (purification), a process similar to Schwitters' extraction of the elements of his sculptures and collages from their original context, a stage in the process that is then followed by his separation of them into isolated components (*Entformung*) *entmaterialisient*. After being gathered and redistributed, he would then wash the objects and materials before (re)assembling them (*Formung*) in the *Merzbilder*.[50] Furthering the confusion attached to alchemical processes, the process of "washing" is not merely a literal purification of the elements, but is connected to a series of processes themselves metaphors, thus blurring the distinction between objects and activities. Silberer culls from Christian Rosenkreuz's explanation of a 'Chemical Wedding' in order to provide a simplified map of the process: "mechanical purification, trituration, dismemberment, grinding (mill), the bath and the solution (itself)."[51]

In *Die heilige Bekümmernis*, the dismemberment of the body and the coffee grind (mill) signals the possibility of Schwitters' incorporation of alchemical symbols, associations that will become even more evident in the development and "literary content" of the *Merzbau*. The activity of the coffee grind (in alchemy, grinding is equivalent to the sexual act) and the playing of Christmas carols may appear unremarkable at first: yet the choice of "Come All Ye Children" and "Silent Night, Holy Night" was perhaps not accidental, given the nature of Schwitters' usual care when appropriating particular references. The themes that reside in these two carols: virginity, gestation, and the "pure" (albeit highly paradoxical) circumstances of incarnation and transubstantiation associated with Christ's birth are but a few of the possible symbolic associations suggested by the popular songs. The entreaty to "all children," along with the vernacular traces evident in these two carols undoubtedly appealed to Schwitters' irreverent tendency to blur the distinction between the profane and the sacred. Even the fact that the subject (a subject that might have one or several names) is not revealed is in itself indicative of Schwitters' alchemical game, for it is the "subject" that alchemists most wish to conceal.[52] In Schwitters' word play, the reference to "holy affliction" suggests the conflicted nature of sexual desire and matters of faith: in the Christian tradition, engaging in sexual relations is at once profane and sacred. Moreover, the Christian female saints have been particularly burdened with

multiple paradoxes, most if not all of which are associated with gender characterizations. Heilige Kümmernis, a legendary figure who seems to exist somewhere between the norms of Christian tradition and hermeticism (neither the occult arts or mysticism are sanctioned by the Church), presents an exceedingly dense field of possible interpretations or riddles. Given the sum of the evidence, it is more than likely that Schwitters was engaged in a stealthy alliance with alchemical and hermetic processes on two fronts: he in part mirrors the material and object valuations of the alchemical legend in his sculpture, while at the same time exhibiting a similar process in the formation of his various artworks. In so doing, Schwitters alludes to alchemy's complex blurring of the distinctions between the identity of the objects and the activity of artistic creation.

Several other sculptures from the late-teens and early-twenties are notable, not only because they were eventually subsumed into the body of the *Merzbau*, but because they represent a condensed version of the *Merzbau's* thematic content. They are: *Die Kultpumpe* (*The Cult Pump*) (1919), *Der Lustgalgen* (*The Pleasure Gallows or The Gallows of Desire*) (1919), *Haus Merz* (*House Merz*) (1920), and the previously mentioned *Schloss und Kathedrale mit Hofbrunnen* (*Castle and Cathedral with Courtyard Well*) (1922). Made up of various abstract and figurative elements, the assemblages are composed in similar fashion to Schwitters' collages. However, they differ somewhat from the *Merzbilder* since the discrete components and materials almost always retain their original identity. Entailing a curious admixture of both religious and erotic themes, the pieces are densely constructed allegories whose titles are at least as significant as the composite nature of the forms themselves. In a sense, this particular collection of sculptures, including *Die heilige Bekümmernis*, operates as a talisman for Schwitters' future development.

Explicitly bearing the residue of expressionism's religious sentiments, the sculptures are best viewed as a constellation. Each is suggestive of particular themes that, when arrayed proximate to one another, elicit myriad literary, historical, and figurative interpretations that further the analysis of Schwitters' project in Merz. While playing on the romantic tendencies prevalent in expressionism, both the method and content Schwitters used to create the assemblages depart significantly from the synthetic approach found in expressionist works. *Die Kultpumpe* (*fig. 14*) and *Der Lustgalgen* (*fig. 15*) (both from 1919), though clearly inconsistent with *Die heilige Bekümmernis* in their figurative content, both resonate nonetheless with similar literary

(alchemical) aspirations. The use of the word "assemblage" is critical in this context, for Schwitters' approach to both the method and the content of the sculptures is similar to that of the constructed paintings (*Merzbilder*) of the same period. Materials, artifacts, pieces of prior sculptures, paintings, and collages are either effaced, collaged into other artifacts, re-appropriated, or simply dis-assembled and reassembled to create a matrix of references and associations indicative of a matrial (applied) approach to hermetic processes. Though it is true that the *Entformung* is overshadowed by the *Formung* of the works, the individual pieces do not lose their identity as much as they do in the collages. In this sense, the "transubstantiation" realized in the *Merzbilder* is effectively thwarted. The assemblages do, however, consolidate a series of literary themes that require the interpreter to perform something of a de-construction of the works in order to engage their "perceptual field." Moreover, the themes are further complicated by the appropriation of linguistic elements (names) Schwitters has given the works.

With the sculpture entitled *Die Kultpumpe*, there are actually two images that can be used in understanding and analyzing the work: the publicity photograph and a postcard of the image produced for one of Schwitters' exhibitions that is inscribed by the artist. In addition, the postcard image is slightly different, with the vantage point of the photography shifted to the left, a significant change from the publicity photograph's vantage point that helps clarify with certainty the depth and detail of the piece. At first glance, the sculpture appears to be a small assemblage fashioned from bits and pieces of industrial and household detritus (*Abfall*). Perhaps assembled according to compositional principles, the piece consists of strong vertical and horizontal elements arranged on a rectilinear wooden base. A disc, etched or painted with what are apparently incidental marks, establishes the point of intersection among the disparate elements, unifying the piece. A thick steel wire and a spool-like element activate the field around the larger components of the construction, implying dynamic motion. The assemblage is similar to a number of the Schwitters' collages from the same year, all of which introduce a large circular element or elements into the frame. Whether constructed of or painted as found objects, these "wheels" suggest a turbulence that extends beyond the limits of the frame, while also pointing in the direction of Schwitters' embrace of modern technological processes. Yet the cosmic associations of the circle common to expressionist works—as sun, moon, planets—cannot be dismissed either.

Schwitters' frequent use of the circle during the late-teens and early-twen-

ties must not be viewed as convenient compositional devices. Rather, the deliberateness with which the element appears, as well as the frequency of its use and the successive dissociation of its prior contexts in Schwitters' works, implies the use of a talisman or perhaps a key encryption device necessary for unlocking a secret code. In other words, the use of the circular element does not depend on one unifying theme, but on the fact that it occurs in multiples, multiples that can be read in a manner similar to words or "texts," either backwards or forwards. The various readings are altered depending on the relative juxtaposition or arrangement of the series. The repeated use of the circular form in diverse contexts implies an infinite, continuous number of associations that require the establishment of contingent (combinatory) systemics. Elderfield suggests that Schwitters' use of iconic elements across several artworks is performative, a "perceptual field" in operation. As linguistic, figurative, and symbolic "play," *Die Kultpumpe*, like *Die heilige Bekümmernis*, constitutes an active matrix of associations, resonating with a force intended to go beyond the mere fact of the object. With Schwitters' elaborate deployment of both obscure and banal linguistic references and titles written and pasted on the publicity postcards prior to their being disseminated through the post, the performance of the project continues in ways no longer controlled by the artist, further expanding the perceptual field. Similar to the continual reworking of the *Anna Blume* poems and *Merzbilder*, and a further indicator of the premises *Formung* and *Entformung*, Schwitters often used reproductions of various works of art as a slate for additional collages and editorial material, sending them to friends and associates by mail with the caveat that they may require additional embellishment in the future. Much as the sowing of seeds in the wind, these postcard *Merzbilder* entertain a new context for creative play, where the artist's action signifies the fact that, at all stages and in all forms, the work of art constitutes a form of life, a condition that sets in motion processes attendant to regeneration.[53] A prominent word displayed on the front of the Schwitters' postcard rendition of *Die Kultpumpe*, "Bademerz" (literally, Merz-bath) further supports his interest in alchemical enterprise: washing (the purification of elements or artifacts) succeeds the initial dissolution and gathering by the alchemist-artist. Followed by a "wedding of materials" (Rosenkreuz's chemical wedding), the piece condenses, begetting yet another cycle. Static forms and fixed images of forms, reactivated by the exchange of energy, are transformed into engaged and engaging forms of life.

Schwitters, in identifying the assemblage as a "cult-pump," alludes to

both the wellsprings of vernacular Christianity (the various medieval cults were emblematic of demotic faith), as well as the alchemical transfiguration of the profane into the sacred. Medieval cathedrals, regarded as sites devoted to transfiguration and transubstantiation, were constructed as not only exemplars, but receptacles for the accumulation of myriad references and associations. Essentially palimpsests, layer upon layer of sculptural figures, textual references, images, and rituals were condensed in one location, gathered by a matrix of diaphanous structure and light, and arrayed in such a way and with such specificity that the spaces became pulsating rhythms of dynamic exchange and virtual energy. While recognized as sites for the performance of particular rites, the edifices, soaring from the depths of the earth towards the infinitude of the heavens, constituted a space that flows through time—a simultaneous negation and preservation of the past and the present in anticipation of a future. The rituals, allegorical figures, material, and structure of cathedrals constitute the metrics of faith, reinforcing the intrinsic relationship between art, life, nature, and faith. The whole exceeds the sum of the parts, a revelatory moment that transcends normative time and space. Schwitters' *Merzbilder* and sculptures from the late-teens express similar motives. Infused with suggestive references to cultic activity and mechanisms of faith, *Die Kultpumpe* signals the issues that would become central to Merz.

Aided by the work's title, as well as the previous analysis of *Die Heilige Bekümmernis*, the latent meaning of *Die Kultpumpe* appears to reference alchemical processes. The designation of a "pump" alludes to both water (fluids) and sexuality: in alchemical processes, water, or *aqua vitae*, represents seminal and other bodily fluids such as menstruum, amniotic fluid, and urine. Used in baptismal rituals, water is also a symbol for the mother, the primary aid and giver of all life.[54] The pump on the other hand can be viewed as an iconic representation of the male organ, while the thick metal wire can be interpreted as a conductor facilitating the transfer of energy begotten by the spark of sexual union and its consequence, conception. The meaning of the spool-like device is more difficult to ascertain, though "spooling" is sometimes associated with the activity of the wheel (spinning, grinding, milling) and thus energy exchange. A significant symbol in hermeticism, the mill-wheel signifies a multitude of other ideas as well, ideas pertinent to the occult arts and mysticism. These include the seven virtues and planets linking virtue and time and thus the alchemist's processes, Hildegard von Bingen's mechanics of the macrocosmos (God), and Böhme's "two fold trinity" and celestial Jerusalem (*fig. 16*).[55] According to alchemical legend, wheels are often quite

specific, symbolizing millwork (the sexual act as grinding, the organs which grind out the child) and hence sexuality and procreation, thus granting a specific meaning or action that binds with a significant part of Christian cosmology, the medieval "Wheel of Fortune."[56] While the appropriation of the image would have indicated Schwitters' interest in an affiliation with Ernst and the beginnings of his alchemical investigations in Merz, it was also a figurative pun, a play on the indefinite allegorical references of Ernst's piece.

The popular German mystic Jakob Böhme's (c. 1600) vision of the wheel is of central importance to understanding its use in the works of Schwitters and other dadaists. Relying on Ezekiel, Böhme saw the wheeling configuration of the solar system in terms of "spirit forces of wheels mounted within wheels."[57] Within the obscure articles of Böhme's nature mysticism, the wheel also represents "*das Cirkel des Lebens*," the mysterious "circle of life." A device Schwitters used frequently in the early *Merzbilder*, the wheel also appears in the Aquarelles from 1919–1920, for example *Das Herz geht von Zucker zum Kaffee*, (*The Heart Goes from Sugar to Coffee*) (1919) (*fig. 17*), Aq. 9: *Windmühle*, ("The Windmill") (1919) (*fig. 9*), and the *Stempelzeichen* (stamp drawings) of which (*mit Rot vier*)(*with Red four*) (1919) (*fig. 10*) is an example. The wheel also appears prominently in the works of other dadaists around this time, most notably Francis Picabia, Marcel Duchamp, and Max Ernst, all of whom worked in association with one another at the time the symbol makes its appearance in their works. In the case of Ernst's work—a representative "stamp drawing" from the period—the wheel is, as noted dada scholar Dr. William Camfield has shown, clearly associated with alchemy (*fig. 18*). Incautious when compared to Schwitters' approach, Ernst's sexual/alchemical references include a plant-like form (possibly gonads) and a blue and red penis positioned within the orbit of one of the roulette wheels. Numbers themselves, as well as chance and occasion, extend the possible readings of the piece as a foray into alchemy and hermeticism. The accompanying poem Ernst writes along the lower margin contributes to both the allusive quality and the mystery of the work: "The canalisation of refrigerated gas activates sputtering little numbers/The compressed heart flees in time/we lean against the delphic poet."[59]

Within this context, three other small works by Schwitters from the same year, works which may initially appear to be incidental to the overall formation of his oeuvre, are also significant to apprehending the meaning of the artist's ubiquitous wheels. Covered in bits and pieces of phrases, news clippings, and other kinds of marks, the merzed images are listed according to

the date of their execution. They are entitled as follows: *Collaged Postcard with Photograph of Schwitters: Anna Blume*, (5 May, 1921); *Collaged Postcard with Photograph of Schwitters: Wheel*, (27 May, 1921); and *Collaged Postcard with Photograph of Schwitters: Damenkonfection* (*Woman's Ready to Wear*) (*figs. 19-21*). Like the postcard images of *Die Kultpumpe* and the successive editions of *An Anna Blume*, Schwitters often worked additional images, news clippings, commentary and bits of material into earlier works. The result of his action not only resurrected the memory of the original work, but resituated it within the context of his current development. Returning to certain projects repeatedly became a way for Schwitters to signal the continued relevance of the work—he was not above his own particular brand of hucksterism. At the same time the tactic represented a way of successively redefining, and in some cases refining the latent meanings contained within the original images, thereby distributing creative energy in using a quasi-anonymous mechanical means.[60] A series of lithographs published by Steegemann under the title *Die Kathedrale* in 1919, represented a literal moving exhibition. Subject to the processes of Merz, another publicity postcard from 1920, in this case a portrait of Schwitters, represents further evidence of the artist's developing context. In this case, there are three *Merzbilder* that are developed from the same image, thus implying that the images should be read as a series or a group.

The conflation of *Anna Blume* and *Wheel*—both of which appear at the center of Schwitters' portrait—suggests an overlay of ideas consistent with the poetry, prose, and sculpture pieces of the period. Having been created within a few weeks of one another, the first two works in this series of *Collaged Postcards* appear to bear a direct relationship to one another. Whereas Schwitters is evidently "blinded" by his female protagonist and muse "Anna Blume," the wheel, which appears at the center of Schwitters' forehead in the second postcard, seems to suggest that the primary locus of his thought process centers on the revolving wheel. The wheel is divided into six segments and, perhaps not incidentally, this same diagrammatic wheel appears at the lower end of the region that would contain the heart in Schwitters' *Die heilige Bekümmernis* sculpture from the previous year—if the dressmaker's dummy indeed signified a human figure as is assumed. A close study of the wheel in the photograph of the sculpture and the wheel affixed to Schwitters' forehead suggests that they may be the same wheel. Thus, Schwitters could be signaling the earlier work (his holy affliction) or the general significance of the wheel in his artistic lexicon—or both. It should also be noted that the wheel's detail—the segment of the circle into six identical

partitions—indicates a hexagon, itself a mysterious figure that plays a role in Goethe's color theory of 1810, a theory repopularized by the expressionists and dadaists precisely for its affiliation with a mystically-inspired experience of nature.[61] In addition, the implication of a hexagon suggests innumerable hermetic meanings, including the ethical, spiritual and human capacities of man.[62] The relationship between these two collages and *Damenkonfektion*, the third in the series, is unclear, as is the meaning of the newsprint article culled from an article referring to items of women's clothing. However, aspects of the text appear to have autobiographical associations, though the specific meanings which Schwitters may have ascribed to the words is not altogether obvious, a condition that could perhaps also be said of the other two postcards. While it may not be obvious from the tripartite arrangement of these images and the reflexive associations appended to them what Schwitters' intentions were, it is probable that they were created at the same time and should be read in light of one another. Given the artist's ongoing deliberations in his literary works, the allegorical themes attached to these small works suggest that they were indeed meant to reference one another in a dynamic field of associations, in particular those that might address the Schwitters' thriving erotic sublimations.

While *Die Lustgalgen* also resonates with expressionist themes, it too is a construction that establishes a dynamic field of operative contingencies. More literal in its associations with architecture, the use of the corner 'L,' merzed with various pieces of text, suggests a spatial enclosure, while the vertical piece, topped by a wheel, connotes the figure of a tower. The base of the sculpture is covered with fabric clippings that resemble burlap and printed cloth. Attached to the base of the tower is a small reproduction of a painting showing an oblique view of Christ on the Cross. When assembled, the entirety resembles a religious edifice, or perhaps the events of Golgotha.[64] However, the title, in introducing themes associated with eroticism, creates an ambiguous reading. The pursuit of pleasure is clearly associated with death: one of the seven cardinal sins—all of which are geared towards the discouragement of excess—is lust. Coupled with the title *Pleasure Gallows*, the use of the figure of a church implies the complex relationship between religious and sexual ecstasy, and death. At its most extreme, sexual ecstasy—found in the spiritual ecstasy of female mystics in meditation and upon death and thought to be the moment of their unmediated communion with Christ—implies the obliteration of self in union with another, and has been linked by Freud and his adherents to mankind's "death drive." In addi-

tion, Schwitters may be signaling an autobiographical impulse towards martyrdom, martyrdom conceived according to the highly conflicted nature of religious faith and sexuality. Consistent with the idea of Merz, still other readings are possible. Annegreth Nill suggests a more profane reading, one that would be in line with Schwitters' ongoing difficulty with his critics and his perceived martyrdom on the cross of their words. In a postcard containing the 'worked through' image of *Die Lustgalgen* sent to his fellow dadaist Jacques Molzahn, Schwitters provides a response to the apparently negative criticism of him tendered by an anonymous critic in Hildesheim. In Nill's words, the sculpture "... shows a stick figure clearly labeled '*Kritiker*' [critic] suspended from the wheel... A picture of Michaelis church and the cathedral [Dom] have been added to the postcard in collage and pencil. Also clearly identified, they flank [*Die Lustgalgen*] like witnesses and locate the event in Hildesheim... the postcard is no longer titled *Merzplastik Lustgalgen* (*Merzsculpture Pleasure Gallows*), but has been renamed *Hildesheim, Galgen von Galgenberg*, or *Hildesheim, Gallows of Gallows Mountain*... Schwitters [had] transformed... his *Pleasure Gallows* into a passion play in which he acted out the martyrdom of Christ while the critic was cast in the role of the betraying disciple Judas."[65]

The continued infusion of ideas from alchemy and hermeticism is also a likely source of inspiration for *Der Lustgalgen*. As a literary metaphor, alchemy represents a confrontation with desire, that is desire in terms of sexuality and knowledge.[66] According to Nathan Schwartz-Salant, "... [the] structure that alchemy claims to create, the lapis, lives in a 'third realm' between space-time and atemporal worlds. To create it finally in a stable form requires that one come to terms with desire. No longer something to be heroically overcome, now desire can be an integral part of the process, a fire that drives the creation of an embodied self."[67] In the explicit terms of alchemical symbolism, there is again the suggestion of grinding (milling). The subtleties that follow are consistent with Schwitters' artistic aims, including the inarticulable, suspended space between time and no-time, the incorporation of creative energy, and the dispensation of the ego—all of which drive the creation of 'an embodied self,' that is, a form of life.

The multiple ambiguities that reside in the work also connote the idea that 'pleasure,' associated with the sexual act (or, in the case of Jesus Christ, the paradoxical dissociation of sex from the conception and birth of Christ, an issue which continues to be debated within the Roman Church) is what

leads to one's demise, insofar as all living beings must eventually die. In short, to suffer birth, a condition initiated by the pleasurable act of sex, is to also suffer death. The alternative translation of Schwitters' title, *The Gallows of Desire*, could also point to Schwitters' preoccupation with his sexuality, life and death—not only as it is centered around the desiring associated with the sex act (grinding), but the inevitable play associated with cycles of life. Thus, desire implicates not only the first action that accords birth, but life, death and rebirth-the mysterious *Cirkel des Lebens* (*circle of life*) proffered by Böhme. While Schwitters never spoke publicly of his first son, Gerd's, death, the fact that a son of Helma and Kurt Schwitters had died within its first year of life has been the subject of some speculation. The event of death was evidently so little discussed at the time that there is no credible evidence of the first son's existence in the anecdotes on Schwitters and his family, nor in any of the artist's surviving correspondence. Nonetheless, it appears that Schwitters could not forget the loss of his son: the family's tragedy apparently preoccupied the artist since memorials to his infant son appear in the form of portraits of his wife, Helma, and in other pieces that, in retrospect, can now be interpreted as two- and three-dimensional lamentations. Several of these come into play with the development of the elusive *Merzbau*, Schwitters' *Cathedral of Erotic Misery*.

Two additional projects that are key to the *Merzbau*'s conceptual and thematic development are the aforementioned sculptures *Haus Merz* (*House Merz*) (*fig. 22*) of 1920 and the expressionist architectural construction *Schloss und Kathedrale mit Hofbrunnen* (*Castle and Cathedral with Courtyard Well*) (1922) (*fig. 7*). Both of these works are at once more obviously figurative and more benign. As evidence of the artist's search for the context of his work at the earliest stages of Merz, *Haus Merz* and *Schloss and Kathedrale* play a significant, if subtle role in the formation of his artistic program. In addition, the sculptures substantiate aspects of other works from this period, all of which contribute to the emergence of the Schwitters' most important project, the *Merzbau*.

Formally, *Haus Merz* is a rectilinear volume attached to a vertical tower. Sitting atop a rough-hewn wooden base inscribed with the title *Haus Merz*, the year (1920), and Schwitters' initials, the assemblage clearly represents a church edifice or cathedral. The tower itself is made of simple children's blocks, thereby suggesting Schwitters' ethic of playfulness in the formation of art. What appears to be a button torn from an article of clothing is attached to the top of the tower, thus implying a clock. According to traditional read-

ings of clock towers, in particular those that are found in the design of a church, the presence of a timepiece signifies the temporal nature of life. The interior, a collection of gears possibly taken from a clock or children's toy not only suggests there is no room for worship (and hence a lack of denomination), but reinforces an understanding of the piece as a critique of historical progress. The notion of historical progress secularizes the process of redemption, implying that progress, in this case the progressive forces of modern technology, portends an unfolding of God's will. Filled with the mechanical apparatus—a conflation of historical time and modern technology—the church is no longer available to those in need of deliverance: there is 'no room in the church' for those who seek divine (messianic) revelation. However, the lack of a 'denomination' could also allude to Schwitters' own separation from the various avant-garde movements with the formation of Merz. The title for the sculpture reinforces this reading.

Simple representational assumptions can be misleading, in particular when the sculptures are grouped as an array of works that may harbor similar themes. The sculpture bears a partial, though nonetheless significant resemblance to Francis Picabia's *Réveil-Matin* (*Alarm Clock*), the title page for *Anthologie dada 4-5* (1919) (*fig. 23*). The use of such a strong symbolic reference implies a connection not only to the 'gears and mechanism' of modern life, but betrays the possibility of a strong revisionist reading of the same mechanisms similar to that which is found in Schwitters' attention to alchemical processes in *Die heilige Bekümmernis*, *Die Kultpumpe*, and *Der Lustgalgen*. Since he was known to be interested in publications associated with dada, it is probable that Schwitters saw or even owned this issue of *Anthologie dada*, a publication that has been called "one of the most outstanding dada publications in both design and content."[68] Superficially, the title of Picabia's illustration clearly suggests the edict that artists must "wake up" to the abrupt changes that surrounded them. Schwitters, in incorporating this image-artifact, at once embraces the inherent ambiguities of time itself while signaling his own alliance with the immediacy of the avant-garde project. This embrace of temporal ambiguity and paradox is inherent in alchemical and occult texts, a phenomena Schwitters cleverly expressed in his aphorism "eternity lasts longest." To some of his friends and critics, the designation of this particular work as *Haus Merz* declares that Merz would constitute a new religion.[69] In her analysis of the piece, Dietrich suggests that the modest assemblage points directly to a number of significant themes that would later appear in the *Merzbau*, though her analysis of the

work still casts the work as cultural critique, "a mixture of private home and pubic structure":

> The sculpture's modest size, only a few inches…belies its ambitious program. Schwitters effected a major transformation: The house of God—the church or the cathedral—has been transformed into a house for Merz…the cogwheels as [aspects] of machinery, and therefore of modernity, define Merz itself as modern. Nevertheless, Merz is housed in a traditional structure…although it is a building constructed of uncommon materials. Merz, then, is shown as linking traditional form, here the architectural shell of a church, with innovative method and content, the collage materials and the cogwheels of a modern technological world…[In addition] Haus Merz [is] a mixture of private home and public structure [thereby prefiguring the *Merzbau*].[70]

When he first saw *Haus Merz*, the Hannoverian art critic Christof Spengemann, a close friend of Schwitters', reaffirmed Schwitters' reputation as an expressionist by suggesting the religious underpinnings of the diminutive construction: "I see in *Haus Merz* a cathedral: the cathedral. Not a church building. No, it is the veritable expression of spiritual intuition, an intuition which is elevated towards infinity: an absolute art."[71] The pursuit of a spiritual intuition 'elevated towards infinity' recalls the idealized anagogic perspective of Gothic cathedrals. In romanticism, the anagogic is subsumed into the realm of art, whereby the pursuit of art becomes imbued with the tenets of religious revelation. This idea permeates the writings and artworks of nineteenth-century German art, reaching its apotheosis in twentieth-century German expressionism. The cathedral, in becoming *Haus Merz*, effectively signals the sublation—the simultaneous negation and preservation—of expressionist ideals in Schwitters' work.

The second sculpture, *Schloss und Kathedrale mit Hofbrunnen* (*Castle and Cathedral with Courtyard Well*) (1922) is not a representative piece of Merzassemblage, but appears to be explicitly aligned with the formal terms of expressionist architecture. The piece, published by the German expressionist architect Bruno Taut in his magazine *Frühlicht*, indicates Schwitters' embrace of at least some aspects of the expressionist program. In an article entitled "Fantasms and Fragments: expressionist Architecture," Martin Filler encapsulated the motivations that underlay the specifics of the German expressionists' approach to built form:

The expressionist architects were convicted in their belief that architecture not only could but must transform the world, embracing an architectural language that spoke of the shattered vision of the world, one that at best could only be reassembled in a highly fragmented manner.[72]

The fact that the sculpture is dated 1922 suggests that Schwitters' program for Merz retained a similar atmosphere of utopian and dystopian themes. In addition, the evocation of a cathedral again signals the formation of a new spiritual contract, albeit one that would use art, rather than theological doctrine, to exhibit its articles of faith. The supposition that art constitutes the primary means by which social change would be enacted is also reminiscent of the use of iconography and pictures in medieval cathedrals, an idea that was articulated as *laicorum literatura*, "the literature of the laity."[73]

In sum, the assemblages *Die Kultpumpe, Die Lustgalgen*, and to a somewhat lesser extent *Haus Merz* and *Schloss und Kathedrale mit Hofbrunnen*, are not only representative of both the "...violence and disorder" in Weimar Germany immediately following World War I rather, they are expressions of the "alternative, hermetic fantasy" one finds in much of Schwitters' work throughout the course of his career.[74] Both the use of materials—profane and ubiquitous household artifacts and industrial objects (*Abfall*)—and the methodology with which Schwitters transformed the mundane and banal into the sacred is suggestive of alchemical processes. In addition, the works connote an affinity, albeit literary, with certain aspects of German mysticism, in particular the overlapping themes of erotism, pleasure, pain, and revelation that informs mystical tradition. Moving away from the overtly dadaist sensibility that informs *Die heilige Bekümmernis*, the pieces constitute a thematic refinement of both the ideas and methodology that would propel the development of Schwitters' *Merzbau*. Yet again, dada is sublimated into the general project of Schwitters' construction. Schwitters' take on dada was that it had to be, fundamentally, the recognition of art as a form of life. Hence, reality itself was in flux, and art, should it reach a point of inertia, would inevitably die for lack of desire. It is in this sense the *Kathedrale des Erotischen Elends* is informed by dadaist "principles." However, these principles were shared by a select few of Schwitters' dada compatriots—the reason for his divorce from any general association with the movement. The threads of this particular form of dada would continue to provide ample material and inspiration for subsequent artistic developments, some of which Schwitters incorporated into his living organism, the cathedral that became in effect his *summa theologia*.

NOTES

1 Kurt Schwitters, *PPPPP: Poems Performance Pieces Proses Plays Poetics*, ed. and trans. by Jerome Rothenberg and Pierre Joris (Philadelphia: Temple University Press, 1993), pp. 121-27. "Der Zwiebel" was originally published in Kurt Schwitters, *Anna Blume Dichtungen, Die Silbergäule* 39/40 (Hannover, 1919), pp. 16-27. This piece is also published in volume 2 of the five-volume edition of Kurt Schwitters' work. See *Das literarische Werk*, 2, pp. 22-25.

2 Tristan Tzara, "Manifeste dada 1918," *dada*, no. 3, December 1918, in. Robert Motherwell, *The dada Painters and Poets*, pp.76-81. For further insight into the dispute between Zürich (Tzara's group) and Cologne dada (Picabia, Ernst, Baargeld), see William Camfield, *Max Ernst*, p. 53.

3 Elderfield, *Kurt Schwitters*, p. 96. Dada-Constructivist Laszlo Moholy-Nagy, a friend and compatriot of Schwitters in the twenties and thirties wrote an extensive, and illuminating account of Schwitters' approach to literature that reflects these themes: "...without trying to define Schwitters' peculiar poetic quality, it can be said that most of his writing is emotional purgation, an outburst of subconscious pandemonium. But they [the writings] are fused with external reality, with the existing social status...Schwitters' writings of that time end with a desperate and at the same time challenging cry...the only possible solution [to Schwitters] seemed to be a return to the elements of poetry, to noise and articulated sound, which are fundamental to all languages. In his *Ursonate* (*Primordial Sonata*) (1924)...the words used do not exist, rather they might exist in any language; they have no logical, only an emotional context; they affect the ear with their phonetic vibrations like music."

4 Kandinsky's *Der gelbe Klange* (*The Yellow Sound*) was first published in the almanac *Der Blaue Reiter* in 1912. An English translation of the piece is contained in Jelena Hahl-Koch (edit.), *Arnold Schönberg Wassily Kandinsky: Letters, Pictures and Documents*, trans. John C. Crawford (London: Faber and Faber, 1984), pp. 111-16.

5 The search for primal origins was a significant component of German art, politics and culture in the early-twentieth century. See August K. Wiedmann, *The German Quest for Primal Origins in Art, Culture, and Politics, 1900–1933: Die 'Flucht in Urzustände'* (Studies in German Thought and History, v. 1), (New York: Edwin Mellon Press, 1995).

6 Tristan Tzara, "Manifeste dada 1918," *dada*, no. 3, December 1918, in Motherwell, *The dada Painters and Poets*, New York, 1951, pp. 76-81.

7 Kurt Schwitters, *Die Zwiebel: Merzpoem 8*, in Schwitters: *Poems Performance Pieces Proses, Plays Poetics*, edit. and trans. Jerome Rothenberg and Pierre Joris (Philadelphia: Temple University Press, 1993), pp. 121-127.

8 Dietrich, *Collages of Kurt Schwitters*, p. 72.

9 Schwitters, *Anna Blume Dichtungen*, pp. 11-14. Also see Kurt Schwitters, "Grünes Kind,"

in *Das literarische Werk*, 1, pp. 45-47.

10 Schwitters, *PPPPPP: Poems Performances*, pp. 6-7.

11 Silberer, *Probleme der Mystik und ihrer Symbolik*, p. 369. English: Hidden Symbolism of Alchemy and the Occult Arts, trans. Smith E. Jeliffe (New York: Dover, 1971).

12 Nathan Schwartz-Salant, *Jung on Alchemy* (Princeton: Princeton University Press, 1995), pp. 36-37.

13 Schwartz-Salant, *Jung on Alchemy*, pp.103-104. There has been some debate on the significance of the color green in alchemy. According to more recent studies, there are really only three significant colors: black, red, and white. In *The Secret Language of Symbols*, David Fontana asserts that the color green symbolizes sensate life (the life of the senses). It also stands for nature, though not just for nature's creative urge or developmental growth, but for its necessary opposite, decomposition, death, and decay. The color green is also linked with jealousy and as such is "an ambivalent color" in this case as well. See David Fontana, *The Secret Language of Symbols: A Visual Key to Symbols and Their Meanings* (San Francisco: Chronicle Books, 1997), p.67.

14 Fontana, *The Secret Language of Symbols*, p. 67.

15 Schwitters, *Das literarische Werk, 1*, pp. 58-59. The poem is also contained in Kurt Schwitters, *PPPPP: Poems Performance Pieces* (eds. Rothenberg and Joris).

16 Ernst Nündel recorded the extent of the poem's popularity at the time of its publication; "In a short time everyone was talking about the poem and its author. There is no comparable situation in recent literary history: A poem became a best seller... *Anna Blume* was translated into French, English, Dutch, Italian, and Hungarian. How can one explain the unusual dissemination of a single poem? See Nündel, *Kurt Schwitters in Selbstzeugnissen und Bilddokumenten* (Reinbeck bei Hamburg: Rowohlt, 1981), p. 60; cit. Nill, *Decoding Merz*, p. 209.

17 See Bernd Sheffer, *Anfänge experimenteller Literatur: Das literarishe Werk von Kurt Schwitters* (Bonn: Bourvier Verlag Herbert Grundmann, 1978), p. 82 and Christof Spengemann, *Die Wahrheit über Anna Blume: Kritik der Kunst/Dritik der Kritik/Kritik der Zeit* (Hannover: Der Zweemann, 1920), p. 5. Quoted in Nill, *Decoding Merz*, p. 267 (fn. 55).

18 Schwitters, *PPPPP: Poems Performance Pieces*, pp. 16-17; also *Das literarische Werk, 1*, p. 150. There are other poems from this period which expose Schwitters' preoccupations with eroticism, chromatic associations, cooking, death, and violence, including the "thinly disguised fantasy of sex" entitled *Nachte* (*Nights*) which Elderfield analyses. See Elderfield, *Kurt Schwitters*, pp. 97-98.

19 Previous analyses deal specifically with the word-play and syntactical specificities of Hannoverian German (vernacular) sayings, sayings which Schwitters was fond of observing and repeating. Many vernacular sentiments were woven into numerous poems

and prose pieces he composed over the course of his artistic and literary career. In his book *Vision in Motion* (Chicago, 1947), Moholy-Nagy stated the following: "At first reading the poem seems to be only double-talk. In reality, it is a penetrating satire of obsolete love poems." See Motherwell, The dada Painters and Poets, p.xxvii.

20 It is difficult to describe the full import of "Anna Blume" when considering Schwitters' work. Throughout the course of his life, "she" continually fired his imagination, becoming almost a battle cry, with the poem, or sections of it, becoming an anthem. This is perhaps the result of the poem being the spark that drove Richard Huelsenbeck to explicitly reject Schwitters' application for membership to the Berlin dadaist group. As Huelsenbeck wrote in May of 1920: "dada rejects fundamentally and resolutely works like the famous *Anna Blume* of Mr. Kurt Schwitters." (Huelsenbeck, *dada Almanach*, p. 9). The phenomenon of *Anna Blume* as a manifesto or anthem is detailed in Sibyl Moholy-Nagy's recounting of Schwitters' behavior when confronting the members of Hitler's cultural cabinet on the evening of Marinetti's performance and banquet in Berlin in 1937. See Motherwell, *The dada Painters and Poets*, pp. xxix-xxx. It should also be noted that there is some dispute regarding the actual nature of Huelsenbeck's 'rejection' of Schwitters. See Webster, *Kurt Merz Schwitters*, p. 48-51.

21 There is the possibility that "Anna Blume" represented Schwitters' first love, a girl named Else he met in Norway in 1937. According to Schwitters (as recorded by Nill), "Else had been his favorite playmate until she became a teenager and then Schwitters was no longer allowed to play with her. On evening walks after dark he would try to get a glimpse of her and, if successful, he would note the event in his diary. One summer night in Isernhagen (the same place where he had had his ill-fated garden), he woke up in the dark of night and saw Else hover in front of him in a long, white lace gown. The following day a death announcement appeared in the paper: Else had died suddenly at age 18 of blood poisoning." See Kurt Schwitters, "Meine erste Liebe (My first love)" in "Prosa 1931–1948," *Das literarische Werk*, 3, p. 135.

22 Schwitters, *An Anna Blume* in *Das literarische Werk*, 1, pp. 58-59; 4, p. 447 (trans. Nill, Decoding Merz, pp. 258-259).

23 This second publication, *Die Kathedrale*, appears to represent an assertion of Schwitters' break with Berlin dada and the formation of Merz. The front cover shows the word "Merz," underlined and in bold, as well as the proclamation "Vorsicht: Anti-dada" (Danger: Anti-dada).

24 The most obvious association with Schwitters' conception of *le flâneur* (lit. "stroller") is Walter Benjamin's conception of the nineteenth- century *urbaniste*. See Richard Wolin, *Walter Benjamin, The Aesthetic of Redemption* (New York: Columbia University Press, 1982). Also see Susan Buck-Morss, *The Dialectics of Seeing: The Arcades Project*.

25 William Camfield's analysis of several of Ernst's works—(*Canalisation of Refrigerated Gas* (1919–20), *Portable Handbook You Are Warned* (1919–20) and *Self-constructed Little Machine* (ca. 1920)—containing references to the wheel are instructive in this case. Many of the notes appended to Camfield's text on Ernst delve into the complexities of alchemical and hermetic symbolism. See Camfield, *Max Ernst*, p.68.

26 Schwitters was a supporter and advocate of Marinetti's work in particular. This support was clearly not based on the underlying Nietzschean aspects of Marinetti's work, with their somewhat fatalistic embrace of world destruction, but on Futurism's mission to move (and look) forward rather than backward, replacing the old with the new.

27 Dietrich's analysis lends additional insight into Schwitters' parallel motives. See Dietrich, *Collages of Kurt Schwitters*, pp. 71-82.

28 Schwitters himself suggested as much in a fragment written in 1926 entitled "Grotesken und Satiren: Ein Samelbuch für meine Dichtungen" (Grotesques and satires: for a gathering of my poems): See Schwitters, *Das literarische Werk*, 5, p. 250; see also Kurt Schwitters, *PPPPPP: Poems Performance Pieces*, p. 229.

29 Schmalenbach, *Kurt Schwitters* (Köln, 1967), p. 205.

30 A full accounting of the variations of *An Anna Blume, A Eve Blossom, Die Anna Blume,* and *Anna Blossom Has Wheels*, among other revised titles can be found in *Das literarische Werk*, 1, pp. 291-294 and *Das literarische Werk*, 5, p. 447.

31 The rendering of Anna Blume's memoirs in lead is even more pointed when associated with alchemical transformation. According to Silberer, the doctrine that metals were vested with body and soul like humans, and that the soul was regarded as a finer form of corporeality, was developed "under philosophical influences." The soul, or *prima materia* (primitive material)—also known as the Philosopher's Stone—was "common to all metals, and in order to transmute one metal into another they had to produce a tincture of its soul."

32 According to Dietrich, Heilige Kümmernis (St. Uncumber) was the "Christian daughter of a heathen king who legend has it asked Christ that she be disfigured to avoid marriage (and the consequent loss of her virginity) to her heathen suitor. Her prayers were answered; she sprouted a beard and, thus disfigured, could thwart the desire of prospective suitors." See Dietrich, *Collages of Kurt Schwitters*, p. 172.

33 Elderfield, *Kurt Schwitters*, p. 144. According to Elderfield, the Christmas carols played by Schwitters' sculpture were "Silent Night, Holy Night" and "Come Ye Little Children."

34 Schwitters' internationalist outlook was consistent throughout his life, despite the fact that fact that publicly holding such a position was a threat to his person during the 20s and 30s in Germany.

35 Dietrich, *Collages of Kurt Schwitters*, p. 174.

81

36 A discussion of dada's political program is contained in numerous sources, among them a collection of articles and photographs documenting Berlin dada, one of the more politically virulent dada organizations. See Hanne Bergius, *Das Lachen dadas: die Berliner dadaisten und ihre Aktionen* (Giessen: Anabas-Verlag Günter-Kampf , 1989).

37 Dietrich suggests as much, calling the piece a "religious icon" and equating it with the "quasi-religious yearning for values that no longer seem attainable." See Dietrich, *Collages of Kurt Schwitters*, p. 174.

38 Elderfield, *Kurt Schwitters*, p. 20.

39 Webster, *Kurt Merz Schwitters*, p.29. Schwitters usually referred to this episode with the army to prove his cleverly feigned idiocy. How much is true and how much has been exaggerated or embellished is not known.

40 Schwitters referred to himself as a "bürger und idiot" on at least one occasion, signing Käte Steinitz' *Gästebuch* (guestbook) accordingly on the 19th of June, 1925. *See Kurt Schwitters: "Bürger und Idiot,"* ed. Gerhard Schaub (Berlin: Fannei und Walz, 1993).

41 Käte Steinitz, *Kurt Schwitters* (Berkeley: University of California Press, 1968), p. 4. "But was Kurt Schwitters really born in Hannover? Biographies and documents seem to confirm it; yet he often pretended he was born in Einbeck or Lüneberg or even somewhere else."

42 Steinitz, *Kurt Schwitters*, p. 3.

43 Nill's research supports the thesis that Schwitters' early artistic enterprise maintains a strong spiritual bias, suggesting that Schwitters' work referred to the writings of St. John of the Cross and to the Book of Revelation.

44 According to Silberer, to "unlock the secrets" of the alchemical code is to possess extensive and great knowledge pertaining to the primal continuum of all creative production—a power that in itself speaks to Schwitters' embrace of the transhistorical when describing the measure (or meaning) of his art. The alchemist's stone (also known as the Philosopher's Stone) represents a table that allows the initiate ("one who knows") to produce extensive material and spiritual wealth which would provide a "panacea that should free mankind of all sufferings and make men young"—a statement remarkably close to Schwitters' belief that "the work of art liberates man from the worries of daily life." According to alchemical ideals, the fundamental source of energy that keeps the world going is that of sexual desire. Sexuality in the form of male and female forms exhibits the life-force or creative energy manifest of a higher order of things and the underlying nature of all things simultaneously. See Herbert Silberer, *Probleme der Mystik*, pp. 114-15.

45 This is an important point. The resurfacing of subjects characterized as romantic or medievalist in expressionist painting and literature—images that included medieval monasteries, Gothic cathedrals, pervasive contrasts, existential figures, infinite landscapes—was considered to be adverse to classical art and philosophy, and thus was not

sufficiently 'traditional' or 'academic' in nature.

46 Wolf-Dieter Dube, *The expressionists*, trans. Mary Whittall (New York: Thames and Hudson, 1985), p. 125. For a brief overview, see H.H. Arnason, *The History of Modern Art* (New York: Harry N. Abrams, Inc. 1984), pp.162-92. Also see *German Expressionism: Documents from the End of the Wilhelmine Empire to the Rise of National Socialism*, edit. Rose-Carol Washton Long (Berkeley: University of California Press, 1993).

47 Motherwell, *The dada Painters and Poets*, pp. 154-155. This quote was first published in Kurt Schwitters inaugural issue of his journal *Merz* entitled *Merz 1*

48 Schwitters continued to elaborate the indifference of life. See "About me by myself," *Das literarische Werk*, 5, pp. 321-23. This piece is also contained in Kurt Schwitters, *PPPPPP: Poems Performance Pieces*, p. 238.

49 Arnold (Rosicrucians, II, 17): "So it clearly appears that the philosophers spoke the truth about it, although it seems impossible to simpletons and fools, that there was indeed only one stone, one medicine, one regulation, one work, one vessel, both identical with the white and red sulfur, and to be made at the same time." In the Turba philosophorum "the woman is called Magnesia, the white, the man is called red, sulphur." "Red and white = man and woman (male and female activity)." See Silberer, *Probleme der Mystik*, p. 122.

50 It is interesting to note both Schwitters' linguistic and figurative symbols in his description of Merz (1920): wheels, streams of water (hot and cold), the "wedding of materials," the "marriage between Anna Blume and A-natural," cooking, boiling, etc. granting the possibility of further allusions to alchemical processes. See Schwitters, "Merz (1920)," in Motherwell, *The dada Painters and Poets: An Anthology* (Cambridge, Massachusetts: Harvard University Press, 1981), pp. 55-80.

51 Silberer, *Probleme der Mystik*, p. 123.

52 Silberer, Ibid.

53 Undoubtedly inspired by Schwitters' 'actions', German artist Joseph Beuys created images ("Multiples") that were then sent via post with the intention of proliferating anonymous creative energy. The possibility of associating Beuys' and Schwitters' actions with alchemical processes should also be noted. See Joseph Beuys, Joseph Beuys, *the Multiples: Catalogue Raisonée of Multiples and Prints*, ed. Jorg Schellmann (New York: Distributed Art Publishers, 1997).

54 Silberer, *Probleme der Mystik*, p. 308.

55 In Alexander Roob's anthology-catalogue entitled *The Hermetic Museum*, there are numerous mentions of the wheel or circle throughout. Of particular interest in this regard are the sections "Fortresses," "Genesis," and "Wheel."

56 According to J.C.J. Metford, in Christian "lore" the wheel is the "symbol of the dynamic power of God the Father, derived from Ezekiel's vision of the Throne of God carried on flaming wheels adorned with eyes and wings (EZL 1: 1-28). The Wheel of Fortune specifically pertains to the instability of human experience, showing men "carried up on a wheel to the height of fortune, only to be borne downwards again to poverty and despair as the wheel turns." See J.C.J. Metford, *Christain Lore and Legend*, p. 262.

57 Andrew Weeks, *Jacob Böhme: An Intellectual Biography of the Seventeenth-Century Philosopher and Mystic* (Buffalo: State University of New York Press), p. 74.

58 Weeks, *Jacob Böhme*, p. 91.

59 See Camfield, *Max Ernst*, p. 69.

60 Two of the images he used most often, *Die Kultpumpe* and *Die Lustgalgen*, were contained in the series of lithographs published by Steegemann entitled *Die Kathedrale*. A complete set of the *Die Kathedrale* lithographs, a series that was designed with the intention of mailing it to patrons and other interested parties as a notice of gallery representation and, at times, exhibitions, is currently held by the Beinecke Rare Book and Manuscript Archive at Yale University, New Haven.

61 The German romantic writer, Johann Wolfgang von Goethe, was also interested in the science of alchemy at the time he developed his theory of color. See Roob, *The Hermetic Museum*, p. 686.

62 Roob, *The Hermetic Museum*, p. 689.

63 In her book, *The Collages of Kurt Schwitters*, Dorothea Dietrich interprets the possible meaning of this series of works at some length. Using anecdotal evidence such as the text from the newsprint article, Dietrich associates the works with a myriad of themes, including the suggestion of Schwitters' latent critique of the relationship between fashion and modernity. According to Dietrich, *Damenkonfektion* is directly associated with fashion and desire, *Anna Blume* announces his identification with the female figure of "Anna Blume" ("...taking Anna Blume's identity in order to see the world through female eyes."), and in her view, the Wheel is associated with "rational thought and intellectual empowerment." See Dietrich, *Collages of Kurt Schwitters*, pp. 156-158.

64 Nill, *Decoding Merz*, p. 314.

65 Idem.

66 The cross-fertilization of desire and knowledge is reflected in the following quote from *The Interpreter's Dictionary of the Bible*: "However, the fact that knowledge can be used to designate sexual intercourse...points to the fact that for the Hebrews, "to know" does not simply mean to be aware of the existence or nature of a particular object. Knowledge implies also the awareness of the specific relationship in which the individual stands with that object, or of the significance the object has for him. Cited in Annette Michelson, "Bodies in Space," in *The Discontinuous Universe: Selected Writings in Contemporary*

Consciousness, edit. Sallie Sears and Georgiana W. Lord (New York: Basic Books, 1972), p. 328.

67 Nathan Schwarz-Salant, *Jung on Alchemy* (Princeton: Princeton University Press, 1995), pp. 36-37.

68 Camfield, *Max Ernst*, p. 53.

69 Dietrich, *Collages of Kurt Schwitters*, p. 170.

70 Idem.

71 Christof Spengemann, "Merz-Die offizielle Kunst," in *Der Zweemann*, i-8/9/10, Hannover, 1920, p. 41. Cited in Dietmar Elger, *L'oeuvre d'une vie*, p. 145. Elderfield translates this passage as "In *Haus Merz* I see the cathedral. No, building as the expression of a truly spiritual vision of the kind that lifts us into the infinite: absolute art...This is absolute architecture, the only meaning of which is artistic." See Elderfield, *Kurt Schwitters*, p. 114.

72 Martin Filler, "Fantasms and Fragments: expressionist Architecture," in *Art in America*, v. 71, no. 1, p. 102.

73 Umberto Eco discusses the notion of *laicorum literatura*, a concept set forth by Honorius of Autun in *Gemma Animae* (chap. 132). See Eco, *Art and Beauty in the Middle Ages* (New Haven: Yale University Press, 1986), p. 54.

74 Elderfield, *Kurt Schwitters*, p. 113.

DIE KATHEDRALE DES EROTISCHEN ELENDS: KURT SCHWITTERS' *MERZBAU*

This is perhaps what we seek throughout life, that and nothing more, the greatest possible sorrow so as to become fully ourselves before dying.

—Céline, *Journey to the End of the Night*

From its inception Kurt Schwitters' *Merzbau* has been confused with the names of particular aspects of the project and even other projects altogether. Schwitters only added to the uncertainty surrounding the project and its various attributes by shifting the project's nomenclature from *Die Kathedrale des erotischen Elends* (*The Cathedral of Erotic Misery*) and the anagram *KdeE* (the titles he used in his first full public pronouncement of the work *Ich und meine Ziele*) to the *Merzbau*, the name by which it is most well known. Depending on the circumstance and thus not completely interchangeable, all three titles were used to refer to the project at different times, suggesting that Schwitters merzed not only the spatial and temporal dimensions of his *Cathedral*, its meaning and associated contexts were subject to *Formung* and *Entformung* as well.

The course of events leading to Schwitters' conscious execution of the *Merzbau* has been difficult to discern from the beginning. Gwendolen Webster states that a sculpture from 1917 entitled *Leiden* (*Suffering*), a proclamation device similar to other 'dada-columns' or 'towers' exhibited in dadaist *Festen* (exhibitions) and publications at the time, marks the origin of the project.[1] The sculpture, a "tall, slender column topped by a plaster bust of his wife, Helma," was installed in the corner of Schwitters' studio, only to be joined shortly thereafter by his dadaist assemblage, *Die heilige Bekümmernis* (*Holy Affliction*).[2] The column with the *Leiden* sculpture, published in the magazine *G* and the Hans Arp/El Lissitzky book *The Isms*, has also been referred to as *Der erste Tag Merz-säule* (*The First Day Merz-column*) (*fig. 24*), a designation that implies that it may have been the initial point of Schwitters' inspiration for the construction of his *Kathedrale*. While the

change of name for the column indeed suggests a heightened degree of consciousness with respect to the project, the column itself is also modified in significant ways, with attachments and elaborations that contain potentially important clues to the thematic content of the *Merzbau*. One of these elaborations is actually a replacement of the bust from the *Leiden* column with another plaster head (*fig. 25*). As with the bust of the artist's wife, this sculpture of a head is also quite personal: it is the plaster death mask of the Schwitters' infant son, Gerd.[3] While the artist's gesture could inevitably be viewed as morbid, it is nonetheless important to consider the complexities involved in the replacement of one bust with the other and, at the same time, to reflect on the motives for placing his son's figurative visage at the heart of his work.

Before these issues can be addressed, however, it is necessary to recount the array of comments and observations on Schwitters' burgeoning and unique work of art. An account by Schwitters' friend and collaborator, Kate Steinitz, supports the view that the modified column is indicative of a strong relationship between the *First Day Merz-Column* and what was to become the *Merzbau*:

> One day something appeared in the studio which looked like a cross between a cylinder or wooden barrel and a table-high tree stump with the bark run wild. It had evolved from a chaotic heap of various materials: wood, cardboard, scraps of iron, broken furniture, and picture frames. Soon, however, the object lost all relationship to anything made by man or nature. Kurt called it a column.[4]

In December of 1919, Richard Huelsenbeck visited Schwitters' atelier and described seeing a similar piece:

> This tower or tree or house had apertures, concavities, and hollows in which Schwitters kept souvenirs, photos, birth dates, and other respectable and less respectable data. The room was a mixture of hopeless disarray and meticulous accuracy. You could see incipient collages, wooden sculptures, pictures of stone and plaster. Books, whose pages rustled in time to our steps, were lying about. Materials of all kinds, rags, limestone, cufflinks, logs of all sizes, newspaper clippings... We asked him for details, but Schwitters shrugged: "It's all crap..."[5]

Max Ernst, a visitor to Schwitters' atelier in 1920, saw either the same or a similar object, recalling that he was told that the column or tower was noth-

ing more than a repository for *Abfall* (refuse) that had not been used in the *Merzbilder*. Tellingly, Ernst's comments betray nothing of an intentional exercise on Schwitters' part, a circumstance that continued to be the case throughout the construction of the work.[6]

In an article published in 1920, Alfred Dudelsack, a prominent art critic at the time, had an entirely different take on the project, apparently intuiting the unfolding of a process that was to consolidate Schwitters' artistic ethos:[7]

> The visitor to this most holy place, the master's studio, is struck by a holy shudder, and only then dares raise his eyes when he has found a little spot for himself, but where he cannot stay because there is not enough room to stand. The interior does not give the impression of being a studio but a carpentry shop. Planks, cigar chests, wheels from a perambulator for Merz-sculptures, various carpentry tools for the nailed-together pictures, are lying between bundles of newspapers, as are the necessary materials for the "pasted" pictures and for the Anna Blume poems. With loving care, broken light-switches, damaged neckties, colored lids from Camembert cheese boxes, colored buttons torn off clothes, and tram-tickets are all stored up to find a grateful use in future creations.

Despite these anecdotes the initial date and location marking the beginning of the *Merzbau's* development remains unclear—an uncertainty that was likely exaggerated due to Schwitters' habitual relocations of certain pieces contained within and without his atelier along with his persistent habit of deassembling and assembling artifacts and drawings that already existed. Yet in calling the piece a tower or tree or house with "apertures, concavities, and hollows," Huelsenbeck suggests something more extensive than the image of an isolated sculpture that appears in a photograph of 1920. He could have been describing the entirety of the atelier, with the column as merely one aspect. Contemporary statements Schwitters made regarding the existence of the column create an ambiguous sense of the overall limits; at times he even uses the word "column" to refer to the entirety of the *Merzbau*, though this may be due to the fact that he understood the initial moment of the *Merzbau's* inception, as well as its heart or center, to be the highly mutable *First Day Merz-column*.

In the photograph of the column from the early 1920s, an image that is unfortunately of relatively poor quality, the column is shown standing in what is evidently the corner of Schwitters' first atelier, a room that had once been the bedroom of Schwitters' father.[8] In this case crowned by the *Leiden* sculpture, the image contains additional information, including numerous

newspaper and magazine clippings and artifacts typical of Schwitters' collages and assemblages—though it is nearly impossible to ascertain the specific materials used to make up this early version of the piece. However, it is clear that both the column and the walls of Schwitters' studio have been subject to the same collage process as the *Merzbilder*.

According to both Elderfield and Webster, the initial impulse for Schwitters' column is thought to have been influenced by Johannes Baader's column-construction of 1920 entitled *Das grosse Plasto-Dio-Dada-Drama* *"Deutschlands Grösse und Untergang"* (*The Great Plastic Dio-dada-Drama* *"Germany's Greatness and Downfall"*) (*fig. 26*). In assessing the photographs of the two pieces side by side, it is true that the formal mechanisms Schwitters employed can be read in comparison to Baader's column. However, it is unlikely the initial impulse to begin the *Merzbau* was directly tied to Baader's work; nor does it appear that Baader's highly charged cultural critique has any direct bearing on either the original or subsequent versions of the column. Baader, an artist associated with more than one dada group, identified himself as the modern Christ and the builder of a new society, aspects of his program clearly extend the expressionist idea of a *Zukunftskathedrale* (*Cathedral of the Future*)—despite his criticisms of "neo-expressionist dada" in the Cologne dada publication *Die Schammade*. Thus while Baader's idea of himself as a provocateur supports an interpretation of Christianity as a proactive social program, Schwitters' view may have been more conservative in nature—Christ as a martyr who sacrificed himself for the love of humanity.[9] The theme of his 1923 "Manifest Proletkunst" exemplifies this notion: "Art is a spiritual function of man with the purpose of delivering him from the chaos of life [tragedy]."[10]

Fortunately, the later photograph of the *The First Day Merz-column* is more explicit in rendering the details of the piece. Accordingly, it is clear the column had not only been moved (in the interim, Schwitters took up residence in another part of the apartment building in which he lived) the material affixed to the column has been both altered and elaborated upon as well. Despite these changes, however, the essential nature of the column remains the same. As in the earlier rendition, a rectilinear base holds a series of 'offerings' that, when assembled, act as a transition to the terminus of the death mask. Artifacts affixed to the column that provide the spire-like transition from the lower region to the upper region include what appears to be the sculpture *Haus Merz* (what Spengemann refers to as the 'cathedral'), drawings, tiny figurines, a cartoon of a child's toy bear, a candle-sconce contain-

ing artificial flowers, a phallus-like cow's horn, a human figure clinging to a small pine tree, and a twig. In addition to the collection of artifacts which form much of the column's aesthetic, there are a series of collages made from sheets of paper culled from recent publications by Schwitters and others, including the *Anthologie Bonset* issue of Theo van Doesburg's *de Stijl* (November 1921) and the *Holland Dada* issue of *Merz* published in January 1923.[11] The words "Merzidee Merz Merzidee" (Merz-idea Merz Merz-idea) are affixed to the base, suggesting a trilogic construction similar to the three stars which appear above the Lyonel Feininger's rendering of the Bauhaus *Zukunftskathedrale,* or perhaps the sing-song of a children's rhyme. The word "dada," peeking out from behind the word "Merz," suggests either a displacement or perhaps a conflation of Merz's intentions with dada.

A framed collage dating from 1918 or 1919, one of Schwitters earliest productions using this method, is affixed to the base of the column.[12] Entitled *Der Erste Tag Collage* (*The First Day Collage*) (*fig. 27*)—it is not clear whether the column takes its name from the piece or vice-versa)—the collage contains a series of extra-textual references pertaining to religious and/or esoteric art, including winged Renaissance *putti* and fabric folds of a section of drapery, evidently taken from a reproduction of Stefan Lochner's painting *Muttergottes in der Rosenlaube* (*Madonna in the Rose Bower*) (c. 1440) (*fig. 28*).[13] In assessing the piece, albeit through the medium of an occluded photograph, there are other figures and references that appear within the frames of the collage, though it is nearly impossible to determine the provenance of anything other than the Lochner painting. In what may again be an acknowledgement of Schwitters' allegiances, Stefan Lochner's paintings were of particular interest to Max Ernst, Schwitters' fellow dadaist and at the time a somewhat vocal critic of the artist. In addition to a possible homage to Ernst, Schwitters' incorporation of Lochner's painting is, in itself, important. A piece replete with the figure of the Virgin and the Child Jesus and their various attendants, the colors and figures contain both particular and circumstantial meanings, including vernacular symbolic references that point to mystical aspects of Christianity.

Another significant figure in the collage is a column, a visual device in the manner of a literary trope made up of a "... composite (columnar) form–shaft, fluted capital, and animal protome (bust), apparently a lion's head (a protome), perched on top."[14] Next to the column is a female figure, or angel, whose outstretched arm touches the lower portion of the column. The only text associated with this particular *Merzbild* is the partial word "*Kunst*" (art), rendered in German Gothic script. The compositional arrangement suggests the rectilinear

influences of de Stijl, and might be regarded as a textual mosaic composed in the manner of a tapestry or weaving. The images themselves appear to be quite dense, chosen as much for their reference to specific materials as for their iconography. Though Schwitters did not refer to this particular piece as a primary component of his *Merzbau*, both the column and its collage, are the first clear evidence of the thematic material that would inform the development of *The Cathedral of Erotic Misery.*

In her book *The Collages of Kurt Schwitters*, Dorothea Dietrich suggests that the column, in not looking like a traditional column, but rather acting as a representamen for the 'first column,' may, for Schwitters, represent the *Ur-column*, the most primitive enunciation of the impulse for the creation of a vertical vestige which condenses meaning: a 'memorial' column.[15] The association of the column with the first day of the book of Genesis furthers this suggestion, becoming a marker or seminal condition that, in its vertical placement, extends itself towards the heavens, perhaps alluding to its function as a conductor of spiritual forces. The notion of an *Ur-column* is also in keeping with Schwitters' research into the primitive nature of language in his sound-poems and *Ursonate.*

The idea of absolute origins—suggestive of the inner sound found in Kandinsky's rendering of the "spiritual in art"—is concomitant with Schwitters' understanding of art as the conduit for all human creativity. To Kandinsky, art was the "primordial concept (*Urbegriff*), exalted as the godhead, inexplicable as life." Primordial concepts, ideas that according to Kandinsky could only be understood through creative action, are understood as constants suggestive of the resonating echos of impulses that flow through time. The artist, an agent of creativity, is entrusted with the ability to reveal the "mystical inner construction" found in all human creations.[16] Art, if it is properly art, resonates with a field of associations which, when brought together, provide a dense myriad of inter-textual aspirations. However, the literal associations are not as important to Schwitters as the formative processes, the essential creative play that resides as much in the making (*Formung, Entformung*) as in the 'performance' of the piece. Like Kandinsky (along with his other Sturm associate Paul Klee), for Schwitters creative action was inextricably bound with the performative aspects of the piece. Thus, the play is the performance just as the performance constitutes the play. This is apparent in his ongoing manipulation of the columns as much as it is evident in his reworking of the *Merzbilder*, the postcards, various literary works, the *Ursonaten*, and the loosely struc-

tured dada-soirées Schwitters held at Waldhausenstrasse 5. Ongoing speculative interpretations of the art's thematic content are a necessary part of Schwitters' method, in most cases becoming a vital aspect of the work itself. In short, the processes of Merz are transferred to the interpreter of Merz, thereby enlisting the critic (where even the critique constitutes a work of art) in the cycle by redeeming and resituating the works both within Schwitters' œuvre and without, transforming the world in which it exists.[17]

Though Dietrich does not go so far as to suggest that the column, coupled with the support of a winged female figure, might signal the symbolic marriage of female purity and male desire, the interpretation immediately surfaces in the context of Schwitters' work at the time. In addition, the marriage of esoteric images with more conventional religious art (Renaissance *putti* and Stephan Lochner's drapery folds) signals the intrinsic relationship between sanctioned and unsanctioned faith, a relationship that C. G. Jung discussed in his book *Psychology and Alchemy*: "Alchemy is rather like an undercurrent to the Christianity that ruled on the surface. It is to this surface as the dream is to consciousness, and just as the dream compensates the conflicts of the conscious mind, so alchemy endeavors to fill in the gaps left open by the Christian tension of opposites. [The fundamental idea] of alchemy points back to the...primordial matriarchal world which [was] overthrown by the masculine world of the father."[18] This notion of a mystical inner construction points up the underlying possibility of Schwitters confrontation with the tension of opposites in his search for the integration of his own "human soul"—a soul that did not distinguish between life and art.

By his own account, the idea that the project constituted a total environment, or *"Merzkunstwerk,"* did not occur to Schwitters until sometime around 1923. By that time, he had created at least three columns; the first *Merz-säule* of 1917–1920, the altered *Die Erste Tag Merz-säule* of 1923 and another column entitled *Die Kathedrale des erotischen Elends* he discusses in the article "Ich und meine Ziele"[19] However, the column Schwitters refers to as the *Kathedrale des Erotischen Elends* (his "great column") may reference the entire project: it can be read as a summation of his undertaking in both figurative and literary terms. In the same article, Schwitters states that he has been working on the *Merzbau* for seven years, noting that there are "about ten" columns.[20] From this point on, the ensuing development of the construction appears to have had a life of its own, quickly extending beyond the limits of Schwitters' atelier located in the Schwitters' family apartment at Waldhausenstrasse 5 (*fig. 29*). Ernst Schwitters (Schwitters' second and sur-

viving son), in discussing what is apparently an intuitive beginning to the project, alludes to the fact that the *Merzbau* eventually incorporated almost the entirety of the family apartment:

> His pictures would decorate the walls, his sculptures standing along the walls. As anybody who has ever hung pictures knows, an interrelation between the pictures results. Kurt Schwitters, with his particular interest in the interaction of the components of his works, quite naturally reacted to this. He started by tying strings to emphasize this interaction. Eventually they became wires, then were replaced with wooden structures which, in turn, were joined with plaster of paris. This structure grew and grew and eventually filled several rooms on various floors of our home, resembling a huge, abstract grotto.[21]

A sketch shows the physical location of the *Merzbau*, though it is still difficult to fully acknowledge the extent and complexity of the construction from a plan drawing (*fig. 30*). Outside of the parameters of the plan, for instance, there is evidence that the onto the balcony at the rear of the house, eventually extending down the back facade to the cistern in the side yard and up to the floor (attic) above. According to Webster, by 1936 "the *Merzbau* had expanded so rapidly that it started to sprout through the outer shell of the house." In addition, "a skylight in the attic was too tempting to overlook and Kurt erected a little platform on the roof for sunbathing, accessible by means of a tiny staircase." Webster's detail of Schwitters' progress is illuminating:

> In February 1936 he bored a circular aperture in the balcony floor and built a spiral staircase of plaster and wood leading to the area below. This was in turn walled in so that he could extend the *Merzbau* downwards. From the space below the balcony it spread to two rooms of the basement (whose ceilings were well above ground level). Then, to Kurt's delight, a large concrete cistern was discovered in the earth below the floor of the balcony, and the spiral staircase was continued down to the water level two metres below.[22]

The suggestion that the project was a *Kathedrale* is underlined by the metaphoric mechanisms the artist engenders through this particular aspect of the construction. As Elderfield states, "the principal sculptural motif of this final addition to the *Merzbau* was arrow-shaped, pointing down to the water, where it was reflected back to point upwards—thereby reminding visitors to this most astonishing structure that the *Merzbau*, while not as vast as is commonly assumed, did in fact stretch, after thirteen years of building, from the

subterranean to the sky." Like a sanctuary, the symbolic drawing of water suggested by the connection of the cistern into the body of the *KdeE* recognizes the project's association with the font of life, the essential spring from which all living forms are generated. Similar to many Gothic cathedrals (and medieval monasteries), the location of a source of water was a programmatic necessity in the siting of cathedrals and monasteries. The spiral staircase, extending from the water source, acts as the conduit for adjoining the earth and the heavens, a particularly significant aspect of alchemical enterprise and a cornerstone of German nature mysticism. Mirroring Böhmes' "circle of life," a closed system of infinite variations, Schwitters' action feeds his *Kathedrale* with the primary source material (water) necessary to its continued vitality. In this sense, the fact that the project remained hidden from passers-by—any glimpse of the *Merzbau* through a window was impossible because Schwitters had whitewashed them from the inside—is not surprising. Like the mysterious circle of life, closed yet infinite within its boundaries, the *Merzbau* reflected the remoteness of Schwitters' private research, thus recognizing the ongoing conflict between his innermost thoughts and actions and his public self was reflected in both subtle and obvious ways. To the artist, the whitewashing of the windows—perhaps cleansing it metaphorically while permanently occluding the project from external observation—was indicative of his persistent melancholy. Accordingly, it made him "utterly depressed at the lack of contact. I can't show my studio to anyone, of course ... it saddens me so."[23]

Recalling his Hannover *Merzbau* in a letter he wrote in 1946, Schwitters states that his "... Merz tower was not confined to a single room, but spread over the whole house ... Parts of it were in the adjoining rooms, on the balcony, in two rooms of the cellar, on the second floor, in the attic..."[24] Within the *Merzbau* itself, there were significant sectional characteristics, including a loft space in which Schwitters' would periodically rest. While the 1986 reconstruction in Hannover is suggestive of what one may have encountered when entering the piece, its manifestation depends almost entirely on the later photographs showing the "constructivist" or "*puriste*" phase of development.[25] Earlier developments are almost entirely covered over, contained within the white plaster walls—nearly eradicating the sense that the piece was originally an extended working studio, itself a large assemblage made up of *Abfall* (refuse) and found objects.[25] Accounts suggest that the project was up to six layers deep in places; walls and 'columns' could be moved to allow visitors to pass into the inner sanctum in order to view the material contained within. It was, in short, a "growth which did not cease to grow."[27]

The labyrinthine nature of the project is suggested by the numerous anecdotes that describe the *Merzbau*. Schwitters himself wrote a detailed account in 1931.[28] Other than the detailed account Schwitters wrote in 1931, there are also statements regarding the progress and nature of the work in his correspondence. For the most part, however, Schwitters remained circumspect, preferring the project remain a largely private episode. To reconstruct the project from the various sources is to be presented with a vast array of material, requiring a textual weaving of sorts. What is known is that there were numerous "*Grotte* (grottoes)," "*Höhlen* (holes, caves)," and "*Zimmer* (rooms)"—designated as such by Schwitters himself—as well as containers in which materials for future *Merzbilder* and "*Merz-konstruktions*" were kept. A detailed outline of the contents of the *Merzbau*, which Schwitters alternately referred to as *KdeE*, "for short, because we live in shortened times (*der Zeit der Abkürzungen*)," presents an incontestably enigmatic array of material and literary sources.

While classifying separate entities into the categories "grottoes," "caves," and "rooms" may actually limit the interpretation of Schwitters' overall project, it is nonetheless a useful mechanism for providing a comprehensive account of the range of material and associations contained within the *Merzbau*. It also gives some idea of Schwitters' personal and professional associations, along with a preliminary insight into the artist's cultural preoccupations. Since the project was destroyed, however, the evidence that remains is largely anecdotal; as both his associates and he alluded, it is probable that there were more caves, grottoes and rooms than those that are noted in the various accounts.

The use of the word "rooms" (*Zimmer*) in referring to particular aspects of the *Merzbau* was probably incidental; given the analysis of the various 'types' of grottoes, it appears unlikely that the term "room" referred to a specific kind of space distinct from that of the grottoes and caves. However limited in number, there are nonetheless subtle thematic distinctions, with the 'rooms' including references to more general aspects of German history and culture such as specific geographical regions, styles, and mythological and historical figures. The *Biedermeierzimmer* (*Biedermeier Room*) and the *Stijlzimmer* (either *Style Room* or *De Stijl Room*, as the name suggests a likely recognition of Theo van Doesburg's movement of the same name), can be grouped with *Luthersecke* (*Luther's Corner*), a probable reference to Martin Luther, *Das Ruhrgebiet* (*The Ruhr Region*), an industrial region in Germany, *Die Nibelungenhort* (*The Nibelungen Hoard*), which refers to the *Nibelungenlied*, the "great German *Iliad*," and *Der Kyffhäuser* (*The Kyffhäuser*), a site governed by the great mythological kings of Germany that

included a stone table, possibly for the sake of political, social and economic transactions.

The *Höhlen* are most often used to designate the space of particular individuals; Schwitters' friendships and professional relationships fall into this category, thus leading to interpretation of the caves as kinds of shrines. There are caves devoted to the architects Ludwig Mies van der Rohe and Walter Gropius; caves for the artists Jean (Hans) Arp, the constructivists Naum Gabo, El Lissitzky, Hans Richter, and Laszlo Moholy-Nagy (each of whom merited a cave), Raoul Hausmann, Herwarth Walden, Theo Van Doesburg, Sophie Täuber-Arp, the Dutch painter and erstwhile associate of Van Doesburg, Piet Mondrian, dadaist and Schwitters collaborator Hannah Höch, who had the honor of two caves, and writer and Schwitters' close friend and associate Kate Steinitz, who merited two caves as well. Johann Wolfgang von Goethe, the principal voice of the *Frühromantiker* (Early romantics), was also given an honorary cave. As Webster notes, the caves grew by accretion and according to the developmental aims of Merz to the point where "... Schwitters extended an invitation to all artists to donate grottoes, waste paper, kitsch and photos to the *KdeE*." Some of his fellow artists even took him up on his offer, with both Kate Steinitz and Hannah Höch involved, at least in part, in the construction of their respective grottoes.

In addition to the caves devoted to various personages, there were caves that recognize particular groups or entities, all of which could point to real events, though they were likely indictments of broader cultural conditions and therefore more abstract. These include; *Die Mördenhöhle* (*Cave of the Murderers*), *Die Missbilliggenerheldhöhle* (*Cave of the Deprecated Heroes*), *Die Anbetungheldhöhle* (*Caves of Hero Worship*), *Der Lustmordhöhle* (*Cave of the Sex Murders*), and *Die Puppenhöhle* (*The Doll [Puppet] Hole*). In most literature on the *Merzbau*, these caves have been interpreted as either Schwitters' diagnosis of the underlying pathologies of German culture, pathologies reflected in the disturbing events that occurred in or near Hannover in the years surrounding the First World War or his recognition of underlying pathologies inherent in German culture in general. In this sense, they could either be thought of as a manner of cultural critique, or as a brief, if veiled exposure of Schwitters' own fascination with the darker side of humanity, a proposition that suggests aspects of Surrealism.

One particular grotto, *Die Goldgrotte* (*the Gold Grotto*), however, stands out among the field of grottoes, caves and rooms in several ways. First it is the only part of the *Merzbau* clearly devoted to a 'material.' Secondly, in photographs of

the *Merzbau*, the *Gold Grotto* is considered important enough to detail. In these photographs, the *Gold Grotto* appears to have two transparent boxes that contain any number of small and medium-sized objects, many of which appear to be parts of children's toys. In addition, a doll-like child's head—what is probably the relocated death mask of Schwitters' son, Gerd, also appears. Thus the *Gold Grotto* may be the principal tableau for the *Merzbau*, signifying death, life, and love while also recognizing the *materia* associated with alchemical processes, where lead, the basest of all metals (dross), is transmuted into gold.

In published accounts of the *Merzbau*, there are at least forty different grottoes, rooms, and caves mentioned.[30] According to Kate Steinitz, the most secret caves were never seen by anyone except Sturm gallery owner and critic Herwarth Walden, the architectural historian Sigfried Giedion, and "kernel-dadaist" Arp. In the article "Ich und meine Ziele," Schwitters mentions these three individuals specifically, with the qualification that only they would understand it.[31] In this same article Schwitters further elaborated the contents of the various grottoes:

> Each grotto takes its character from some principal components. There is the *Nibelungen Hoard* with the glittering treasure; the *Kyffhäuser* with the stone table; the *Goethe Grotto* with one of Goethe's legs as a relic and a lot of pencils worn down to stubs; the submerged personal-union city of Braunschweig-Lüneberg with houses from Weimar by Feininger, Persil adverts, and with my design of the official emblem of the city of Karlsruhe; the *Sex-Crime Cavern* with an abominable mutilated corpse of an unfortunate young girl, painted tomato-red, and splendid votive offerings; the Ruhr district with authentic brown coal and authentic gas coke; an art exhibition with paintings and sculptures by Michelangelo and myself being viewed by a dog on a leash; the dog kennel with lavatory and a red dog; the organ which you can turn anti-clockwise to play "Silent Night, Holy Night" and "Come Ye Little Children"; the 10% disabled war veteran with his daughter who has no head but is still well preserved, the *Mona Hausmann*, consisting of a reproduction of the Mona Lisa with the pasted-on face of Raoul Hausmann covering over the stereotyped smile; the brothel with the 3-legged lady made by Hannah Höch; and the great *Grotto of Love*.[32]

At this point in the article, Schwitters goes on to describe the *Grosse Grotto der Liebe* (*Great Grotto of Love*) in more detail:

> The *Grotto of Love* alone takes up approximately one quarter of the base of the column; a wide outside stair leads to it, underneath stands the *Klosettfrau des Lebens* (*Female Lavatory*

Attendant of Life) in a long narrow corridor with scattered camel dung. Two children greet us and step into life; owing to damage only part of mother and child remain. Shiny and fissured objects set the mood. In the middle is a couple embracing: he has no head, she no arms; between his legs he is holding a huge blank cartridge. The big twisted-around child's head with the syphilitic eyes is warning the embracing couple to be careful. This is disturbing, but there is reassurance in the little bottle of my own urine in which *Immortelles* (*everlasting flowers*) are suspended.[33]

Given the gruesome nature of this particular grotto, it is likely that Schwitters retained an ongoing battle with questions involving sexuality, procreation, and women. It is known that he had significant difficulty with Helma and her family at the time of their betrothal. In addition, other autobiographical facts, including the thwarted relationship with his childhood sweetheart, Else, and the tragic death of his first son during infancy, may have contributed to his obvious anxiety regarding conjugal relations.[32] Thus, Schwitters reference to "two children," who "step into life," of whom, due to some unspecified catastrophe, only "a part of the mother" and "a child" remain, is an apparent allusion to the loss of one of the children, a loss experienced as a lack by both the mother and child. The particularity of this reference, along with the fact that the figures were contained within the domain of the *Grotto of Love*, (of which only a partial representation remains) appears as a thinly-veiled autobiographical statement. Yet the possibility that the "Grotto of Love" is autobiographical in nature becomes increasingly alarming as the details are further fleshed out to reveal an obvious sexual symbolism. Thus the suggestion that the male figure "holds between his legs a blank cartridge" leads to several provocative interpretations, some of which are obviously more personal than others, a suggestion Schwitters makes at the close of "Ich und meine Ziele":

I have recounted only a tiny part of the literary content of the column. Besides, many grottoes have vanished from sight under later additions, for example, *Luther's Corner*. The literary content is dadaist: that goes without saying, for it dates from the year 1923, and I was a dadaist then . . . I have given a fairly detailed description of the *KdeE*, because this is the first reference to it in print, and because it is very hard to understand because of its ambiguities.[33]

Still other information is disclosed by this statement, including Schwitters' residual anxiety regarding his relationship to dada. Hence, to

make the blanket statement that the project is "dadaist"—despite his obvious difficulties with dada's program indicates at least some degree of dissimulation on Schwitters' part. German dada had been largely subsumed into the constructivist and, in some cases, surrealist movements by 1922, a change that profoundly affected Schwitters' work as early as 1920. Schwitters' suggestion that the "literary content" is dadaist implies that the substance, the meanings originally ascribed to the project, is no longer relevant. While aspects of the *KdeE* do maintain some degree of dadaist protest, both the personal nature of the work, as well as various literary aspects, do not substantively support dada's urban-oriented propagandistic aims. It is more likely, however, that Schwitters found it necessary to continue to treat his *Kathedrale* as a remote and personal exercise, despite the fact that it was clearly his paramount project. The extent of the project, as well as its remote and highly personal characteristics, probably made any explicit and detailed statements an overwhelming exercise that would, in Schwitters' mind, only require still further elaboration and exposure. These conditions, coupled with the psychological reasons for continuing the project unabated—it was clearly a private, obsessive search for redemption—indicate the possibility of additional, or alternative, motives on Schwitters' part, motives which he preferred to address in the remote confines of his domestic space.

Fortunately, Kurt and Ernst Schwitters' photographic essay of the *Merzbau* gives some indication of the materials contained within. Taken at periodic intervals, the photographs operate in a three-fold fashion: first, they show the ongoing generation of what might be referred to as the stylistic effects; second, they supplement information regarding Schwitters' process; and third, they give additional information regarding the content of the *Merzbau.*

The first photographs detailing the Merz-columns from 1920 and 1923 have already been noted. In 1928, Schwitters took two photographs of what he called the *KdeE* (*figs. 31 and 32*) In contrast to the later and better-known images of the *Merzbau*, these photographs display the startling crudeness, even disarray, of Schwitters' process. Similar in execution to the *Merzbilder* and sculptures, the work recorded by the images also suggest the transitional nature of Schwitters' explorations. The materials—a collection of abstract and figurative elements—are affixed to one another in the manner of a low relief. Given the fact that the sculptures are made up of a series of vertical and horizontal elements appended to one another, the actual spatial ramifications are minimal. The figurative elements—elements that include a Madonna and

child, a diminutive angel-like figurine, a doll, a small ceramic animal, and various other toy-like objects—are arranged on platforms or affixed to the vertical and horizontal pieces. To the front of one of the pieces (*fig. 31*) is the "stair" Schwitters mentions in his detail of the *KdeE* column, though it is clear that, given the scale and detail of the piece, the stair is not meant to be operational, but descriptive; it is a narrative element which suggests that the overall intention of the piece is that of an altar or platform of votives. The use of the angelic figurine(s) and Madonna and child, as well as the designation of the piece as a "cathedral," further supports this reading.

While the *Merzbau* remained a highly personal project, there were several friends and associates who were initiates of Schwitters' private realm over the course of its early development. Individual reports and assessments regarding the work range from critical awe to a diagnosis of Schwitters' psychological stress to an embrace of its spiritual effects. For the museum director Alexander Dorner, a well known and respected supporter of the avant-garde, Schwitters' construction was as appalling as it was unsettling, "...the free expression of the socially uncontrolled self [who] had here bridged the gap between sanity and madness." Seeing the project as a manifestation of Schwitters' arrested development, Dorner went on to characterize it as "a kind of fecal smearing—a sick and sickening relapse into the social irresponsibility of the infant who plays with trash and filth."[35] Yet Dorner was not the only one who found the *Merzbau*'s contents extremely disturbing. El Lissitzky and his wife Sophie Lissitzky-Küppers expressed similar views, stating that they too were unable to "...draw the line between originality and madness."[36] In a more measured response to the construction, Kate Steinitz thought the *Merzbau* represented "...a hallucinatory confusion of tiny fetish objects displayed like specimens in glass boxes: a miniature theatre of the absurd. In each cave was a sediment of impressions and emotions with significant literary and symbolic allusions."[37] On the other hand, the Swiss art historian Carola Giedion-Welcker preferred to resist psychoanalytic or diagnostic aspersions, writing in more euphemistic terms (terms she attributes to Schwitters himself): "[It is] ...a little world of branching and building where the imagination is free to climb at will."[38] Art critic Rudolf Jahns, one of Schwitters' closest friends, visited the *Merzbau* following the inaugural meeting of the group "*die abstrakten hannover*," a gathering that took place in Schwitters' apartment on March 12, 1927. At the conclusion of the meeting, Schwitters took Jahns and his wife to see the construction, an experience Jahns elaborated in both descriptive and metaphorical terms. While the statement of

reminiscence is lengthy, it presents one of the more detailed accounts of the *Merzbau* at this stage of development. In the concluding paragraph recounting his experience, Jahns also explicates the experience of Schwitters' construction in a way that encapsulates the full impact and specificity of the work.

Even the way to it, along a narrow corridor, revealed some interesting things. I remember one chest, about 50 cm [20 in.] long: the back half-closed by a board, the front covered with a wire screen. Two strange creatures with big, dirty white bodies were lying inside on hay. Each of them had only one thick, S-shaped, bent, black leg. The chest was filled with a mysterious half-light, which meant that one sensed rather than saw these creatures. They were two large porcelain insulators, such as one sees on telegraph poles beside train tracks. Their appearance was entirely transformed.

Then we entered the column itself through a narrow door, which was more like a grotto: plaster construction was hanging over the door paneling...Schwitters asked me to go through the grotto alone. So I went into the construction which, with all its bends, resembled a snail-shell and a grotto at the same time. The path by which you reached the middle was very narrow, because new structures and assemblages, as well as existing grottoes and Merz-reliefs, hung over from all sides into the still-unoccupied part of the room. Right at the back, to the left of the entrance, hung a bottle containing Schwitters' urine, in which everlasting flowers were floating. Then there were grottoes of various types and shapes, whose entrances were not always on the same level. If you walked all the way around, you finally reached the middle, where I found a place to sit, and sat down. I then experienced a strange, enraptured feeling. This room had a very special life of its own. The sound of my footsteps faded away and there was absolute silence. There was only the form of the grotto whirling around me, and when I was able to find words to describe it they alluded to the absolute in art. I saw the grotto again soon afterwards, and it had changed once more. Many of the grottoes were [covered up] and my impression was more of a unified whole.[39]

In keeping the project hidden from public view, Schwitters was perhaps aware of the disturbing nature of his construction. Evidence suggests that he had begun to enclose the grottoes and caves as early as 1924, only one year after his stated inception of the work. The variety and extent of the grottoes, however repressed by successive developments, nonetheless represent the initial impulse and core of the *Merzbau*. What each of the apertures and cavities entailed could not have been arbitrary given Schwitters' deliberate use of language and symbolism; that he did not speak to the specifics of the various elements does not discount the significance of their literary

and historical allusions.

The friendship caves—among them the *Arp Cave*, the *Mies Cave*, the *Gabo Cave*, the *Mondrian Cave*, the *Sophie Täuber-Arp Cave*, and the *Richter Cave*—were composed of objects and artifacts assigned to each individual. These objects and artifacts were frequently elicited—or in some cases pilfered—from the representative individuals themselves; for instance, Sophie Täuber-Arp's cave contained her bra while Theo van Doesburg was represented by a piece of his tie. Among other things contained in Mies van der Rohe's cave there was a pencil Schwitters may (or may not) have taken from Mies' drafting table during one of the artist's visits to Mies' office. In a particularly poignant memoir, the dada-constructivist Hans Richter noted his own experience with Schwitters' means and methods as follows:

> He cut off a lock of my hair, and put it in my hole. A thick pencil, filched from Mies van der Rohe's drawing board, lay in his cavity. In others there were a piece of a shoelace, a half-smoked cigarette, a nailparing, a piece of tie [Doesburg's], a broken pen. There were also some odd (and more than odd) things such as a dental bridge with several teeth on it, and even a little bottle of urine bearing the donor's name. All these were placed in the separate holes reserved for the individual entries. Schwitters gave some of us several holes each, as the spirit moved him... and the column grew.[40]

The friendship caves were not merely confined to the inner sanctum of the *Merzbau*, but made their way into the *Merzbilder* as well. According to Ernst Nündel, "Schwitters collected friendships the way some people collect stamps."[41] Yet Nündel's statement in some ways trivializes the importance of these individuals to Schwitters. As with his close friend Hans Arp, these friendships were both the foundation and sustenance for his artistic and personal development. The conversations and interactions with not only their persons, but also their works provided Schwitters with the ability to apprehend the flow of developments around him. They also represented his attempts to formulate patterns in the chaos of the social and political milieu that surrounded him.[42]

The combinatory effect of the friendship caves are further informed by their being situated in the context of the other holes and caves: it was not a unified obliteration of the specificity of each venue which Schwitters sought, but the paratactic arrangements suggestive of a transhistorical, organic relationship between art and life. The designation of the holes and cavities as grottoes reiterates the religious nature of the work: they are meditations on

Schwitters' many friendships and professional associations. As grotto-reliquaries, the spaces, many of them quite small, contained a significant artifact or artifacts by which his friends could be remembered, a not-so-subtle signal of Schwitters' fetishistic tendencies. Thus the capture of a profane object or remembrance from an individual is transformed into a sacred object of adoration. Each reliquary constitutes an iconic representation of its designated 'saint' as a star in Schwitters' elaborate mapping of multiple constellations. As such, these 'stars' could be used to chart the course of events in both a personal and universal sense. Much like Roman Catholic reliquaries, in which physical aspects (teeth, fingers, a piece of a martyr's clothing) specific to the various saints are stored, the presence of the various objects would elicit the presence of the individual's spirit or aura.[43]

Schwitters' spiritual life, and the spiritual nature of his art, was sustained by his visitations, either literal or figurative, to the grottoes. In this sense, the friendship caves are explicit attempts by Schwitters to turn the profane into the sacred. Schwitters' appropriation of, among other "profane" items, locks of hair, articles of clothing, pencils, and nail parings does not undermine the notion of the sacred, but connotes an element of transubstantiation. The doctrinal concept of transubstantiation asserts that in the Eucharist, "... the entire substance of the bread and wine is converted into the entire substance of the Body and Blood of Christ; only the appearances (or 'accidents') of the bread and wine remain."[44] The accidents or appearances of *Abfall* may have remained in Schwitters' appropriation of the various items, but their elevation to the status of art bespeaks the sacred nature of his undertaking: the original terms in which each object or artifact appeared were accordingly effaced. This idea, the transubstantiation of the profane into the sacred, is marked by the ritual affects of religious faith, such as that which takes place in the celebration of the Mass according to the Roman rite; to Schwitters the containment and ongoing elaboration of the *Merzbau* constituted a sacred ritual. However, it should be remarked that the use of the doctrine of transubstantiation to explain Schwitters' project in the friendship caves does carry with it an inherent paradox with respect to Schwitters' ideas. Traditional readings of transubstantiation explicitly state that the 'essences' are not hidden, but constitute a literal exchange of substance and thus a change of state. The 'reality' of an exchange of substance, while not empirically apparent is, as a matter of faith, absolute. Hence, the measures of faith recorded by the act of transmutation are evidenced in the processes of alchemy and hermeticism as well, a mode of research reflected in Schwitters' Merz.

Accordingly, the caves of friendship constituted the spatial and temporal indexing of Schwitters' insistent *Formung and Entformung*. The pursuit of his aesthetic of redemption required that, in the manner of Walter Benjamin, "…each important relationship figures as an entrance to a maze"; the caves accorded Mondrian, Moholy-Nagy, Hannah Höch, Theo van Doesberg, and others, registered the transformation and development of his work: they are archives which record Schwitters' successive attempts to negotiate a path through the chaos of his existence.[45]

The second type of 'grotto'—not all of which where designated as such, but were apparently constructed in similar fashion to the friendship caves— were holes or cavities that functioned in a slightly different manner. The underlying connotations of the caves must be taken together: the *Nibelungen Hoard, Luther's Corner*, the *Kyffhäuser*, the *Goethe Cave* all bear incantatory themes. Each one of these themes or episodes (or singular individuals in the case of Goethe) have acted as a lightning rod in the development of German cultural identity. What Schwitters had in mind with these particular grottoes is initially difficult to ascertain without looking at them as a collective grouping, though a particular German expression, "*Es spukt hier*" (literally, "it haunts here"), is perhaps instructive in unearthing Schwitters' intentions.[46]

Schwitters' understanding of the significance of *Kultur* (culture) in the development of his art is indicative of the nineteenth-century distinction between *Kultur* and *Zivilisation* (civilization) in German intellectual thought. Whereas *Kultur* was thought to be representative of the underlying impulse and specificity of German national identity, *Zivilisation* was wedded to the development of Enlightenment ideals. The consequences of the debate between *Kultur* and *Zivilisation*, mirroring the debate between collective identity (*Gemeinschaft*) and the fundaments of a society based on universal human (civil) rights (*Gesellschaft*), were far-reaching. According to the proponents of *Kultur*, the instinct and intuition which marked the development of the German nation could not be compromised or structured according to an arbitrary social and political constitution based on the rule of law, but developed through time, inevitably and without recourse. Dietrich characterizes the debate as follows:

> The central terms in this debate–which intensified with the rise of industrial capital-ism–were *Zivilisation* (civilization) and *Kultur* (culture). *Zivilisation*, declared Oswald Spengler–author of *Der Untergang des Abendlandes* (*Decline of the West*) first published in 1918–developed from urbanism and pervasive materialism, the world of commerce and

abstract thought. Characterized by chaos, *Zivilisation* signaled a moment of cultural decline. *Kultur*, by contrast, defined an economic world of production rather than commerce and implied the reign of the soul over the intellect. Characterized by organic unity and unbroken tradition, it described a moment of cultural cohesion. According to Spengler, then, *Zivilisation* was experienced in terms of fragmentation, *Kultur* as a period of wholeness.47

This same argument was used to distinguish between romantic and Classical ideals. Where the romantic *Geist* (spirit) appealed to the intuitive and the spiritual, and the subsequent dispensation of limits, the Classical *cogito* sought harmony through rules, principles, and the consensus of the polis. While the absolute separation between *Kultur* and *Zivilisation* (or community and society) and spirit and mind is false in practice, the particular theoretical foundation, set forth by academics and politicians in the nineteenth and early-twentieth century, paved the way for the protracted conflicts between modern Western nations.

The distinct nature of the two world-views continued to inform not only early twentieth century social and political thought, but cultural production as well. German expressionism, with its embrace of subjectivity and mysticism was an extension of the romantic ideal. Schwitters' use of religious and erotic themes, as well as the hermetic underpinnings of his creative process, is indicative of his consignment to the general 'tenets' of expressionism. Yet here too is additional evidence of the complexity of Schwitters' approach to art. While he may appear to be appropriating, even celebrating, the specific nature of German *Kultur*, Schwitters is clearly not a proponent of the politicized approaches to cultural production. Like most avant-garde artists and writers, in particular those with whom he maintained close and personal relationships, Schwitters was adamantly internationalist in his outlook, going so far as to compose his correspondence in two or three different languages in order to stress his position. The outlook of his journal *Merz*, which featured the works of artists from across Europe (and Russia) provides the clearest evidence of this.

How to read the incorporation of the "cultural" caves, then, depends on their re-contextualization in the field of associations Schwitters sets up in the *Merzbau*. Another series of caves is at once more abstract and timelier in its references. These caves, which include the *Cave of the Sex*, or *Lust-Murderers*, the *Cave of the Deprecated Heroes*, and the *Caves of Hero Worship*, among others, attend to specific events and conditions which informed the social, cultural, and political arena during the incipient years of the Weimar Republic. The

Cave of the Sex Murderers is thought to make specific reference to the rise of social, psychological, and sexual deviance in Germany immediately following the close of the war.[48] Sex crimes rose markedly due to what were thought to be the "unchained atavistic impulses" released by the experience of war. In addition, the incipient critique of gender relationships, found in various forms of dada and surrealism are potential influences on the overall development of the *Kathedrale*, exemplified by the caves (and columns) dealing with eroticism, sexual deviance, and death. Yet Richter's comments regarding Schwitters' physical perversion of bodies, as well as his use of dolls and bodily fluids, suggests deeper motives on the artist's part. While the initial impulse for Schwitters' creative production in this regard may have been the cultural and social conditions and subsequent 'loss of meaning' surrounding him, the incorporative evidence portends a 'research' into the underlying pathologies that support 'impulses' (natural or psychological) of religion, eroticism, violence, disease, insanity, and death. As Dietrich suggests, the issues surrounding sexual deviance and disfiguration are clearly at the core of Schwitters' project, yet these issues must be viewed within the overall context of the *Merzbau*.[49] Moreover, the *KdeE* does not attend only to the current or even recent state of affairs, but is manifest of a protracted series of conditions that inform not only the modern psyche, but the development of the European cultural context as well.

Two other caves in this series, the *Cave of the Deprecated Heroes* and the *Caves of Hero Worship* harbor similar implications. Perhaps conceived as a pair, the notion of "deprecated" (fallen) heroes and "hero worship" may have contained either specific allusions to individuals from German history or, given the nature of Merz, been populated with abstract elements—or both. In German culture, the focus on historical and cultural deliverance through the actions of a singular individual or 'hero' (most often an agent of the culture) is longstanding and complicated. Though tantalizing as separate artifacts, what is most significant about these grottoes is their necessary absorption (sublation) into a 'field of operation.' This field, which includes *Der Kyffhäuser*, with its miniature stone table, *Die Goethehöhle* and the *Die Nibelungenhort*, invokes the cultural panoply of German mythology.[50]

As Dorothea Dietrich has pointed out, *Die Nibelungenhort* (*The Nibelungen Hoard*) is yet another play on the mythological construction of German national identity. The legend of the Nibelungens, represented by Richard Wagner in his opera *Das Nibelungenlied* (*The Song of the Nibelungen*), is the pre-eminent legend in German mythology. In terms of Schwitters' immediate context, the theme was reconstituted in Fritz Lang's

1924 film entitled *Die Nibelungen*. Immediately following Lang's notation of *Der Kyffhäuser*, the legendary mountain in which Frederick Barbarossa, the great Emperor of the German Reich, resides prior to his resurrection and consequent reclamation of German greatness, Schwitters' citation of the *Nibelungen* treasure alludes to the German nationalist's tendency to reach back into the realm of Teutonic mythology in search of national greatness.[51]

The essential plot of the *Nibelungenlied*, featuring the mythological figures of Brunhild, Siegfried, and Kriemhild, is one of deceit, vainglory, and the annihilation of all, Christian and pagan alike, without consideration given to afterlife. While the complicated, difficult, and often violent nature of the poem may be the reason Schwitters chose to frame the work within the confines of his *Merzbau*, suggesting the relevance of its themes in terms of contemporary political and social events, there are other possibilities which should be addressed. That the *Nibelungenlied* is compared to the *Iliad*, is noteworthy. Both poems are extended lamentations concerning the horrors and "terrible beauty" of war. The dedication to violence, however, leaves no one standing, neither victor nor victim. Hence, the *Nibelungenlied* is a tragic odyssey that mirrors the "terrible beauty" and violence of modernity; unlike in the courtly romances that were popular during the same period, "injustice and calamity are not resolved in the ultimate reconciliation of hostile forces or in the development of an individual self-awareness and understanding of one's place in the order of things."[52] The epic's popularity throughout the late nineteenth and early twentieth centuries—including its glorification of violence, the repudiation of war, and the subsequent resurrection of these themes during the decades immediately preceding World War II—obviously did not go unnoticed by Schwitters. His entombment of the *Nibelungenlied* within his elaborate crypt articulates the dual nature of his vision: the sources of modernity must be preserved and effaced simultaneously. The effect of the multiple resurrections of the *Nibelungenlied*, especially in light of the ongoing events of Germany's conduct on the world-stage, suggests both a preoccupation with the primal forces underscoring violence and destruction coupled with a search for a means of 'overcoming' and thus redeeming the perpetual tragedy that was (as it still is) understood as the history of the German people.

Standing out among Schwitters' various grottoes is *Die Goethehöhle* (*the Goethe Cave*). Dedicated to the "romantic" German author of *The Sorrows of Young Werther*, *Elective Affinities*, and *Faust*, the *Goethe Cave* achieves a breadth of associations which surmount not only the 'abstract' caves, but the

caves dedicated to the mythological constructions of German cultural iden-
tity.[53] While Goethe is most well-known for his literary (and scientific) pur-
suits, his social and political positions were decidedly critical of the national-
ist sentiments of his time; he was known to be a supporter of Napoleon I,
and despite his German origins subscribed to many Enlightenment ideals.
Hence, Goethe's political positions did not support the notion of a distinct
German *Kultur*, but regarded French society (*Zivilisation*) as the high point
of Western development. Schwitters' *Goethe Cave*, with "one of Goethe's legs
as a relic and a lot of pencils worn down to the stubs," signifies the fact that
Schwitters saw Goethe as a kind of saint in his panoply of associations—
which the relic of Goethe's leg clearly implies—while also paying homage to
Goethe's prolific artistic, literary, scientific, and philosophical productions
over the course of his lifetime.[54] Yet the appropriation of the leg also suggests
both the mutilation of Goethe's corpse as well as the notion that his ideas
have been fragmented and scattered widely. Schwitters, in elaborating a grot-
to specifically on the subject and person of Goethe, may have viewed himself
in terms of Goethe's legacy: as an artist and writer, Goethe was neither
romantic (despite the proto-romantic nature of his youthful writings) nor a
man entirely disposed to the rules and principles of Classicism. As a true
cosmopolitan, Goethe thus became a model for an outward-looking
Germany; while maintaining a respect for history and tradition, he also rec-
ognized the significance of modern social, political, and cultural ideals. In
addition, the dynamic with which Goethe's ideas have taken hold, from the
nineteenth through the early twentieth century, as well as the prolific nature
of his life's work and the sheer force of his creative style, have had far-reach-
ing consequences, an impact on the world that Schwitters anticipated for
himself when allowing that he was "more of his time than any politician."
Nonetheless, the description of the grottoes, columns and caves, however,
do not in themselves grant insight into the underlying motives of the
Merzbau, a fact Schwitters himself inferred in "Ich und meine Ziele," stat-
ing that, despite "fairly detailed descriptions," his *Kathedrale* is still "difficult
to understand."

NOTES

1 The actual date for the sculpture *Der erste Tag* is unclear, with some authors stating that
 it appeared as early as 1919 in situ, that is in the atelier, though it was photographed for
 the magazine *G* and the Arp/Lissitzky book in 1917 (if indeed it is the same sculpture).

2 Webster, *Kurt Merz Schwitters*, p. 210.

3 The issue of whether or not this is the death-mask of Schwitters' son is complicated by
 the debate over whether or not there were two sons. Schwitters makes no mention of the
 birth of a first son in his autobiographical writings (nor to his first for that matter, pre-
 ferring oblique references to the event). However, Dorothea Dietrich and John
 Elderfield have confirmed the birth—and death—of the first son in conversations with
 Schwitters' late son Ernst. There are also statements regarding the "two children" in
 Huelsenbeck's account of his visit to Schwitters' home, where he mentions that Helma
 Schwitters was "putting the two children to bed." See Dietrich, *The Collages of Kurt
 Schwitters*, fn. 19, p. 221. The mention of the two children is probably a mistake given
 that the Schwitters' second son, Ernst, was born two years (in 1918) after the death of
 Gerd. Gwendolen Webster's research appears to reach closure on the subject, finding
 that there were two sons, Gerd and Ernst and that Gerd, b. 1916, died before the birth
 of Ernst. See Webster, *Kurt Merz Schwitters*, p. xiii. Previous chronologies of Schwitters'
 life, including those by Ernst Nündel (*Kurt Schwitters*, pp.143-4) and Elderfield did not
 contain the birth of Schwitters first child.

4 Steinitz, *Kurt Schwitters*, p. 90.

5 Richard Huelsenbeck, 1920–22, p. 66; cit. Elderfield, *Kurt Schwitters*, p. 145.

6 Patrick Waldberg, *Max Ernst* (Paris, 1958), pp. 162-63, cited in Webster, *Kurt Merz
 Schwitters*, p. 210.

7 Alfred Dudelsack in *Beilage zur Braunschweiger Illustrieten Woche* (Braunschweig,
 1920), cit. in Elderfield, p. 144.

8 The actual date of the photograph is uncertain and varies from publication to publication.

9 Nill elaborates the possibility of Schwitters' self-conscious appropriation of biblical texts
 and images throughout the early Merz projects. See Nill, *Decoding Merz*, 230-337.

10 Schwitters, "Manifest Proletkunst," *Das literarische Werk*, 5, p. 143; cit. Nill, p. 319.

11 *Anthologie Bonset* refers to one of Theo van Doesburg's pseudonyms, I.K. Bonset.

12 Elderfield, *Kurt Schwitters*, p. 158.

13 Stephan Lochner, *Müttergottes in der Rosenlaube*, 1440. See Otto H. Förster, Stefan
 Lochner: Ein Maler zu Köln (Prestel-Verlag K.G. München, Köln, 1941), 25. The other
 images Schwitters used in his collage do not appear to originate from this painting,
 though it is possible that they occur in other paintings by Lochner. Why this particular
 painter may have been significant to Schwitters is unclear, though images culled from
 Lochner's paintings appear in the works of Max Ernst during the early 1920s. Schwitters

was also interested in other Madonna images, using Raphael's Sistine Madonna for *Das Wenzel Kind* (1920), cit. in Nill, *Decoding Merz*. For references to Ernst, see Camfield, *Max Ernst*, p. 93 and inclusive.

14 Dietrich, *Collages of Kurt Schwitters*, p. 176.

15 Dietrich speculates that the column may be "...an Egyptian column, possibly from Karnak, or it could come from the Mesopotamian site of Persepolis. As a free-standing pillar without a fluted shaft, it is particularly reminiscent of columns popular in India in the Maurya period." See Dorothea Dietrich, *Collages of Kurt Schwitters*, p. 184.

16 Wassily Kandinsky, *Concerning the Spiritual in Art*, trans. M.T.H. Sadler (New York: Dover Publications, 1977). In the introduction to his book, Kandinsky suggests the divinity associated with the "setting up of marble"—a possible allusion to the use of the column (p. 5).

17 Nill, *Decoding Merz*, pp. 251-268.

18 Schwartz-Salant, *Jung on Alchemy*, p. 25.

19 The general chronology of the *Merzbau* is difficult to verify exactly since Schwitters used the term column to designate both aspects contained within the piece as well as the entire construction. See Elderfield, *Kurt Schwitters*, p. 147.

20 Schwitters, "Ich und meine Ziele," in *Das literarishe Werk*, 5, pp. 344-45; cit. Elderfield, *Kurt Schwitters*, p. 147.

21 This quote is from an exhibition catalogue written for an exhibition on Kurt Schwitters work. See Tokyo, Seibu Museum of Art and Museum of Modern Art, Seibu Takanawa, *Kurt Schwitters* (exhibition catalogue), 1983, p. 142; cit. Elderfield, *Kurt Schwitters*, p. 148.

22 Webster, *Kurt Merz Schwitters*, p. 270.

23 Webster, Ibid.

24 Kurt Schwitters, *PPPPPP: Poetry Performance Pieces*, p. xvii. The actual extent of the *Merzbau* has been the source of some controversy. John Elderfield claims that the project did not extend to the floor above and that the "most popularized feature of it, its phenomenal growth" has been exaggerated. Yet Elderfield does not claim to know the exact limits of the project either. See Elderfield, *Kurt Schwitters*, p. 56.

25 In a recent article on the Merzbau, Dietmar Elger refers to the latter phases of development as the "*puriste*" (purist) phase. See Dietmar Elger, *L'oeuvre d'une vie*.

26 Schwitters compared the developmental process of the Merzbau to the processes of his paintings: "Like the paintings, composed in accordance with the breaking down of the fragments of daily use (*die Brocken des täglichen Abfalls*), the construction is built up of refuse and artifacts of particular expression." Kurt Schwitters, "Ich und meine Ziele," *Das literarische Werk*, 5, p. 343. The original text is emphasized.

27 Hans Richter, *Dada: Kunst und Anti Art*; cit. Elger, "L'oeuvre d'une vie," p. 141.

28 Schwitters, "Ich und meine Ziele," in *Das literarische Werk*, 5, p. 340.

29 Webster, *Kurt Merz Schwitters*, p. 222.

30 The principle written accounts include those by Hans Richter, Kate Steinitz, and Schwitters.

31 "Ich kenne nur 3 Menschen, von denen ich annehme, dass sie mich in meiner Säule restlos verstehen werden: Herwarth Walden, Doktor S. Giedion und Hans Arp." Kurt Schwitters, "Ich und meine Ziele," p. 345. For an explanation of the reasons for Schwitters' mention of these particular individuals, see Webster, *Kurt Merz Schwitters*, pp. 222-23.

32 Schwitters, "Ich und meine Ziele," in *Das literarische Werk*, 5, pp. 344-345, trans. John Elderfield, *Kurt Schwitters*, p. 161.

33 Schwitters, "Ich und meine Ziele," *Das literarische Werk*, 5, p. 345, trans. Dietrich, *Collages of Kurt Schwitters*, p. 192.

34 Schwitters, Ibid., trans. Elderfield, Kurt Schwitters, p. 161.

35 Samuel Cauman, *The Living Museum. Experiences of an Art Historian and Museum Director*, Alexander Dorner (New York, 1958), cit. John Elderfield, *Kurt Schwitters*, p. 162.

36 Elderfield, *Kurt Schwitters*, p. 162.

37 Steinitz, *Kurt Schwitters*, p. 90.

38 Elderfield., *Kurt Schwitters*, p. 162.

39 Rudolf Jahns, quoted. in Elger, L'oeuvre d'une vie," pp. 34-35; cit. Elderfield, *Kurt Schwitters*, p. 154.

40 Hans Richter, *Dada: Kunst und Anti-Art*, p. 152; cit. Elderfield, *Kurt Schwitters*, p. 160.

41 Nündel, *Kurt Schwitters*, p. 59; cit. Annegreth Nill, Ibid., p. 22.

42 The suggestion of Schwitters' visual and literary artworks as attempts to consolidate "patterns in the midst of chaos" is made by Dorothea Dietrich. See Dietrich, Op.C.t., pp. 108-34.

43 As represented in the Heidelberg Castle, an image that Schwitters was more than likely aware of, the grottoes also designate a principle component of Rosicrucian epistemology. The city of Heidelberg, "capital" of the Palitinate and the hotbed of Rosicrucian activity, was the scene of the English Rosicrucian's incursion onto the Continent. See Frances Yates, *The Rosicrucian Enlightenment* (London: Routledge and Kegan Paul, 1972).

44 J.C.J. Metford, *Dictionary of Christian Lore and Legend*, pp. 245-246. See also Geddes MacGregor, *Dictionary of Religion and Philosophy* (New York: Paragon House, 1991), p. 621. The doctrine of transubstantiation, developed and refined by Thomas Aquinas and reaffirmed in the face of Reformers by the Council of Trent in the sixteenth century, is a much-debated aspect of Roman Catholic faith and has lead to multiple '"heretical" episodes.

45 Susan Sontag, *Under the Sign of Saturn* (New York: Anchor Books, 1991), pp. 111-113.

46 Rudolf Otto, *The Idea of the Holy: An Inquiry into the non-rational factor of the idea of the divine and its relation to the rational*, trans. John W. Harvey (London: Oxford University Press, 1958), p. 127.

47 Dietrich, *Collages of Kurt Schwitters*, p. 180. See also Oswald Spengler, *Der Untergang des Abendlandes* (*The Decline of the West*), abridged version ed. Helmut Werner, trans. Charles F. Atkinson (London: Oxford University Press, 1991.

48 Dietrich, *Collages of Kurt Schwitters*, pp. 193-194. Dietrich elaborates on the studies by Magnus Hirschfeld, founder of the Institut für Sexualforshung in Berlin in 1919. Hirschfeld specifically cited the deprivation of the soldier during the war as a cause for the increase in pathological disorders. In addition, Dietrich discusses the difficulties in male-female relationships following the war, in particular those conflicts resulting from the liberation of women amidst the retention of bourgeois conservative norms that had existed prior to the conflict.

49 Dietrich discusses Schwitters' project as a sublimation of the "theme(s) of love" into a representation of the wrongs of society. According to her, "Schwitters' caves dedicated to deviant sexuality reflect…on current obsessions and social problems. [By] placing the representation of modernity at its most abject at the core of the Merzbau and linking it to other depictions of reproduction as processes of mulilation…[Schwitters] declares modernity as a form of dismemberment and loss of identity." See Dietrich, *Collages of Kurt Schwitters*, p. 194.

50 *Der Kyffhäuser* is clearly an allusion to the twelfth-century German king and crusader Barbarossa (Friedrich I of Hohenstaufen). Over time, German conservatives saw Barbarossa as the hero of Germany's glorious past; his mythological resting place was thought to be in the Kyffhäuser mountain range in the state of Thuringia. Schwitters' cave is a reiteration, albeit a playful one given the miniature stone table, on the legend and myth of Barbarossa.

51 Dorothea Dietrich develops this particular point at some length. See Dietrich, *Collages of Kurt Schwitters*, pp. 195-196.

52 Winder McConnell, *The Nibelungenlied* (Boston: Twayne Publishers, 1984), pp. 1-2.

53 To classify Goethe as principally romantic is to misrepresent both his works and person. In many ways, the author, critic, scientist, diplomat, and artist personifies the attempt to bridge the classical and romantic in literature and the arts. See John Wolfgang von Goethe, *The Sufferings of Young Werther* and *Elective Affinities*, The German Library v. 19, ed. Victor Lange (New York: The Continuum Publishing Company, 1990). Of particular note are Thomas Mann's commentary on Goethe's contributions to the intellectual and political landscape (ibid.).

54 Elderfield, *Kurt Schwitters*, p. 161.

55 There are still other aspects of the ongoing development of the Merzbau that deserve
mention. Schwitters alluded to the profane and sacred realms in his laundry-list of the
materials and artifacts contained within the construction: there is the "submerged per-
sonal-union city of Braunschweig-Lüneberg with houses from Weimar by Feininger, the
Persil (soap) adverts, [his] design of the official emblem of the city of Karlsruhe...the
Ruhr district with authentic brown coal and authentic gas coke [a possible allusion to
the geographic and material exhaustion of Germany's industrial center]; an art exhibi-
tion with paintings and sculptures by Michelangelo and myself being viewed by a dog
on a leash; the dog kennel with lavatory and a red dog...and the Brothel with the three-
legged lady made by Hannah Höch." A work entitled *Mona Hausmann*, consisting of a
"reproduction of the Mona Lisa with the pasted-on face of Raoul Hausmann covered
over the stereotyped smile" is also mentioned. Juxtaposed to these components is an
area or sculpture (it was not clear which) entitled *Sodom and Gomorrah*, a *Madonna*, and
the *Cross of the Redeemer*. In the *Sex-Crime Cavern*, Schwitters specifically mentions a
"mutilated corpse of a young girl, painted tomato-red, and splendid votive offerings." In
addition, Schwitters has incorporated *Die heilige Bekümmernis*, which he refers to as the
"10% disabled war veteran," and the great "Grotto of Love." According to the descrip-
tion, the *100% disabled war veteran* had apparently been joined by his daughter "who has
no head but is still well-preserved." See Elderfield, *Kurt Schwitters*, pp. 160-161.

CHAPTER IV

STONE UPON STONE IS BUILDING

There is actually nothing that is totally without a deep religious undercurrent.
—Joseph Beuys

The assemblage of the project's myriad aspects, while useful, does not overcome the essential opacity of the *Merzbau*. This is not to say that the grottoes, caves, and columns are unimportant: they are essential to maintaining the project's status as a developmental organism. Yet the outcome of Schwitters' process of assemblage, exemplified by the gathering of material and artifacts in the *Merzbau*, was not intended as discrete sculptures, but represented Schwitters' pursuit of a four-dimensional matrix, an integrative field that can be likened to a rhythmic, incantatory whole. As the term *Merzbau* indicates, Schwitters sought to evidence Merz as a spatial and temporal model for architecture and urban planning, thus expanding his vision of Merz. The unveiling of the *Merzbau*'s hermeneutic content, however, requires a still broader scope of research.

On several occasions, key aspects of Schwitters' thought process were evidenced by his response to remarks made by viewers of his work. Schwitters was particularly fond of quoting Christof Spengemann's interpretation of the sculpture *Haus Merz* as a non-representational, "spiritual vision of the kind that lifts us into the infinite: absolute art...an absolute architecture" a distinction that extended his initial reading of the work as a miniature cathedral.[1] With this observation, Spengemann suggests that the small sculpture is a concrete manifestation of the spiritual in art and architecture. Spengemann's reading is commensurate with the artist's intuition of Merz: to Schwitters, the work of art, if it was an "absolute art," must be possessed of a deep spiritual or mystical force, a force that, in the moment of engagement provoked a revelatory, instantaneous 'shock.' In an article published in *Merz* 2 in 1923 entitled "i (Ein Manifest)" or "i-manifest," as it has come to be known, Schwitters discusses the 'shock-therapy' inherent in his work:

Today every child knows what Merz is. But what is i? i is the middle vowel of the alphabet and the designation for the consequence of Merz in relation to an intensive apprehension of the art form. For the shaping of the work of art Merz uses large ready-made complexes that count as the material, to shorten as much as possible the path leading from the intuition to the actualization [*Sichtbarmachung*] of the artistic idea, so as to avoid heat loss through friction. i defines this path as = o [*i setzt diesen Weg = null*] . Idea, material, and work of art are the same. i apprehends the work of art in nature. Here the artistic shaping is the recognition of rhythm and expression in a part of nature. Thus no loss through friction, i.e., no disturbing distraction during creation occurs here.[2]

Schwitters' resistance to friction, characterized as a disturbing condition that distracts from the activity of creation, suggests that such disturbances lessen, or at the very least compromise the productive energies found in natural rhythms and expression. From this perspective, the accidents and circumstances associated with the infusion of new material would be regarded as an impediment rather than an essential component of living organisms. Yet any concerted effort to resist new information and material paradoxically results in the dissolution of energies. Like alchemical and hermetic experimentation, Merz (or "i") is a process that reflects living systems, thus apprehending the work of art in nature. The artistic shaping (*Formung*) in Merz is the recognition of the terms and methods—the rhythm and expression—of living systems. At first, Schwitters' argument appears at first to be a contradiction of the terms of Merz. More likely, what Schwitters is referring to a specific source of friction, in this case the antagonisms of external criticism, an issue he struggled with while attempting to come to terms with his obvious violation of the unmediated concern for objects and representational criteria that characterized the art of much of the avant-garde.[3]

In proposing an absolute, concrete (non-representational) art, implicitly suggested the alliance of Merz with principles common to all living systems. The first of these is the recognition that art, like any form of life, is sustained by the introduction of diverse matter (*materia*) which, in its turn, produces the additional energies necessary to sustain further development. The introduction of *materia*, usually in a form that creates tension (friction) for the host, effects changes of state (the source of energy) as it is incorporated into an ever-developing field of associations and reactions. The introduction of friction in the form of diverse matter is a primary aspect of alchemical and

hermetic experimentation as well. Self-replicating systems, lacking the complexity necessary to the continued vitality of procreative, living systems, are not developmental but static.

Another aspect of Merz embedded in the "i-manifest" is the intimation of Schwitters' artistic intuition, his *Kathedrale des erotischen Elends*. According to the "i-manifest," the forming of the work of art requires "large ready-made complexes that count as the material, to shorten as much as possible the path leading from the intuition to the actualization [*Sichtbarmachung*] of the artistic idea, so as to avoid heat loss through friction." The "ready-made complexes," what may here be regarded as the *prima materia* (primary material), are the grottoes, caves, rooms and columns. Over time these constructions constituted an actualized expression of an idea that occurred through the process of gathering and assembling myriad bits of information. It is as though the processes themselves have developed a rhythm and expression, bearing an impulse that is unselfconscious and unimpeded by external pressures. In this sense, the *Merzbau*, conditioned by a specific and peculiar *Rhythmus* represents an immersive, mystical experience in which the artist (or initiate) is placed within a domain where the descriptive normative measures of space and time are missing. All that remains is the pulse, the unmediated actualization of an intuition grounded in an individual's immersive experience. What Schwitters describes in the "i-manifest" is the anonymity and spiritual generosity of (natural) love, the inherent eroticism that governs all living systems. The liberative energies of art mirror the energies begotten by the sexual act, the mark of *eros*. The *Kathedrale* is the site in which and through which the intuition of Schwitters' art, a living, erotic system, is actualized. In this sense, the artist is an anonymous mediator, an individual responsible for both the receiving and nursing of intuitive impressions until the moment of actualization, the material confluence of creative energy, is realized.

There are additional dimensions of Schwitters' Merz program that bear commenting on. One of these is the projected outcome that Schwitters intends with Merz, a program or process or idea that can be given to the world. According to Schwitters, anyone could do or 'be' Merz. In seeking an actualization of intuition, the artist is proffering a revelatory, transgressive 'shock.' This revelatory shock constitutes a spark that in turn propels a change of state (as a mystical episode induces a mystical compulsion). Akin to Thomas Kuhn's 'paradigm shift,' Merz is the actualization of an intuition that, because of the power (energy) created from the shock, propels revolution. In a distinct shift away from the more politicized avant-garde programs,

Schwitters' 'revolution' manifests itself as a liberation of spirit, a liberation that, after a period of turbulence, resonates like waves of auditory signals, across space and through time. As much as there could be a well-articulated intention, Merz, a self-perpetuating and transformative process, would, according to Schwitters, effect the inevitable—in this case a resistance to the destructive and often reactive pre-determinations of violence by turning proactively towards a universal and creative spiritual energy.4

Schwitters' view of art as an intuited spiritual enterprise reflects a view of nature that resists objectification. Setting 'i' equal to 'o' in the "i-manifest," an equation that exhibits the degree of Theo van Doesburg's influence on Schwitters' thought, connotes the diminishment of figurative (representational, measured) time and space as a criterion of judgment, a criterion that is replaced by a 'higher' form of reason, 'intuition.'5 Intuition, here equated with mystical immersion (as a governing and inscrutable reason), suggests that there lies in wait a consciousness of pure presence, a *unio mystica* (a unified whole), or God. According to the terms of alchemy and hermeticism, the zero degree efficiency of frictionless energy exchange—found at the moment of conception and thus at the infinitesimal instant when male and female become one—is distinguished by its movement towards a *unio mystica*. Like the processes associated with Merz, a 'unified whole' is itself driven by natural processes and is therefore immediately subject to dispersion, only to be gathered and reconstituted in other states and forms that, in accordance with nature's rhythms, seek the same zero-degree moment of absolution.

Thus the development and intention of Kurt Schwitters' *Merzbau* is consistent with the construction and performance of the *Merzbilder*, *Merzgedichten* and *Merz-säulen*. Mirroring Paul Klee's creative intentions ("Ingres is said to have created an artistic order out of rest; I should like to create an order from feeling and, going still further, from motion.") Schwitters' *Kathedrale* is also conceived as a formed incantation—an order of motion, albeit rendered in spatial terms. Yet it is not the mystical abstractions of pure space that Schwitters seeks, but the mystical formulations present in the assemblage of the materials themselves, a significant distinction when considering the potential relationships between mysticism and architectural space—and form.

The attempt to understand, if not apprehend, the mystical underpinnings of architectural space and form, was propelled by nineteenth-century scientific inquiries into the nature of time and space, a body of enquiry that often seemed only incidentally based in the rigors of scientific process and thought.

Schwitters' interest in considering the emotive and spiritual aspects (*Einfühlung*) of space was a prominent aspect of German avant-garde architecture in late-teens and early-twenties, in particular those artists working in hybridized modes such as dada-expressionism and dada-constructivism. Materials, structure, and space became significant components of architectural experimentation, in particular as they appeared in vernacular building traditions. The idea that order can be wrested from feeling or motion was articulated by a particular German concept laden with significant theo-philosophical biases. The word given to the concept, *Aufbau*, does not easily translate into other languages and therefore provides only limited insight into the manifold dimensions of the idea itself. As a fundamental principle in the development of the design arts in late nineteenth and particularly early twentieth century Germany, *Aufbau* reflected the search for primal origins. At the same time, invoking the concept of *Aufbau* signaled an ideological shift in art and architecture, a turning away from the received knowledge of antiquity towards a concern for principles that are usually associated with natural processes and vernacular traditions. This shift is reflected throughout German art and architecture, including the early programs of the Weimar Bauhaus, programs that, under the direction of the artistic mystic and practicing Perozoroastrian Johannes Itten and Paul Klee (in a noticeably more leavened form), betrayed characteristics closely associated with expressionist art and architecture.[6]

As above, *Aufbau*, a term that, while literally meaning "of building," alludes to the intuitive, mystical nature of the 'building art.' In English, *Aufbau* roughly translates into three words, all of which are interrelated: construction, organization, and structure.[7] Conceptually, however, the term *Aufbau* implicitly invokes the construction, organization, and structure of *living systems*. Though not disconnected from this idea, the term is also used ideologically, inferring a concern for the distinctive *Ur-grund* (original ground) of German *Kultur*. Hence, *Aufbau* suggests both living systems and the search for foundational premises. In architecture, the term recognizes the order inherent in the methods and means of construction as well as the perception of a distinctive origin and nature of German art and architecture, an art and architecture that was, in accordance with the retrospective efforts of German art historians and cultural philosophers, perceived as having vernacular Christian origins.

The German word *bauen*, from which the compound *Aufbau* originates, means not only "to build," but "to farm" or "cultivate the land." The etymology of *Aufbau* thus describes a strong affiliation with the earth and its

materials, 'common' programs such as barns and housing, and vernacular traditions of building. Rejecting academic traditions and canonical history when developing its alternative approach to the study of art and architecture, the Weimar Bauhaus self-consciously adopted *Aufbau* as its credo, even displaying its affiliation with the concept in the underlying principle for its school's title, Bauhaus or "House of Building."[8]

From this point of view, methods for constructing an edifice or work of art—material upon material, artifact upon artifact—are dependent not only on the inherent properties of the material or artifact, but on the underlying orders that structure the process. The construction of a building and the experimentation with form are equally subject to the same parameters as living systems and are therefore both resistant to and accepting of governance by mechanical means. *Aufbau* also implies the presence of the craftsman or artist, plying their trades in relative anonymity for the sake of the whole. Schwitters' Merz reflects an alliance with the principles of *Aufbau*, described as a gathering, assembling, and manipulating (*entmaterialisiert*) of materials and artifacts in order to construct an organic, living entity that continues to incrementally evolve through further incorporation, motion and development. The retention of expressionist ideals, however sublated into various other movements and ideologies, is a strong component of *Aufbau*, in particular as space, structure, and program became identified, like Merz, with matters of nature and spirit.

Schwitters' proffering of concepts resembling *Aufbau* reflects a critical difference between the program of Merz and those of other avant-garde movements with which he was affiliated. Schwitters' close relationships with Theo van Doesburg and El Lissitzky, the two artists who were most responsible for the expansion and development of Schwitters' Merz project in the twenties and thirties, are a case in point. The unadulterated precision found in the written and visual works of De Stijl founder Theo van Doesburg and the Russian constructivist El Lissitzky is not the same 'exactitude winged by intuition' that underscores the artistic endeavors of Schwitters and many other German artists."[9] This is an important distinction and one that goes a long way in comprehending the divergent mystical bias of German art and architecture. Artists who shared Schwitters' interests in rhythm and expression— Hugo Ball, Arp, and Klee among others were, like Schwitters, interested in the immersive aspects of art, the writings of the "Glass Chain," Bruno Taut's secret society of architects dedicated to the use of glass, light, and structure and a group whose ideas Schwitters experimented with, are heavily imbued with mystical ideas and attitudes.

The most significant relationships Schwitters had in this regard were with the artists who are identified with Zürich dada and the artists and architects of the Weimar Bauhaus, a program the harbored a strong dada-expressionist component during its early years in Weimar. A further indication of the general fragmentation of the dada movement, there remained areas of critical difference that informed the distinct turns artists were to take after the movement's 'demise.' While the public and private mystical episodes of Zürich dadaist Hugo Ball (Ball was a frequent participant in Cabaret Voltaire) signaled his search for refuge from the world, Arp and Klee developed an art that sought to recognize and reveal the *unio mystica* of the world, both with the hope that such a revelation would enable the redemption of humanity. Like Schwitters, they too were propelled by a 'scientific,' rigorous pursuit of art, although their approach was not mechanical or productive (as it was for several dada-constructivists and members of Neue Sachlichkeit), but was grounded in a research into living systems.[10] The world (*die Welt*) was not something from which one retreats, but a dynamic environment of "presence" that was spiritually animate and living. In this sense, the world was understood dialogically as it, in Walter Benjamin's terms, "turned its face solely and directly to them." It was therefore not as an abstraction or a simulation, but a concrete reality: nothing was hidden. Through acute observation and intuitive research (like the "serious play" of children) the physical and spiritual world, intimately bound to one another, would reveal the processes fundamental to life itself.

Schwitters, like Klee and Arp, understood that the processes that governed natural forms of life were transferable to all forms of human activity, including matters of faith, sexuality, eroticism, death, and life. Accordingly, Schwitters' comparison of his project to a *Kathedrale* is instructive. Rather than concentrating on the *representation* of a cathedral, Schwitters pursued the underlying discourse projected by the cathedrals, incorporating their hermeneutic content into the body of the *Merzbau*. Representative of a belief in the necessary and intrinsic relationship between the plane of experience on earth and the realm of the infinite, Gothic cathedrals were constructed as mirrors of life and nature, providing the stage for the dense interplay of faith, sexuality, daily life, and death, aspects of life regarded as both sacred and profane.[11] In a manner similar to the "cathedral of humanity" proposed by the Weimar Bauhaus, a Gothic cathedral did not exemplify a particular social and political order, but was instead a site for the dynamic exchange necessary to the maintenance and perpetuity of all living systems. Cathedrals, reflective

of a perceived connection between that which was above and that which is below, sought to both mediate and describe he relationship between the two through a careful rendering in stone of the construction, structure, and organization of living (organic) systems. As religious edifices devoted to the intrinsic relationship of daily life and faith, cathedrals were programmed to function *as* living systems: rather than function following form, form and function were intertwined, wedded in a unified whole.

Another aspect of the cathedrals that likely impressed Schwitters was the fact that Gothic cathedrals (and monasteries) were conceived as densely woven tapestries where idea, form, function, and construction became inseparable from one another. Thus no single thread or element could be removed without corrupting the entirety and, as a further signal of Schwitters' use of vestigial symbolic references, the whole of the cathedral, like the *KdeE*, exceeded the sum of its parts. Moreover, the excess resident in the whole was viewed not as dispensable *Abfall*, but rather constituted a necessary product of the energy expended in building, worship, life and death. This *Abfall*— ash, bodily fluids, wax, relics of the saints and their sacrificial artifacts, catacombs, tears, and exultations—all of which represented the nature of faith, were incorporated in the space and material of the cathedral. In effect, decay and degeneration were contained within the building material, thus recognizing a process similar to that of alchemy and hermeticism. These articles of faith, the *materia* that exceeds the sum of the parts, were thought of as aids to intercessions and miracles. Exhibited as excess, the evidence of miraculous transmutation such as the transubstantiation of material and mutating states of energy (glowing, disappearing and reappearing, gesturing, the blood and body of Christ, weeping human tears or bleeding from the stigmata and orifices etched on figures) would have appealed to Schwitters' pursuit of an absolute art. Schwitters' *Kathedrale*, in its incorporation of and drive towards excess, constitutes the same pursuit of energies that result from the belief in a cathedral's embodiment of all matters of spiritual faith.

As reflected in the paintings of romantic artists, the cathedral was a generalized icon that acted as a kind of talismanic device associated with not only faith, but *Innerlichkeit* (inwardness), *Einfühlung* (feeling, in the expressive, spiritual sense) and the primary antecedent of romanticism and German expressionism, German nature mysticism. In the early part of the twentieth-century, Wilhelm Worringer, a controversial German art historian and critic, published theoretical arguments promoting the significance of the Gothic imagination for German culture. In *Abstraktion und Einfühlung (Abstraction*

and Empathy) and *Formproblem der Gothik* (*Form in Gothic*), published in
1907 and 1912 respectively, Worringer revalidated the spiritual foundations of
Gothic art and architecture, an analysis that suggested that the pursuit of
mystical, organic unity and rhythm, or in Worringer's terms, the empathic
was central to German culture. Worringer's writings, along with those of
other academic historians who ventured into the realm of cultural criticism,
propelled not only academic and artistic interest in medieval Christianity, but
popular interest as well. According to Worringer, the revaluation of the
Gothic spirit would enable humanity's redemption through a "liberation of
energy" that would produce a "complete emancipation" of the German soul.[13]

According to Worringer, the question of mystical sublimation, or, as
Williams James referred to its consequence, "mystical compulsion," is the
pre-eminent condition of Gothic space.[14] In Gothic space, a space pro-
grammed for the rituals of the sacraments, mystical compulsion is associated
with the abstraction and empathy of a mystical experience, an experience
unimpeded by the mechanics and objectification of critical knowledge.
Schwitters' consideration of the *Merzbau* as a *Kathedrale*, along with the pro-
ject's characterization by others as a "mystical" enterprise, likely refers to
Worringer's suggestion that abstraction and empathy are the *Ur-grund*, the
vernacular, "primal" origin of the German soul. In Schwitters, however, the
ideological component of Worringer—the author's projection of a unique
and exclusive German identity—is inverted by the inclusive nature of Merz,
a difference that had far-reaching consequences for Schwitters during the
period in which Hitler's fascist regime was intent on defining its own
Kulturkampf (cultural struggle).

In his book entitled *The Gothic Cathedral*, Otto von Simson discusses the
peculiar nature of mystical experiences induced by cathedral spaces, experi-
ences he refers to, in the terms of late-medieval thought, as "anagogic subli-
mation." Simson's discourse is significant for its attempt to explain the spe-
cific characteristics of cathedrals, not in terms of their formal mechanisms
but according to the intentions Church fathers and their architects had for
constructing the spaces. He also discusses the inductive nature of cathedral
space, suggesting a sensibility that can best be described as *Einfühlung*.
According to Simson, the space of a cathedral, a structure that is essentially a
denial of gravity and determinate form, undermines normative categories
(measurable) of space and time by creating a spatial and temporal dimension
that, through the complex interplay of ritual, light, and structure, is immea-
surable. At the same time, the uncertainty a denial of clear boundaries engen-

ders creates a condition where the discrete differences between subjects and objects are questioned; without clearly defined objects, there can be no separate, identifiable subjects. In cathedrals, space and time are wedded to structure, construction, light, and material, while the program is structured according to the traces and orchestrations of movement that occur within an indeterminate realm of the space governed by a indefinite temporality.

Simson's observations of the experience of cathedrals are significant when considering Schwitters' *Kathedrale*. Mirroring the rhythms and expressions of living systems in both its form and program, the experience of alternative modes of space and time within the space of the *Merzbau* was an attempt by Schwitters to induce immersive, mystical episodes that would compel a new, albeit concrete reality. This condition may have been responsible for Dudelsack's feeling a "holy shudder" upon entering Schwitters' studio in 1920, a condition Schwitters would have likely tried to intensify in subsequent additions with the intention that his *Kathedrale* would create the "shock therapy" necessary to the revolutionary aims of Merz.

As the project continued to mutate and metasticize over the course of several years, the processes of Merz dictated that the grottoes, caves, columns, and rooms housed within the *Merzbau* were subject to ongoing supplementation and change. In an ironic twist, however, a number of elements in the *Merzbau*, including several of the columns and grottoes, became inaccessible, hidden under layer upon layer of paint and material. Like the labyrinths under Chartres or the further reaches of Rome's catacombs, some of the grottoes and columns disappeared altogether. Despite Schwitters' extraordinary attempts to find or in some cases manufacture whatever additional space he could to enable the project's unimpeded growth, the sheer density of material housed in the spaces, as well as the successive structuring of additional spaces dedicated to his expanding vision of Merz gradually transformed Schwitters' cathedral into something that resembled an entombment of the time and space of his autobiographical impulse: moveable columns and secret passageways only increased the compressive effect of the *Merzbau*. Over time the *Merzbau* began to even more closely recall catacombs, chambers full of reliquaries, votives and shrines dedicated to the dead. As a series of labyrinthine spaces that had no end and were perpetually in flux, Schwitters' catacombs, imbued with a reverence and far removed from the light of day, acknowledged that there were darker sides to the circle of life.

In removing components of the *Merzbau* even further from sight and in some cases closing them off altogether, they become even more deeply

immersed in the unfamiliar logic of the *KdeE*, a troubling development that suggests Schwitters is standing at the threshold of creating a distinct separation between the deliberative, private world of the *Kathedrale* and his public life, a situation attenuated by his reticence regarding the project. As though standing at the edge of a black hole, the incipient closure of the project suggested Schwitters' increasingly tenuous balance between the centripetal foment of internalized attributes, aspects of the project that represented the artist's inner turbulence, and the centrifugal force of an expanding, dynamic, and participant universe.

For the artist, however, the personal struggles the project may represent are veiled by a more general philosophical project entailing the displacement of rational objective logic with a concern for concrete reality and the generative, unselfconscious play of living systems, an idea found in Schwitters' description of his *Merzbühne* (Merz-theater) from 1920 (*fig. 33*):

> The materials for the text are all experiences that excite the brain and the emotions. These materials are not to be used logically in their objective relationships, but only within the logic of the work of art. The more intensively the work of art destroys rational objective logic, the greater the possibilities of objective form. Just as in poetry word is played off against word, so in this instance one will play off factor against factor, material against material.[15]

The use of the work of art to "destroy rational objective logic" in the pursuit of "the possibilities of objective form" is a critique of any external (reality-based) criteria being brought to bear on the work art: objective form is concrete form, a reality resulting from factor against factor, material against material. With absolute integrity (a condition of "absolute art"), the inexpressible is not represented, but rather *shows itself.* In a poem Schwitters wrote in 1934 entitled *Stein auf Stein is der Bau* (*Stone upon stone is building*) Schwitters, in what may be a description of his *Kathedrale*, uses the analogy of building to write a description of the processes of Merz:

> Stone upon stone is building.
> But not as sum, building is form.
> Building is form out of mass and space.
> The hands create the form and give it color. Though they give more: Time.
> Creating hands give to space everything the person who creates it, is:
> His world.

In the form, the play of forms, of colors, of images, of laws, yes, even of the things that are not named in the building, time lives in space for all times. Thus space becomes a parable for time and points toward eternal creation [*ewige Gestaltung*].[16]

While the poem appears to be an additional reiteration of Merz, it supplements Schwitters' previous explanations of Merz with a more detailed acknowledgment of the myriad dimensions of his project, incorporating several aspects that had previously lingered as intuitions. "Stone upon stone is building," like material upon material, artifact upon artifact, refers to the processes of Merz, processes that entail processes of building rather than purging; of assembling and manipulating (*entmaterialisert*) in order to construct an organic, living entity that is itself receptive to further incorporation, motion and development. "Stone upon stone" also suggests an underlying affiliation with the notion of *Aufbau* and thus the primitive, or vernacular traditions of art and architecture—traditions that did not view conceptual ideation as distinct from either materials or processes. The second line, "But not as sum, building is form," supports an analysis of the *Merzbau* as first a unified whole and only secondarily as a collection of artifacts and references. The fourth line, "The hands create the form and give it color." "Though they give more: Time" stands as enigmatic, though the fifth line gives rise to the interpretation that the process of working through (Schwitters' creating hands) is the tool by which the process of 'building' occurs and the revelation of the artist's world is realized. Accordingly, the revelation constitutes a redemptive act that revises and revalues time, not as history, but as a field of associations that live through and according to their responses and relationships. The idea that "space becomes a parable for time" and that it "points toward eternal creation" references both the space of a Gothic cathedral and Schwitters' *Kathedrale*. As spaces conceived of and built according to the rhythms and cycles of life and in accordance with the integrity of living systems they represent the *Ur-grund*, the organic unity of reality and spiritual faith, as they, at least from this perspective, are one and the same.

The idea that a construction or building transcends particulars in its search for an incantatory, integrated whole is similar to the philosophical tenets underlying the concept *Aufbau*. Schwitters' association with Mies van der Rohe, Walter Gropius, and Ludwig Hilberseimer (Schwitters was the first to publish Hilberseimer's work, taking up the entirety of an issue of his journal, *Merz*), and other artist-architects predisposed to absolute objectivity, was dependent upon a shared concern for the spiritual and concrete

nature of art and architecture. In Gropius and Mies, and even more clearly in the works and writings of Klee, Arp, Kandinsky, Van Doesburg, and Lissitzky, the adoption of ideas associated with *Aufbau* signaled their intentions to make art and construct buildings and cities dependent on an inextricable relationship between structure, construction, use, method, form, and material. Rhythm and expression, found in the *integritas* (relation) of the mechanics (rituals) of construction, the use of materials, structure, and functional form, are fundamental to the notion of art and architecture as a form of life (*Lebensformen*). The concrete (material) revelation of permeating spiritual enterprise indicates a merging of life and art, time and space in the *unio mystica* of absolute, objective form. For Schwitters, Arp, and Klee in particular, art and architecture are, like nature, possessed of non-hierarchical interdependencies and mutualities that insistently and perpetually evolve.

The notion of the *Merzbau* as a form of incantation is further suggested by Schwitters' assertion of the primacy of *Rhythmus* (rhythm) in his work.[17] Incantation entails a use of spells or verbal charms spoken or sung as a part of a ritual. The previously cited "i-manifest" exemplifies Schwitters' understanding of the importance of rhythm in art and nature. Here artistic shaping depends on the recognition that rhythm and expression are intrinsic parts of nature: rhythm is the underlying pulse, the constant, subtle meter of a life-force. Friction on the other hand is a condition that corrupts the movement or fluctuation marked by the regular recurrence or natural flow of related elements. Thus, the work of art—contingent as it is on the natural, unmediated flow of events between intuition and actualization—is only realized unequivocally if there is "no loss through friction, i.e., no disturbing distraction during creation." The middle vowel sound (*Klang*) in the alphabet, "i" is the simplest and most minimal *Vokal* (vowel) and is thus inherently resistant to friction. Thus "i" suggests the rhythmic function of an echo effect, an effect that diffuses over time and is therefore progressively less subject to the embattled corruption of its energy through friction.

In the formation of the work of art, friction can manifest itself in any number of ways: through adverse criticism (to which Schwitters was especially sensitive) and perhaps more to the point, through the deliberation of a rationalizing mind. By definition, the flow of associations that characterizes intuition is contrary to the refining thrust of the cognitive logic. Always in flux, "i" is the momentary revelation afforded by 'intuition being actualized' in the instant of work of art's reception and consequent "revelation." The imposition of reason is undermined by the well-springs that mark the focal

vision of intuitive consciousness, a mystical state that performs seemingly of its own accord. Instrumental, cognitive logic, thinking processes adverse to creative production and mystical immersion, is at the core of Schwitters' problem with works of art that are predetermined according to a specific idea. To him, art that pays homage to conceptual logic is based on externally generated rules and principles and thus centripetal and exclusive, even decorative, while a work of art that comes into being according to its own laws is expansive, self-evident, and inclusive. Accordingly, if the work of art represents something other than itself, or if the intention of the artist stands outside the inevitable *Formung* inherent in the play of associations, the rhythms embedded in the work, the work of art that results can only be viewed in terms of its lack, that is, what it is not. This lack, the space between the idealized content and the form of the work, is the space in which Schwitters' "loss through friction" occurs. The mystical immersion that occurs when intuition is actualized does not expose a lack; on the contrary, the experience is one of the fullness of revelation. Schwitters' idea of "i" also suggests the diminishment of the individual self, the designate "I." This diffusion of self requires the rejection of the supremacy of the *cogito* (subject), as well as the subject's object, for the sake of an unimpeded union between the subject and the object.

The adoption of rhythm as the *Ur-grund* of art and life, a key component of the "i-manifest," is most prominent in Zürich dada (Schwitters' kernel-dadaists), a group whose members Schwitters counted as friends and artistic soul-mates. According to Janice Schall's interpretation of dada, "rhythm was a watch word for dada in each of its manifestations."[19] Rhythm (*Rhythnus*), in this context a term that stood for the notion of organic unity and flux in the work of art, was indicative of attempts to formulate a counterclaim to the incipient developments of modern society as a bourgeois and technocratic "machine age."[20] In Merz, Schwitters was engaged with the problem of rhythm in the work of art, proclaiming that "artistic construction is the recognition of rhythm and expression as part of nature," a proposition clearly allied with the thoughts of his contemporary and major influence, Hans Arp:[21]

Dada aimed to destroy the reasonable deceptions of man and recover the natural and unreasonable order...That is why we pounded with all our might on the big drum of dada and trumpeted the praises of unreason...Dada is for the senseless, which does not mean non-sense. Dada is senseless like nature. Dada is for nature and against art. Dada is direct like nature. Dada is for infinite sense and definite means.[22]

As reflected in Arp's declaration, nineteenth-century philologist Friedrich Nietzsche represented a primary influence. Rejecting the cognitive logic of Socratic philosophy, Nietzsche's recovery of the writings of the pre-Socratic philosopher of *dynamis* Heraclitus provided the impetus for much of the dadaist attempt to critique the fundamental foundations of Western thought. Richard Huelsenbeck encapsulates the major thrust of the Zürich group's arguments in his memoirs:

> The public has been interested mostly in what may be called the Nietzschean character of [dada]—its nihilism and its love of paradox. What the critics did not see was dada's love of vitality and its love of life. Life, as the original dada held...cannot be lived on the expectation of the permanent. The dadaist sides with Heraclitus against Parmenides. He began doing so long before Zen became fashionable; he sees life as change and motion.[23]

According to Schall, the dadaists embraced the essential paradox of evil belonging to good, destruction becoming a constituent of creation, and chaos as intrinsically bound to logos.[24] Kandinsky collaborated with Hugo Ball during the first half of 1914 on Ball's project for a new theater, a project Ball felt would provide the performative mechanism for the destruction of the artifice of reason and the concomitant creation of a new society.[25] Ball's creative impulse verged on overt mysticism, as explicated in the recall of his reading at Zürich's Cabaret Voltaire, the principle site for dada performances on June 23, 1916 (*fig. 34*). During the performance, the force of his own rhythmic incantations evidently overcame Ball. Flapping the wings of his strange costume, he had begun to conclude his presentation with his "Labada's Song to the Clouds" and the "Elephant Caravan" when, as he asserted in his published diaries *Flight Out of Time*, he became subject to an intervening emotional experience. In one of the diary's entries, Ball records the event as follows:

> The heavy vowel sequence and the plodding rhythm of the elephants have given me one last crescendo. But how was I to get to the end? Then I noticed that my voice had no choice but to take on the ancient cadence of priestly lamentation, that style of liturgical singing that wails in all the Catholic churches of East and West. I do not know what gave me the idea of this music, but I began to chant my vowel sequences in a church style like a recitative, and tried not only to look serious but [also] to force myself to be serious...Then the lights went out, as I had ordered, and bathed in sweat, I was carried off the stage like a magical bishop.[26]

The enunciation of the primacy of rhythm in art and life became the touchstone, even the battle cry for a creative activity that would be "like nature." To simulate the natural, unmediated activity of small children, to conduct oneself like primitive peoples, or live according to the terms of the natural processes, was a key component of the kernel-dadaist's aims.[27] Hans Arp in particular sought a spontaneous expression in his art, developing a method that would elicit unmediated "free forms." These forms were, according to Arp, divested of any "meaning or cerebral intention."[28] Accordingly, Arp's drawings and constructions were like nature in that they were unconscious, free of the reins of cognitive predilection and control.

Though clearly influenced by Arp, Schwitters was also interested in the more arcane theoretical pronouncements of Kandinsky, a member of the Bauhaus known for his abstract painting and mystical theories of creativity. Kandinsky's movement from his earlier Der Blaue Reiter works, the abstract mysticism recorded by his work in the twenties and thirties displays a clear shift away from intuitive, empathic paintings steeped in flowing colors and "a fairytale quality of narrative, reminiscent of his early interest in Russian folktales and mythology."[29] Like Schwitters, Arp and his Bauhaus associate Paul Klee, Kandinsky was nonetheless commited to the possibilities that existed in nature, finding inspiration in theosophy and mysticism. To this end, he regarded "the unveiling to his inner vision the 'secret soul' of all things, the cosmic unity underlying reality, the harmony of the spheres as the central mission of his art.[30] Like most artists of the period, Kandinsky migrated across several movements in his search for the 'inner force' that characterized the 'spiritual in art.' His consignment to the theories of Madame Blavatsky, Gurdieff and other Russian mystics promoted a level of abstraction and thus a resistance to the nature mysticism of Arp, Schwitters, and Klee. To Kandinsky, music, by definition non-representational, was reflected in the rhythms of nature, though in this case a nature limited to the terms of factor against factor, material against material. Militantly non-referential, Kandinsky's bypass of dada and subsequent resort to non-objective painting underscores the foundation of Kandinsky's ideals as well as the distinct differences between Russian and German mysticism.[31]

Kandinsky's relationship to Schwitters was intermittent, though Nina Kandinsky's recollection of Schwitters' *Merzbau* provides some evidence of a continuing association. Their association may have been key in signaling the beginning of Schwitters' Merz project; some of Schwitters' early paintings indicate a familiarity with Kandinsky's work during the *Blaue Reiter* period.

According to Elderfield, Schwitters' *G Expression 2, die Sonne im Hochgebirge* (*G expression 2: The Sun in High Mountains*) (1917) (*fig. 3*) is "unmistakably indebted to Kandinsky."[32] Kandinsky's own non-objective stance may have informed the development of Merz though it is unclear how direct the relationship between Kandinsky's and Schwitters' positions may have been. It is likely that during Schwitters' repeated visits to the Weimar Bauhaus he either discussed Kandinsky's pursuit of abstract, non-representational art with Kandinsky or saw the results of the Russian painter's abstract experiments in the frequent Bauhaus painting exhibitions. For a time, Kandinsky, like Schwitters, was also represented by Berliner Herwarth Walden's Sturm Gallery; the two were probably acquainted through their association with Walden in the years prior to Kandinsky's appointment in 1922 to the Weimar Bauhaus faculty. This point in particular suggests Schwitters was familiar with Kandinsky's work at the time he was self-consciously develop his own positions on art. Kandinsky's writings on art, published immediately before the war, began to reach a larger audience immediately following the war and it is probable that Schwitters became familiar with the terms of Kandinsky's argument. These writings developed a broad influence, with Kandinsky's 1914 work entitled *Concerning the Spiritual in Art* becoming a seminal event with its attempt to arrive at a theoretical formulation of art as the "expression of the soul of nature and humanity," in Kandinsky's terms the *innerer Klang* (inner sound).[33] Essentially a manifesto, Kandinsky's book maintains an orientation that suggests the influence of German romanticism's lyricism as it is subject to the abstract nature of Russian mysticism, both of which found common ground in their adaptation of vernacular Christian mysticism. The artist's overriding faith in the transcendent function of art, that it is revelatory of higher orders, along with his attempts to create a scientific approach to art, is what allowed Kandinsky to enter into his contract with Gropius during the transitional years of the Weimar Bauhaus, a move that proved instrumental to the Bauhaus' shift from expressionism and dada to constructivism.

Thus Kandinsky and Schwitters shared the belief that art constitutes a religious enterprise or, more precisely, that it is a matter of faith. Kandinsky's swerve into an increasingly cognitive approach to abstraction, however, created a tension between the two artists. Kandinsky's "science of art," seen in the use of abstract geometric figures connoting actions and reactions, suggested a divergence from his original empirical methods, a development abetted by the appropriation of Russian iconography's more abstract mysticism. Kandinsky's knowledge of music predisposed the artist to advanced theories

on space and time (including non-Euclidean and n-dimensional geometry) Kandinsky's interest in a quasi-scientific, rigorously calculated sensibility.[34] In fact, Schwitters wrote a letter to Kandinsky upon the publication of the latter's 1926 *Punkt und Linie zu Fläche: Beitrag zur Analyse der malerischen Elemente* (*Point and Line to Plane: Contribution to the Pictorial Elements*), complaining "that its theoretical approach to form was unworkable and that the artist should concentrate on recognizing natural rhythms"—a clear indication of Schwitters' continued interest in art as nature (nature's activity) and disinterested perspectives when engaging in artistic enterprise.[35]

Hugo Ball, on the other hand, found recourse in the spiritual rhythms of religious incantation. Ball's sound poetry reflected an attention to, if not an obsession with, Kandinsky's collection of sound poems, *Klänge*, an elementarist treatise that sought "the most abstract expression of sound in language."[36] Ball's dada 'manifesto,' *Die Flucht aus der Zeit* (*Flight Out of Time*), was influenced by Kandinsky's *Concerning the Spiritual in Art*, in particular Kandinsky's assertion of the spiritual interpretation of the function of art. Mirroring Kandinsky's seriousness, Ball's performances at Cabaret Voltaire in Zürich were, according to Hans Richter, characterized by an "abbé-like earnestness." Ball's tendency to formulate a priestly air (complete with the rudiments of a clerical costume), as well as his fetish-like fascination with theology, matters of spiritual faith and clerical conduct, only increased over time. As early as 1917, Ball's manic search for rhythm and spiritual expression led him to remove himself from the artistic arena in order to pursue his long sought flight out of time, a flight that required his return to the Catholicism of his youth and the further distancing of himself from all humanity for the sake of a hermetic "spiritual authenticity." The fact that the world was "falling into nothingness all around, was crying out for magic to fill its void" did not dissuade Ball from his eventual renunciation of all political and aesthetic activity. Ball finally accomplished his artistic suicide in the late-teens, resorting to a traditional approach to faith, and seeking redemption in the mechanisms of religious poetry and day-to-day struggle with the demonic forces.[37]

Hans Arp maintained a similar search for rhythm and expression in the work of art throughout his career. A close friend of Schwitters, Arp was also known for his child-like play with materials, artifacts, and correspondences between nature and art. Both artists (Schwitters and Arp) resisted the notion of art as a re-creation (representation) of nature, stating that art is nature, creative, and direct. In a statement regarding his art, Arp was adamant on this point:

We do not want to imitate nature. We do not want to re-create, we want to create. We want to create, as the plant creates its fruit and not re-create. We want to create, not indirectly, but directly. As there is no trace of abstraction in this kind of art, we call it concrete art.[38]

Accordingly, Arp was not taking a leaf "and stylizing it by extracting its 'leaf-ness': and he was certainly not reproducing patterns generated from within his own mind which have little or no direct relation to the world outside the self ... [rather, the point for Arp was] to give physical—concrete—form to the 'basic shapes' of the universe."[39]

Schwitters' use of sound poetry in the *Ursonate* is yet another example of his experiments with the inextricable relationship between rhythm and expression. Again, the meaning of words was irrelevant to Schwitters, so much so that when told a certain word sounded like a Dutch word, he became distressed that his sounds had any relationship whatsoever to a known language. Rather the relationship between the abstract sounds—metered according to sound and silence—was central to his art (*fig. 35*). Sound-poetry was by definition performative: it could not be written or read (though he did attempt to set down the parameters for several works, including the *Ursonate*), but was realized in the instant in which it is presented, an idea recorded in El Lissitzky's photograph of Schwitters performing (*fig. 36*). These instances themselves were never absolute, but were dependent on the immediacy of the conditions in which they were realized: observers, the performer, and the context. The rhythms of the sound, however structured, played off the flow of events, the circumstances in which they were expressed. The goal of the *Ursonate*—a neologism of Schwitters' that roughly translates as "primal sonata" (or "Sonata in Primitive Sounds")—was to expose the *Urbegriff* (primary concept or ground) that underlay the natural impulse of music and language. Both in practice and in play, the *Ursonate* reflected the influence of Kandinsky's mystical *innerer Klang*, an empathic condition Kandinsky and Schwitters understood as constant through time:[42]

Every work of art is the child of its age and, in many cases, the mother of our emotions. It follows that each period of culture produces an art of its own which can never be repeated. Efforts to revive the art-principles of the past will at best produce an art that is still born ... There is, however, in art another kind of external similarity which is founded on a fundamental truth. When there is a similarity of inner tendency in the whole moral and spiritual atmosphere, a similarity of ideals, at first closely pursued but later lost to sight, a

similarity in the inner feeling of any one period to that of another, the logical result will be a revival of the external forms which serve to express those inner feelings in an earlier age. An example of this today is our sympathy, our spiritual relationship, with the Primitives. Like ourselves, these artists sought to express in their work only internal truths.[43]

This idea, which finds its origin in Böhme's *Natursprache* (language of nature), asserts that spirit is manifest in the sound-producing actions of the organs of speech. According to Andrew Weeks, the "two salient corollaries of *Natursprache* are the subordination of natural, causal processes to the mystical process of meaning, and the postulation of a universal brotherhood of all peoples."[44] The resort to the *Urphänomen* (original or primal phenomenon) of speech, an idea that would be furthered by several dadaists, including Schwitters' close friend and colleague Raoul Hausmann, connotes not only a search for the mystical underpinnings of being (*Sein*), but for a language that would allow all humanity—irrespective of race or nation—to communicate as one people.[45]

Schwitters elaborated on these ideas consistently throughout the twenties. In 1924, Schwitters' "Konsequente Dichtung" ("Consistent Poetry") defined art as "inexplicable, infinite," made up of material that is "clear, unambiguous."[46] In "[Was Kunst is, wissen Sie...]" ("[What art is, you know...]"), written two years later, Schwitters essentialized the relationship between art and rhythm. He also cautioned the reader not to pursue the representational aspects of his art, but to apprehend art as a hermetic condition, developed and extant of its own terms.

> What art is, you know as well as I do: it is nothing more than rhythm. And if that's true, I don't have to burden myself with imitation or with soul, but can modestly and simply give you rhythm, in any material whatsoever: bus tickets, oil paints, building blocks, that's right, you heard me, building blocks, or words in poetry or sounds in music, or you must name it. That's why you mustn't look too hard at the material; because that isn't what it's all about. Don't look for some hidden imitation of nature, don't ask about expressions of the soul, but try, in spite of the unusual materials, to catch the rhythm of the forms and colors. This has about as much to do with bolshevism as a flapper's hairdo. It is, however, the essence of all art, i.e. that every artwork throughout history has had to fulfill this primary requirement: to be rhythm, or else it isn't art.[47]

The discussion regarding Schwitters' poetry, and more particularly the ideas of rhythm and expression in the work of art begin hint at the developmental aspects of the *Merzbau*. There are also a number of clues regarding his alternate

titles—*Kathedrale des Erotischen Elends* and *KdeE*—that emerge during the period in which he was developing the *Ursonate* and other works of sound poetry. Hence, the effaced and refined nature of the 1930 *Merzbau* (*figs. 1 and 2*) does not represent a departure from the earlier work, but an incorporative, developmental episode that sought the source of the creative impulse in the constancy of rhythms that flow through time.

NOTES

1 Elderfield, *Kurt Schwitters*, p. 114.

2 Schwitters, "i (Ein Manifest)" (1922), in *Das literarische Werk*, 5, p. 120.

3 Schwitters attempts to wrestle with the criticism of his peers and professional art critics was eventually resolved by becoming yet another 'process' that could be incorporated into the Merz productions, whereby critique became a work of art. See Nill, *Decoding Merz*, pp. 243-268 and pp. 283-316.

4 In critiquing the avant-garde, Schwitters was particularly adverse to the dictates of historical progress found in the ideological agendas of many avant-garde movements.

5 Reflected in the work and ideas of the early Bauhäusler, this idea was a guiding principle of the Weimar Bauhaus, in particular during the years 1919–1921. See Wingler, *The Bauhaus*. See also Johannes Itten, *The Art of Color: The Subjective Experience and Objective Rationale of Color* (New York: John Wiley and Sons, 1997). An associate of Schwitters through the Sturm Galerie, in Berlin, Paul Klee is of particular significance in this regard. See Paul Klee, *Notebooks Volume 1: The Thinking Eye* (London: Lund Humphries, 1956), trans. Ralph Manheim, Marcel Franciscono, *Paul Klee: His Work and Thought* (Chicago: University of Chicago Press, 1991) and particularly Carola Giedion-Welcker, *Paul Klee* (New York: Viking Press, 1952). This idea is also reflected throughout the traditions of alchemy and hermeticism. See Alexander Roob, *The Hermetic Museum* (Köln: Benedikt Taschen Verlag GmbH, 1997) [inclusive].

6 The residual affects of expressionism in Weimar resulted in accusations that the Bauhaus was a retrograde romantic institution dedicated to the vagaries of idiosyncratic creativity. At the time, these criticisms were exceedingly difficult to withstand, particularly because of the unstable political climate. In general, this is one of the most critical and instructive episodes in the history of German art and architecture. In 1919, Walter Gropius created a school and faculty that, according to its first program, would revolutionize art and architectural education. Signed by Gropius and with the consent of the faculty, its mission was to "desire, conceive, and create the new structure of the future, which will embrace architecture and sculpture and painting in one unity and which will one day rise toward heaven from the hands of a million workers like the crystal symbol of a new faith." In addition, signets created for the Weimar Bauhaus invoke images of Freemasonry and mysticism. The central tenet of the *Vorkurs* (first-year course) at the Weimar Bauhaus was simply *Bau* (building), encircled with an array of materials. *Aufbau* was also used as central principle in the discussion of pedagogical principles, appearing in Walter Gropius' statements regarding the Bauhaus program. In 1922, a new seal, designed by Oskar Schlemmer and referred to as "Constructivist Man," ushered in a new era under the aegis of "Art and Technology: A New Unity." See Wingler, *The Bauhaus*.

7 Peter Galison, "Aufbau/Bauhaus," in *Critical Inquiry*, v. 17, no. 4 (Chicago: University

of Chicago Press, 1991).

8 Schwitters was familiar with the discussions in Weimar and throughout Germany, as the turn towards an embrace of modernity and the attempt to see Germany as a part of a larger world (Europe)—the project of Weimar Germany—began to appeal to artists and in some cases to collective consciousness as well.

9 Paul Klee, *Pedagogical Sketchbook* (Bauhausbuch 2) (London: Faber and Faber, Ltd., 1953), p. 8.

10 While Schwitters' relationships to both Hugo Ball and Hans Arp are recognized as playing significant roles in his artistic development, his relationship to Paul Klee, an artist who taught at the Bauhaus in Weimar and who has a great affinity to Schwitters, is never mentioned. Klee's disciplined analysis of nature is instructive in this regard. Like Schwitters, to him nothing was hidden; all truth resided in the world of appearances.

11 Mâle, Emile, *The Gothic Image: Religious Art in France of the Thirteenth Century,* tran. *Dora Nussey* (Icon [Harpe], 1973).

12 Worringer's writings were timely, in particular for their suggestion that German Kultur was distinct in origins and substance from the rest of European culture. Worringer thus validated the nineteenth-century argument that Germany *Kultur* rests on empathic, collective desires, while the *Zivilisation* of France and its recognition of individual, constitutional rights is distinctly "un-German." See Hans Köhn, *The Mind of Germany: The Education of a Nation* (New York: Charles Scribner and Sons, 1960), pp. 49-68. See also Worringer, Wilhelm, *Form in Gothic,* trans. from the German by Herbert Read (New York: Schocken, 1967).

13 Worringer, p. 141.

14 Idem.

15 Kurt Schwitters, "Merz," in *Das literarische Werk,* 5, p. 187; trans. in *Kurt Schwitters: PPPPPP: Poems Performance Pieces,* p. xvii. See also "Merz: Für den Ararat geschrieben," in *Das literarische Werk,* 5, p. 74. An English translation of the latter is contained in the same volume of Schwitters' literary work, p. 404.

16 Kurt Schwitters, "Stein auf Stein ist der Bau," in *Das literarische Werk,* 1, p. 120; partial trans. in Kurt Schwitters, *PPPPPP: Poems Performance Pieces,* p. 240.

17 In the "i (Ein Manifest)," a piece written for *Der Sturm* (1922), Schwitters wrote, "Artistic construction is the recognition of rhythm and expression as part of nature, thus reasserting his ideas on rhythm voiced in "Merz" (1920). In his 1931 article "Ich und meine Ziele"—itself a summary of his artistic pursuits—Schwitters again asserts the primacy of *Rhythmus* (rhythm) in his process: "... but it does not depend on the means, but on the artistic evaluation of elements that develop the rhythm." (*Das literarishe Werk,* p. 342. See Schall, *Rhythm and Art in Germany, 1900–1933,* pp. 268-276, and inclusive.

18 The question of rhythm is not original to the modern imagination: both the pre-Socratics and Aristotle spoke of rhythmic life-force. According to Friedrich Nietzsche, rhythm is an empathic, pulsating life force and an alternative structure of consciousness. In his seminal work, particularly *The Birth of Tragedy*, Friedrich Nietzsche exposes the disjunction between original (primal) rhythm and cognitive rhythm.

19 Schall, *Rhythm and Art in Germany*, p. 215.

20 The constitution of dada in Zürich is far too extensive to undertake given the parameters of this book. Janice Schall's deliberation on the relevant relationships between dada and "rhythm" provides an excellent in-depth survey of the ideas present in the formulation of the "kernel-dadaists." See Schall, *Rhythm and Art in Germany*, pp. 215-277.

21 Schwitters, "i (Ein Manifest)," (1922), in *Das literarische Werk*, 5, p. 120.

22 Hans Arp, "I Became More and More Removed from Aesthetics" in *Arp on Arp: Poems, Essays, Memories*, ed. Marcel Jean, trans. Joachim Neugroschel (New York: Viking, 1948), p. 238); cit. Schall, *Rhythm and Art in Germany*, p. 245.

23 Richard Huelsenbeck, "Psychoanalytical Notes on Modern Art," (1960) in *Richard Huselenbeck, Memoirs of a dada Drummer*, ed. Hans J. Kleinschmidt (New York: Viking, 1974 (1969), p. 160; cit. Janice Schall, *Rhythm and Art in Germany*, p. 216.

24 Janice Schall, *Rhythm and Art in Germany*, p. 217.

25 Hugo Ball, diary entry, Berlin, November 1914, *in Flight out of Time*; cit. Schall, *Rhythm and Art in Germany*, p. 218.

26 It is interesting to note that Ball's mystical-Catholicism eventually became his primary focus, retreating with Emmy Hennings in late 1916 to the mountains in Ticino near Ascona where he could live a more reflective life. In 1917, Ball, acknowledging the edge of madness inherent in dada and the "fragility of his own soul," along with his girlfriend and muse Emmy Hennings withdrew from dada altogether. As he put it approximately one year after his dramatic performance, he wanted to "live as methodically as the yogis and Jesuits." His recitative chants mirrored Novalis' quasi-mystical proposition on the fundamental nature of language, restating in his diary one of Novalis' aphoristic "chants:" "Linguistic theory is the dynamic of the spiritual world;" cit. Schall, *Rhythm and Art in Germany*, p. 228.

27 Schall, *Rhythm and Art in Germany*, pp. 246-253.

28 Ibid., pp. 246.

29 H.H. Arnason, *History of Modern Art: Painting, Sculpture, Architecture* (New York: Harry N. Abrams, Inc., 1984), p. 180.

30 Steven A. Mansbach, *Visions of Totality: Laszlo Moholy-Nagy, Theo van Doesburg, El Lissitzky* (Ann Arbor: University of Michigan Research Press, 1978), p. 7.

31 Even though his works are usually presented as a clear succession of one phase displacing another, Kandinsky, like many members of his generation including

Schwitters, continued to mine various approaches to technique and subject-matter throughout the course of his career. Kandinsky's position as a faculty member at the Bauhaus (1921) probably led to Gropius' sanction of constructivism in the program, an event that was signaled by the firing of nature mystic Johannes Itten and the placement of Hungarian constructivist, Laszlo Moholy-Nagy, on the faculty.

32 Elderfield, *Kurt Schwitters*, p. 18.

33 Wasily Kandinsky, *Concerning the Spiritual in Art*, trans. of *Über das Geistige in der Kunst* by M.T.H. Sadler (New York: Dover Publications, Inc., 1977).

34 For an explanation of Kandinsky's embrace of advanced scientific theories, in particular as they provided material for the possible revision of normative formal and spatial conditions, see Linda Dalrymple Henderson, *The Fourth Dimension and Non-Euclidean Geometry in Modern Art* (Princeton: Princeton University Press, 1983). Of particular interest are the chapters one ("The Nineteenth-Century Background") and five ("Transcending the Present: The Fourth Dimension in the Philosophy of Ouspensky and in Russian Futurism and Suprematism"). Collected in Arnold Schönberg, *Wassily Kandinsky: Letters, Pictures and Documents* (London, 1984), the correspondence between Wassily Kandinsky and German composer and music theorist Arnold Schönberg, inventor of the highly abstract twelve-tone system, is instructive of Kandinsky's shift towards a cognitive abstraction he thought would reveal the absolute nature of spirit.

35 Kandinsky's book was originally published in a series of books issued by the Bauhaus as *Bauhausbuch* (*Bauhaus Book*) no. 9. Elderfield notes that it may be because of this letter that the preliminary acceptance of a draft of Schwitters' writings (most from 1926) was eventually rejected by the Bauhaus for publication in their series. This could also be due to editorial discrimination: Schwitters' writings apparently continued to maintain a dadaist stress on finding "order amidst the flux of nature"—despite the fact that he soon acknowledged that nature itself was not always as rhythmically balanced as a *Merzbilder* might demand. See Elderfield, *Kurt Schwitters*, p. 189.

36 Hugo Ball, *Flight Out of Time: A dada Diary*, ed. John Elderfield, trans of *Die Flucht aus der Zeit* by Ann Raimes (Berkeley: University of California Press, 1996), pp. 232-34.

37 Hugo Ball, *Flight Out of Time*, pp. xxxiii-xliii

38 Rex W. Last, *German dadaist Literature: Kurt Schwitters, Hugo Ball, Hans Arp* (New York: Twayne Publishers, Inc., 1973), p. 145.

39 Ibid., p. 145.

40 Kurt Schwitters, "Meine Sonate in Urlauten" ("My Sonata in Primal Sounds") (1927), in *Das literarishe Werk*, 5, pp. 288-289. Schwitters' explanation of his *Ursonate* presents the structural characteristics, as well as a prescription for its performance. The final paragraph, however, clarifies his intentions for the essay: "I have limited myself to proposing one possible version for a performer lacking imagination (*phantasielosen Vortragenden*).

I myself perform a different version each time, which allows the cadenza—as the rest of the piece is performed work for word—to sound especially alive and to create a strong countermovement to the more rigid part of the sonata. So there." (tran. Rothenberg and Joris, *PPPPPP: Poems Performance Pieces*, p. 237).

41 The *Ursonate* is actually structured in traditional sonata form. See Kurt Schwitters, "Ursonate" (1922–1932) in *Das literarische Werk*, 1, pp. 214-242. His comments regarding the structure of the Ursonate appear in "Meine Sonate in Urlauten," *Das literarische Werk*, 5, pp. 288-289.

42 Wassily Kandinsky, *Concerning the Spiritual in Art*, p. xiii (trans. intro. M.T.H. Sadler).

43 Kandinsky, *Concerning the Spiritual*, p. 1.

44 Weeks, *Jakob Böhme*.

45 This idea of a "universal brotherhood" is also reflected in the alchemical search for a panacea to relieve the sufferings of all people. See Roob, *The Hermetic Museum*, with emphasis on sections pertaining to the Order of the Rosy Cross (Rosicrucians) and Jakob Böhme.

46 Schwitters, "Konsequente Dichtung" (1924), in *Das literarische Werk*, 5, pp. 190-191: "Art is unending interpretation; material must be unique, and consistently formed."

47 Schwitters, "[Was Kunst ist, wissen Sie...]." in *Das literarishe Werk*, 5, pp. 244-245; and in Schwitters, *PPPPPP: Poems Performance Pieces*, p. 229.

CHAPTER V

MERZING LIFE, MERZING ART, MERZING LIFE

Nothing is hidden. —Ludwig Wittgenstein

The processes associated with Merz were not confined to Schwitters' art: events, circumstances and relationships were also worked on and through, "stone upon stone, material upon material," idea upon idea. Neither was the artist's revolution limited to the succession of artistic styles and practices in which he endeavored prior to his articulation of Merz. Rather, the principles and mechanics of Merz were reflected in Schwitters' sublation of the ideas and works of friends and associates throughout the course of his artistic career. This process of absorption, representative of Schwitters' tendency to fetishize the artistic ideas of his associates, was both necessary and critical to the function of Merz, seeding Merz with new energies that left both Schwitters' artistic project and the respective projects of his associates significantly altered.

Schwitters' merzing of life and art is manifest in the transformation of the *Merzbau* into a whitened and fluid spatial edifice—what is evidently the concluding phase of the Hannover *Merzbau*—in the late-twenties and early-thirties. In a series of well-known photographs taken in 1930 and 1932, the evidence of so important to the earlier phases of the construction is absent (*figs. 37 and 38*). Photographs of the *Merzbau* taken only two years prior display the marked characteristics of the early *Merzbilder*, processes and materials that anticipate none of the project's future *puriste* quality. The only exception to this is the *Gold Grotto*, an aspect of the project that harbors the dense flush of artifacts apparent in the earlier phases of the *Merzbau*. (*fig. 39*) Signaling the primary hermetic tract of turning dross (lead) into gold, the *Gold Grotto* is the most potent example of Schwitters' appropriation of alchemical ideals and processes within the domain of the *KdeE*.[1]

These views of the *Merzbau* demonstrate the principles of Merz. What at first glance appears to be yet another edition of the 1923 column, rendered in the sharp contrast of *noir* images, could be yet another baby-doll assemblage

made up from the artist's vast collection of children's toys. It is also possible that the assemblage is made up of remnants of the earlier column, a worked through version of the memorial upon which the death-mask of his infant son was placed. The original base, replete with materials and artifacts at the base and along the 'shaft' of the piece is now devoid of excess, unadulterated white surfaces and volumes denoting the same *puriste* forms of the overall project. Schwitters' description of the doll and its context as a "big twisted-around child's head with the syphilitic eyes... warning the embracing couple to be careful" may be autobiographical, containing important clues to the underlying motives for creating the small assemblage, or could perhaps refer to external events—or both.[2]

"Constructivist," "constructivist-inspired," and "purist" are the terms commonly used to describe the images of the *Merzbau* Schwitters recorded in 1930 and 1932. Though at least partially the result of situating the work within a coherent stylistic context, the formal connotations noted by critics should not be read as the mannered appropriation of stylistic or formalist references. As a well-traveled, educated, and deliberative artist, Schwitters was undoubtedly aware of the ramifications of the form and material he chose to work with. He was also conscious of the myriad and diverse contexts that condition natural processes, referenced by his underlying ethos that art, like nature, must be developmental and incorporative in order to maintain its function as a form of life.

Though it is possible to see the latter phases of the *Merzbau* as constructivist, it is also possible to view the project in terms of Schwitters' expressionist phase: the plastic and fluid cave-like forms—a type of three-dimensional impasto—are reminiscent of the emotive turbulence of expressionist painting, albeit reconstituted in a purified, abstract state. Schwitters, in describing his *Kathedrale des Erotischen Elends* in "Ich und meine Ziele," stated that the project resembled a Cubist construction (*kubistische Gemälde*) or Gothic architecture (*Gothik* or *gothische Architektur*)—references that could not be more different (though any assertion of the critical differences between Cubism and Gothic architecture would probably not have bothered Schwitters in the least).[3] Moreover, the designation of the project as a cathedral lends further credence to the view that Schwitters' underlying motive was both spiritual and psychological. Thus the material, formal, and literary evidence contained within the *KdeE* was secondary to the processes and practices of Merz, practices that supercede the project's nominal particulars in order to pursue a *unio mystica*. The *Merzbau*, a 'concrete' and non-represen-

tational work of art, was a living, organic unity, the meaning of which was simultaneous with its appearance. Schwitters' appropriation of fluid forms, complicated constructions that efface the dense profusion of growth that lay beneath, actually maintain and in some ways clarify the essential nature of the project.

Embedded in any geometric configuration is a reciprocity, an energy exchange made explicit by the juxtaposition of one element to another. Over time, the exchange accelerates in intensity, producing an increase in energy and turbulence that results in a flow or flows characteristic of ongoing change. Utilizing fluid geometries, Schwitters expresses the internal logic of the project, thus acknowledging the basic 'forms' of the universe as organic, developmental processes rather than fixed static and self-sufficient entities. The *Merzbau* reflects the flow of events and materials that foment the exchange of energy denotive of sexual communion—alchemy's necessary spark that signals the joining of two different, albeit mutual, elements into a single, productive organism. In Schwitters, the increased turbulence and intensity that ensues during creative action is akin to the birth process, an issuance of intuition that has reached its moment of actualization (*Sichtbarmachung*). In the terms of Merz, this is accomplished through *Formung* and *Entformung*. Like all natural processes, energy is begotten in conflict and sublation, the result being the transmutation of a whole which, mirroring alchemical and hermetic processes, guarantees more than a mere sum of parts.

Given the artist's preoccupations with nature and mysticism, the idea of flow or fluidity also signals the abiding influence of Jakob Böhme's *Natursprache* in Schwitters' work. In Böhme's *Aurora: The Dayspring, or Dawning of the Day in the East*, the rhythmic constants of flowing, made up of seven attributes, (dry, sweet, bitter, hot, love, sound, and corpus), comprise the corporeality of things, with corpus becoming one with spirit.[4] Accordingly, the concrete manifestation of spirit, found in the unimpeded flow of undulating surfaces and forms, appears (is revealed) as the phenomenon (object) itself.[5] This same idea is recalled in Wittgenstein's statement on the performative nature of the ineffable cited previously, a proposition that efficiently portends the inherent falsehood of metaphysical philosophy: "There is indeed the inexpressible. This shows itself." In Böhme, the infinitesimal moment of actualization is paradoxically wedded to the flow of metamorphic change; like musical rhythms, the singular instant of a note is both conditioned by and understood in light of its operation, the immersive auratic experience

of its being performed. This is the essential value of alchemical love, whereby "freedom is reconciled with order, and the spirit-order of eternal nature is both stable and variable." To Böhme, *Natur* (nature), the *Urphänomen* that is everywhere and always present, constitutes the primal impulse of desire expressed, manifest in the "signature of things."[6] Schwitters' corollary of art and nature resonates in kind. Art, in being like nature, is the manifestation of both desire and expression in the moment of its actualization. Thus flowing forms of his *Kathedrale* become the actualized expression of desire.

In accordance with Schwitters' artistic credo, the ideas and processes that are embedded in the *Merzbau* constitute a labyrinth of associations that are by definition arrayed non-hierarchically. Rhythms and expression that resonate in the work produce a turbulent, fluid mix of possibilities. While interpretation can reveal the meaning of certain isolated components (demonstrated in the textual rendering of the grottoes, caves, and columns), Schwitters' labyrinth exists, or rather becomes according to an interconnected and unabated flow of events. Like music, these 'events' depend more on the performative aspects of the work, the temporal and spatial working through, than on the pursuit of particular formal characteristics. The formal objectivity that results from the processes of Merz constitutes the concrete reality of *Geist* (spirit). According to Schwitters, this is precisely the reason for its endless possibilities: it is not merely symbolic or representational form, but pure presence, albeit presence that reveals itself perpetually and substantively through time and space.

Given the transformation of the *Merzbau* into a decidedly spatial construction in the late-twenties and early-thirties, it is necessary to note again Ernst Schwitters' recollection of his father's method, however abbreviated in terms of the spatial and temporal sequence of the project's development:

> His pictures would decorate the walls, his sculptures standing along the walls. As anybody who has ever hung pictures knows, an interrelation between the pictures results. Kurt Schwitters, with his particular interest in the interaction of the components of his works, quite naturally reacted to this. He started by tying strings to emphasize this interaction. Eventually they became wires, then were replaced with wooden structures which, in turn, were joined with plaster of paris. This structure grew and grew and eventually filled several rooms on various floors of our home, resembling a huge, abstract grotto.[7]

While on the 1923 Holland Dada tour with Van Doesburg and Hannah Höch, Schwitters gave performances of both his play *Revolution in Revon* and

sound poem, the *Ursonate*. He also recited his famous dada-poem *An Anna Blume*. In order to further represent the development of Schwitters' project during the early-twenties, it is useful to reintroduce several of the ideas that informed his literary evolution (or revolution). These works, including *Revolution in Revon*, the *Ursonate*, and various editions of *An Anna Blume*, while a small representation of his overall literary output, elucidate the ongoing refinements of the *Merzbau*.[8]

Retaining many impulses indicative of Schwitters' flirtations with dada, the play *Revolution in Revon* exemplified his attempt to produce an integrated totality, a *Merzkunstwerk*. In order to facilitate his *Merzkunstwerk*, Schwitters created another, in this case transportable spatial and temporal 'residence' for the production of Merz, the *Normalbühne* or *Merzbühne* (Merz-theater) (*fig. 33*). The concept for the *Merzbühne*, a project that reflects the *Merzbau* in substantial ways, adopted many of the performative environmental components of Zürich-dada's famed Cabaret Voltaire, a locus for dada concerts and rituals. Schwitters, having cultivated friendships with members of Zürich dada, was clearly familiar with Cabaret Voltaire and adopted several of its modalities in the development of the play. While the play *Revolution in Revon* retained remnants of social protest, eliciting the outrage and discordance familiar to dada performance, it was not primarily a means of social protest, at least not to Schwitters; rather, like the *Merzbilder* and *Merzbau*, constituted an allegorical parable woven of personal and literary sources. John Elderfield, in describing Schwitters' *Revolution in Revon*, suggests that the play represents a watershed event, an event that resulted in critical shift in Schwitters' intentions and directions in the early-twenties. According to Elderfield, *Revolution in Revon*, a project he describes in terms similar to his portrayal of the *Merzbau*, underlines the influence of Van Doesburg and the beginnings of Schwitters' affiliation with El Lissitzky. The play also portended a more pronounced support of Zürich dada:

[*Revolution in Revon*] draws on environmental material to create a world in which the artist, as passive victim of the oppression his passivity invites, gains first attention and then omnipotence [even to causing the whole world to be changed] . . . The world it creates is one in which fantasy is given full reign, because materials drawn from the environment are rearranged and subordinated to structures drawn not from the world but from the artist's own imagination. A private and privileged environment (but one that was populated with the raw material of the outside world); a place in which "found" objects and events could be controlled and manipulated on the grandest of scales; an

insulated world that was both fantastic and formalized, and over which its creator reigned supreme: this was how Schwitters imagined his "total work of art."9

Schwitters' affiliation with Van Doesburg began during a relatively early period in the development of Merz. Markedly different in character and artistic aspirations than Schwitters (Van Doesburg's personality was considerably more caustic and his theoretical positions more resistant to the contingencies and circumstances advocated in Merz), both artists nonetheless professed a shared concern for a concrete, cosmological, and spiritual orientation to art. An essay by Van Doesburg, written in 1921 entitled "Classic-Baroque-modern," suggests the mutual ground upon which Van Doesburg and Kurt Schwitters could forge a relation: "As I [Van Doesburg] have explained in minute detail ... I replace the scheme birth, flourishing and decay with a continuous evolution. This continuous evolution [is] in life and art ... everything is in a state of continuous development."10

There were other sources of their affiliation as well. Like Schwitters, Van Doesburg had endeavored in the expressionist search for the relationship between art, nature and spirit in the beginning stages of his artistic career. As early as 1915, Van Doesburg produced a series of phonetic poems that subordinated linguistic meaning to the pure effects of sound, thereby enunciating an affiliation with the concept of *Natursprache*. He also subscribed to the notion of the artist as a messianic figure or, at the very least, a spiritual leader. To this end, Van Doesburg wrote a poem in 1916 entitled *De priesterkunstenaar* (*Priest-artist*). Dedicated to his friend, the artist Janus de Winter, the poem represents a declaration of Van Doesburg's understanding of the role of the artist in society:11

The Artist the priest who
pictures the will of the world in
shapes,
colors,
words,
sounds,
the Priest to whom,
we owe the new life.

During this period of time, Van Doesburg took on two pseudonyms, I.K. Bonset and Aldo Camini, both dadaists in orientation. As artists, Bonset and

Camini stressed the dynamic principles (*movement perpetuel*) embedded in time and space, ideas that were also of interest to individuals interested in alchemical traditions and hermeticism, including Kandinsky's advisor, the Russian mystic and author P.D. Ouspensky, author of *Tertium Organum* and a friend and philosophical mentor of the Russian artists El Lissitzky, Kasimir Malevich, and Wassily Kandinsky.[12] Time and space ("the fourth dimension") and non-Euclidean geometries were thought to indicate the inevitable linkage of science and mysticism, an idea that Van Doesburg's dadaist reformers, Bonset and Camini, were apparently quite interested in.[13]

In light of the future development of Merz, Schwitters' relationship with Van Doesburg was vital to his recognition of constructivism as a salient component of Merz. Like Schwitters and many of their colleagues, Van Doesburg's artistic orientation began to move away from expressionist and dadaist sentiments around 1920. Perhaps foreshadowed by *De priesterkunstenaar*, Van Doesburg's writings at the time exhibit his changing attitude, a shift also reflected in his embrace of modern technology and science. In his 1921 article, "Towards a Newly Shaped World," Van Doesburg sketched the rudiments for a subsequent publication entitled "Appeal for an Elementary Art," a manifesto that appeared in the October issue of his magazine *De Stijl.* Signed by Hausmann, Arp, the Hungarian dada-constructivist Laszlo Moholy-Nagy, and others within Van Doesburg's circle, the statement asserted the need to regard art as primarily the pursuit of *Stil* (style).[14]

During the period of his greatest involvement with Schwitters, Van Doesburg arrived at a critical turning point in his development, a shift that anticipated his future interest into the esoteric realms of a quasi-utilitarian mathematical mysticism. In "Der Wille zum Stil ("The Will to Style")," a lecture Van Doesburg gave in 1921 that marks the initiation of this new phase of development, he stated with his usual certainty that "elemental style could only be created by the overcoming of nature (*die Überwindung des Natürlichen*) with scientifically rigorous methods." The De Stijl manifesto "Manifesto V: - [] + = R," a document also signed by De Stijl architects Cor van Eesteren and Gerrit Rietveld, elaborated more fully Van Doesburg's Elementarist aims and objectives, objectives that sought to eliminate emotions in the production of an objective, universal language for art and architecture.[15]

When Schwitters read or was told of Van Doesburg's statement on elemental style, it is likely that he felt some cause for concern; overcoming nature was not a position he would have considered salient to Merz. Consistent with the organic and unbiased nature of Merz, however, and a

further indication of Schwitters' willingness to reconsider and address others' ideas, Schwitters almost immediately incorporated certain aspects of Van Doesburg's proposition into Merz. Thus, while the overcoming of nature, the elimination of emotions, and the use of scientifically rigorous methods appear to counter Schwitters' approach to his work, Van Doesburg's pursuit of a redemptive universal language for art, coupled with artistic autonomy, was effectively worked into various *Merzbilder* and the first issues of his *Merzheft*. In sublating ideas that stood outside or were even contrary to his own, Schwitters effectively destabilized and domesticated them, wrestling with the isolating effects of well-framed ideologies in order to reincorporate them a larger, developmental organism.

Van Doesburg's ideas were not unaffected by Schwitters either. In turn, the final tenet of Van Doesburg's 1923 "De Stijl Manifesto" (entitled "Manifesto V, no. 7"), "The time of destruction is at an end. A new age is dawning: the age of construction" is likely a result of Van Doesburg's association with Schwitters, though the correspondence between the two artists proclamations diminished somewhat as the twenties progressed.[16] At the time, Van Doesburg was also espousing Bergson's formulation of the intuitive nature of space and time, an esoteric philosophy that may have also piqued Schwitters' interest. These issues, coupled with Van Doesburg's pursuit of practical application (theory must be put to work, it must be realized and constructed), must have impressed Schwitters, in particular as they lend further credence to his artistic ethos.

On the other hand, Van Doesburg's need to "overcome nature," along with his utilitarian bent and requirement of "scientifically rigorous methods drawn from the abstract universality found in the study of mathematics, differs substantially from Schwitters' understanding of the autonomous life-forces of the work of art.[17] Accordingly, Van Doesburg's De Stijl approach remained decidedly mechanical, inorganic, and abstract, while Merz continued to mine an alternative vein in the search for "objective, autonomous art." Perhaps a result of their contrasting directions, Schwitters' became even more adamant that Merz continue to stress the concrete nature of *Geist* (Spirit). As a matter of loyalty—an aspect of the artist's character that should not be underestimated—Schwitters continued to respect Van Doesburg's program for art, granting the artist significant exposure through repeated publications of his work in his journal. The evidence of the Schwitters' loyalty extended to his creative work as well, with Schwitters paying homage to Van Doesburg by creating a rather unique *Merzbild* that draws on Van

Doesburg's stylistic predilections, albeit one rendered in a carefully *imprecise* manner in 1924 (*fig. 40*).[19]

The first issue of Schwitters' journal *Merz*, entitled *Holland Dada*, gives an indication of the depth of Schwitters' close association with Van Doesburg and Dutch dada-constructivism. Featuring the statement that "Holland ist dada" ("Holland is dada"), the issue is essentially a celebration of the De Stijl dada tour undertaken by Nelly and Theo Van Doesburg, Hannah Höch, and Schwitters, all of whom were stunned by the overwhelming and wholly unexpected support for their dada performances in Holland.[20] As in most of the issues of the journal, *Holland Dada* featured advertisements for Schwitters' various Merz productions, including the *Sturmbilderbuch IV* in which he was featured, the play *Auguste Bolte* (both the *Bilderbuch* and play were published by Herwarth Walden's Verlag der Sturm in Berlin), the poem *An Anna Blume* and a set of eight lithographs published by Steegemann under the title *Die Kathedrale* (*The Cathedral*). It also featured Theo van Doesburg's Dutch translation of *An Anna Blume* and an article by Van Doesburg on dada.

More importantly, the contents of Schwitters' *Holland dada* issue of the *Merz* contain Schwitters' clarification of his own relationship to dada, a process of public deliberation that mirrored his successive reiterations of the project. Yet the underlying themes that resonate throughout his defense—arguments that continued to be the subject of editorial debate throughout the early issues of the *Merzheft*—also indicate Schwitters' departure from dada. In one of his statements on the subject, Schwitters counsels that the death of dada is much overrated, a proposition that, in its context, is laden with irony. In addition, the artist's use of particular terms for dada, as well as his proposal that "dada ist ewig" (dada is eternal), further disclose an antagonistic view of the movement, albeit an antagonism that is nearly unrecognizable given the subtlety with which it is presented. Schwitters' 'memorandum' concerning the death of dada suggests his coming to terms with the substantive differences between Merz and dada, in particular his divergence from the programmatic aims of Huelsenbeck and Berlin dada. Signed simply "Merz," the nature of his dissent, written as a refutation for "all those who would detract from" the dada program by warning of its imminent demise, suggests with subtle irony his final resolution of the matter.

The successive issues of *Merz*, most of which were planned and written in the mid-twenties, are instructive in tracking Schwitters' interests and direction at the time: while the influence of dada remains to some degree intact, the later issues increasingly feature De Stijl and finally constructivist works. The

second issue of *Merz 2, nummer i* (*Number i*), featured the "Manifest Proletkunst," a statement assailing social organizations and political art:

> (Either) proletarian... or bourgeois art could not be universal or reflect a sense of world citizenship... The sole object of art is, by its own means, to arouse man's creative powers; its target is the mature human being, not the proletarian or the bourgeois. Only petty talents, lacking the breadth of view to see things in proportion, create 'proletarian art,' that is to say politics in pictorial form; the true artist is not bound by the specifics of social organization.[21]

Signed by Van Doesburg, Schwitters, Spengemann, and Arp, "Manifest Proletkunst," concludes with the warning that there was essentially only one choice that any one individual needed to make: either adopt dada or embrace Communist dictatorship. Eliding code words from dada and Communism (spiritual, workers) the headline statement for the issue was "Die Zeitschrift des geisitigen Arbeiters ist MERZ" ("The magazine of spiritual workers is MERZ"). The issue also contained a series of "dada notes" (*dada Nachrichten*), further explanations of Merz, and an article by De Stijl member I.K. Bonset (Van Doesburg) written in Dutch. The only illustrations were a photograph of a factory interior, Schwitters' *Merzbild: Das Kreisen*, and Van Doesburg's *Komposite 20.* the next issue *Merz 4: Banalitäten* (*Banalities*), continues its dadaist tone, but features photographs of Rietveld's renowned chair, an interiors project on which J.J.P. Oud and Van Doesburg collaborated, a sculpture by Hans Arp, and one of Moholy-Nagy's photograms. Following *Merz 4* (*Merzheftes 3* and *5* were planned but not published) *Merz 6: Jmitatoren watch step!* features one of Lissitzky's Prouns, entitled *Stadt* (city) and another painting by Mondrian.

Published in January of 1924, the seventh issue of the journal *Merz* represents the clearest dividing line between Schwitters' original affiliation with dada and his rejection of its aims. While the issue remains dadaist in tone, the format changes radically, increasing to almost twice the size of the preceding *Merzheftes*. In addition, Schwitters asserts on the front cover, "Merz is form. Form signifies deformalizing," in effect signaling that the journal will now become more an extension of Schwitters' own development and concerns rather than an organ for the dissemination of dadaist propaganda and ideas. The issue includes a reiteration of the ideas of "i-architektur" in an essay entitled "i-Madgeburg," the destination for one of his upcoming *Merzabenden* (Merz-evenings), a new *Proun* by Lissitzky, a brief literary tour

of the various *Merzabenden* that had taken place in various cities throughout Holland and Germany (including the assertion by Schwitters that every city should have one), and a photograph of a model for Walter Gropius' *Verwaltungsbau* (administration building). The last page includes advertisements for a double issue of the *Merzheft*, *Merz 8-9*, the issue Schwitters would co-edit with El Lissitzky. Perhaps anticipating the ideas for *Merz 8-9*, the centerpiece of the advertisement is a fluid sculpture, a wire diagram signed by "S. Charchoune, Bois."

Like the artistic 'revolutions' experienced by many of his friends and colleagues during the teens, Schwitters' continued development of a hybrid approach to art (some historians refer to his work as dada-Merz) was not an isolated circumstance. While many of the dadaists were drawn to surrealism in the early-twenties, just as many German dadaists began to adopt the methods and ideas of Russian constructivism. Decidedly broader in scope than many of his colleagues, Schwitters' forays into De Stijl, constructivism, Neue Sachlichkeit, as well his recognition of particular surrealist ideas, did not indicate a consignment to specific movements (there were perhaps as many constructivist and surrealist programs as there were dada programs), but represent a continuation and further clarification of his most important research, Merz.

Schwitters' relationship with El Lissitzky, a relationship that was of singular importance with respect to the *Merzbau*, was relatively inauspicious to begin with.[22] Having first made Schwitters' acquaintance at the 1922 dada-constructivist Congress in Weimar, Lissitzky, in the third issue of his constructivist organ *Veshch*, noted his general support for Schwitters and his "Merz-idée," but was at the same time critical of what he perceived as Schwitters' inability to advance beyond "what he achieved in his early works."[23] Rather than reacting negatively to Lissitzky's criticism, Schwitters immediately asked Lissitzky to come to Hannover to view his *Merzbilder* and to become further acquainted with Hannover culture.[24] It was surprisingly easy for Schwitters and Lissitzky to form a working friendship—given their respective personalities, many of Schwitters' and Lissitzky's friends found it remarkable how quickly Schwitters became a devoted advocate of Lissitzky's work. For his part, Lissitzky, though Russian, was not unfamiliar with German ideas. A significant contribution of his to the cultural landscape was Lissitzky's shepherding of Russian constructivism to the West (Germany) through exhibitions, essays, and translations.[25] Fluent in German due to his having immigrated to Germany in the teens, Lissitzky undertook the task of

translating documents from Russian to German, though his attempts to characterize Russian ideas in German did not seem to help matters. As remarked on by several critics of the translations, the subtleties necessary to the adaptation of complex and original thought became caught up in the space between the expression of concepts in one language versus the other. This problem was even more exaggerated in this case since Russian and German differ substantially in grammatical structures and linguistic roots.

Superficially, Schwitters' collaborative efforts with Lissitzky might seem to have required a departure from his own intentions. Like Van Doesburg's program for De Stijl, Lissitzky's brand of constructivism was largely geared towards the logical, precise and clear rendering of instrumental form; to several contemporary observers, Lissitzky's approach was the "exact opposite" of Schwitters'.[26] Yet the seeds of Schwitters' embrace of constructivism probably had less to do with the "logical, precise, and clear" nature of Lissitzky's art than with his perception of Lissitzky's source material, the underlying motivations and aims that supported the Russian's artistic ethos.

Lissitzky's *Prouns* provide important insight into the variable projects of constructivism, in so far as the projects, as Lissitzky concedes, can be explained in terms outside the project itself. For similar reasons to those of Schwitters', Lissitzky also undertook to define an individual research. Lissitzky's version of an individual, independent art program was given the title Proun, the artist's "project for the affirmation of the new." Like Schwitters' Merz, Proun, an acronym for "Pro-Unovis," served as a unifying and economical term for Lissitzky's manifold formal and spatial experiments. In her book on Lissitzky's ideas and work, Lissitzky's wife and life long friend of Schwitters', Sophie Lissitzky-Küppers, introduces Lissitzky's theory of Proun with a statement uncanny in its similarity to Schwitters statements regarding Merz from the same time period. Entitled "Proun: NOT world visions, BUT world reality," Lissitzky's statement was written in 1920:

> I cannot define absolutely ... for this work is not yet finished ... My aim [and] ... the meaning of the new art—is not to represent, but to form something independent of every conditioning factor. To this thing I give the independent name Proun. When its life is fulfilled and it lies down gently in the grave ... only then will this idea be defined.[27]

Reflecting the influence of both Van Doesburg and Lissitzky, Schwitters' project for a *Merzbühne*—the development and construction of which was, in turn,

of great interest to Lissitzky for the further development of his *Prounenraum* (Proun spaces)—alludes to ideas that would almost immediately become part of the material and conceptual focus in the *Merzbau* (*fig. 42*).

> Materials for the stage set are all solid, liquid and gaseous bodies, such as white wall, man, wire-entablement, waterjet, blue distance, cone of light. Use is made of surfaces, which can compress or can dissolve into meshes; surfaces which can fold like curtains, expand or shrink. Objects will be allowed to move and revolve, and lines will be allowed to expand into surfaces. Parts will be inserted into the stage set, and parts taken out. Materials for the score are all the tones and noises that violin, drum, trombone, sewing-machine, tick-tock clock, waterjet, etc. are capable of producing. Materials for the text are all experiences that stimulate the intelligence and the emotions...The parts of the set move and transform themselves, and the set lives its life.[28]

The material components and display of interactions in Schwitters' *Merzbühne* mirror the material interactions of his collages and assemblages: the elements are arrayed as discrete entities, objects, sounds, and phenomena that did not produce a coherent synthesis, but were instead presented as a series of isolated fragments of experience—entities that could not only be constructed, but could also be taken apart and reconfigured. The idea that "the parts of the set move and transform themselves" suggests the dadaist dictum that "reality is flux" while at the same time, it marks the beginnings of Schwitters search for alternatives to dadaist programs.

The *Merzbühne* demonstrates the constancy of Schwitters' belief in alchemical and hermetic enterprise, as well as his continuing interest in nature mysticism. Dependent on the mutual necessity of expression and form, the elements of the *Merzbühne*, "all solid, liquid, and gaseous bodies," reflect the dynamics of energy exchange: materials and elements are compressed, dissolved, and folded while simultaneously expanding, shrinking, moving, and revolving. Consistent with his articulations of Merz, it is not so much the structural or formal characteristics of these elements that impress Schwitters, but the animating interaction between the various materials and objects:

> Take gigantic surfaces, conceived as imaginative infinity, cloak them with color, shift them menacingly and break with vaulting their smooth bashfulness. Shatter and embroil finite parts, and twist perforating parts of night infinitely together. Paste smoothing sur-

faces over each other... flaming lines, crawling lines, expansive lines interweave. Let lines fight with each other and caress each other in generous affection... Bend the lines, break and smash angles, throttling and whirling around a point... Make lines drawing sketch a net glazing. Nets enclose, contract Anthony's torment. Cause nets to billow into flames, and dissolve into lines, thicken into surfaces. Net the nets. Make veils flutter, soft folds fall... Lift up air soft and white through thousand-candlepower arc lamps.[29]

The theater, a mechanized turbulence that could perhaps be described as an "aesthetics of chaosmos," supports Schwitters' ongoing search for the primal, generative life-force of nature. Schwitters' explanation of the *Merzbühne* is also suggestive of Abstract expressionism, in particular as it describes the kind of mystical hallucination that might be experienced when considering the phenomenal implications of quantum physics and thermodynamics. Like expressionism, the movement that anticipates mid-twentieth century abstract-expressionism, none of the elements Schwitters imagines are devoid of animate energies and emotions; nor do they exist in isolation from one another, but are part of the indeterminate mix of events which occur in the process of their interaction.

The shift of consciousness Schwitters implies in the use of dynamic, responsive elements is significant: suggesting the artist's embrace of uncertainty and flux. "Fabrics and fluids: nets, veils, folds, and flames dissolving, thickening, fluttering and falling" indicate a complex display of highly volatile, generative activity that is anything but static. The principles of Merz (*Formung* and *Entformung*), as they are realized in the *Merzbühne,* manifest the pandect of alchemy: momentary coalescence, dissolution, the insertion of occasional elements, recombinant temporal moments and spatial figures, re-informed contexts, and the ultimate revelatory shock, the spark (what Böhme refers to as the 'flash' that connotes the presence of the *Héilige Geist* [Holy Spirit]) that incites the cycle yet again.[30]

The differences between the projects of Merz and Proun did not seem to bother either artist, and in 1924 Schwitters asked Lissitzky to co-edit an issue of *Merz*, a request Lissitzky immediately accepted. Edited by both Schwitters and Lissitzky despite Lissitzky's diagnosis of tuberculosis and his subsequent remission to a Locarno sanitarium for treatment, the issue, *Merz 8-9* was published as a double issue in the spring of 1924.[31] Often referred to as the *Nasci* issue, the front cover displays in prominent red block letters a definition of nature (*Natur*), with *Nasci* defined by the co-editors as "becoming" or "being born." (*fig. 43*) Assimilated to the original Latin, the full procla-

mation read:

"Natur, from the Latin Nasci, i.e. to become or come into being, everything that through its own force develops, forms or moves"[32]

A mutual pronouncement of Schwitters and Lissitzky's affirmation of *Natur, Merz 8/9: Nasci* was an attempt by both artists to create an art that was non-representational and independent of external "conditioning factors" — critical speculation, academic traditions, and political aims. Coupled with the various images and statements contained within, *Nasci* represented the clearest delineation of Schwitters' artistic belief system to date. Several editorials, written in conjunction with Lissitzky, state that nature signified "human nature, including man's biological nature," as well, the universal human denominator that lay beneath—and was often masked by—individuality, nationality, and cultural traditions.[33] In what can only be regarded as an homage to Nietzsche's definition of the creative impulse, "man" was proclaimed to have a "natural desire to express his creativity in a controlled and logical will to form." Not coincidentally, this particular issue of *Merz* was written and published around the time that Schwitters elaborated on and performed the *Ursonate*. It was also around this time that Schwitters began to speak, albeit in circumspect terms, of his *Kathedrale*, perhaps due to Lissitzky's support for the project and their shared vision of an incorporative, "absolute art."

Ultimately, however, the contrast between Schwitters and Lissitzky's brands of mysticism is as important as their shared beliefs. While both were engaged in the pursuit of higher orders, the origin and means for either artist's journey into the realm of mysticism results in a different understanding of the role of art as a mystical enterprise. In Schwitters' artistic work, the processes of deforming and forming exhibit a direct and unmediated relationship to the *unio mystica*; the spirit of nature is reflected in regenerative processes, materials and structure, and organic integrity. For Lissitzky (and Van Doesburg), on the other hand, the abstractions of nature, reflected in the use of elemental forms, appear primarily as a Nietzschean "will to form." In contrast to Schwitters' belief in objective form (where art is as nature), Lissitzky's art is abstract and transcendent or "non-objective," and thus only tentatively connected to nature's regenerative processes.[34]

What is significant about this particular collaborative effort between Schwitters and Lissitzky is the insight it lends to both Merz and the constructivist idea, albeit through the lens of Lissitsky's specific vision for construc-

tivism, Proun. The magazine, "a word and picture book demonstrating analogies between geometric and natural forms and positing a vocabulary of vitalist and primordial elements which are seen as the bases of constructions of every kind, be they in nature, art and architecture or objects of utility (machines)," was understood as a positive reworking of dada's aims with constructivism's concern for concrete processes.[35] Conceived as a system of elemental (primary) forms so designated by the editors, these forms, in "becoming" or "being born," would elicit the "regeneration of art" as an *absolute* proposition.

Schwitters' and Lissitzky's 'elemental forms,' however, were distinct from the elemental forms of Platonic solids. Displayed boldly in one of the pictorial editorials of *Nasci*, these forms are element as an element of a sum, with one factor being an image of Dauphinéer's quartz and the other a list of scientific geometric figures, in this case a crystal, sphere, cylinders, rods, ribbons [tape], spiral, and cone. As stated in the description at the bottom half of the page, these "fundamental technical forms (*forms primitives*) of the universe [are evident] in architecture, mechanics . . . geography, astronomy, art . . . every technique (*Technik*) in the entire world (*ganzen Welt*)."[36] In this sense the embrace of the objects of utility (the machine) was not a celebration of form. The activity, the means by which an object was constructed and operated, as well as its function (utility) connoted its meaning or reason for existence.[37] To Schwitters and Lissitzky, there was a spiritual impulse, an internal force embedded in all forms of life, whether they be "nature, art and architecture or objects of utility." By definition, technology *(Technik)* was possessed of an inherent spiritual force that spoke of the primary ground *(Ur-grund)* of creative action, thus enabling the "development, forming, and moving" of *die Welt* in all its facets.

The images contained throughout *Nasci* support these ideas, showing clearly that the point of the issue was not the promotion of a particular style or movement, but an attempt to reveal the underlying motives that unified the works. Among other artworks represented in *Nasci*, there are several that lend support to the editors' view of "technological nature," a conceptual apparatus that represents an extension of their mutual pursuit of an absolute art. Among those already discussed, these include a reproduction of Kasimir Malevich's *Black Square*, one of Lissitzky's *Prouns*, one of Schwitters' *Merzbilder* and two of his graphic stamp drawings (*Stempelzeichung*), a collage by Arp, a photograph of one of Mies' skyscrapers juxtaposed to a human thighbone, Vladimir Tatlin's *Tower*, and two photographs showing natural

forms, the last of which is entitled "*?.*"[38] Taken together, the images and texts are set forth as supportive of the "fundamental [iconic] technical forms of the universe."

Added to the images by specific artists, the editors included texts and diagrams that provide insight into the fundamental nature of Merz and Proun and their affiliates, in particular as both movements are principled by the technology of *Natur*. One of these, a graphic showing a + and a - sign on either side of the symbol for infinity, represents Lissitzky's reiteration of Schwitters' zero-degree equation in the "i-manifest." (*fig. 44*) Perhaps the most important image, however, is spread across two pages of *Nasci* (*fig. 45*). Containing three iconic figures, J.J.P. Oud's temporary superintendent's house in Oud-Mathenesse of 1923, Mies van der Rohe's Glass Skyscraper project and a human thighbone, the page is pointedly designed to suggest a matrix or field of associations, associations that include not only the relationships between the specific images, but the complex relations between the participants found within the field.

While Oud's temporary house signifies Schwitters' and Lissitzky's continued affiliation with De Stijl and is particularly useful to exhibiting the 'showing' (rather than the saying) of the group's experiments, the incorporation of Mies' skyscraper juxtaposed to a thighbone promotes the fundamental substance of *Nasci*. At first glance, it appears that the editors are merely suggesting a formal or aesthetic similarity between Mies' building and the form of the bone fragment. Though undoubtedly true, it is also obvious that Lissitzky and Schwitters' intentions do not conclude with this observation. Given the collection of texts and images found in *Nasci*, there are several readings (in addition to the one above) that are portended by the juxtaposition of skyscraper and thighbone. First, the processes that elicited the architect's (Mies') technological feat are an example of objective form, form that is organic and thus logical. Second, the conceptual organization of organic processes represents a dynamic continuum that is perpetually in flux and yet maintains the integrity from which these processes arose. A model of *Aufbau*, Mies' skyscraper exemplified concrete art, wedding form and concept according to the reality or 'fact' of organic processes; the building is a function of its *Forming* (being formed) as well as a forming of its function. From this point of view, Mies' skyscraper mirrors the (re)generative forces of nature, thus pronouncing the architect's affiliation with an architectural mysticism. Consonant with the artistic projects of Lissitzky and Schwitters, the creative forces of architecture reflect the same creative

forces of forms of life. To Mies, the architect who once suggested that "God is in the details," architecture was non-representational and absolute, a spiritual and revolutionary enterprise guided by the logic of its own organic integrity.[39]

In Schwitters' mind, the vitality of modern technology depended on the fact that man was ultimately the one who had engendered technological development. Consistent with Schwitters' analysis and elevation of method, Mies' architecture was technologically and conceptually transparent. Mies, recognizing the tenets of *Aufbau*, exhibited the complicit, non-hierarchical integrity of form, use (program), material, and structure in his building, the same integrity apparent in the thighbone.

The presentation of multiple works of art in *Nasci* is indicative of the method that Schwitters had begun to develop in his *Merzbilder* and assemblages. Placed alongside one another as specific circumstances of the Merz idea, the images constitute a paratactical array that, in any number of combinations, operate as a performative field of inquiry. In this sense, Schwitters' method is similar to Walter Benjamin's theory of "dialectical images," an idea also known as "Dialectic at a Standstill [*Stillstand*]"). In 1955, Theodor Adorno explicated Benjamin's method—exemplified in Benjamin's book *Einbahnstrasse* (*One-Way Street*)—in this way:

> The fragments of *Einbahnstrasse*...are picture puzzles, attempts to conjure through parables that which cannot be expressed in words. They aim not as much to give check to conceptual thinking as to shock by way of their enigmatic form and thereby to set thinking in motion; for in its traditional conceptual form, thinking grows obdurate, appears conventional and antiquated.[40]

Schwitters' method of placing side-by-side apparently disparate approaches to the problem of art suggests a similar intention: the initiation of a conceptual shock that sets thinking in motion. The performative rudiments of Benjamin's approach, an approach that could be extrapolated from Schwitters' editorial exercises and art, are expressed in Benjamin's clarification of "Dialectics at a Standstill":

> Again and again, in Shakespeare, in Calderon, battles fill the last act, and kings, princes, attendants and followers, "enter, fleeing." The moment in which they become visible to spectators brings them to a standstill. The flight of the *dramatis personae* is arrested by the stage. Their entry into the visual field of non-participating and truly impartial per-

sons allows the harassed to draw breath, bathes them in new air. The appearance on stage of those who enter "fleeing" takes from this its hidden meaning. Our reading of this formula is imbued with the expectation of a place, a light, a footlight glare, in which our flight through life may be likewise sheltered in the presence of onlooking strangers.[41]

The series of 'forms' Schwitters and Lissitzky use to make their point also attend to an ultimate belief in art as the fashioning of a concrete poetry that both mirrors and elicits the unconscious poetry of nature. Rather than the forms themselves, it is the activity of art (defined here as Merz and/or Proun) that engenders a breaking through the obdurate thought of convention.

Thus in art as in nature subject and object are not conceived as separate entities, but are mutually bound, the manifestation of the flow of becoming through space and time, coupled with the shock of its revelation (being born). In this sense, art is not remote, contained within a gallery or studied as a course, but an active participant in the revolution of consciousness. Absolute art is revelatory, an explosion of convention and tradition that effectively redeems the entirety of the history of human consciousness at the moment of its actualization. Change is not brought about through social and political discourse and upheaval, but through a revelation of Spirit which, in turn, provides the lynch-pin for revolution. In Schwitters' work, the intimate relationship between *Formung* and *Entformung*, brought about through the activity of the artist, speaks to the processes of production, not the representational capacity of form itself. In this sense, the artist is a vehicle for that which is "becoming" or "being born." The artist, despite his immersion in the process, fades away, leaves the stage: he is the conductor of the unconscious in the conscious, not the subject of the work itself. This last point may appear to be ironic given the highly personal nature of Schwitters' work. However, in the final stages of the *Merzbau* (the photographs of which represent the purified, abstract and flowing forms), Schwitters' burial of all but a few traces of the personal, an effective blurring and compression of myriad bits of information and materials, projected his overarching belief that art, like nature, was part of the flow of experience and thus both mutable and eternal. It was an art that, according to John Elderfield, constituted an "organicist approach to Elementarist theory."

While remarks have been made about Lissitzky's influence on Schwitters, the reverse was also true. In statements regarding concepts central to Proun, Lissitzky embraces the 'shock-therapy' of Schwitters' *Merz-idée*, stating, "Every form is the frozen ... picture of a process ... a stopping-place on the

road to becoming and not the fixed goal." In addition, Schwitters' advance of typographical principles reflected throughout his *Merzheftes* undoubtedly influenced Lissitzky, who began to profess the significance of typography for constructivism. In the *Nasci* issue of *Merz*, Lissitzky published an essay on his typographical ideas, including the principles that "concepts [must be] expressed with the greatest economy ... the rhythm of the content should be reflected in the deployment of the typographical layout and vice versa, and ideas [should] be projected through visual layouts so that seeing would eventually supplant reading until, finally, an 'electro-library' would replace all libraries that contain books."[42]

It has often been suggested that it is difficult to make sense of Schwitters' overall project in light of those individuals he supported. Conversely, it is difficult to see how artists and architects as diverse as Hilberseimer, Mies, Van Doesburg, Kandinsky, Arp, and Lissitzky subscribed to Schwitters' point of view. Schwitters' relationship with Lissitzky, a primary representative of Russian constructivism (albeit according to the somewhat rarified terms of Proun) and an associate of Kandinsky, Naum Gabo, Kasimir Malevich, and Erich Buchholz, represents a significant moment in Schwitters' career, in particular because his association with Lissitzky was to have a lasting impact on the development of not only the *Merzbau* but the entire project of Merz.

A significant component of Schwitters' approach is reflected in the differences between German nature mysticism, an extension of the philosophy of Jacob Böhme, and Russian mysticism. Regarded as "the Teutonic philosopher and reformer of religious philosophy" and "*le ministère de l'homme-esprit* (the minister of man's spirit)," Böhme, the author of *Aurora* and *Die Drei Principien*, preached that innate knowledge provides "insight into the being of all being."[43] His works professed that an individual, if he or she allowed themselves to approach the world directly, could have an intuitive grasp of any number of "natural" circumstances. These circumstances included, but were not limited to, "the source of evil; the essence and laws of the universe, the origin of gravity and water, the seven wheels and seven powers of nature, the nature of the prevarication of the angels of darkness, the nature of man, and the way of reconciliation which eternal love employed to reinstate man in his rights."[44] Böhme suggested that his works would be a sign of "the final period of Christian soteriology, the time of the lilies, [the time when] Christian revelation would no longer present itself as letter, but as spiritual knowledge, as philosophy of spirit."[45] Rediscovered in the early-nineteenth century by German theologians, philosophers, and writers, the further devel-

opment and articulation of Böhme's mysticism provided ample source material for German romanticism and Idealism. Thus the medieval German mystics Meister Eckhart and Jakob Böhme became the touchstones for a general recovery of theo-philosophical ideas in German arts and letters, effecting a recovery of the separation of art, science, theology, and philosophy into distinct areas of endeavor during the final years of the Middle Ages. The consequences of these rediscoveries for nineteenth century German thought were a blurring of the distinction between human emotion (love, misery), matters of survival (life and death), the mysteries of nature, and the pursuit of the noumenal in art and philosophy.

Böhme's ideas provided ample impulse for the resurgence of mysticism in art throughout the nineteenth century, a development that continued well into the twentieth century. As Fritz Stahl suggested in his commentary on the first major exhibition of Russian constructivist art in Berlin in 1922: "In the place of the delicate color harmonies of France or the mystical strivings of Germany, the Russians have revealed a stronger movement towards a greater plasticity and spatial force." As Stahl's statement reflects, the "mystical strivings" underlying German art were not initially recognized in the work of the Russians, however profoundly Russian constructivism was interlaced with mysticism. That this mysticism was nearly unrecognizable to the Germans is not surprising since the underlying premises of Russian mysticism were substantially different from those of nature mysticism.[46]

There are other ways that Schwitters' artistic project intersected with individuals as diverse as Hilberseimer, Mies, Van Doesburg, Kandinsky, Arp, and Lissitzky. The source of much of his material, like many of the dadaists, was both literally and figuratively the city. Schwitters had even considered becoming an architect immediately following World War I, though he only completed two semesters of study at the Technical University in Hannover before resuming his artistic career.[47] He continued to maintain a significant interest in architecture throughout his life: architectural projects and programs for architecture were often featured in his *Merzheft*, and in the mid-twenties, Schwitters seriously considered starting a journal devoted entirely to architecture. In addition, there are various critical essays throughout the course of his career regarding the work of architects he supported, one of which, "Kunst und Zeiten" ("Art and Times") (1926) is particularly enlightening when considering Schwitters' overall artistic ethos.

In "Kunst und Zeiten," Schwitters states his support for, among others, Van Doesburg, Lissitzky, Mies, and Hilberseimer.[48] In an article critiquing

the Weissenhof Exhibition written for Herwarth Walden's *Der Sturm* "Stuttgart die Wohnung Werkbundaustellung" (1927), Schwitters reiterates his support for Mies, stating that, "Mies van der Rohe has designed to good effect; instead of varied, the house is straightforward and is sited correctly."[49] He also praised Hilberseimer's work, referring to his Weissenhof projects as "basic, normal, and devoid of daydreams" ("grundlich, normal, und unphantastisch").[50] In the same article, he asserts that Le Corbusier is a "romantic genius" who is not concerned with the practical effects of the machine—the opposite of Hilberseimer—while the works of the architects Peter Behrens and Hans Poelzig are "...modern in the prevailing sense," that is "trendy."[51] Hugo Häring's work is considered singularly functional ("auto-funktionel"), while Walter Gropius' house is of interest because of its use of new materials. The architecture of Mart Stam and Bruno Taut, two expressionist architects who shifted to a more pragmatic (non-objectivist) style in the twenties, were supported as well. In "Kunst und Zeiten," Schwitters expressed his view that dada represented a "mirror of the times...[it] reflected not only the old and dead part of tradition but also the new and vital." In this sense, Mies, Hilberseimer, and Gropius were, according to Schwitters, all dadaists.[52]

The development of these ideas begins to clarify Schwitters' intentions with respect to his own works, intentions that are reflected in the working through of the various stages of the *Merzbau*,[53] Still, expanding the search for Schwitters' underlying motivations in constructing the *Merzbau* requires an assemblage of not only those associations which were immediate to the construction of certain phases of the *Merzbau*—such as his relationship to Lissitzky—but the recognition of still other sources for Schwitters' project, sources that depend on recovering the essential ground of his artistic development and the subtle impulses that informed his earlier works.

NOTES

1 The transmutation of lead into gold is at the center of alchemy. See Roob, *The Hermetic Museum*, in particular notes on the Rosicrucians ('Order of the Rosy Cross').

2 Schwitters, "Ich und meine Ziele," *Das literarische Werk*, 5, p. 345 (an English translation of "Ich und meine Ziele" by Eugène Zolas entitled "CoEM" for *Transition*, 24 (July 1936) is found on pp. 423-424 in *Das literarische Werk*, 5.

3 Kurt Schwitters, Ibid.

4 See Jakob Böhme, *Aurora* (New York: Kessinger Publishing Co., 1997). See also Andrew Weeks, *German Mysticism from Hildegard of Bingen to Ludwig Wittgenstein: A Literary and Intellectual History* (Purchase: State University of New York Press, 1993).

5 Andrew Weeks, *Jakob Böhme: An Intellectual Biography of the Seventeenth Century Philosopher and Mystic* (Purchase: State University of New York Press, 1991) pp. 40-45.

6 Weeks, Jakob Böhme, pp. 78-79.

7 This quote is from a catalogue written for an exhibition on Kurt Schwitters' work. See Tokyo, Seibu Museum of Art and Museum of Modern Art, Seibu Takanawa, Kurt Schwitters (exhibition catalogue), 1983, p. 142. Cited in Elderfield, *Kurt Schwitters*, p. 148.

8 Schwitters' literary works—poems, plays, prose, manifestos, correspondence, and performance pieces—come to over 2220 hundred pages and fill five volumes. The entire collection, with the exception of the correspondence, is contained in Kurt Schwitters, *Das literariche Werk*, Bands 1-5, edit. Friedhelm Lach (Köln: DuMont Buchverlag, 1981). The correspondence is contained in the volume entitled *Wir spielen, bis uns der Tod abholt: Briefe aus fünf Jahrzehnten* (Frankfurt-am-Main: Verlag Ullstein, 1974).

9 Elderfield, *Kurt Schwitters*, pp. 103-104.

10 Van Doesburg, "The Will to Style: The new form expression of life, art and technology" (1922), in Joost Baljeu, *Theo van Doesburg* (New York: Macmillan, 1974), p.117, cited in Christina Lodder, *Russian Constructivism*, (New Haven: Yale University Press, 1983), p.13.

11 Carel Blotkamp, *De Stijl: The formative years*, trans. Charlotte Loeb and Arthur Loeb (Cambridge, Massachusetts: MIT Press, 1986), p. 27.

12 Roob, *The Hermetic Museum*, p. 655.

13 Barbara Henderson, *The Fourth Dimension and Non-Euclidean Geometry in Modern Art* (Princeton: Princeton University Press, 1983).

14 Carel Blotkamp, *De Stijl*, p. 47.

15 "Manifesto V: - [] + = R," (1923) in Ulrich Conrads, *Programs and manifestoes on twentieth-century architecture* (Cambridge, Massachusetts: MIT Press, 1971), p. 66.

16 Conrads, *Programs and manifestoes*, p. 65.

17 Schwitters did contribute to Van Doesburg's magazine *Mecano*. In addition, Van

Doesburg acted in kind, contributing pieces to Schwitters' *Merzheft* (*Merz 2*). The "Manifest Proletkunst" (Manifesto on Proletarian Art) which appeared in *Merz 2* is signed by Theo van Doesburg, Schwitters, Hans Arpt, Tristan Tzara, and Christof Spengemann. See Schwitters, *Das literarische Werk*, 5, p. 143. An English translation is recorded in LW-5, p. 413. "There is no such thing as art relating to a particular class of human beings, and, if there were, it would have no relation to life... What we on our part are striving for is the universal work of art that rises above all forms of advertisement, be they for champagne, dadaism, or Communist dictatorship." signed, et.al. The Hague, 6 March, 1923. (trans. P.S. Falla).

18 Van Doesburg's contributions are also featured in the second issue of *Merz* (nummer i) and in subsequent editions of the *Merzheft* (4, 6, 8/9), issues that include additional recognition and promotion of major other Dutch artists and architects, including literary, architectural, and visual works by Piet Mondrian, Gerrit Rietveld, and J.J.P. Oud. *Merz 3* and *Merz 5* were entirely devoted to sets of lithographs by Kurt Schwitters (*Die Kathedrale*, Merz 3) and Hans Arp (*Merz 5*). Many of the odd-numbered Merzheftes remained unpublished.

19 Other *Merzbilder* were constructed for Moholy-Nagy, Käte Steinitz, Lissitzky, Hausmann, and Walter Dexel among others.

20 Ironically, Schwitters, Hannah Höch, and the Van Doesburgs did not choose to follow a traditional dada program, with Schwitters calling it "*Immermitdenhammer*" (always with the hammer) instead. In what can only be described as another ironic twist, the group also made money on the tour. For an account of their 'tour,' see Webster, *Kurt Merz Schwitters*, pp. 128-134.

21 "Manifest Proletkunst," (*Merz 2*, nummer i), tran. in *Das literarische Werk*, 5, pp. 412-413, tran. in *Catalogue Kurt Schwitters im Exil: Das Spätwerk 1937–1948*, Austellung Marlborough Fine Art Ltd., London, 2-31 October, 1981, pp. 23-24.

22 Lissitzky had introduced his Proun theory of the environment to Hannover's Kestner Society in 1923 (an event Schwitters participated in), a gathering that resulted in not only in the friendship and collaboration of Schwitters and Lissitzky, but coincided with Schwitters'suggestion of the birthdate' for the *Merzbau*.

23 Webster, *Kurt Merz Schwitters*, p. 8: fn. 22, p. 411.

24 Elderfield, *Kurt Schwitters*, p. 131.

25 Elizabeth English's forthcoming dissertation (University of Pennsylvania, 2000) entitled *Arkhitektura i mnimosti: The Origins of "Soviet" avant-garde "Rationalist: Theory in the Russian Mystical-Philosophical and Mathematical Intellectual Tradition* details these difficulties. Her work, outlining the various forms of constructivism (including material on the impact of Russian mysticism in contrast with productivist outlooks) also illustrates the impact of various misinterpretations of constructivism on the development of the

movement in the West.

26 In her book entitled *El Lissitzky: Life, Letters, Texts,* Sophie Lissitzky-Küppers states: "The friendly, sociable Schwitters was devoted to Lissitzky, who was his exact opposite—so clear, precise and logical. He suggested to him that he edit an issue of the periodical Merz." See Sophie Lissitzky-Küppers, El Lissitzky. Life, Letters, Texts, (London: 1968), p. 36; cit. *Elderfield,* op.cit., p. 132.

27 Mansbach, *Visions of Totality,* p. 13. Mansbach quotes from Sophie Lissitzky-Küppers, *El Lissitzky: Life, Essays, Texts* (London, 1968), p. 344

28 Schwitters, "Merzbühne," (1919) in *Das literarische Werk,* 5, p. 42. See also "Die normale Bühne Merz," *Das literarische Werk,* 5, p. 202.

29 Schwitters, "Erklärungen," in *Das literarische Werk,* 5, pp. 43-44; trans. Elderfield, Kurt Schwitters, pp. 108-109.

30 Weeks, *Böhme,* p. 68.

31 While Schwitters and Lissitzky did indeed edit *Merz 8/9* together, Lissitzky had to leave Hannover for a sanitarium early in the process due to his being diagnosed with tuberculosis. However, the two editors corresponded and the issue came together as planned.

32 Kurt Schwitters and El Lissitzky, *Nasci/Natur: Merz 8-9* (Hannover, April-July 1924), front cover. Reproduced by H. Lang Verlag, Bern, 1972.

33 Mansbach, *Visions of Totality,* pp. 3-4.

34 The difference can also be demonstrated through an account of the relationship between medieval mysticism and the German language, a condition that informs the difficulty of establishing a relationship between nature mysticism and Russian mysticism for instance. philosophical and literary perspective that was, in turn, informed by German mysticism. The German language, on the other hand, is distinct from the French language. It did not correlate with Latin nor embrace the terms of scholastic philosophy; rather, the original terms of the German language are poetic. Lissitzky had immigrated to Germany in the teens and spoke fluent German. While he was responsible for bringing many of the ideas associated with Russian constructivism into the West, there were difficulties in achieving an adequate translation, a difficulty that has continued to create misinterpretations of the programs and documents of Russian constructivism.

35 Elderfield, *Kurt Schwitters,* p. 16.

36 El Lissitzky and Kurt Schwitters, *Merz 8/9 (Nasci),* v. 2, no. 8-9, April-July 1924.

37 Nill, *Decoding Merz,* pp. 260-277.

38 This is not a comprehensive inventory of works presented in *Merz 8/9.* In addition to those listed above, there are also paintings, constructions, photographs, and architecture by Mondrian, Mondrian, Archipenko, J.J.P. Oud, and Braque, among others.

39 Fritz Neumeyer discusses Mies van der Rohe's theo-philosophical perspectives in his book *The Artless Word* (Cambridge: MIT Press, 1991). The focus on the conceptual orga-

nization of organic processes and the notion of integrity is concomitant with Scholasticism's aesthetic ideals, principles to which Mies subscribed. Of particular note are pp. 145-194. Mies is also responsible for the architectural dictum "less is more," at first glance an ironic statement given his friendship with Schwitters. Further analysis, however, indicates that Mies' concern, in a direct connection to *Aufbau*, is for the general economy of building.

40 Theodor Adorno, "*Benjamins Einbahnstrasse*," in *Über Walter Benjamin* (Frankfurt-am-Main: 1970), p. 53, cit. in Richard Wolin, Walter Benjamin, p. 124.

41 Walter Benjamin, *Gesammelte Schriften*, 4(1): 143; cit. in Richard Wolin, *Walter Benjamin*, p. 124.

42 Mansbach, *Visions of Totality* p.13, quoting from *Nasci* (1924) in Lissitzky-Küppers, *El Lissitzky*, p. 347.

43 The German text reads as "*en Blick ins Wesen aller Wesen.*"

44 Ernst Benz, *The Mystical Sources of German romantic Philosophy* (*Les Sources Mystiques de la Philosophie Romantique Allemande*), tran. Blair R. Reynolds and Eunice M. Paul (Allison Park, Pennsylvania: Pickwick Publications, 1983), p. 12; cit. *Saint Martin, Le ministère de l'homme-esprit* (Paris, 1802). See also Weeks, *Jakob Böhme*, pp. 61-80 (inclusive).

45 Benz, The Mystical Sources of German romantic Philosophy, p. 11.

46 For insight into the tenets and ideas of Russian mysticism and its impact on Russian art in the late-nineteenth and early-twentieth centuries see Henderson, *The Fourth Dimension* specifically pp. 238-299.

47 Elderfield, *Kurt Schwitters*, p. 12.

48 Schwitters, "Kunst und Zeiten," in *Das literarische Werk*, 5, p. 236.

49 "...*Mies van der Rohe hat es gut berechnet, daß das bunte Haus im Gesamtilde gerade und der richtigen Stelle steht...,*" Kurt Schwitters, "*Stuttgart die Wohnung Werkbundausstellung,*" in *Das literarishe Werk*, 5, p. 286.

50 Schwitters, "*Stuttgart...,*" *Das literari sche*, 5, pp. 284-285.

51 In his book entitled *Modernism and the Posthumanist Subject: The Architecture of Hannes Meyer and Ludwig Hilberseimer*, (Cambridge: Massachusetts: MIT Press, 1992), K. Michael Hayes discusses Schwitters' affiliation with Hilberseimer specifically (pp. 225-227).

52 In issue number 7 of the *Merzhefi*—the issue immediately preceding the issue he put together with El Lissitzky and which refocused his aims—Schwitters explicitly aligns Mies van der Rohe with dada, while also explaining that artists as varied as El Lissitzky, Moholy-Nagy, Walter Gropius, and Hans Richter are all "helped by dada." See Elderfield, *Kurt Schwitters*, p. 133.

MERZING LOVE: EROTIC MISERY AND THE REDEMPTION OF KURT SCHWITTERS

Architecture is actually more like the idea of Merz than all other arts.

—Kurt Schwitters

According to Gwendolen Webster, "...the story of the *Merzbau* is one of paradox, misunderstanding, and confusion. [It] had no definite beginning and never came to an end, [and while the *Merzbau's*] outer structure had plenty of precedents in the sculpture, architecture and fantastic film sets of the twenties [it remains] a unique and baffling composition."[1] Kurt Schwitters, an artist who once answered a question about his work with the remark "It's all crap...," could be alternately pithy, elusive, and deliberately obfuscatory when discussing his *Kathedrale*.

In developing a compelling argument regarding the hermeneutic content of the piece—as this book sets out to do—it is necessary to rely on statements the artist made regarding the project, despite Schwitters' warnings against it, statements that included additional Merz productions as well. Schwitters was not only resistant to any explanation of his work, he actively thwarted critical interrogation of the piece by dissembling, recreating, or just simply forgetting key information—a tendency, whether conscious or not, that he recognized and even justified as consistent with his Merz project. For Schwitters, the facts of the project or the relevance of any intentions he may have had were demands consistent with representational work; thus they only stood to compromise the integrity of not only the work, but the entire project of Merz. Nor was the original source of the *Abfall* gathered within the *KdeE* at issue; Schwitters appeared to have little or no regard for the original circumstances or content of the refuse, thus countering speculation that the project was a protracted fetishistic essay. An "absolute art" could not, by definition, be expressed outside of or in addition to the work itself: any explanation the artist might attach to the project would concede its inadequacy as a living organism, diminishing its inherent power. Fortunately, there are additional,

albeit speculative, references that speak to the dimensions and contexts of Schwitters' *Kathedrale*, contexts representative of the intersection between external influences and the internal preoccupations of the artist. As Webster notes, the *Merzbau* "explored the gamut of the passions and preoccupations of Schwitters' age... the idea of the room as a work of art was not new [and given that] the exploration of the three-dimensional environment was such a popular topic among artists and architects... it was difficult to avoid."[2] The role of external concerns in Schwitters' art has been explored by scholars of his work, and has provided the necessary opportunity to redress the artist's contributions to the European avant-garde. Schwitters pursuit of absolute art and his consequent bias against representational form implicitly suggests that the complex social and political anxieties of the time—and there were many—did not affect either him or his work, an assertion that given the facts is highly unlikely. While there were times when Schwitters appeared to be almost naively unconcerned about external events to the point where he seemed to be unable to realize the extent to which he was in jeopardy, his statement that he was "more of his time" than politicians is indicative of a somewhat arrogant belief that he was afforded a broader perspective from which a contemporary events and circumstances appeared trivial or even irrelevant. Sometimes characterized as remote and hovering above it all, it was observed by several of his friends and colleagues that he really didn't appear to experience the anxiety appropriate to his situation, the call to action that may have actually blunted the magnitude of the tragedy he suffered.[3] Yet Schwitters may have been fundamentally incapable of realizing what was happening to the world around him in order to experience the necessary survival instinct. As the existential psychologist and philosopher Ludwig Binswanger proposed, such behavior is often a defense mechanism experienced under extreme duress, providing the individual concerned with the appearance of distanced imperviousness in the face of successive assaults on the psyche.

The question of *internal* preoccupations, however, do appear to have motivated Schwitters' artistic research. Thus there is a curious play between the gathered *Abfall*, artifacts and materials that displayed evidence of their being part of daily life, and the events and conditions that appeared to be a part of Schwitters' domestic and psychological space. When gathered together, the literal sum of autobiographical events and circumstances presents a confusing picture of disarray, an arbitrariness that mirrors the disorder of his collected refuse and often repelling those who wish to approach either the

artist or the work with due seriousness. Thus, despite the surfeit of known artifacts and activities, the body of artwork produced under the rubric of Merz, and recent additions of biographical detail, Annegreth Nill's query regarding the *Merzbau's* literary (hermeneutic) content lingers.

There are several twentiety-century writers who might provide the necessary lens to focus Schwitters' project. One writer, an individual whose life and ideas were in several important respects to Schwitters, was the philosopher Ludwig Wittgenstein. Growing up in *fin-de-siècle* Vienna, the "laboratory for world destruction" according to his contemporary, Viennese writer Karl Kraus, Wittgenstein served in the army during World War I, though he served actively while Schwitters did not. In addition, Wittgenstein also endeavored in architecture, building a house for his sister in Vienna in the thirties. The suggestion of parallels between Schwitters and Wittgenstein has been demonstrated by another author as well; Lambert Wiesing's book entitled *Stil Statt Wahrheit: über ästhetishe Lebensformen* (*Style becomes Reality: Kurt Schwitters and Ludwig Wittgenstein on the aesthetics of Forms of Life*), focuses on the relationship between their respective approaches to creative production (art), finding their ideas to be, if not the same, of a similar cast.[4]

Beginning with the *Tractatus Logico-Philosophicus* (*Treatise on Logic Philosophy*) Wittgenstein questioned the adequacy of language as a useful tool in our attempts to apprehend and therefore 'know' the world (*die Welt*). In the *Tractatus*, Wittgenstein inverts the usual approach, defining what it is and what it does—formulating the limits of language—what it does not and cannot do. According to Wittgenstein, language is not limitless, the usual intuition of its scope, but functionally limited. Arriving at the proposition that "There is indeed the inexpressible. This shows itself. It is the mystical (*das Mystische*)," the philosopher grounds language in the limits of the world: like all worldly conduct, language too is a form of life (*Lebensformen*) defined and limited by its contexts.[5] Wittgenstein's promotion of 'saying' versus 'showing' explicates the difference between, on the one hand, the embrace of metaphysics (representation) as the source of truth and, on the other, the promotion of concrete reality, including nature and its processes, as 'truths.'

The art and architecture of Merz, an idea exemplified by Schwitters' *Kathedrale* (and *Merzbühne*), resists representation. An absolute art and architecture of objective forms, Merz, like nature, is conceptually transparent and therefore non-representational. From this point of view any attempt at a linguistic analysis of architecture, an analysis that would imply a consistent grammar and thus 'proper use,' would be absurd. Accordingly, the citation or

speculation of an artwork proffered from outside the limits of its material and dimensional context, also constitutes a specious act. As Wittgenstein has shown, even language is not a fixed condition but a mutable form of life that 'means' only in the sense of communicative discourse: 'meaning' is conditioned through use. For both Wittgenstein and Schwitters, the reason ('meaning') of art and architecture is formulated according to the *Urphanomen* supporting its coming into being, a process that occurs through what Schwitters' specifically defines as forming and deforming (*Formung* and *Entformung*). Thus the reason of the object is inseparable from the object's appearance and any language used to describe a thing (whether an art work, tree, or animal) denies the complex development and play of actions, interactions, and reactions that condition its being born. Exemplified by his *Kathedrale*, 'meaning' in art and architecture resides for Schwitters in a project's discursivity, aspects of which include the project's impulse, processes of construction (*Aufbau*), and the inscription and effects of use and time (*Rhythmus*).

Art, language, and human sexuality, are all articulate dimensions of human existence and activity, the reason of any one of these does not lie outside its activity. Here, reason ('meaning') is not the idealized proposition governed by abstract logic, but instead a matter of desire and play—both of which harbor an unselfconscious interest in the pursuit of life. The transgression of boundaries, a moment or space in which separate identities co-mingle, results in the momentary suspension of measurable time. Thus transgression (Schwitters' revolution) is essential to the continued regeneration of forms of life. Indeed forms of life, intuitions that become actualized through activity, continually stress—and at times contravene—boundaries, an action vital to developing organisms. The erotic nature of human activity, a play of function and, conversely, a function of play, exacts a dynamic, organic exchange that results in the creation of new life. Death, decay, love, and life are all vital constituents in this exchange, effecting a performative economy where loss and lack are remedied through the re-incorporation of excess.

The outcomes of Schwitters' Merz are a function of both play and desire. This is particularly true of the *Merzbau*, a project that constitutes an exercise in aesthetic redemption for Schwitters. The fact that the *Kathedrale* was actively and visibly worked on over an extended period of time and thus facilitated the working through of the many events and traumas of his life. This condition is of utmost importance in determining the *Ur-grund* of Merz. As a living art, it could not be laid aside, forgotten, sold or dismantled: it demanded par-

ticipation and activity by and through its very existence. Along with its labyrinthine collection of allegorical and personal grottoes and columns hidden within the inner recesses of its precinct, the temporal complexity of the *Merzbau* reflects Schwitters' lifelong spiritual journey. The artist's *Kathedrale,* an allegorical edict of his journey, reflected the complicity of revelation and redemption, suffering and loss.

The suggestion of allegory is not incidental to Schwitters' artistic pursuits. Schwitters, often in collaboration with Käte Steinitz, was fond of writing children's stories and fables (*Märchen*), one of which, *Der Hahnepeter,* was published as an entire issue of *Merz,* thus reflecting the pervasiveness of allegory in Schwitters' literary and visual pursuits. The allegorical nature of the *Merzbau,* a narrative project that intends the recovery of a distant past in the ruins of the present, reflexively signals the foundational premise upon which the *Merzbau* rests.[6] The fabled quality of the *Merzbau,* something of a *Märchen,* further exaggerates its allegorical premise, becoming a retelling of the artist's life, as well as the lives of his friends and associates, in the form of a parable of redemption. According to Nill, " . . . it is no longer an uninhabited landscape out there in front of us that Schwitters deals with [in the *Merzbau*]. Rather, it is a landscape for living, a landscape that harbors the memory of its ideal, the Garden of Eden, paradise."[7] Accordingly, the artifacts and materials that occupied the *KdeE* were not limited to found materials, but included characters from his literature as well. Thus, "Alves Bäsenstiel," "Grünes Kind," "Anna Blume,"and the individuals and events registered by the grottoes, caves and columns comprise the material for Schwitters'allegorical construction, a project that can be construed as an attempt to rebuild the present on the ruins of a past in order to regain a sense of future's promise.

In gathering material on the generative phases of Schwitters' *Kathedrale,* it becomes clear that the project represented his attempt to grapple with his diffuse and chronic melancholy, a condition he recognized as fundamental to his personality.[8] Susan Sontag and Julia Kristeva, writers who have analyzed the melancholic nature of creative individuals, both suggest that allegory is the preferred method of writers and artists prone to the indistinct, indecisive longing for a past that did not exist (*Sehnsucht*). A fitting tribute to melancholia, allegory, imbued with a sense of the forbidden, is distinguished by the sense of having lost one's way, a sense analogous to disorientation and the loss of time. Thus allegory does not project a plan or proposal but is characterized in spatial and temporal terms as "a place where one gets lost."[9] The

melancholic's need to make whole that which has been shattered is exemplified by the haunting experience of imperceptible lack. Thus, melancholics often exhibit the obsession of "the collector," gathering and indexing to excess any number of things in a vain attempt to hold onto a world that does not appear to include them.[10]

In proposing that Schwitters' *Merzbau* is a constructed allegory created at least in part to allay his chronic depression, the subject of Schwitters' much-lamented garden of his youth resurfaces, a matter he found important enough to discuss in the autobiographical sketch he wrote for the *Sturmbilderbuch* (Sturm Yearbook). In this piece he recalls how his "little garden," located in the Dorf Isernhagen suburb near Hannover, had "roses, strawberries, an artificial mountain [and] a carved-out pond." According to Schwitters' account of the incident, neighborhood boys "before his own eyes" destroyed the garden in the spring of 1901, and as a result he was sick for two years. It is also known that Schwitters suffered from protracted bouts with epilepsy, and that he did in fact suffer from medically diagnosed depression.[11] The flowers of Schwitters' youthful garden were destroyed—and with it a world of his own creation, sending him into a state of protracted grieving and loss. His regret over the loss of his "little garden" was punctuated by an increase in spiritual and emotional sickness, including an increase in epileptic seizures ("St. Vitus' Dance"), a significant problem that resurfaced whenever Schwitters was under extreme emotional duress. Schwitters understood that his medical and spiritual condition did not disable him entirely, instead treating his illness as fortuitous. In the same *Sturm* article, he even suggested that his condition was the primary motive for his turn to art: "Because of the illness, my interests changed. I noticed my love for art."[12]

As implied in his autobiography, Schwitters' youthful play and loss were intimately bound to his notion of creative play. As an activity, creative play or production contained the seeds of liberation and recovery and was thus inherently redemptive. Even Schwitters' fabrication of a parallel Hannover "lived in reverse" (Revonnah, a name he often shortened to Revon, as in *Revolution in Revon*) was allegorical, a world that could be read either backward or forward in a way that countered the nineteenth and early twentieth century norms of temporal progress.

Reflected in *Revolution in Revon* and a fundamental component of Merz in general, Schwitters dissenting opinion of the 'truth' of historical progress was part of a wide-ranging modernist debate on the nature of time and experience. Like many of his contemporaries in the arts and abstract sciences, the

usual breaking of time into past, present, and future was arbitrary to Schwitters, even illogical. As a thing or event (in this case Revonnah) shows itself in the present, it revises both its past and future, rendering any attempts to objectively explain the past or anticipate future intellectual and spiritual developments a logical impossibility. For Schwitters, time could also be subject to merzing since all events, circumstances and particularities were always in play, part of a tapestry of life that could not be lived 'in front of us,' outside of oneself, but " . . . a landscape that harbors the memory of its ideal, the Garden of Eden, a paradise" a place and time not subject to the limits of temporality.[13]

The suggestion that the *KdeE* was mystical points in this direction as well. While the world is 'as it is,' the particularities and contingencies found in concrete existence can provide the material for immediate, if momentary, redemption. Schwitters' use of detritus and banalities, the seemingly indifferent affects of daily life, provided the substance for his explorations, explorations where there was little or no space for critical doubt. Rather, in Schwitters, as in Klee and Arp, the work of art is as child's play; a world-as-cosmos and, as such, a 'limited whole' subject only to the immediacies and particularities of its existence. In a selection from *Einbahnstrasse* (One-Way Street), an aphoristic work that resembles Schwitters' creative project, Walter Benjamin suggests a similar notion of "child's play."[14]

CONSTRUCTION SITE: Pedantic brooding over the production of objects—visual aides, toys, books—that are supposed to be suitable for children is folly. Since the Enlightenment this has been one of the mustiest speculations of pedagogues. Their infatuation with psychology keeps them from perceiving that the world is full of the most unrivaled objects for childish attention and use. And the most specific. For children are particularly fond of haunting any site where things are being visibly worked upon. They are irresistibly drawn by the detritus generated by building, gardening, housework, tailoring, or carpentry. In waste products (*Abfall*) they recognize the face that the world of things turns directly and solely to them. In using these things they do not so much imitate the world of adults as bring together, in the artifact produced in play, materials of widely differing kinds in a new intuitive relationship. . . .

Like a child at play, Schwitters haunted the site of modernity, choosing those things that "were visibly being worked upon." In *Abfall* he recognized "the face of the world of things as it turned directly and solely to him." In using 'things that had been or were visibly being worked upon,' as his mate-

rial, Schwitters did not seek to imitate or represent the world but sought to bring together in Merz, artifacts and language-games produced in accordance with the play of "materials of widely differing kinds in a new intuitive relationship." As Nündel stated, "Schwitters saw the world's refuse [as] his art," a proposition the artist affirmed in the first sentence of his article "Ich und meine Ziele": "I like to compose my paintings from the leftovers of daily refuse."[15] The *Merzbau*, suffused with endless possibilities and always under development, became not only a repository—it was a site of construction, "a place where the world of things turned directly and solely to him." A further indication of his embrace of play as an article of *Merz*, another of Schwitters' aphorisms connotes the artist's deeply held belief in play as the fundamental condition, the *Ur-grund*, of life itself: "*Wir spielen, bis uns der Tod abholdt*" (We play until death shuts the door).[16]

In child's play, one perceives the moment when "habit has not yet done its work... Once we begin to find our way about a place, [the] earliest image cannot be restored."[17] In a telling anecdote, the architect Mies van der Rohe records seeing Schwitters on a train carrying the limbs and roots of a tree. According to Mies, someone asked Schwitters what the roots were, "... and he replied that they constituted a cathedral. "But that is not cathedral, that is only wood!" the stranger exclaimed; to which Schwitters replied: "But don't you know that cathedrals are made out of wood?"[18] There are myriad inflections contained within Mies' short remembrance of the artist, some pertaining to Schwitters' imagination, some to his characteristic sense of humor and irony. Yet there is also the suggestion of Schwitters' childlike ability to transfigure what may have appeared to be useless detritus into a limited whole, a world-as-cosmos in which the play of wit and imagination, occasion and chance constituted a sea of particularities and multiplicities that resisted limits and consequently, representation.

The question of Schwitters'concern for organic unity is linked to his understanding of art as a redemptive project, what Richard Wolin refers to in his work on Walter Benjamin as Benjamin's "aesthetic of redemption."[19] Over time, the particulars of the *Merzbau* became more effaced, finally taking on the fluid crystalline appearance shown in the later photographs. Tellingly, this development occurs roughly coincident with Schwitters'pronouncements on the *Merzbau* as his "cathedral."

In 1933, Schwitters provided what is apparently a clue to a seemingly radical shift in aesthetic, beginning a *Merzbilder* that consisted of real organic growth. In a photograph contained in Schmalenbach's encyclopedic account

of Schwitters' life and work, there is indeed a frame, listed as part of the contents of the *Merzbau*, that contains the growth of some kind of organic material. An indication of its material source, Schwitters gave the small piece the title *Die Erinnergung an Molde* (*Grotto in remembrance of Mold*). In retrospect, *Die Erinnergung an Molde* appears to be a preliminary study for his last *Merzbau* project, the *Merzbarn*, the third and final attempt to continue the efforts of his original *Merzbau* (*fig. 46*).[20] Similar to the puns Schwitters was so fond of making (the title of one of his earliest sculptures, *Die heilige Bekümmernis*, constituted a pun) the title for the work also referred to Molde, Norway, a small town Schwitters retreated to with his family and the location of his first attempt to escape the events leading up to the Second World War.[21]

As if he could anticipate the future, it was to Molde that Ernst and Kurt Schwitters eventually escaped to in 1937, and the location of his attempt to build the second of three *Merzbau*s (the Oslo *Merzbau*, also referred to as the *Haus am Bakken*, or *House on a Slope*) he would attempt while in exile.[22] The stay in Norway lasted for several years, though Schwitters hoped to eventually become a permanent resident did not last. With German troops invading Norway in 1940, Ernst and Kurt Schwitters, both in jeopardy of being arrested, escaped to Great Britain in 1940. Interred in the famed Hutchinson Camp on the Isle of Man (where Kurt attempted to construct another *Merzbau* in his dormitory/studio space), both Schwitters were finally released November of 1941. After living in and around London, the artist moved to Ambleside in the Lake District in 1945, where he eventually started his third and final *Merzbau* in an area referred to as Little Langdale.

While the sum of the *Merzbau*s support his commitment to Merz, the third and final *Merzbau*, the *Merzbarn*, provides the greatest insight into the Hannover *Merzbau*. The *Merzbarn* was constructed as an inextricable part of a stone shed on the private property of an acquaintance of Schwitters', Harry Pierce. Often referred to as the *Elterwater Merzbarn*, the artist's construction was named, like his previous *Merzbau*s, for the location in which it existed. This version of the *Merzbau*, like the Oslo and Hutchinson *Merzbau*s, did not represent a starting over of the project, but was understood as a recovery and hence a successive addition to the earlier projects, with the Hannover *Merzbau* acknowledged as the origin or *Ur-grund*. As he declared often, despite his many hardships and losses, "The Spirit cannot be stopped. It can be changed, but not stopped."[23]

Appearing as a highly organic edifice of fluid forms that suggested the *Merzkunstwerk*, Schwitters' unified approach to painting, sculpture, and

architecture, the *Merzbarn* was painted to resemble the pale pink, green, and brown hues of nature. Here too, nature was "... not only forms but objects, [including] a tin can painted bright red, a piece of metal framing which encloses a miniature collage, a china egg hidden in a crevice." As Pierce observed, materials were gathered "... from wherever Schwitters could find them: stones from Langdale Beck, a rubber ball, part of a child's watering can, a hank of twine... hidden in niches were pieces of tree roots, even gentians from the garden, all contained and sheltered by a large projecting ridge of plaster."24 Like the *Merzbau*, the *Merzbarn* was inextricably adjoined to its context, with various aspects of the project extending far beyond its limited domain, assuming a relationship to areas and vistas surrounding the building as well.

As was his fashion, Schwitters began to incorporate his benefactor and associate, Harry Pierce into the project. As a character in this new version of his allegory, Schwitters suggested that Pierce, a gardener, was something of an artist himself. As Schwitters observed: "He lets the weeds grow, yet by means of slight touches he transforms them into a new composition as I create out of rubbish... the new Merz construction will stand close to nature...."25 Begun the year before Schwitters died, this final project, along with the mold, the bottle of urine, the guinea pigs, Schwitters' beloved mice and other *Abfall* and marginalia normally associated with animal and plant refuse, vital to life processes, affirms the artist's search for organic unity, a *unio mystica*, in what is revealed of the world (*Lebenswelt*).

In addressing the consistency of Schwitters' artistic program, in particular as it is expressed in the *Merzbau*, the artist's celebratory use of mold as a *prima materia* represents a case in point. Mold, from the Latin *molere* (to grind), constitutes the breakdown and transformation of organic matter into *Abfall*. Like any component of decay, it maintains the decomposition of organic life, providing the necessary soft friable earth for the genesis, maintenance, and vitality of animal and plant life; it is also defined as the surface of the earth (*die Erde*), the earth of the burying ground, and archaically, the earth that is the substance of the human body. Thus, Schwitters' *Grotto in Remembrance of Mold* can be viewed as a reissue of several themes contained within the *Merzbau*: life, death, love, decay, and rebirth. It is doubtful, however, that either Van Doesburg or Lissitzky would have embraced Schwitters' inventive use of materials and ideas.

The presence of the *Grotto in Remembrance of Mold* in the *Merzbau*, read in conjunction with the visual and material affects of the *Merzbarn*, signals

the artist's recovery of the incipient phases of the Hannover project—in effect a retrieval and therefore a 'regrinding' of material and ideas that were present in the initial months and years of Merz. As suggested in the earliest known photograph of the *Merzbau* (the view showing the 1920 Merz-column crowned with the *Leiden* bust) Schwitters' Hannover studio was disorderly, a space filled with an array of materials (objects, papers, organic material, commercial effects) that had begun to be informed by methods facilitating the "pictures that [were] nailed together."[26] What is important about this initial gathering of material is that it was exceedingly visceral or, as Webster has characterized it, "tangible." Whereas Van Doesburg, Lissitzky, and Kandinsky sought clarity and precision through the abstraction and distillation of "elemental forms," Schwitters worked with and through a vast collection of refuse and organic material that in some cases maintained a strong relationship with its original status despite the intervening processes of *Formung* and *Entformung*. Thus Schwitters' dedication to nature's processes, processes that contravene precision and mathematical exactitude, continued to be a central component of the *Merzbau*s, reaching its highest apogee in the *Merzbarn*. While the *Merzbarn* reflecting the artist's uniquely tangible approach to allegory, is undeniably useful in understanding certain conditions that underlay the Hannover *Merzbau*, other significant components of the Hannover project are sublimated by the organic processes exemplified in the short lived *Merzbarn*.[27]

As previously noted, the last photographs of the Hannover *Cathedral of Erotic Misery* show whitened sculptural forms reminiscent of Lissitzky's spatial figures. The white surfaces and unified space of the *Merzbau* should not be read as a capitulation to Lissitzky's purist iconic forms, nor is it the adoption of an editing process to guard against the transgressions and excess found in the early phases of the *Merzbau*. Rather, the white surfaces, at once recalling the pallor of death and the presence of spirit, can be thought of in terms of the ambiguous relationship between fullness and lack.[28]

In discussing the source for his 'erotic misery,' Schwitters' use of allegory afforded a veil behind which he could retreat. Given the complexities of his personal life, the *Merzbau* was not only a work of art, it was a domestic theater, a stage for the artist's inner privations as they were interwoven with the intimate substance and circumstances of his family's daily life. The subtle violence of domestic life is also found in Schwitters' cataloging of the darker side of erotic activity (Georges Bataille's *Ur-grund*), a condition that may have been exaggerated by the perversions of the *Lustmord* ("desire death") phe-

nomenon in Germany around the turn-of-the century. The derivative excess of erotic activity—carnality, murder, sado-masochism, dismemberment, hidden springs and caves, labyrinths, fetishism, death, and loss—was undoubtedly a significant component of Schwitters' *Kathedrale*, transforming the benign friendship caves and grottoes into allegorical plays concerning the fundamental nature (*Ur-grund*) of the human spirit and the struggle for the *Weltgeist* (World-soul). From this perspective, the wrestling match between good and evil, concentrated in and by erotism, locates itself in the ambiguous and incautious madness exhibited by admonitory romantic tales such as *Faust, Heloise and Abelard,* and *The Sufferings of Young Werther.* The events of the First World War, a broadly construed Faustian enterprise, exposed the eroticism of war, an endless orgasm of destruction that appeared to unify Europe in a universal death drive. Artists and poets who sought to articulate the tragedy of imploding humanity often gave up when confronted with inadequacy of language in the face of the inexpressible, a confrontation that led to a general protracted and inexorable sense of tragedy and longing (*Sehnsucht*).

While the search for the *Merzbau's* literary (hermeneutic) content could be endless, given the allegorical dimensions of the project, there are still other aspects of the project's context alluded to by Schwitters' use of the word *Kathedrale.* The artist was certainly aware of the ramifications of referring to the project as a cathedral; Schwitters used the image of a Gothic cathedral in his expressionist paintings and across the breadth of his Merz projects. The discovery of alchemical and hermetic associations in his work inevitably suggests that the cathedral was a significant site of interest for Schwitters who, like many artists and architects at the time, self-consciously referenced the Gothic cathedrals found in nineteenth-century romantiic painting and literature. According to H. H. Arnason, to invoke a cathedral during the nineteenth and early twentieth centuries was "... by definition a statement of the infinite and immeasurable ... [the paintings], filled with mysterious light and vast distances [where] human beings, when they appear, occupy a subordinate or purely contemplative place."[29]

Represented through painting's visual effects, the experience of cathedral space provided an even greater challenge to the normative dimensions of knowledge and thus the nature of human experience: time and space appeared as altered substances within its realm. Otto von Simson, along with Georges Duby the preeminent modern scholar on the subject of medieval cathedrals, describes Gothic cathedrals as densely arrayed articulations of

faith where "...the intimation of an ineffable truth [counseled by] the medieval cosmos was theologically transparent. The Creation appeared as the first of God's revelations, the Incarnation of the Word as the second. Between these two theophanies medieval man perceived innumerable mystical correspondences..."[30]

According to both scholarly and popular interpretations of cathedrals during the nineteenth and early twentieth centuries, cathedrals were thought to represent the lost cultural traditions of vernacular Christianity, an idea reflected in the concept of *Aufbau*. As previously noted, vernacular ecclesiastical (religious) symbols and icons—cathedrals, figures of Mary (mother and child), allusions to saints—are frequent occurrences in Schwitters' works. Schwitters also appears to have held a particular fascination for images of the Madonna, with several allegorical and iconic references to Mary recorded in his *Merzgedichte* and *Merzbilder*. (*figs. 47 and 48*) Though this book is not focusing on the images as a central component of his *Kathedrale*, at least two *Merzbilder* containing images of Mary, *Modemadonna* (1924) (*fig. 49*) and Madonna (ca. 1930) (*fig. 50*), along with sculptural forms referencing Mary and the Mother and Child, could be found within the inner recesses of the *KdeE*.

Gothic cathedrals also bear a significant relationship to the aspirant, mystical 'truths' reflected in alchemical and hermetic practices. The evidence of alchemical practice during the medieval period, in particular in the construction and social structures of cathedral building, extends well beyond rumor and legend. Instances of purported applications of alchemical transmutation abound, including many that were either absorbed into or borrowed from the ritual practices of Roman Catholicism. As an instance of the use of the secretive nature of alchemical processes, the original stained glass windows of Chartres Cathedral are thought to have been fabricated, at least in part, in accordance with alchemical practice. Despite contemporary methods of materials of analysis, the fundamental chemical composition of the glass remains unknown and there are no records of the chemical formulas used in making the glass. Glass was not the only material subject to alchemical processes, of course. As in Merz, all manner of materials were transmuted in some way, by altering their chemical composition or engaging in techniques (*Technik*) associated with the manifold secret societies that provided the labor and instruction for cathedral building.

To the medieval imagination, entering a cathedral was entering the residence of God and thus experienceing pure presence. Regarded as "Palaces of

the Virgin," their principle resident was Mary, the Mother of God, a vernacular tradition that remains in evidence still today.[31] Accordingly, cathedrals were constructed as allegories of the material and immaterial universe: nature, including the full range of human experience was thought of in terms of their correspondence to God's universe. Nature, art, human endeavor (works, creative production), erotism, birth, life, decay, and death were regarded as part of the manifold 'mirrors' (*specula*) of God's universe, mirrors indexed as '*nature*,' '*instruction*,' '*morals*,' and '*history*.'[32] Considered to be faith writ in stone, cathedral buildings were also recognized as practical *specula* and were thus understood as exemplars of the *unio mystica*, the integrated connectivity of all things in God's universe. In this sense they were didactic, manifestations of the organic plan of God's universe, albeit a plan that was first and foremost spatial and temporal. Instructions to the faithful were developed into a *literatum laicorum* (literature of the laity), a means by which the teachings and history of the church, the doctrinal evidence (stones) of faith were communicated. Living vessels of Spirit, and the site for the consecration of the flesh and blood of Christ and the spiritual residence many saints and figures that populate the annals of Roman Catholicism, Gothic cathedrals were vast *Wunderkammer*, visual and formal allegories that bespoke the transparency of God's universe.[33]

The allegorical texts contained within the cathedral noted the full range of human experience; in particular as it pertained to the spiritual journey of a life lived "in the light of the faith." Several emblems of spiritual journeying, including the Labyrinth, Catacombs, Stations of the Cross, and the temporal devices fitted into the structure and stones of the edifice, may have provided an additional impulse for Schwitters construction. As his principal allegorical production, the *Cathedral of Erotic Misery* mirrored the themes of birth, life, decay, degeneration, death, and regeneration found in the medieval cathedrals, all of which reflect the belief that life is essentially a journey of the Spirit. 'Palaces of the Virgin,' cathedrals dedicated to Mary, an ordinary woman granted the gift of receiving the seeds of eternal life. In vernacular Christianity, she is regarded as the principal Intercessor and arbiter of daily life, the singular source of creative redemption. At once the Mother of God and an allegory of nature, Mary was, as she remains still today, the primary countenance of faith in life.

The complex relationships of nature, life and faith described by Mary contribute to the hermeneutic content of Schwitters' *Kathedrale*. In 'advocating' Mary, Schwitters exposes his view of women in general: for the artist, women were the principal means of redemption, a spiritual journey that included the

excesses attributed to their erotic nature.[34] His fascination with the inscrutable "Anna Blume," a mosaic of alchemical and hermetic experimentation rendered, appropriately, in the guise of a female, exposes the artist's intentions for the *Kathedrale*. In Merz, she was regarded as a symbol of erotic desire, while in the *Kathedrale* "Anna," a mysterious figure who is at once material and immaterial, is the primary adviser for the fashioning of his redemptive enterprise.

Schwitters' fascination with women was, at least in part, an extension of his adoption of romantic and expressionist themes. The role of 'woman' in romantic and expressionist literature is widely noted, literature that almost universally describes women as childlike, empathic, compelling intuition and being intuitive, and prone to locate truth in the subject. Allegorically, women are considered givers of life, subjects of longing, fonts of emotion, vessels of eroticism, and the passive 'other.' In literature and art, the depiction of a particular woman or women almost always contains the potential for allegorical interpolation: 'she' can be alternately virgin, mother, whore or death.

The artist's most prominent and longstanding female subject is of course rendered in the figure of "Anna Blume," the 'woman' who preoccupied (some would say obsessed) Schwitters over the course of a number of years. Her name appears regularly in his literary work and correspondence, and her 'presence' was usually simultaneous with that of the artist, 'their' mutual visitation noted by the application of red and white "*Anna Blume*" stickers on walls, windows, and doors in the wake of the Schwitters' visits. Referencing his sexual experience and desire while acting as a stand-in for the intended recipients of his various flirtations, she ("Anna") is the primary focus of Schwitters' erotic desire and longing (*Sehnsucht*).

Beginning with the publication of his 1919 poem *An Anna Blume*, 'Anna' is alternately the Virgin Mary—Co-Redemptrix, Intercessor and *Mater Dolorosa* (Mother of Sorrows)—the Great Mother and Goddess of the Earth (Novalis), child, whore, muse, mother, nurse, and widow. Like James Joyce's Molly Bloom, Schwitters' inscrutable paramour, "Anna," a woman who was described as the same "backwards and forwards," adduced the inexpressible ambiguity of lack and fullness: necessary and ruinous to his soul, body and mind, she was at once benevolent and unloving, caring and unforgiving, here and there.

Novalis, in a dedication to his lost childhood sweetheart, Sophie von Kühn, a young woman who like Schwitters' Else and Dante's Beatrice died in her teenage years, explored the full range of emotion granted by a female subject. The poem, a tragic soliloquy of love and desire, is uncannily reminiscent of Schwitters' *An Anna Blume* :

You have awaked the noble urge in me
To gaze into the wide world's soul and meaning
I found a trust while on your kind arm leaning
That bears me safe through every stormy sea
Your perfect understanding nursed the boy
And went with him through worlds and fields of faery
And as a primal maiden sweet and merry
You moved his youthful heart to highest joy
In early frailties I am prone to welter–
And why? Is not my life forever yours?
Is not you love my refuge and my shelter?
Dear Love, I consecrate myself to art
For you, since you will be the Muse that pours
Her genius on my songs and fills my heart
On earth below we feel the secret power
Of song in forms and hues forever changing. ...

The citation of Novalis is not incidental. In an article written in 1948 entitled "Kurt Schwitters. Konstruktive Metamorphose des Chaos" (Kurt Schwitters. The Constructive Metamorphosis of Chaos), Giedion-Welcker suggests the intrinsic relationship between Schwitters' art and the works of the early nineteenth century German *Frühromantiker* (Early romantics), a group of poets and philosophers of whom Novalis is considered an exemplary figure. The works *Frühromantiker* are characterized by their inwardness (*Innerlichkeit*) and their high regard for mystical experience, intuition, empathy, and the pursuit of organic unity in nature and thought.

An attempt to induce a mystical experience (and perhaps compulsion), the lighting of the *KdeE*, tiny lights and candles used to negotiate one's way through the project, underscored the mysteriousness of Schwitters' *Kathedrale*.[35] That it was so dark (the painted, stained and boarded-up windows all but negated the use of natural light in the project) is somewhat difficult to fathom since Schwitters was thought to have used at least some of the space as a working studio. However, any large expanse of glass or wall surface was treated in a way that effaced any awareness of limits to the rooms and building as a whole, thereby enabling those that experienced the space to lose themselves within the mysteries of the experience. Reflecting a cathedral's diaphanous architecture, where all was "movement, music and light," Schwitters attempted to create a sense of otherworldly weightlessness that

resulted in an unimpeded (friction-less) emotional and spiritual response mediated only by multiple, sensory *Rhythmus* (rhythm)—a strong component of the focal awareness that characterizes mystical experience. With its labyrinthine density, hidden grottoes, mysterious light and disbursement of normative spatial and temporal distinctions, Schwitters' *Kathedrale* reflected the didactic *specula* (mirror) of instruction, morals, eroticism, nature and history, all of which found correspondence in the world of things. A *technological* enterprise (*Technik*) in the spiritual sense, the *Merzbau* was built to compel a revolution of spirit, space and time and thus a wholesale redemption of humanity.[36]

As noted by Lambert Wiesing in *Stil Statt Wahrheit*, Wittgenstein's discussion of *Lebensformen* and art, defined as the style or signature of things created in time and space, does not represent a specialized category or discipline that can be speculated on absent from the world in which it is found.[37] Rather, art, like the associations between language and the act of building, and other forms of life, is an activity that participates in and through which the intertwined array of communicative, resonant acts inseparable from the life-world (*Weltleben*). Fundamentally an activity and not a 'thing,' creative enterprise is primary to the artifact produced; it bears a vitality that exceeds the artifact in time and in space. In Merz, the effects, the 'work' of artistic enterprise, is unsettlingly diffuse, imbued with creative purpose by virtue of its being an activity, a participatory form of life where the edges of its speculative identity are inexact and imprecise. In his *Tractatus*, Wittgenstein suggests a similar condition when he writes of the mystical, albeit seemingly paradoxical, relationship between language and things in suggesting that the inexpressible can only "show itself." With the proposition, Wittgenstein encapsulates the "intuition" of the world as a "limited whole," whereby the world is radically indifferent to the operative effects that occur in the world.[38] It is a simple exercise to replace Wittgenstein's use of the phrase "limited whole" ("world") with the term *Merzbau*.

Similar to Walter Benjamin's "aesthetic of redemption," Schwitters' notion of a redemptive practice did not stand above or apart from life itself, but was deeply embedded in the nature of change. As such, form is conditioned by the contingencies of its coming into being as well as the circumstances of its present 'experience.' Manifest not of generalities, but particularities, *stil* (style), conveyed by the efficacy of (an objective) form, is a "limited whole" that can only be intuited or felt. Thus the 'time' in which a form—a work of art—is situated is not conditioned by the "logic of the

logos" (temporal reason), but is "limitless in the same way that our field of vision is limitless" (*Tractatus* 6.4311).[39] This is what is meant by Schwitters' attempt to "communicate the whole of life into art"; the objectivity exhibited by the work of art constitutes a limited whole, its laws, like the laws of *Lebensformen*, is present in accordance with its own terms.[40] The style of the object is manifest of its signature, a signature brought about through the experiences accrued in the course of its coming to be. Again, Wittgenstein: "Life can educate one to a belief in God. And experiences too are what bring this about: but I don't mean visions and other forms of experience which show us the 'existence of this being,' but, e.g. sufferings of various sorts. These neither show us an object, nor do they give rise to conjectures about Him. Experiences, thoughts, life can force this concept on us. So perhaps it is similar to the concept of object."

Objective form, an idea that is central to vernacular Christianity—the expression of which is found in the concept *Aufbau*—portends an art manifest of its own 'truth,' a truth that can not be generalized, but is specific to its context. It also rests on the belief that the object, like nature, pursues a developmental course that seeks its own sustenance, thereby functioning as a form of life. Merz, a form of life, required a consistent resistance to the imposition of external criteria: the work of art was autonomous and, like nature, unbiased. It did not promulgate universal, unyielding truths, but rather existed in each instance as an objective fact (form), a momentary and contingent 'truth.' In Merz, 'objective form' was the ultimate aim of artistic production. Accordingly, in the moment a work of art was realized, it was no longer subject to the artist's determination, but existed in and for the world as a 'limited whole': it could not be owned or governed (as property or according to any particular interpretation) anymore than a life-form or life-force (Spirit) could be possessed.

It should also be noted that Merz, despite its designation as a one-man movement, was not an isolated aside, but reflected ideas that have consistently influenced the development of successive paradigm-shifts. Resisting even the ownership of a process, Schwitters thought of Merz as a way of life, an idea that could be picked up and used by anyone who happened to come across it. In this sense, Merz was not a technique that required the initiate be trained to produce work in the manner of the artist or according to a set of rules. Rather, the function of Merz was to propel a new way of seeing and thus knowing the world which we are both suspended in and subject to. Like the sacred springs upon which cathedrals were built, the idea of Merz was and

is always present in some degree; the context may change, but the compulsive and necessary nature of creative action (in terms of Spirit) does not. Schwitters, in seeking the *Ur-grund*, challenged the notion of unadulterated, pure invention (an original idea) by implicitly partaking in a process of discovery that denied the need for individual genius: since the artist, like Nietzsche's God, was essentially powerless, he could no longer play the role of hero, but, consistent with an art 'being born' like nature, was given the role of nurse, shepherd or husbandman.

As many critics and associates of Schwitters have acknowledged, Merz was not an invention; nor was it intended as a project to be pursued in isolation. On the contrary, it was a movement that existed in and of the world in which it was found, the "limited whole" of events and circumstances that conditioned its context. Merz had a rather extensive lineage as well, borne of impulses that appear more prominent at different periods of human history than others, a discussion Jacques Barzun takes up in his attempt to recover the substance and significance of romantiicism in modern art and literature. According to Barzun, many of the ideas found in vernacular Christianity were subsumed into the project of romanticism—a movement that, in turn, has been absorbed into the modern project. Formulated in opposition to classicism's adoption of rules, principles, and order in its pursuit of a totalizing canon, romantiicism is a prominent, if suppressed feature in the development of modern art and architecture.[41] Unlike classical modernism's pursuit of transparency and universal application, however, romantic modernism, maintains a strong bias towards context and, in its more expressive forms, is characterized by the density and opacity of mysticism and intuited forms of logic.

Paradoxically, developments in modern science have largely depended on the recovery of these alternative, often paradoxical states of consciousness, evidenced by the pursuit of space-time, the development of non-Euclidean geometry and Heisenberg's uncertainty principle. In the early twentieth century, the linkages between mathematics and mysticism is found in twentieth-century esoteric literature, including the works of Madame Blavatsky, G.I. Gurdieff, and P.D. Ouspensky. While these and other individuals have been identified as seekers of alternatives to what is considered normal consciousness, developments in modern physics have also been heavily influenced by nature mysticism and esoteric knowledge, a condition noted by Werner Heisenberg and other fathers of quantum theory and abstract mathematics. It is perhaps no accident that art and science are viewed, in contrast to C.P

Snow's suggestion of "two separate and distinct worlds," as mutual necessities for the formation of new ways of thinking, seeing and apprehending the world in which we find ourselves. Medieval cathedrals functioned in much the same way. The production of an alternative model of reality depended on its context; as *specula* of daily life and inclusive of all forms and affects of life, cathedrals consisted "limited wholes" made up of temporal and spatial rhythms that sought to transgress the boundaries between that which was seen and not seen. The inducement of mystical compulsion so important to the experience of cathedral space was intended to spark (conduce) dynamic growth and change. Schwitters designation of the *Merzbau* as a *Kathedrale* explicates a similar vision.

According to medievalist scholar Georges Duby, Dante Alighieri's *Divine Comedy* was "the last great cathedral of the middle ages." Schwitters' *Merzbau*, the *Cathedral of Erotic Misery*, can be seen as an equally episodic correlate to Dante's trilogy. The humors of Dante's trilogy, along with its promotion of a path of redemption, are indubitable miracles of artistic creation. Like Schwitters, Dante's women—those that propelled and compelled his imagination—guided him on his spiritual journey. Bearing an uncanny relationship to Schwitters' "Anna Blume," the celebrated presence within Schwitters' *Kathedrale* and an equally distanced and distancing female guide, Dante's Beatrice is accorded the principle responsibility of leading the poet on a spiritual path of redemption through the later cantos of the *Commedia*. Constructed as a cathedral, the outcome of the Dante's journey is found in the *Empyrean*, the flower of heaven graced by the divine Intercessor and Co-Redemptrix, Mary. Yet while Beatrice shows Dante the way of redemption, an activity that is slow and evolving, he recognizes in her the benevolence and mysteries of common reality, focusing on the idea that love is an aspect of daily life, a simple unmediated actualization of an intuition. In recognizing her in this way, the poet affords Beatrice a particular kind of intelligence that could be apprehended, in the fell moment of something so simple as "the experience of the natural eyes of a laughing girl [Beatrice] in a city street."42 As in Schwitters' gathering of refuse and the apprehension of an idea through successive, accruing deformations, information, and reformations (*Formung* and *Entformung*), Dante's apprehension of this moment of coincidence represented a mystical transfiguring of a seemingly innocuous event, invested as it were with an intimation of something beyond its immediate facticity while remaining both wholly natural and mundane. Herewith, the physical and the symbolized, the visible and the invisible are adjoined; yet they are not entire-

ly sublated into one another, remaining at a threshold, distinct and discontinuous, outliving the momentary experience of their intuitive apprehension.[43]

Like Dante's references to moments of simple intuition and actualization, Schwitters engagement with the mundane, common material found in the course of daily life (tram tickets, packaging materials, pieces of children's toys, tree branches, news clippings, hamsters, and mice), as well as the spatial and temporal rhythms that inform life, at once harbor and exhibit Spirit. From this viewpoint, the investment of material with Spirit and, vice versa, the notion of Spirit manifest in the *Abfall* of daily life does not correspond to the hierarchy of worth found in classical aesthetics. Like romanticism, classicism's 'parallel reality,' Merz endeavored to formulate the horizontal communion of nature, life, and the World-soul (*Weltgeist*).[44] The pursuit of matters of Spirit—implied by Schwitters' analogy of art and religion—is reflected in the artist's choice of materials and subject matter.

Resisting the role of priest and magician, Kurt Schwitters understood the artist not as an acclaimed shaman, critical interlocutor, savior of society, or author of mimetic representations, but as an anonymous messenger and enjoiner of creative life for all humanity; an idea that is made indelibly clear in the artist's suggestion that "*Die Unsterblichkeit ist nicht jedermanns Sache*" (Immortality is not everybody's thing). An aphorism central to the artistic ethos of the late Joseph Beuys, a lifelong student of Schwitters' work and person, could be enfolded into this statement. Beuys, a late-modern German artist who was known for his own endeavors in *Abfall*, the spiritual nature of organic life, alchemical science and mysticism actively resisted art that represented the elite province of the privileged few or a recourse to social responsibility; for Beuys, as for the founder of Merz, "*Jedermann ist ein Künstler*" (Everyone is an artist).

NOTES

1 Webster, *Kurt Merz Schwitters*, p. 209.

2 Webster, *Kurt Merz Schwitters*, pp. 208-209. In Hannover's Sprengel Museum, it is fitting that a reconstruction of Lissitzky's *Cabinet of Abstraction* (*Kabinet des Abstrakten*) is adjacent to the reconstruction of the *Merzbau*. John Elderfield's analysis of the project is similar to Webster's.

3 Webster, *Kurt Merz Schwitters*, pp. 294-295.

4 Wiesing, *Stil statt Wahrheit*, pp. 10-11 and inclusive.

5 Ludwig Wittgenstein, *Tractatus Logico-Philosophicus*, ed. and trans. David F. Pears and Brian McGuiness (London: Routledge, Kegan and Paul, 1995), S. 6.522.

6 Piranesi's *Carceri* is allegorical, as are Dante Alighieri's *Divine Comedy* and the Romantic fantasms of William Blake.

7 Annegreth Nill puts it another way, shading Schwitters' "cause" with clear allusions to biblical allegory: "it is no longer an uninhabited landscape out there in front of us" that Schwitters deals with here. Rather, it is a landscape for living, a landscape that harbors the memory of its ideal, "the Garden of Eden, paradise." See Nill, *Decoding Merz*,, p. 214.

8 Schwitters, *Sturm Bilderbücher IV* (Berlin: Verlag der Sturm, 1920), reproduced in Herbert Lang and Cie AG, 1975. In his autobiographical essay, Schwitters stated that "*Grundzug meines Wesens Melacholie.*"

9 Sontag, *Under the Sign of Saturn*, (New York: Anchor Books/Doubleday, 1991), p.113.

10 See Susan Sontag, *Under the Sign of Saturn*, pp. 109-134. See also Julia Kristeva, *Black Sun: Depression and Melancholia* (New York: Columbia University Press, 1992) and Susan Buck-Morss, *The Dialectics of Seeing: Walter Benjamin and the Arcades Project* (Cambridge: MIT Press, 1989).

11 This condition suffuses much of nineteenth-century romanticism, in particular the youthful writings of Goethe and Novalis (Friedrich von Hardenberg). In what may or may not be a coincidence, a flower (*Blume*) symbolized the condition of melancholy— Novalis' famous "*blaue Blume*" [blue flower], found in his written expressions of grief for the loss of his "beloved Sophie," is a strong symbol for German literature even today.

12 Schwitters, *Sturm Bilderbücher IV*. Also see Schmalenbach, *Kurt Schwitters*, pp. 28-29. St. Vitus is the patron saint of epileptics.

13 Nill, *Decoding Merz*, pp. (314-329) (inclusive).

14 Walter Benjamin, *Reflections: Essays, Aphorisms, Autobiographical Writings*, ed. Peter Demetz (New York: Schocken Books, 1986), pp. 68-69.

15 Schwitters, "Ich und meine Ziele," *Das literarische Werk*, 5, p. 423 (tran. Jolas).

16 Schwitters, "Letter to Christof Spengemann, 24 July, 1946," *in Briefe*, p. 210.

17 Peter Szondi, "Walter Benjamin's City Portraits," in *On Walter Benjamin: Critical Essays and Recollections*, ed. Gary Smith (Cambridge, Massachusetts: MIT Press, 1991), p. 22.

18 Another interesting anecdote by Mies occurred on the occasion of Schwitters' visit to the architect's office in Berlin, whereupon Schwitters said to Mies: "I know you think I am insane, but let's do a book on architecture together." See Motherwell, *The Dada Painters and Poets*, p. xxvii.

19 Richard Wolin, *Walter Benjamin: An Aesthetic of Redemption* (New York: Columbia University Press, 1982), pp. 62-64 and inclusive

20 There were three *Merzbau* projects, each constructed on a different site and under different circumstances.

21 Webster, *Kurt Merz Schwitters*, pp. 278-305.

22 Begun in 1936, the second *Merzbau* in Oslo, a project Schwitters referred to as the *Haus am Bakken* (house on a slope) was destroyed in 1951, this time by a fire set by local children playing with matches. See Webster, *Kurt Merz Schwitters*, pp. 283-291, 397 Also see Dietmar Elger, *"L'oeuvre d'une vie."*

23 Webster, *Kurt Merz Schwitters*, p. 375.

24 Elderfield, *Kurt Schwitters*, pp. 222-23.

25 Elderfield, *Kurt Schwitters*, p. 221.

26 Webster, *Kurt Merz Schwitters*, p. 209.

27 It should be noted, however, that Schwitters' resistance to the intellectual, spiritual and physical hygiene expressed by the avant-garde movements *L'Esprit Nouveau*, constructivism and *Neue Sachlichkeit* (the "new objectivity") was never stated in ideological terms. Schwitters' adoption of visceral, tangible materials as artistic means was not a deliberate rejection of abstraction, but an affirmation of organic life. Where much of the Dutch, German, and Russian avant-garde began to move toward a reductivist, proto-scientific approach to art Schwitters continued to conduct his own research, interpreting and thus merzing the ideas of the constructivists and Neue Sachlichkeit for his own purposes. In the wake of Gropius' leadership at the Bauhaus, the ideologically, morally, and methodologically based 'science of art' was representative of the 'new objectivity.' For Schwitters, there was no contradiction between publishing the radical and precise urban programs of Ludwig Hilberseimer (*Merz 1 8/9*) and participating in the Dammerstock-Siedlungen, a 1929 housing exhibition (*Gebrauchswohnung*) dedicated to the principles of the *Neue Sachlichkeit*.

28 From this point of view, white is both the recovery of faith and the loss of faith, a simultaneous recovery and loss reflected in Doestoevsky's remarks upon viewing Hans Holbein the Younger's *The Body of the Dead Christ in the Tomb* (c. 1522). Julia Kristeva, *Black Sun: Depression and Melancholia*, trans. Leon S. Roudiez, (New York: Columbia University Press, 1989, pp. 106-138.

29 H.H. Arnason, *History of Modern Art* (New York: Harry N. Abrams, Inc, 1984) p. 20.

30 Otto von Simson, *The Gothic Cathedral: Origins of Gothic Architecture and the Medieval*

Concept of Order (Princeton: Princeton University Press, 1956), pp. 35-37.

31 There are numerous books on the subject. See in particular Marina Warner's *Alone of All Her Sex: Myth and Cult of Virgin Mary* (New York: Random House, 1983).

32 See Emile Mâle, *The Gothic Image: Religious Art in France of the Thirteenth Century* (New York: Harper & Brothers Publishers, 1958), tran. Dora Nussey. Originally published by E. P. Dutton in 1913.

33 Otto von Simson, *The Gothic Cathedral* .

34 Hans Freudenthal, Uta Brandes, and Klau E. Hinrichsen entertain Schwitters' women in *Kurt Schwitters Almanach no. 9*, eds. Michael Erloff und Klaus Stadtmüller (Hannover: Postskriptum Verlag, 1990). See Hans Freudenthal, "Von Herze gerne," "Briefe von Kurt Schwitters an Hans Freudenthal und Susanna Johanna Catharina (Freudenthal-) Lutter," "Annex," and "Kurt Schwitters und die Frauen." See also Ute Brandes' "Helma, Wantee, Käte, Nelly, Suze, Arren und andere," Ibid.

35 Webster, *Kurt Merz Schwitters*, p. 211.

36 The medieval marriage of technology and faith remains part of the contemporary land-scape of technological and intellectual production, producing a hybrid condition that underlies much of modernity's fascination with and belief in development—that of a 'faith' in the goodness (or rightness) of scientific and technological development. In short, "the technological enterprise has been and remains suffused with religious belief." While we may think of technology as a distinctly modern project, the technology of alchemy and hermeticism, remnants of which can be characterized in our contemporary attempts to constitute a "scientific faith" and conversely, abide by a faith in science is, at least in this context, also important to note. See David Noble, *The Religion of Technology: the Divinity of Man and the Spirit of Invention* (New York: Alfred A. Knopf, 1998), p. 5.

37 See also Lambert Wiesing, *Stil Statt Wahrheit*, p. 11 and inclusive, and Weeks, *Jakob Böhme*, p. 62-63.

38 Wittgenstein, *Tractatus Logico-Philosophicus*, 6.522,. cited in Weeks, *German Mysticism*, p. 236.

39 Weeks, *German Mysticism*, p. 236-237.

40 Lambert Wiesing, "Style in Philosophy and Art," p. 40.

41 Jacques Barzun, *Classic, Romantic, and Modern* (Chicago: University of Chicago Press, 1961). In his book, Barzun attempts to recovery the legacy of romanticism—critically adjudged to be escapist, solipsistic, and irrational—in the terms of modern literature and art. According to Barzun, intrinsic romanticism is a human constant.

42 Charles Williams, *The Figure of Beatrice: A Study in Dante*, 3rd ed., rev. (New York: Noonday Press, 1961), p. 230. In this case Williams is referring to Dante's poem of youth, *La Vita Nuova*, in which the figure of Beatrice plays a prominent role in the develop-ment of Dante's imagination.

43 Gamard, "Virgil/Beatrice: Remarks on Discursive Thought and Rational Order in Architecture," in the *Journal of Architectural Education*, v. 48, no. 3, February 1995 (Boston: MIT Press, 1995), pp. 154-167.

44 Plato's *Timaeus* and his discourses on aesthetics are primary sources for classical notions of art. According to Hofstadter and Kuhn's commentary on the *Timaeus, Phaedrus*, and *Republic*, Plato insists on a hierarchy of artistic modes whereby mimesis (the foundational formula for modes of representation in art) governs the 'worth' of various forms of artistic representation, descending from the that which most closely approximates the abstract 'idea' (poetry, music) to that which is two times removed from that ideal (painting). See *Philosophies of Art and Beauty: Selected Readings in Aesthetics from Plato to Heidegger*, edits. Douglas Hofstadter and Richard Kuhns (Chicago: University of Chicago Press, 1976), pp. 3-77.

INDEX